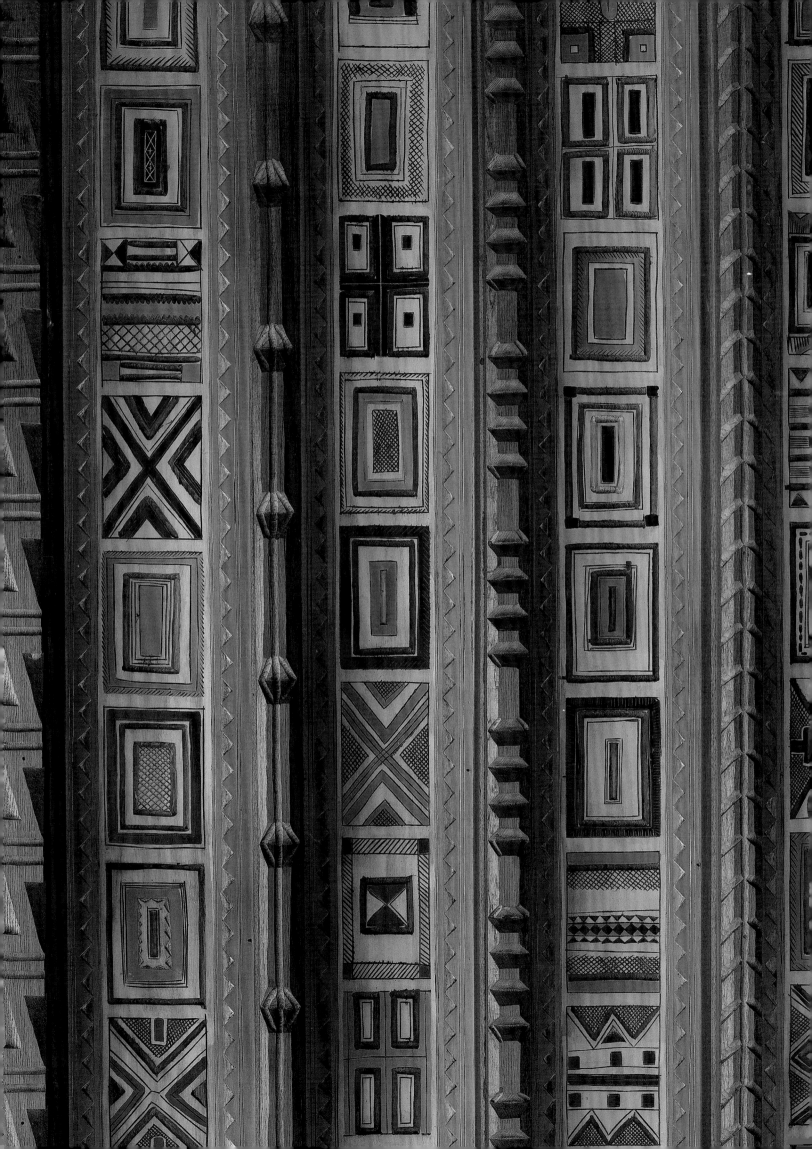

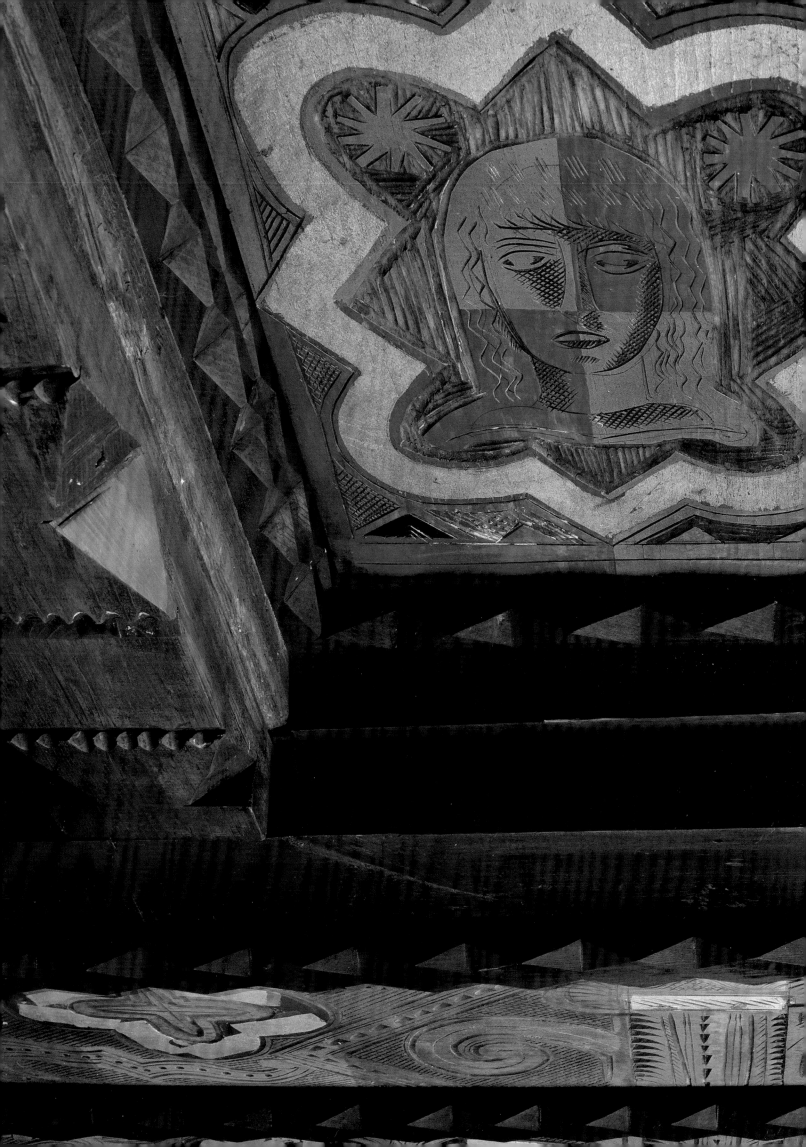

EDGAR MILLER #10 SOL KOGEN

EDGAR MILLER
AND THE HANDMADE HOME

Chicago's Forgotten Renaissance Man

RICHARD CAHAN
MICHAEL WILLIAMS

PHOTOGRAPHS BY
ALEXANDER VERTIKOFF

A CITYFILES PRESS BOOK

Published by CityFiles Press, Chicago
E-Mail: cityfilespress@rcn.com
Website: cityfilespress.com

Produced and designed by Michael Williams

ISBN-13: 9780978545055

First Edition

Printed and bound in Canada

To Mark Mamolen, Glenn Aldinger, Jannine Aldinger, Larry Zgoda and Bob Horn—who have kept Edgar Miller's work and spirit alive

CONTENTS

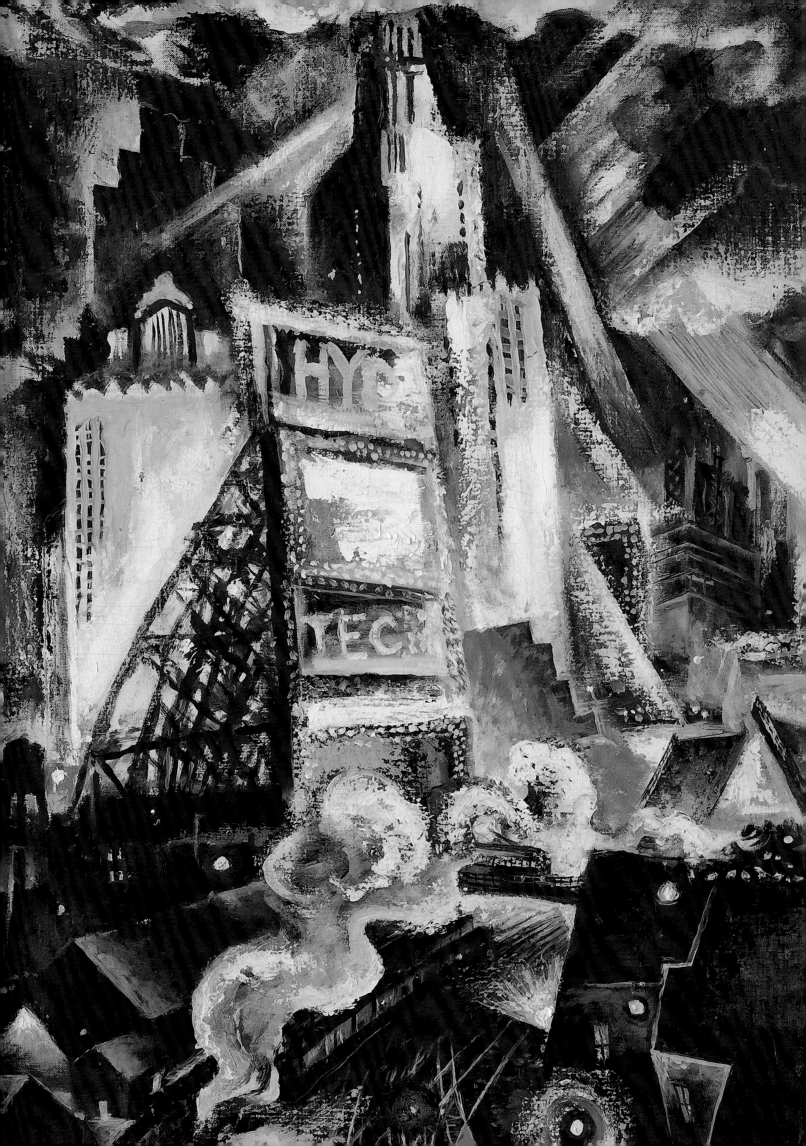

EDGAR MILLER'S CHICAGO
—AND MINE

ROBERT WINTER

I grew up in Elkhart, Indiana, just 110 miles from Chicago, in the very period in which Edgar Miller was doing some of his finest work. Actually, my family felt closer to Indianapolis, where my father was in the newspaper business and where my younger brother and I were born. My mother loved to shop at L. S. Ayres—and my brother and I loved to test out the department store's newly installed escalators—so we visited the city often. My greatest memory of Indianapolis is of seeing the fine houses on North Meridian Street, an experience certainly important in developing my interest in architecture.

Chicago is nearer to Elkhart than Indianapolis and was easier for us to get to by train. We had two choices of railroads: the main line of the New York Central, which passed through our town, or the South Shore Line, which we could catch at South Bend, just fifteen miles away. A ride on the latter was my introduction to the Great Depression, for as we approached the big city, we could see Hoovervilles, clusters of makeshift shelters and out-of-work men hovering over open fires.

The first trip to Chicago that I remember clearly was to the 1933 world's fair, A Century of Progress. We stayed at the Stevens Hotel, with its views of Buckingham Fountain. My brother and I wanted to go on the Sky Ride, an aerial tramway that carried fairgoers from one end of the grounds to the other, but our parents stood in the way of progress. The color and the conscious modernism of the exposition impressed me. In fact, I recently visited the few modernist houses that were saved when the fair was demolished in 1935 and were towed across Lake Michigan to Beverly Shores, Indiana.

What a thrill to see Fred Keck's House of Tomorrow and realize I had been through it in 1933.

We usually went to Chicago to visit the Art Institute, which spans the tracks of the old Illinois Central Railroad. I recall the wonderful El Greco that stood at the top of the grand staircase—though this memory remains largely because my brother and I chased each other up and down the stairs while Mother and Dad were enjoying the considerable collection of impressionist paintings. We were always drawn to the Thorne Miniature Rooms, not realizing that they were pure camp or that across the hall behind a door marked SCHOOL OF THE ART INSTITUTE were classrooms where some of the finest artists and architects in Chicago's history taught or would teach (including Ludwig Mies van der Rohe!). Edgar Miller could have been behind that door, but who was Edgar Miller? I had never heard of him.

My experiences in Chicago were not in modern art circles. They were in other, more conservative areas. A few times in my youth my family would get up early and drive to Chicago's Fourth Presbyterian Church to hear John Timothy Stone preach in Ralph Adam Cram's 1914 neo-Gothic masterpiece. We would follow his edifying message with a smorgasbord lunch at Kungsholm. On one occasion, my mother bought me a violin in a Chicago music store, and in my teens I took a few lessons from George Dasch, a violinist in the Chicago Symphony Orchestra.

I visited Chicago often when I was in the army and, after that, in college and graduate school, and I have toured it several times since then. But until about a year ago, I had never heard of Edgar Miller. I

EDGAR MILLER,
'POWER CITY,'
CIRCA 1930

am told by friends around my age (eighty-five) who grew up in Chicago that I should have, for he was famous in the late 1920s and through the 1930s. But these friends were artists or lived on Chicago's Near North Side, close to Miller's work. I was an outsider. Thanks to a course in American architectural history taught by Hugh Morrison at Dartmouth, I knew of Louis Sullivan's Auditorium Building (1887–89) on Michigan Avenue and his Carson Pirie Scott department store (1899, 1903) on State Street, but frankly I liked Raymond Hood and John Mead Howells's neo-Gothic Tribune Tower (1923–25) better. Still do!

My first acquaintance with Miller's work was when Alexander Vertikoff, the architectural photographer, told me that he had been commissioned to illustrate a book on Miller. Seeing Alex's pictures, I was struck by Miller's fount of ideas and his technical skill in rendering them into art.

When he came to Chicago, Miller entered a high culture. Born in Idaho Falls, Idaho, and raised in rural Australia, he appears to have been unusually receptive to the stimulus of a city that had recovered from the Great Fire of 1871 and whose intellectual and artistic life had blossomed since the World's Columbian Exposition of 1893. It was now the home of Jane Addams's Hull House and Harriet Monroe's *Poetry* magazine. Here Louis Sullivan had developed an aesthetic of the skyscraper. John Dewey, the educational philosopher, had left his stamp on the great University of Chicago. Influenced by the Armory Show, which moved from New York to Chicago in 1913, Chicagoans gave abstract art an importance that had been recognized earlier by only a few, Arthur Jerome Eddy among them. Chicago might be the hog butcher for the world, but it was also a garden of ideas.

When it comes to the effect of the Chicago progressives on Edgar Miller, one can only speculate, something that historians hesitate to do but that Miller actually encouraged. We know that he exhibited in his studio the works of Lyonel Feininger (1871–1956) and the Chicagoans Rudolph Weisenborn (1881–1974), John W. Norton (1876–1934), John Storrs (1885–1956) and Edward Millman (1907–64), and it is not difficult to spot their influence on his work. His designs for art glass seem to have

been affected by Weisenborn's essays on abstraction as well as those of Storrs and Feininger. On the other hand, the social realism of Millman and Norton appears to have been a direct influence on his black-and-white work in linoleum at the Standard Club.

A major force in his life was Alfonso Iannelli (1888–1965), a sculptor who hired Miller to work in his studio and taught with him at the School of the Art Institute in the early 1920s. Iannelli seems to have broadened Miller's knowledge of cubism. Miller followed Iannelli into art deco and streamline moderne at the same time that he absorbed more conservative influences. Certainly his bas-reliefs show signs of Iannelli's abstraction.

Miller said that he had been introduced to and then ignored by Frank Lloyd Wright. He returned the compliment. Nothing in his decorative vocabulary or his occasional forays into architecture suggests the influence of Wright, although Miller worked for other Prairie school architects such as Barry Byrne, one of Wright's first understudies who had developed his own style by the 1920s.

But limiting Miller's sources to his contemporaries is an injustice. A hard look at his work will make clear Pompeian, Byzantine, medieval, Chinese, North American Indian, Spanish baroque and even Ashcan school references. The Art Institute, whose collections Miller knew well, held plenty of ideas for him to draw upon, ideas that a sensitive person could not help but be inspired by. Housed in a Beaux-Arts building erected as an annex to the World's Columbian Exposition by the Boston architectural firm of Shepley, Rutan and Coolidge, the Art Institute was already one of the nation's major art museums thanks to the donations of several rich Chicagoans.

What concerns us, however, is what Miller did with the ideas he gleaned from these many sources. He was an eclectic who, in the words of T. S. Eliot, did not borrow but stole the ideas of others and made them his own. He could not even imitate himself. His details are, when examined carefully, different from each other even when they seem to harmonize. Every spoke in a staircase is different from every other in some small way.

And he made everything himself, from

CUT-LEAD WINDOW,
LAKESIDE PRESS
BUILDING, 1926

idea to completed object. He evokes the spirit of William Morris, the father of the arts and crafts movement at the turn of the century, in his versatility. That he was conscious of this fact is made clear in a passage from his unpublished book: "Our visual culture has suffered from fragmentation by a mechanical technology and a purely commercial point of view. Our economy has reached a point where we can no longer afford the luxury of handicraft, unless we do it as a hobby, ourselves. From the Victorian period we have inherited a polarization of the arts—Fine Art, and denigrated 'Applied Art.'"

Miller goes on to identify himself with Morris: "This version of culture is somewhat similar in intent to the idea of William Morris, who felt that the use of decoration was to establish a delight in our form akin to the delight felt in nature, where a dish or implement would be as natural as something from the woods or mountains, as comfortable to hold as a piece of fossil coral or water-washed stone."

Miller became skilled in even more media than had Morris. Those who believe that the arts and crafts movement died somewhere around 1915 must take a look at Miller's theory as well as his work and reconsider their convenient interpretation of history. Miller was a craftsman until his death in 1993.

I wonder whether I could live in one of Miller's apartments or work or play in one of his other buildings. It would be fun to try, but would I be intimidated by so much going on? Where could my eyes rest?

But his work is great spectator sport.

Robert Winter, a fellow of the Society of Architectural Historians, has spent much of his career studying the arts and crafts movement. He lives in the historic Batchelder House in Pasadena, California, and is the author of *Craftsman Style, American Bungalow Style, At Home in the Heartland* and several other books.

Chicago's Forgotten Renaissance Man

The Renaissance artist was expected to be versatile and expert, too. He didn't leave it up to some workmen to solve the problems of execution from his scrawls on paper.

EDGAR MILLER USED
RECYCLED MATERIAL
TO TURN OLD HOMES
INTO WORKS OF ART.
HE CALLED IT A
'SOCIAL ADVENTURE.'

The noontime lecture was packed. The subject was Edgar Miller. It was one that attracted fans of Chicago architecture because Miller was a mysterious figure in their cultivated world. The designer and builder of some of the city's most original architecture, Miller was not even an architect. Though some in the crowd were distant admirers of his art and life, most were merely intrigued, a few even skeptical. None had a hint of the whole story.

The lecturer matter-of-factly recounted Miller's long career. Slides gave the audience a chance to see Miller's art and architecture hidden behind courtyard walls. Many had encountered the stained-glass weasels peering out of Miller's studio complex on Chicago's North Side or the tile mosaics he once inlaid in the sidewalk out front. These were throwbacks to another time, which likely led some in the crowd to assume that Edgar Miller was long dead. So it was quite a surprise when a fan, who spotted Miller in the back of the room, rose and asked: "Why not let Edgar speak?"

Yes, indeed, there was Edgar Miller, sitting silently. A series of small strokes had weakened him. The frail ninety-three-year-old had not spoken a complete sentence in weeks.

The room quieted, and attention turned to the white-haired man in a black beret. Later, Miller's friend, a physician, speculated that adrenaline must have shot through his body at that moment because suddenly he began to speak—slowly and coherently. Here was Edgar Miller of old. Smiling, charming, funny. Without prompting, he talked eloquently about his life and his art for the remainder of the hour. He spoke as though he knew this would be his last chance to share the ideas that had guided him. It was.

Edgar Miller was Chicago's forgotten Renaissance man.

In a technological age, he embraced old-world skills with strong hands toughened by a lifetime of work. He was a fine painter, a master woodcarver and one of the nation's foremost stained-glass designers. He could sculpt and could draw haunting portraits, and he was considered a pioneer in the use of graphic art in advertising. In the 1920s, he was called "the blond boy Michelangelo"; in the '30s, "a new luminary" by *Architecture* magazine; in the '40s, "one of the most versatile artists in America." By the 1950s, he was the go-to guy for the nation's most successful industrial designers. Later in life, he proudly considered himself a "big thinker."

Born two weeks before 1900, Miller produced art almost every day of every decade in the twentieth century, art marked by spontaneity, originality, resourcefulness and workmanship. His skill and talent were recognized in his time, but he is now largely overlooked because his work does not fit into a single artistic tradition or style. And because his art was meant to hang not in museums but in the homes he created.

Edgar Miller's genius reached its apex in four fully realized artistic studios that he built on Chicago's North Side in the 1920s and '30s. Miller marked almost every inch of the studios with daring and surprise. He took rustic brick, crude stone, salvaged tile, found glass and recycled steel and wood and "Edgarized" the homes, packing them with stained-glass windows, frescoes, murals, mosaics and woodcarvings. He worked on the homes with the same fervor that Antonio Gaudí brought to his Barcelona church or Simon Rodia to Watts Towers.

Remarkably, the homes are still here. Their owners show a relentless drive to keep Miller's masterpieces as original as possible, and their residents are weary of leaving. They trade modern comfort and conveniences for the opportunity to live in Miller's lyrical monuments. The homes have changed over the decades, but much of Miller's work—and the spirit he brought to each home—remains.

In the manner of England's William Morris, the founding master of the arts and crafts movement, Edgar Miller strove to create a total work of art in his four houses.

Miller's homes are the Chicago equivalent of Morris's eighteenth-century Red House in suburban London. Morris emphasized craftsmanship because he rejected the machine age. Miller embraced craftsmanship to honor the natural world. As had Morris with his Red House, Miller created environments that were "more a poem than a house, but admirable to live in, too."

Miller, like Morris, was a doer, not afraid to try anything artistically. "If you don't change the air in your lungs, you die," he once said. "If you do not experience all the changes in growth from childhood to maturity, you are a moron." That was how Miller talked: in absolutes, with the distinct western lilt of his childhood and a confidence he developed over the years. On the surface, art seemed to come easily to him, but he worked at it every day. Attempting to master so many mediums took courage. "Your rationalizations will give you good reasons not to do things," he confided to a young friend in the 1980s. "Rationalization is a thing that can destroy courage, particularly where something has to be decided. There's always a damn good reason why you shouldn't do things, and you either have to give in to it or break through it. Every time you break through it I think it's easier the next time."

Because he caught on quickly to the inherent nature of materials and could organize a two- or three-dimensional space in a totally unaffected manner, Miller was able to work in dozens of disciplines and multiple styles. "I accepted influences from any place," he wrote unabashedly. But like any accomplished artist, he processed what he saw and made it his own: "Influence is nothing but nourishment, and you grow by it," he wrote. "To be afraid of influence is like being scared to eat."

Miller considered himself a worker first and foremost, and he was determined to leave something behind. He wrote often about improving society and felt he was in a constant struggle against art critics, who were not able to comprehend art's role. "So to hell with 'em," he wrote. "Long after they're dead there will be things made by people who loved the world enough to want to help build it. And the survival of what they made is reward enough." Creativity is exhausting, he said, but necessary.

Miller's creativity centered on a simple message: nature is a science that shouldn't be defied, and the world should respect and learn from nature. It was a lesson learned from his father, a beekeeper rewarded with bounty for making life easier for his bees, and as a boy headed to the lava fields of Idaho on expeditions with his brother. The flowers and fauna young Edgar encountered became the building blocks of his art, his lifelong motif. Miller's admiration of nature was so basic that at first it did not seem profound, but it was a theme that occupied him all his life. "Why animals?" he was asked in 1989 by a woman curious about the creatures that dominated his art. "To me, they are life," he replied. On another occasion, a friend asked him how he was able to design the artificial trees for Monkey Island at Brookfield Zoo in suburban Chicago. "I am a monkey," he said.

Miller was not an environmental visionary but a practical man who learned from those who made use of every last piece of material. That's how Miller built his homes, by turning discarded bathroom tiles into a new roof and rearranging salvaged brick to create ornamental walls. Miller's recycled houses point to a new architecture, but it has taken us decades to fully understand them. Miller found beauty and utility in reusing material and thought it tragic that we were tossing out so much. "I've seen the lake in Chicago as a beautiful, clear body of water that you could dip a tin cup in and drink from," he said, "and now I see it floating with dirty newspapers and garbage. No bird defiles its own nest. Man is the only stupid ass that does that."

Miller understood that he was born with a gift, and he felt a lifelong responsibility to use his skill to communicate what was inside him. "The artist takes impressions from life about him, reorganizes them within himself to have form and meaning, then expresses them," he wrote. His entire life was a never-ending search for the meaning of art. Near the end, he believed he had grasped the secret he had long sought, but he was frustrated that he could never adequately put his thoughts on paper. "It is not that I feel the artist to be a 'superior' kind of creature, merely one that has reserved judgment until he sees the whole picture," he wrote. "It may take more than one lifetime."

A Boy from the West

Edgar Miller was an all-American artist—at least by lineage. His father and mother each traced their roots in the New World to before the Revolutionary War, and both sides of his family headed west early. In a 1936 biographical sketch, Edgar wrote that he was 75 percent English, with a "touch" of Scotch and a "dash" of French.

Edgar's father, James Edgar Miller, was born in 1857 and migrated west from Michigan's lumber country, striking out for Oregon as a young man. He wasn't the first of the Millers to do so. Most prominent of his father's family was Joaquin Miller (1837–1913), a Pony Express rider who became a well-known poet and essayist. Joaquin, known as the Byron of the Rockies, was called "the greatest-hearted man I ever knew" and "the greatest liar this country ever produced" by fellow writer Ambrose Bierce. Joaquin is remembered today by two homes that still stand: a rustic log cabin he erected in Washington, D.C.'s Rock Creek Park and a frame home built among the thousands of trees he planted in the foothills east of Oakland, California.

James Miller, according to family stories, dropped out of school in fourth grade because he was too independent a thinker. In Oregon, he met a man who was a watchmaker, a jeweler and an engraver—work that interested young James. He moved to Eagle

Rock (as Idaho Falls, Idaho, was then called) around 1878 and opened a small jewelry store. This was the first of many jobs. He worked for years as the watch inspector for the Oregon Short Line Railroad and traveled to Alaska during the Klondike gold rush in the late 1890s to sell provisions to miners. Around the turn of the century, he completed a correspondence course in optometry, and he later became a beekeeper.

Edgar's mother, Hester Elizabeth Gibson Martin, was born in 1864 in Missouri. She was a schoolteacher who taught Choctaw Indians in the Oklahoma Territory before following her brothers and sister to Idaho, a land known during the nineteenth century as the Great American Desert for its inhospitable conditions. Hester, slender with red hair long enough to sit on, was a mix of strong western pioneer and proud eastern nobility. She used a broom to save little Molly Porter, whose sled slipped onto the partially frozen creek behind her Idaho Falls house, and took her children on her own to Seattle, Washington, to visit the Alaska-Yukon-Pacific Exposition, the world's fair of 1909. But Hester never forgot her colonial link, tracing her family back to Elizabeth "Betsy" Fauntleroy (1736–92), who as a teenage Virginia socialite turned down two marriage proposals from young George Washington. "Mother was a lady," Edgar recalled. "She was hung up on names and lineage." She named her youngest son Fauntleroy. "Mother had the unbelievably silly idea of dressing me in a black velvet jacket," Edgar said. "Out in Idaho's cattle country that was ridiculous, and I was always picked on and chased home almost every night."

Hester and James married in 1895 and had five children: Lucile in 1897, Edgar (actually named James Edgar) in 1899, Frank in 1900, Hester in 1903 and Fauntleroy (thankfully known as Eugene or Buddy) in 1906. (Vistula Miller, born in 1887, was listed in the 1900 census as James Miller's first daughter, but she is not mentioned in any family history.) According to a "cradle roll certificate" that Edgar kept, his parents were members of the Presbyterian Church, although religion was never a major part of family life. Edgar recalled one trip to church. "We passed a hobo that had come in on the night freight from Butte, Montana. His denim outfit had been grimed black by the soot and cinders, all except a white ring around his mouth,

JAMES EDGAR
MILLER,
CIRCA 1905

20

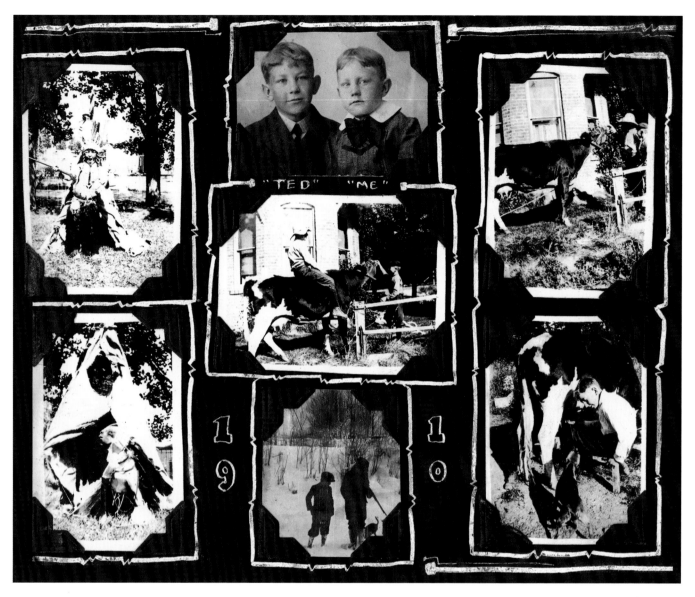

"TED" "ME"

19 10

licked clean by his tongue. Father gave him fifty cents and remarked with humor to the Reverend McDonald, 'There goes your offering.'" The minister was furious. "That was the last time I went to Sunday school."

Edgar loved the West. He never lost his western accent, informality or way of dress and was greatly influenced by his nearby rugged relatives. Cousin Ladd Wright was a local rodeo star who could use a lariat to bulldog a steer. "He was my Hopalong Cassidy," wrote Edgar, who later named a son Ladd after Wright. Aunt Bet Martin devoted her life to helping others, driving her buggy into the foothills of Idaho Falls to tend those suffering from quinsy, smallpox or diphtheria or to wash and dress the dead and bring them into town for funerals. His aunt Josie Martin, who as a girl survived a massacre on a wagon train bound for Oregon, used to invite Edgar to her ranch at Thanksgiving and

take him on cattle drives. Wearing a ten-gallon hat and beaded vest, she killed rattlesnakes with her six-shooter. "To her, this was as simple as swatting a fly," Edgar wrote.

Most of Hester and James's children showed artistic talent. Lucile became a lapidary artist, Frank a skilled woodcarver and young Hester an esteemed church decorator and (as Hester Miller Murray) an artist in the 1930s Works Progress Administration. But from an early age, Edgar showed special ability. "I started drawing as soon as I got hold of a pencil," he wrote. Frank recalled that his mother left baby Edgar with a pencil and paper in his father's optometry office when she went shopping. She returned to find he had filled the page with pictures, including of his father's pocketknife, complete in every detail. Edgar said his first drawing was of the Indian on the Indian Head penny.

About age four, Edgar decided to

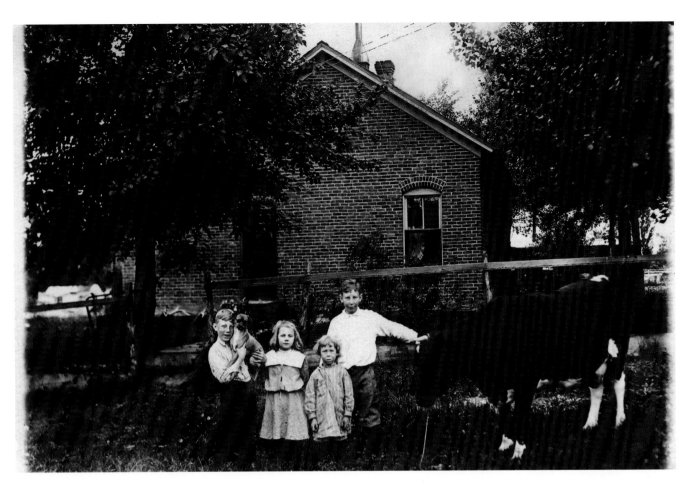

become an artist after he saw a painting at the old Brooks Hotel of George Armstrong Custer's last charge against the Lakota and Northern Cheyenne Indians at the Battle of the Little Bighorn. "I did not know that this morning's happening would determine the pattern of the rest of my life," Edgar later wrote. The painting, probably a lithograph published by Anheuser-Busch, filled a large section of the hotel's saloon. Gazing upon it, young Edgar could not move; he was rooted before the painting. He could feel the grate of the scalping knife on the skull of a cavalry soldier, could hear the victory yell of the warriors and could sense what Custer had—the wind and bullets whipping through his hair. "I could also feel the triumph of the Indian, who was taking care of the invaders of his land," Edgar wrote. The boy stayed an hour after the last spectators left. "Here I was able to get inside each character, and look out his eyes to see what was happening," he wrote.

The experience was absolute. "This was the richest, most exciting slice of life I had ever seen and then and there decided that by God, come hell or high water, I could imagine no other existence than to be an artist."

From then on, art flowed. "My oldest brother was a genius so we all sort of held him in awe," wrote sister Hester. At eight, he began carrying a sketchbook and started making pottery. With the help of his father, Edgar fired clay in a makeshift studio in the family's root cellar. "I made a little vase for mother's birthday and fired it in our heating stove in the red hot ashes," he wrote. Later, he added: "Nothing of any real distinction was produced in the studio. But I was sure that one of these days I would be doing real pottery and that I already knew how."

At nine, Edgar completed intricate pen-and-ink drawings of kings, queens and knights to illustrate his favorite poems, Alfred Tennyson's *Lady of Shalott* and Henry Wadsworth Longfellow's *Skeleton in Armor*. At eleven, he took a job as an apprentice with a local architectural firm, where he added watercolor backgrounds to the architects' renderings to give them a competitive edge. He created dozens of sculptures with the soft rock he found around town, and he gave himself hundreds of white scars on both hands from years of whittling.

"Mother and father had long since ac-

cepted the fact that Edgar was different from other children, and had to receive special consideration," Frank wrote. "Mother being a school teacher managed this problem in such a way that none of the rest of us felt inferior, or less loved. We all accepted his uniqueness and understood the reason for the different treatment. His unusual artistic talent was so obvious and increased so rapidly and made our lives so interesting that we felt privileged to have him as a brother."

Idaho Falls, a town of almost thirteen hundred people in 1900, was Edgar's first inspiration. It was an idyllic place to come of age. All of Edgar's art, his motifs and vocabulary—his love of animals, nature and history—was born from the experiences he had in southeastern Idaho as a boy. Idaho Falls, he wrote, was "a city full of interesting things," from where he could see the Grand Tetons in the distance and tiny desert plants up close.

The Millers lived at the southern edge of town on six lots along Crow Creek, a small but strong current that powered a sawmill and electrical plant to the north and emptied into the nearby Snake River to the west. The creek—filled with trout, silversides, suckers, bullheads and crawfish—flowed so rapidly that it never completely froze in winter. Edgar used a willow pole and string to catch silversides, which his mother would roll in cornmeal and fry for dinner.

Buttercups and sedge flowers grew near the creek, and many other wildflowers grew near the Millers' well at 416 Placer Avenue. "My greatest enthusiasm as a boy was for the wildflower," said Edgar, who went on to draw flowers throughout his life. At the top of the hill on the family's property was a cabin, where two workmen lived. One played the accordion in the evenings, and his melodies drifted down.

"The time was at the ending of the Victorian era, the beginning of the movies,

EDGAR'S CHILD-
HOOD SKETCHES,
CIRCA 1910

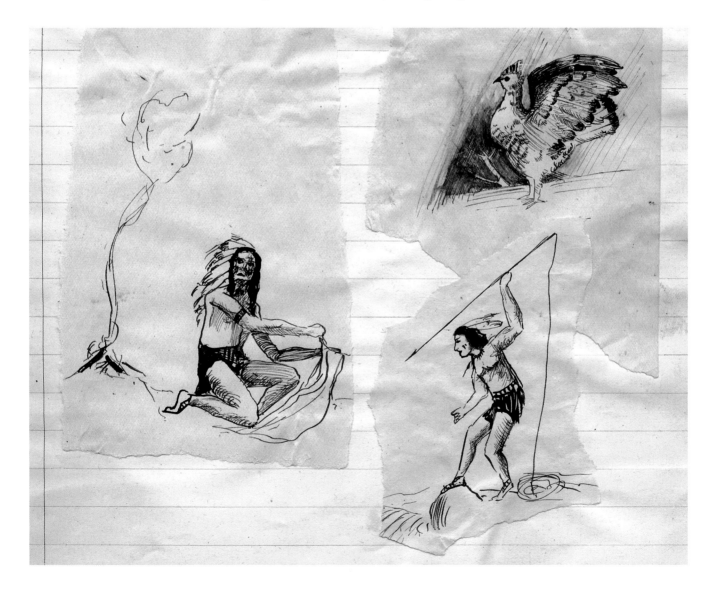

the phonograph, the telephone, and the automobile," wrote Frank, who recalled watching two-reelers with his family at the Dime, Scenic and Rex theaters and remembered the family phone number: 207 Red. Immense wheat harvests helped Idaho Falls grow during the first years of the new century, to almost five thousand by 1910. A dam was installed on the Snake River that created something of a real "falls" in town, Broadway Street and Park Avenue were paved, and cement sidewalks were constructed. By 1907, the town had its first car, an Olds Runabout owned by Dr. Bridges, Edgar's neighbor. "We ran out in the middle of the street when the car had passed to smell the new magic odor of gasoline," Frank wrote. Life was changing in Idaho Falls.

As a child, Edgar was a bookworm. He read Shakespeare, Scott, Kipling and Longfellow before he was nine. He didn't like baseball or football, marbles or spinning tops. "Who kicked, batted, tossed, sunk, threw, or caught a ball, was completely meaningless and irrelevant as far as he was concerned," said Frank. "Running and jumping the same." But walking was different. By the age of four or five, independent Edgar was sneaking away from home and roaming Idaho Falls for a few hours. Within a few years, he would head out of town and wander across the lava beds to the west or the sand dunes to the east. Hikes were a perfect way for Edgar to study animals, birds and flowers. His only problem was finding a companion. Most of his boyhood friends were timid, worried as soon as they couldn't see Idaho Falls in the distance. So Edgar usually took his loyal younger brother Frank. Once, they hiked with an older friend twenty-three miles northeast to Heise Hot Springs, returning the next day. But mainly they were long day hikes, most often in search of arrowheads among the sagebrush and wildflowers on the east side of the Snake River.

"After a day of rambling we would return before dark to tell our worried but understanding and caring mother, whose only complaint was the condition of our shoes and clothes," Frank wrote. "She seemed to enjoy the enthusiasm of the two hungry little boys, as they related the adventures of the day. The caves in the lava beds where ferns grew, and pools of clear cool water. The currant bushes, the struggling cedar trees, and, of course, the ever present sagebrush whose

aroma saturated our clothing."

Edgar and Frank spotted snakes, lizards, coneys and cottontails, and listened to the distant howl of coyotes. "We always saw magpies and hawks, and sometimes eagles," Frank wrote, as well as sage lilies, ground phlox and beautiful sand lilies in the dunes. Early on, Edgar would draw what he saw from memory when he returned home, but later took to his trusty sketch book. He recorded everything—birds, cloud formations, mountains. He started by using pencil and soon added watercolors.

Not all of Edgar's environmental lessons came from the field. His father taught him about the relationship between man and nature. "Father was a bee man, and in the prosperous hive all the bees were provided for," Edgar wrote. "In nature, no one is left out, he simply becomes part of some living form. If he loses his 'place' in nature, his living substance becomes part of another life, but if he finds his place in his 'kind,' everything is generously provided." Edgar's father made for his bees a home that protected them throughout the year. This required hard work, money and remarkable expertise. "Father saw his work with the bees as nearly an extension of nature's pattern as he could devise," Edgar said.

To reinforce his lessons about nature, Edgar's father gave him a bay pony—"my first intimate friend"—when Edgar was seven. Named Winnie for the roan beloved by the highwayman in Lorna Doone, one of Edgar's favorite books, she was "small and mischievous, almost affectionate," Edgar remembered. The horse had been "gentled" but was not ready to accept a bridle and saddle. Unsure if his father understood Winnie's status, Edgar determined that he would break her. Winnie was kept in the family's barn, about eighty feet from the creek that flowed past the property, and it was Edgar's job to clean her stall, give her hay and take her to the creek for water. But Winnie promptly bucked Edgar off when he tried to ride her and trotted to the creek by herself. "This program was repeated every day and I managed to stay on her back longer with each encounter," Edgar wrote. "Whether her bucking began to diminish in its intensity of purpose, or whether I learned the knack, I was finally able to ride her bare back. The affection for her became a definite part of me from that time"—and horses came to figure

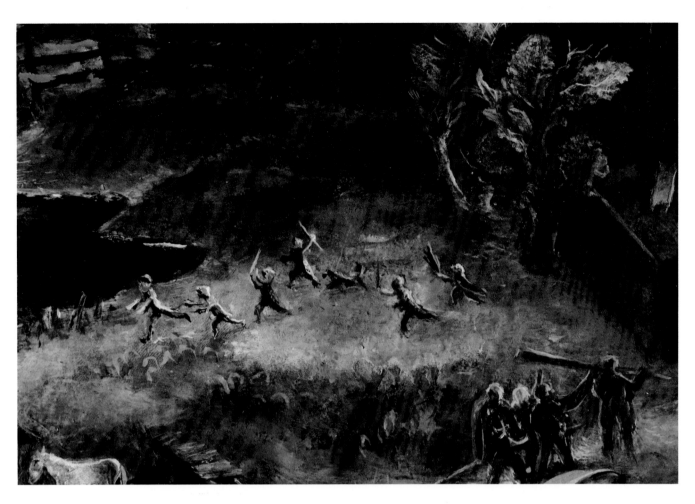

prominently in his work.

It was not just nature that caught Edgar's attention. The cowboys and Indians who lived around Idaho Falls particularly intrigued him, and he somehow sensed that they wouldn't define the West much longer. Edgar wrote that he was pleased he lived in a time when "cowboys were just anybody in Idaho, not a novelty, and not a romantic figure" and when Indians lived in and passed through town. He was proud that he knew the inside of tepees, where acrid sagebrush smoke burned his eyes. "When I was around eight years old, I would walk all over, looking at nature and animals, and go off and visit the Blackfoot and Bannock Indians, who were fishing and hunting up and down the Snake River," he wrote. "While they were dancing or performing their ceremonies, I would sketch them." Edgar drew the hairdos and headdresses, with their detailed beadwork and designs, but was eventually asked to leave when his sketching attracted too much attention. "I left with as much dignity as possible."

Because Edgar lived in his own world, and because art and reading came so easily,

he was disliked by classmates and some teachers. He was a natural speller, fast at math and superior at history, having supplemented his favorite subject by reading library books. "My brother's difficulties in school were caused by his photographic memory, and creative ability," Frank wrote. "We had long accepted the fact that he was different, and it was not a problem in the family. In school, however, it caused great annoyance to the students and teacher alike. He would read his books at the beginning of the term, and spend the rest of his time in class drawing. This was distracting to the students and irksome to the teacher. The fact that his answers were always correct and sometimes came from a different source than the school books added to the general annoyance."

That made Edgar a natural target of both boys and girls. One group, which Edgar identified as the Boy Scouts, frequently chased him, especially when he put their woodcarving skills to shame. Edgar could usually outrun them, but one day he decided to make a stand. After the leader and his "toadies" attempted to push him down, Edgar clipped the bully on the side of the head

with a handmade tomahawk, knocking him senseless for a few minutes and shaving off a section of black hair.

Girls were more difficult to fight, especially Babe Campbell, who lived on Edgar's way home from school. When Edgar was in first grade, the older Babe had tried to grab one of his yellow curls, but he had bitten her to escape. Undaunted, Babe and her high school girlfriends set an ambush for Edgar in an alley near school. "One of the girls urinated in a bottle and I was given a shampoo with incidental slaps and hair pullings, and turned loose to go home," Edgar recalled. "This was a day of shock for me. The picture of the world painted by mother insisted that women and girls would never act like that and the greatest shock came when I told her what had happened and how I had bitten Babe on the wrist. Mother was silent for a few breaths and then she exploded. 'That whore,' was all she said, and I didn't know that mother even knew those words that I had heard from a hired man long ago. If anything 'developed' out of this happening I never heard, and in a day or so I had forgotten most of it." Babe was later sent to reform school in Indiana. This incident, together with the Boy Scouts attack, was remembered in several of Edgar's paintings.

Of all that Edgar took from Idaho Falls, though, nothing compared with what he would learn from Jo He, a mysterious stranger whom Edgar met only a few times.

That Crazy Old Coot

Stories and rumors swirled around Jo He, the old man who lived behind the fence of shining tin cans in the last house at the edge of the sagebrush south of town. Children were afraid of him and knew beyond question that his wife was a witch. Most townspeople were convinced that Jo He was a Danite, an avenging angel of the Mormons, and kept their distance.

Ozro French Eastman, born in 1828, was the son of Joseph Eastman, who converted to the Church of Jesus Christ of Latter-day Saints and moved his family to the Mormon settlement of Nauvoo, Illinois. They were among the thousands forcibly exiled to Nebraska during the continuing war against the Mormons. Though never baptized into the church, Ozro Eastman

joined the Mormon leader Brigham Young and 148 other pioneers who trekked west and founded Great Salt Lake City in 1847; he was one of only five non-Mormons on the journey. After building a home, settling in Salt Lake with his family and establishing the city's first harness shop, Eastman moved on to Eagle Rock in 1884. He and his wife, Mary, had ten children, all of whom had left home by the time Edgar was born.

Jo He was the first man James Miller saw when he arrived in Eagle Rock as the new watch inspector for the Oregon Short Line. James met him on the station platform, selling his line of rattlesnake oil liniment, good for aches and sprains, rheumatism and dislocations. "My father was the only person in my memory that did not refer to Jo He as 'that crazy old coot.' In the eyes of Eagle Rock, he was crazy because everything he did was original."

Edgar first visited Jo He as a young boy. "He was a bearded patriarch who looked very much like Walt Whitman in his old age," Edgar wrote. "His name was Eastman, but he called himself a He, or a man named Jo, which for him stated his generalized human identify before God." (It is unclear why Ozro Eastman took his father's name for his nickname.)

Edgar wrote and spoke many times about his visits with Jo He. The old man taught Edgar that art should be personal, spontaneous and inventive and showed him a home that was to define Edgar's artistic and architectural vision. Jo He could do anything. "He carved stone, built his own home, was a tanner, taxidermist, imaginative gardener, inventor, mural painter, saddle maker, and sheet metal worker," Edgar wrote. "He used his materials with good sense and freshness of attack and found emotional expression in employing his intelligence and perceptiveness in every task."

Everything about Jo He's place amazed Edgar, from the gargantuan sandstone eagle seizing an enraged rattlesnake—the first sculpture Edgar ever saw—in front of his shop to the strange outhouse built from a large wooden beer vat that Jo He had salvaged. Nobody passed Jo He's home and store without taking notice. Iron rods extended twelve feet above his roof with the simple letters JO HE STORE. "He had attached ruby bridle mirrors to the iron letters," Edgar

wrote. "If you saw it catching the sun, Jo He had put his name in lights. This was before electricity had come to Eagle Rock."

And there were also surprises inside. Over his living quarters was a two-story workroom where Jo He did his intricate tooling of fancy saddles, rugged harnesses, braided whips and batwing chaps that cattlemen wore through the brush. "As we passed the workshop Jo He motioned for us to come in and see 'Jo the Wolves,'" Edgar wrote. "The old man had taken two perfect hides,

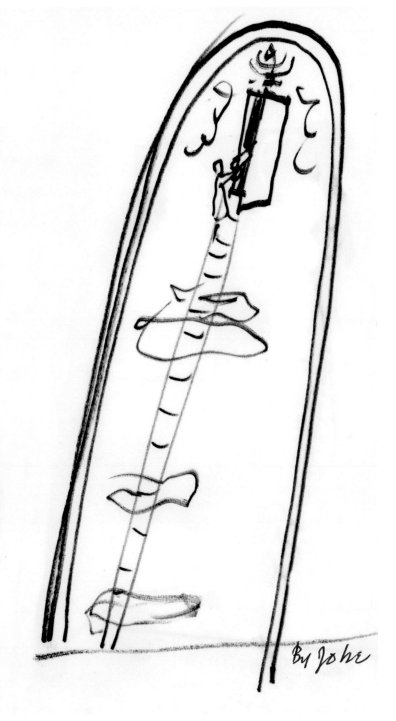

By Jo he

one black and the other white, of yearling heifers. Out of each hide he had carefully cut a series of matching concentric circles and diamond shapes. The black he had sewn into the white and white into black with such care that the seam had no betraying ridge. I remember his knobby finger as it stroked the hide on his work table, blending the hair of the black designs into the white."

An expert taxidermist, Jo He captured his animals in moments of high drama. "There was a terrified meadowlark, perched on the dry skull of a buffalo, enchanted before the weaving head of a rattlesnake," Edgar remembered. "Another instance showed a covey of sage chickens in panic before a coyote whose mouth was filled with the tail feathers of the escaping mother whose brood was scattering to hide in the frozen immobility of camouflage."

Jo He built his house on a piece of land nobody wanted below a bend of the Snake River. "It was a series of one-story blocks that stair stepped down the face of the lava bluff for fifty to sixty feet to a narrow sand beach that was only uncovered at low water," Edgar wrote. "Here the lowest story stood on stilts, just above the level of high water, with a trapdoor that was used to enter a small rowboat." And at the edge of the prairie was Jo He's fence, made from the tops of kerosene cans. "Each square top had a circle cut out of its center, the squares alternated with circles connected by iron links," Edgar wrote.

Lava flows had covered the floor of the valley, but the river had cut through the strata over time, leaving stairsteps with potholes of soil. "Jo He had planted these potholes, according to their size, with berry bushes or small fruit trees," Edgar wrote. "Many of the holes were three or four feet deep, and winter freezing had furnished each pothole with cracks for drainage. The old man had never heard of the European method of running and training fruit trees against a wall (espalier), but this he did as recognition of his special horticultural situation. His sun-warmed lava walls ripened the first fruit of the season in Snake River Valley."

On their first visit, Jo He sat Edgar and his father on a bench under the shade of a cottonwood tree that grew from a pothole outside his largest room and gave them each a glass of clear water from his red sandstone filter. The filter was hollowed out of the porous red rock and carved on its underside

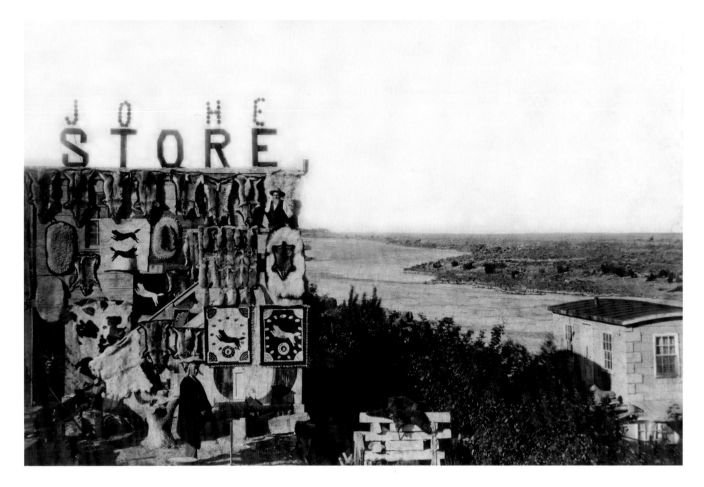

into the apparition of an Indian, whose solemn painted face was beaded with drops of water. A hand, also of red sandstone, caught the drips off the beaky nose. "You see," Edgar remembered Joe He telling them, "his hand is little and weak since the power has gone from him with the coming of the white man. He is in deep trouble."

Jo He's most important lesson was that anyone can take on any project, that nothing is so difficult it should cause hesitation. "His example said one thing to me, 'If you want to do *anything*, go ahead and do it.' All I had to do was try." Joe He taught Edgar to apply his artistic vision to ordinary things. "From that time on," Edgar wrote, "I have tried to be creative in every act, for without the surrounding of small art, there can never be a development of great art."

Eight decades after Edgar first saw it, Jo He's home still inspired him. "It is difficult to convey the lusty enthusiasm that attended all of Jo He's work, and gave me understanding of emotional tones and dramatic approaches to work," he wrote. "It is a kind of love for what one is doing, that one never outgrows. Age does not dim this enthusiasm."

Bees in His Bonnet

Edgar embarked on a great adventure when his father took him and his brother Frank to Australia in late 1913 to raise bees. "This is where I saw the majesty of nature intimately," Edgar wrote. At the time, James Miller had given up a successful career as a watchmaker and optometrist to run an apiary, and that, too, was flourishing. "Happier bees never existed than those whose living and location was provided by him," Edgar wrote. "The extra honey they made provided all of us a good living, and there was always plenty to see the bees through the winter in a warm weatherproof home."

Edgar's father respected bees, and they returned his affection. Raising bees was an essential part of his existence. "Father saw nature based upon complete generosity of both the giver and the receiver," Edgar wrote. "Both profit, and there are no losers." In 1911, James harvested fifty-two tons of honey, enough to merit mention in the *Idaho State Journal*. "He understood the bee so well that he had no resentment at the occasional sting," Edgar wrote. "To an angry bee, I have heard him say 'Quit it little feller. Quit it.'"

JO HE'S STORE
NEAR THE SNAKE
RIVER

In 1913, James got—as Frank put it—a bee in his bonnet. After reading in the *American Bee Journal* that an apiarist in Australia could collect four hundred pounds of honey per colony (twice what his produced), James decided to move his family across the ocean. Such an idea was rash; no one in town had ever been or even thought of traveling to Australia. James concocted a plan: he would relocate there with Edgar and establish a new bee business before sending for the rest of the family. The move, James figured, not only would give him the opportunity to become a better beekeeper but would show his prodigy son new horizons and get Edgar away from the boys he was constantly fighting. Frank, who convinced his father to let him join them, recalled that his mother cried on their last day in Idaho Falls. "She thought father was embarking on a wild goose chase," he wrote. "How right she was."

James sold his truck, the cow and all his bees and beekeeping equipment. He filled the cellar with potatoes, apples and root vegetables and the pantry with flour, rice, navy beans, lentils and dried fruit. "All this, together with the fruit and preserves mother had canned, would feed those left behind for several months," Frank wrote. Mother stayed home with Lucile, Hester and Fauntleroy. To earn money, she worked in a seed factory, and sixteen-year-old Lucile at a department store.

Edgar, Frank and James left Idaho Falls on November 8, 1913. They arrived in San Francisco by train the following night, but with the clang of the cable cars and the light of the flashing signs, they couldn't sleep. They bought third-class tickets for $85 each and boarded a twin-screw freighter, the SS *Tahiti,* for the twenty-eight-day trip across the Pacific. Edgar was sick the first day but after recovering was captivated by the ocean: the whitecaps, the dolphins, the occasional sharks and albatross. At night, he watched the fish bathed in a phosphorescent glow. "When a flying fish was blown on deck, Edgar would make careful drawings noting the colors and proportions minutely," Frank wrote. "All this information was stored in his retentive mind, to be used later."

After twelve days at sea, they reached Papeete, the capital of the French Polynesian island of Tahiti, more than four thousand miles from San Francisco. "There it was as it had been described, a green mountain soaring into the sky, its lower land covered with coconut palms," Edgar wrote. "The sidewalks were squishy with alligator pears that had fallen from the trees, and the mynah birds were calling out to each other. Flowers were everywhere shining in the sun or a few moments later sprinkled with warm rain."

Everyone was so glad to set foot on land that they scattered in all directions, Frank recalled, "like school children at recess; trying to see as much as possible in one day." The Millers were introduced to mangoes, alligator pears and breadfruit. They saw land crabs climbing palm trees, and tried unsuccessfully to open a coconut with a pocketknife and a club. "Under the tall wild orange trees, the ground was covered with their golden fruit," Edgar wrote. "A little Chinaman brought us things to eat, and we went down to watch the bright colored fish at the sea wall. Father had a whole bunch of bananas, and Frank had a papaya fruit as large as the width of his shoulders. I had two pineapples tied together by their prickly leaves. It was evening, and we sailed away."

Three days later, they arrived on the sandy white beaches of Rarotonga, about 750 miles southwest, in the Cook Islands. They then sailed 2,000 miles to Wellington, New Zealand, and another 1,400 miles to the harbor city of Sydney, on the southeast corner of the Australian continent. From there, they boarded a train for the 450-mile trip to Melbourne, their first headquarters.

The Miller boys stayed in Richmond, a suburb of Melbourne, while their father figured out how to start an apiary in this new land. Edgar was happy in his exotic surroundings and took drawing and classifying seriously. He loved the flame and yellow box trees, the golden and silver wattle flowers, and the rosella and grass parrots (which he called grassies), the parakeets and the galah cockatoos. He liked visiting the female orangutan at the Melbourne Zoo and paid several visits with Frank to the Royal Botanic Gardens near the Yarra River. On Christmas Eve 1913, Edgar wrote his family in Idaho Falls that he most missed his mother making dinner and putting away the remains of the morning rush for school. In Richmond, Edgar said, children went to school until fourteen, smoked cigarettes and called him "sonny." He wrote: "It is hard to believe; it is so different here, hot at Christmas, and in the shade of a big awning in front of a toy

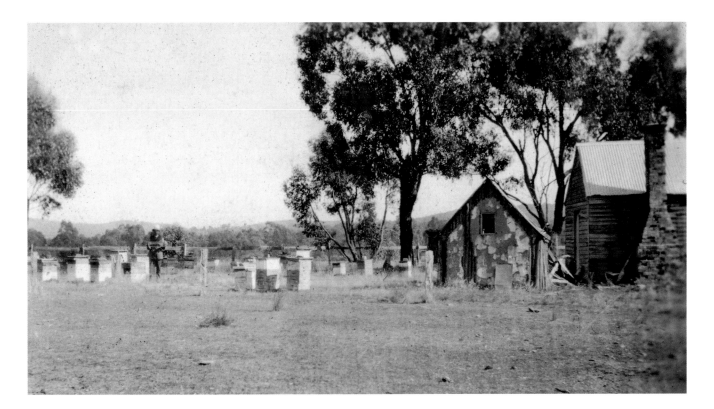

store, a be-furred and snow-covered Santa Claus asks small children what they want for Christmas, while he wishes inwardly he was the cool man in the white ice wagon passing. The Christmas spirit is here though in spite of the temperature."

In early 1914, James bought fifty swarms of bees, and the family set out for Maldon, a small gold-mining town near Mount Tarrengower, about ninety miles northwest of Melbourne. Edgar thought it was the perfect location for an apiary, but it was far from the perfect time. The most severe drought recorded in Australia began in 1911, got worse in 1913 and peaked in 1914 and 1915. Most of James's newly purchased bees died in the heat of the wooden boxcars on the way to Maldon. The Millers vainly attempted to set up an apiary anyway, but beekeeping in this climate turned out to be too daunting, so they started panning for gold. The work was backbreaking and unprofitable. To save money, Frank would chop wood and shoot rabbits, which Edgar skinned.

For the budding artist, Maldon offered great inspiration, with many new flowers and birds to draw. On Mount Tarrengower, Edgar found three-foot orchids and stumpy-tailed lizards. Kangaroos and aborigines had long ago abandoned the locale, but Edgar discovered old canoes and shields made of bark. "I was so tremendously interested in the sights that I was carried away by it day and night," Edgar told a reporter nearly eighty years later. "We were living in a little house in the foothills and there were three or four ancient eucalyptus trees on top of this hill. Now the rest of the country was second-growth small trees, but these were ancient trees. There was something magical about them when you saw them in the moonlight on that hill. I have painted that scene several times because it was the peculiar explosions of several realizations. There was a feeling that there is something larger than the earth."

Edgar spent about two hours a day drawing, and he sent pictures back home. He had no sketchbook in Australia but managed to find some old account books a local grocery store had discarded. He painted orchids and sundew plants, which had small bound leaves that could trap flies. And he had "pages of lovely little fungus that grew in damp spots," he wrote. "This was in springtime, bright red, yellow, vermilion—some little cups, some long cylinders—beautiful little things."

Edgar, hoping to make some money, took a portfolio of sketches to Melbourne publishing houses. Editors treated him with consideration but told him to come back in a year or two. In October 1914, he entered thirty pencil drawings and watercolors in a competition at a local fair. "I think I ought

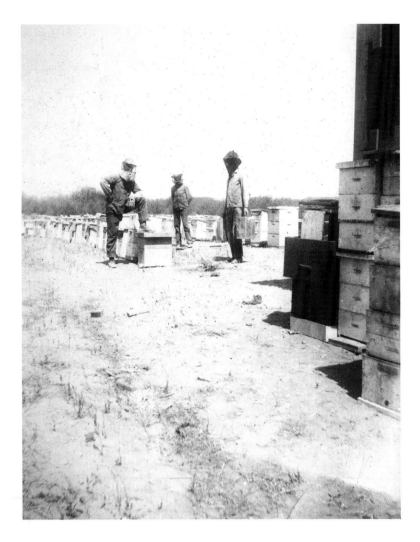

Life was getting hard for the Millers. Work was nearly impossible to find. "I'd like to get some kind of job, but there is no more work here than there is at the bottom of the Pacific," Edgar reported to Idaho Falls in October 1914. "Everything is flat strapped." The next month, he wrote: "Yesterday, the eighth, was the anniversary of our departure from Idaho Falls. One year ago we saw each other last. It seems like centuries." Bored and frustrated, Edgar started thinking about striking out on his own. "For weeks I had been remodeling an old vest to hold in its pockets sketching materials, as well as bottles of medicine: permanganate of potash for snake bites, a laxative and a convenient sized bottle that would hold quinine, for fever, that I would pick up later," he wrote. "I was getting ready to run away to New Guinea, which was somewhere to the north of Australia."

Having watched carefully and without comment as Edgar made his preparations, James asked his son if he wanted to enroll in art school. Edgar won a scholarship to the School of Mines in Ballarat, a city of wide boulevards and opulent public parks about fifty miles south of Maldon. But it soon became apparent that the professors had no idea what to do with the boy who showed extraordinary talent but was too young to work from a nude model.

They placed Edgar in basic drawing classes, but Edgar already knew how to draw. He chafed at the discipline of art school. "The class was at least a century behind the times," he lamented. Edgar suffered "acute boredom" copying pictures thumbtacked to the wall; he wanted to learn the fundamentals behind art itself. "Even the most complex model of an acanthus leaf could not offer me any real interest," he wrote, "and my attempts to ask the instructor about art, what was its objective and how does one prepare oneself with a purpose when one wishes to paint. Needless to say there were no answers to questions so vaguely formulated from instructors who were themselves students in 'advanced' classes."

Uninspired, Edgar dropped out of art school and headed up Lydiard Street to Tulloch and King Lithographers. "Even though I had never done this kind of work, with my techniques in crayon, pen and ink, I fit right in," he recalled. Edgar learned to grind and prepare printing stones for the press and was taught how to use litho-

to get something, but I don't know," he wrote home. "It will do no harm to try." Late that year, Edgar sent a cover design to the editor of the monthly magazine *Lone Hand*. "The cover design came home with its tail between its legs, fleeing from the brutal condemnation of the heartless editors," he wrote, recounting their comments ("Cannot use your design" and "If you needst must paint try the barn in your spare time"). Edgar was discouraged but determined. "Oh well, Rome wasn't built with a pocket knife and a nail. I guess I am reduced to the necessity of trying all over again. . . . I'll swim the sea of slaughter till I sink beneath the wave."

Everything in Australia was touched by the drought. Edgar and his family woke to the sounds of the magpie and grass parrot, but as the scorching day progressed, activity ceased. The Millers saw few people and had few distractions in Maldon. When the sun set, Frank and Edgar would swim at a reef dam in the bush, and they read books by candlelight. At night, Edgar could hear the pathetic cries of sheep starving to death.

graphic brushes, ruling and compass pens and tusche to apply an image on limestone. He started by working on a tomato can label and soon advanced to a state fair poster. "It advertised the races, and when it didn't have the traditional grouping of horses and their legs in the classical positions, the head of the concern looked at the apprentice with new interest," Edgar wrote.

But the job didn't last long. "Unfortunately, father learned that I wasn't going to art classes and sent me home to Idaho," Edgar wrote. But before heading back, Edgar joined James and Frank in Lancaster, about 140 miles northeast of Ballarat, where they were working on a fruit farm in an irrigation district of Australia. Jobs were easier to find in the Goulburn Valley, but living costs were high, and it was difficult for the family to earn enough to return to America. Edgar kept up his drawing as they picked grapes, currants, figs and lemons. In Lancaster, the Great War seemed to be getting closer. One night, neighbors stopped by to question James, suspecting he might be a German sympathizer. In early 1915, Hester sent enough money to get Edgar home. With the push for nationwide conscription heating up as the war lingered, both parents were worried that Edgar would be drafted into the Australian armed forces.

Edgar left Australia on May 15, 1915. On the return home, he came upon a different Tahiti, severely damaged the year before by two German cruisers that had opened fire on the French port of Papeete without warning. "The island I had seen before had disappeared forever," Edgar wrote. For adventure, he swam out to the *Walkure,* which had been sunk by the cruisers. "But on pulling myself aboard the upper deck," he wrote, "I was greeted by a shark, which circled the boat several times. I had waited till I thought he had gone and got the hell out! Papeete was too full of people and I was glad to leave after a long walk on the beach."

When Edgar arrived in San Francisco, he looked for work in a lithography factory but found that jobs were closed to non-Californians. It took several months for Frank and his father to save up for their return. They eventually earned enough for one fare—a ticket for Frank—and James took a job in the first-class scullery aboard the Canadian steamship that brought them back across the Pacific. "I can only guess at the personal

hell father endured," Frank wrote.

Back in Idaho Falls, Edgar resumed high school, where his cartoons caught the attention of an official who made arrangements for Edgar to attend the School of the Art Institute of Chicago. Before he left, Edgar went one final time to the house that Ozro Eastman had built. Not much remained. The fence that Edgar so admired had been torn apart. "I'm glad that I saw it before it was destroyed by the little vandals whose parents could see in Jo He nothing but a crazy old coot, and in all his work something that rebuked their ignorance."

Jo He died in 1916 at eighty-seven, and by 1917 the house was lived in by vagrants. "There was no longer a workshop; it had completely disappeared," Edgar wrote. "The forlorn house stood doorless in the tangle of weeds and brush that covered every pathway." The scene saddened Edgar, who sought out one last piece of inspiration at the local cemetery. Eastman had carved a tombstone for a young girl—a ladder extending to a partly opened door to heaven—that

EDGAR'S DRAWING FOR THE IDAHO FALLS HIGH SCHOOL YEARBOOK, CIRCA 1915

33

Edgar thought stood out from all the proper grave markers, which competed by quality and weight of stone, as the cemetery's only human statement of love.

"This was my goodbye to Joe He," Edgar wrote, "and I left the next day for the Art Institute of Chicago." He departed Idaho with a toughness and skills hard earned from an unusual childhood. Unafraid of an uncertain future, he carried a steely determination to succeed as an artist.

Bound for Chicago

Edgar arrived in Chicago in January 1917 with high hopes, taking a room in Jane Addams's Hull House, the nation's first settlement house, on the Near West Side. Edgar had applied to the School of the Art Institute because he thought that teachers there, some of the best in America, might answer his questions about art—its nature, its meaning and its objective.

Edgar, who went by James Edgar Miller at the time, started his "brief, formal training" in 1917. Then as now, the School of the Art Institute was one of the nation's largest and most prestigious art schools, with twenty-two skylighted classrooms, fifty exhibition galleries, a rarefied library and an august lecture hall in Chicago's Grant Park, just east of the Loop. The school brochure boasted: "We believe our school studios to be not only the most extensive, but also the best appointed with regard to lighting, heat and ventilation, in the whole country, perhaps the world." Even more important was the environment, for the school was very much a part of the museum itself. Edgar would be surrounded by inspiration: galleries filled with a "choice collection" of the old masters as well as sculptures, textiles, metals and vases from the ancient, medieval, Renaissance and modern periods. "The students spend their working hours in the beautiful museum building, in which the permanent collections are of the highest order," the brochure stated. "Every year there are twenty or more passing exhibitions of the best current art."

Edgar first heard about the school from a cousin in Idaho who attended. His high school teachers also recommended it. "I thought the Art Institute of Chicago was sophisticated enough to answer the questions that I had never been able to get answered from the art school in Australia." But his experience in Chicago was not unlike what he had encountered in Ballarat. "I was utterly miserable," he wrote. "In the art schools they are geared to teaching the students of mediocre ability; if there is a student with any native ability, with ideas of his own, he is an unknown quantity; he cannot be assimilated. The art schools depend on making an artist out of unworked material. If they get an artist who already is self-fashioned, they don't know what to do with him."

For most of its nearly three thousand students, the School of the Art Institute was a three-year program. Students were not graded, but progressed from foundation courses to advanced ateliers, courses taught in studios by master teachers. In the mornings, Edgar took drawing classes from Frank H. Dillon, which Edgar characteristically eschewed. "That was ridiculous for me because I had been drawing for many years at that time," he later said. "I got out of that class as soon as possible." In the afternoons, he took painting from Jessie P. Lacey, who had studied in Paris.

Edgar took a much more challenging load during the 1917–18 school year, including courses taught by the painters Elmer Forsberg, Enella Benedict and Allen E. Philbrick, the muralist John W. Norton, the illustrator and publisher Ralph Fletcher Seymour and Louis W. Wilson, who espoused theories about the relationship of sound to color that intrigued Edgar. To Wilson, an F minor gave off a "strange purple tone," an A major produced a "warm, sunny green" and an E-flat major—the favorite key of musicians and painters according to Wilson—generated a "violet night effect."

Edgar hypothesized about art and considered it in a large context. During his first year at the Art Institute, he encountered reproductions of prehistoric cave paintings found around the turn of the century in France and Spain. Edgar believed that the remarkably beautiful thirty-thousand-year-old cave paintings of animals held the key to the meaning of art. His instructors, however, showed no interest in helping the young student make connections between the Stone Age cave paintings and contemporary art. "In my questions to instructors of what art was all about, I received a semi-embarrassed evasion; 'Art, you know, you learn how to paint the figure. Of course you need a knowledge of anatomy and perspective, etc., etc.'"

Edgar wanted deeper answers. "Here was a mystery obvious to everyone, with no one having curiosity enough to try to imagine the answer. We are so accustomed to art. The examples and objects of it have been around us for 30,000 years, yet what it is the artist has never been able to tell us. Only by identifying the subject matter can we tell what it is 'about,'" he wrote. "I had already discovered that the arts are governed by a nonverbal awareness of shape, color, sound, time, etc. In other words, direct perceptions experienced by feeling. To think, believe, or know may reflect what you have learned; feeling can come only from direct perception. It has a sensory logic of its own that can only be learned through experience."

Edgar said he searched hard to figure out the meaning of art while a student. Around 1919, he met George Bellows, a guest instructor at the School of the Art Institute. Bellows, now remembered for his 1924 *Dempsey and Firpo,* had attained prominence as a painter in 1908 and first came to the school to discuss his geometric formula for composing a painting.

Bellows's lecture on the theory of dynamic symmetry—the mathematical laws that seemingly covered the design of such things as the spirals in ferns, seashells and animal horns and the helical patterns of fish scales and sunflower heads—"brought to the intellectually starved student the most stimulating idea current that year," Edgar wrote. "It was rumored that this theory answered all the difficult questions of composition, and told what art is all about. In fact, it was supposed to be fundament to nature itself." But Edgar ultimately dismissed dynamic symmetry because he did not think it was universally true.

After the talk, Edgar met Bellows in the hall and asked him a challenging question: "What does a line do when you are making a composition?"

The artist took the bait. He drew on the back of Edgar's sketchbook a rectangle and then its diagonals. "Bellows showed me things I had almost discovered myself, and for them to come through another person made them more precious," Edgar wrote. "In one short conversation I learned how to look at a line and see its significant direction of movement, also to see the corner of my canvas as a point where the two lines that are the edges of the canvas intersect with a third

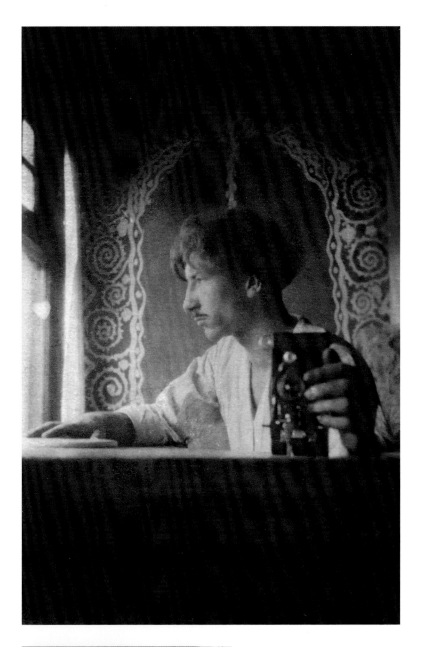

SELF-PORTRAIT AND SNAPSHOT OF MILLER'S CHICAGO APARTMENT, 1920

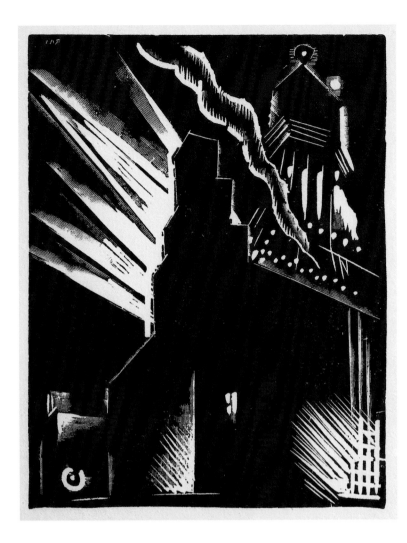

line which is the invisible diagonal. Although you can't see it, the physical reality of space makes you aware of it."

"Now, look on your canvas," Bellows told Miller. "Although it is invisible, the diagonals from corner to corner cross in exactly the center. If you erect a line that is at the right angle to the diagonal that meets the corner of the canvas, there I would put the eye of the portrait I wished to accent," Bellows said.

The eye, Edgar instantly understood, indicated life—a most important notion, Edgar wrote. "By the effect of these two invisible lines I could locate accurately everything I needed to put into the picture." Edgar realized that diagonals invisible to the viewer are not invisible to the artist at all. "I learned more in two minutes than in the preceding six months," Edgar said. "All unrealized experience came to a solid realization. I saw a painting whole all at once. I remembered a quote from Euclid, in high school, that the effect of even a small segment of a straight line continues forever to a vanishing

point on the horizon."

The significance of what Bellows showed Edgar is difficult to understand, but Edgar wrote about the meeting with Bellows many times over the years. "From that talk with Bellows I realized the enormous amount of invisible structure that is underneath painting," he wrote. "That you can control the organization, and that if you haven't that, you haven't anything. A picture is a control of that space. All the straight lines go to the edge of the picture so that the eyes don't wander any place outside of it. You either understand form or you don't."

Edgar now understood that art, like music, had a framework. "With Bellows, I first encountered the idea of a formal analysis of structure in painting," he wrote. "I did not share his enthusiasm for dynamic symmetry because it impressed me as a rigid inversion of the approach of a creative artist, like wearing handcuffs. During subsequent years, I have learned a great deal about how a painting is built through my own search and self-discovery. Nevertheless, my explorations were sparked by my arguments with Bellows."

School was difficult for Edgar because it seldom helped him answer his questions—big or small. Edgar was determined to learn the technique of most art forms, such things as oil and egg tempera painting, sculpture, etching, woodcutting, batik, fresco, tile work and stained glass. Instructors tried to slow him down. "Some wise grownups told me, 'If you broaden too much you tend to flatten out.' In other words, you run out of human material. Again advice: 'Don't be a Jack-of-all-trades. Choose your life's work and stick to it.' In other words, 'Become a specialist.'" But, he wrote, experience taught him differently. "Some aspects of painting can only come through the discipline of sculpture. Nothing sharpens the appetite for color like a long period of work on stone or plaster, conversely form becomes so gratifying after working on flat color masses."

It took a long time for Edgar to grapple with what he was learning and what he was not at the Art Institute. Sight, for instance, a key part of an artist's life, was not mentioned at the school. "It was never revealed that the circular pupil of the eye gives us a circular field of vision," he wrote. "This pattern antedates the conventional rectangular forms that surround us when architecture became

an established part of human life." Even color was hardly addressed. "One conclusion I soon reached," Edgar said, "was that color could not be intelligently discussed because our vocabulary has been built by people who are color blind."

And no instructor told him about the ingredients of a drawing. "Mr. Philbrick's class, only, was concerned with 'line.' His models were female, usually in the most extravagant crinoline. Line, for Mr. Philbrick, was revealed in the loops and folds of the gowns, and 'interest' lay in the 'variety' of twists and turns that were noticed and recorded by the student," Edgar wrote.

The primary difficulty any artist faced in learning to draw was mental, Edgar said. The act of transferring an image experienced in three dimensions to the two-dimensional rectangle of paper or canvas required a substantial amount of understanding. "It would not only have been of interest, but it might have helped me in my understanding of art to know that the Egyptians struggled with this problem for their whole existence and only understood the profile, the silhouette and the overlapping of these to express the third dimension and a surrounding space."

Edgar wrote that he was "conspicuously absent" from classes. "I wasn't a good student." But in his first term, Edgar produced three pieces that were used in the school's promotional circular—more than from any other student.

By 1918, World War I had changed the landscape of America and the School of the Art Institute. Edgar's drawing teacher, Frank Dillon, was accused of trying to escape service by fraudulently stating that his family depended on his salary. His instructor Louis Wilson was criticized in the newspaper for not standing when two officers walked into the Cliff Dwellers Club. A Students War Relief Association was formed in January 1918 to provide aid and comfort to Art Institute students in the armed forces. Just eight months later, the 1918 school circular noted that the Art Institute service flag "shows a proud assemblage of 392 stars, three of which are blazoned in gold." In total, 498 Art Institute students fought in the war and fourteen gave their lives.

Edgar stayed in school through early 1918 but then returned to Idaho Falls and registered for the service in September. He seldom talked about his brief stint in the military, but a photograph of him in uniform shows that he joined the army, presumably just before the signing of the armistice that ended the war.

He returned to the Art Institute in 1919, taking a sculpture course from Albin Polasek, a Czech master who taught advanced students how to model heads and figures as well as decorative, organic and architectural ornament. Edgar was once again dissatisfied, writing that he never learned to actually cast sculpture in his training. During the 1919 school year, Edgar and eight other students left the Art Institute in a dispute with the administration. The students, led by Sol Kogen, who would go on to collaborate with Edgar on many architectural projects, called themselves the Independents. It's unclear exactly why they left. Some accounts cite a high-minded fight for artistic freedom, but Edgar later said it was over an attempt to discipline them. Edgar and friends would fence with foils and épées during rest periods; the school registrar disapproved and marched the group to the office of Theodore J. Keane, the dean. Instead of punishing the boys, Keane, a champion fencer, picked up a sword and challenged them. Soon Edgar, Kogen and Keane were gone from the school. The nine Independents moved their studies to the art program of the Hull House, where they were given studio space for a couple of months and received special attention from Jane Addams, the future Nobel Peace Prize winner. Years later, Edgar told a reporter he was surprised that Addams took their concerns seriously enough to offer the students her time and space.

Edgar never received a degree from the Art Institute. He was later offered one from a school administrator there whom Edgar remembered as a mediocre student. "I asked him how in hell he could give me a degree in art when he had no understanding nor idea of what art was about," Edgar wrote. Later, he added: "A degree from this source would have been valueless to me."

Having left school, Edgar was determined to continue his self-education. He learned plasterwork by making a six-foot-tall Buddha for a stage set at the Chateau Theater. He learned how to make woodcuts by first trying with a pocketknife and then buying a handbook and the proper tools, and he figured out mosaic himself. "All you need to do is to realize mosaics are made

of a lot of little stones set in cement," Edgar wrote.

He took on many assignments in order to learn new techniques. When Edgar received his first stained-glass work, he went to a glass company and informed workers that he wanted to design and configure a window with their help. They told him that he first needed experience. "I burst through the veil of mystery," Edgar wrote. "I asked them, 'Where's the paint? How do you mix it? I'll put the paint on. If it fires, all right. If not, I'll know why not.'" On Edgar's first try, his stained glass fired correctly.

When a New York woman came to Chicago to exhibit her batiks, Edgar asked her to teach him this method of hand-dyeing fabric. "Why should I give away a great secret?" she asked. Finally, she agreed to teach him for $25—which Edgar didn't have. "I thought about it for days," he wrote. "Then it occurred to me perhaps there was something about batik in some good book. I got the *Encyclopedia Britannica.*" The next year, he won the prestigious Frank G. Logan Medal from the Art Institute of Chicago for his batiks, and he later won a Municipal Art League Prize. In 1920, a *Chicago Tribune* reporter wrote that Edgar's batiks were viewed "with astonished rapture."

Edgar felt he learned little about art in school. "I never got any of those answers," he told a reporter in the 1980s. Edgar was gifted enough to figure out technique on his own, but he needed challenging projects to grow as an artist. His restless spirit brought him to the studio of a master.

Of Inestimable Value

Edgar's first job after art school was as an apprentice in the design studio of Alfonso Iannelli, who moved to Chicago in 1914 to create the concrete sprites atop the famed Midway Gardens, a three-acre music pavilion and later a beer garden on Chicago's South Side. Iannelli, a master of many artistic disciplines, was a sculptor, metalworker and commercial designer whose fervor to create must have appealed to Edgar instantly. He was larger than life, called "Iannelli the Great, statue manufacturer of talent and individuality," by writer Ben Hecht.

Edgar was hired in late 1919 and worked in the studio for around five years. "My first awareness of Iannelli was when I saw his work on the Midway Gardens in 1917," Edgar wrote. "The Midway Gardens were in ruins at that time. From the ruins it was obvious that the failure of the project was due to the architect's failure to realize that the climate would not permit an all-season beer garden. Also the ruin showed the kitchen too far from the dining area."

The architect Edgar skewered was Frank Lloyd Wright, one of his favorite targets. The two met more than a dozen times, but Wright always acted as if he did not know him, which irritated Edgar for decades. Ironically, Wright was also the favorite target of Iannelli after taking all the credit for the design of Midway Gardens; Iannelli thought he should have been credited as sculptor and Wright as architect. Iannelli refused Wright's later offer to create sculpture for the Imperial Hotel in Tokyo. He stayed in Chicago and in 1915 opened his studio where later Edgar worked.

The $20-a-week job worked out perfectly for both men. Edgar, who was slender with long, wild hair during those years, was able to carry out Iannelli's ideas with ease and accomplishment as the creative leader of the staff. "My willingness to relate to any medium was of advantage to Iannelli, and at one time or another the problems ranged from decoration to serious expression in sculpture or painting," Edgar wrote. And Iannelli needed design help as his office became busier than ever.

Iannelli taught Edgar how artists could collaborate to create art that was useful in everyday life. Edgar worked on advertising, designed packaging and books, did ink draw-

ings, murals, posters and stained glass, cut stone and made architectural ornament. Iannelli could not have cared less about exhibitions or creating art for museum walls.

Through Iannelli, Edgar was introduced to major businesses and top architects. The studio's clients included Marshall Field and Company, the architect Barry Byrne and the architectural firm of Holabird and Root, all of whom Edgar worked with for years. Byrne, who celebrated beauty by using simple, honest materials, particularly influenced Edgar's building style. And Edgar helped Byrne. Perhaps the most enduring work Edgar did in Iannelli's employ was modeling the distinctive finials atop Byrne's St. Thomas the Apostle Roman Catholic Church on Chicago's South Side, whose terra-cotta terminals represent human reverence reaching skyward. The skill that Edgar brought to that project was again on display in the stone Madonna he carved to grace the entrance of Byrne's Immaculata High School across town. Edgar recalled the consternation on the faces of the school's nuns when the statue was unveiled. He had made Mary look too happy.

Iannelli was impressed with Miller from the start. They were both instructors at the School of the Art Institute, where Edgar taught ornament, interior decoration, drawing and design. In 1924, Iannelli wrote a note of endorsement when Edgar sought a teaching job at the University of Nanking in China: "Mr. J. Edgar Miller, an artist in painting, design and sculpture in the various mediums, has been connected with me for four years, and has been of inestimable value to the Studios. In his experience in teaching at the Art Institute of Chicago and with the students at the Studios, he has shown a very clear way of imparting to them the basic and essential points of the work in question, and he has the capacity to criticize and help the students express themselves without hampering their individual personality and impulses. It gives me the greatest pleasure to recommend him."

Though he did not take the job in China, Edgar left the firm later that year. In 1926, Iannelli and Miller shared a contract to design nine windows for Byrne's Church of Christ the King in Tulsa, Oklahoma. "These windows rank among the best to be found in the United States," wrote Maurice Lovonoux, the contemporary critic at *Liturgical Arts*

magazine. Edgar did three of the windows. He particularly liked the one of Saint Stephen the Great, who battled the Ottoman Empire at the end of the fifteenth century. "It was my favorite window and I still thrill thinking about it," Edgar wrote in 1983. "Stephen was in black armor conquering with his sword a golden lion on which he had placed his fist. Whee! I was able to let loose some enthusiasm."

The Tulsa masterpiece was Edgar's last project with Iannelli. Edgar admired his mentor, but not without limit. He felt that Iannelli did not have a "craftsmanly sense" and speculated that Iannelli was jealous of his young apprentice because "to him I seemed to do things easily." The two saw little of each other after the 1920s. Iannelli

STONE MADONNA CARVED BY MILLER FOR IMMACULATA HIGH SCHOOL, CIRCA 1925

Edgar's promotion of modern art was frenetic and diverse. He introduced musical works by Béla Bartók and Igor Stravinsky and presented *The Golem* and *The Cabinet of Dr. Caligari,* films accompanied by music from such modern masters as Leo Ornstein, Arnold Schoenberg, Cyril Scott, Alexander Scriabin, Claude Debussy, Maurice Ravel, Sir Arnold Bax and Sergei Prokofiev. In the early 1920s, he opened a tiny art gallery at the end of Pearson Street, about three blocks west of the old Water Tower. "My establishment was both modest and had a few short years existence, before moving to a new studio," he wrote. But in those few years, he exhibited work by an exceptional group of modernists at the House at the End of the Street: still lifes by Albert Bloch, color woodcuts by Blanche Lazzell, small drawings by Lyonel Feininger and conceptual drawings of the Einstein Tower by Erich Mendelsohn. When Edgar read that the Chicago sculptor John Storrs had just returned from Paris, he held an exhibition displaying *Study in Pure Form,* Storrs's sleek piece of metal rods and cylinders, which had been classified as "machine parts" by customs officials. Iannelli and Robert Harshe, the director of the Art Institute, had to vouch that the piece was art. "So if you go to the 'The House at the End of the Street' and view this mystifying but decidedly interesting composition, your impressions may or may not be a trifle mixed," *Art World* reported. "But you can be sure of this. It is a piece of art. The government has said so."

By 1923, Edgar was considered the city's authority on all things modern. Ben Hecht, in an essay that year on the artist district known as Gay Bohemia, included Edgar in his compendium of top artists. Hecht, in the *Chicago Literary Times,* wrote: "Mr. Edgar Miller, the piquantly unbarbered gentleman asleep on the pink couch, is one of the star exhibits of the district. Mr. Miller is one of the outstanding primitives. His work is naive and nude, and in his right lapel Mr. Miller wears a button with a photo of Matisse on it. Were we to wait until daylight . . . we would see Mr. Miller journey forth with a pail and brush to do his bit in the evolution of the town as a plasterer."

After his House at the End of the Street closed, Edgar helped run a gallery on the top floor of the nearby Dil Pickle Club, the primary hangout for—depending on your political viewpoint—the city's intellectual

had become a communist, Edgar wrote, and "sensed an objection in me, although I was not political by nature."

Despite their differences, Edgar was empowered by the artistically fearless Iannelli, who taught him to embrace all crafts and to never turn down a job. Iannelli also connected Edgar to some of the exceptional architects of the day and planted architectural and design ideas that were to guide Edgar for decades. By the mid-1920s, Edgar was ready to strike out on his own.

Edgar the Modernist

By the end of his years with Alfonso Iannelli, Edgar had established his reputation as a fresh new force in the Chicago art world. Only a few years out of school, he was already a major player in Chicago's thriving art scene, both as an artist and as an advocate for other artists embracing the modern world. "In the artistic sense, then, Miller became an epicurean," wrote a friend, Lynn Abbie. "He had an insatiable appetite for the arts."

elite or, as the poet Kenneth Rexroth put it, "the lunatic fringe of radical Chicago." Edgar, a sophist and an outsider, fit right in because members of the Dil Pickle were contrarians, as announced by the misspelling of their club's name.

The Dil Pickle was the heart of the bohemian neighborhood of Chicago known as Towertown, named for the castellated water tower that survived the Great Fire of 1871. The neighborhood stretched from the international headquarters of the Industrial Workers of the World (the Wobblies, who fought for "One Big Union") about a mile north to Washington Square, better known as Bughouse Square, where nearly every day dozens of men and women mounted soapboxes to speak their piece. The spirit of the Wobblies and of the soapboxers permeated the art galleries, bookstores, coffee shops and tearooms of Towertown.

For roughly thirty years, from about 1915 to World War II, this neighborhood just north of the Loop was as radical as New York's Greenwich Village and featured an all-star cast of outsiders that included Emma Goldman, whose anarchist views won her the title of America's most hated woman, and her lover, the physician Ben Reitman, who was known as the "hobo doctor" because he treated the poor and downtrodden. In Towertown, nonconformists were conformists.

At the Dil Pickle, Edgar hung out with the writer Ben Hecht, joined club members one night to meet a Satanist, and made sketches of Dorothy Day, a member who would go on to help found the Catholic Worker Movement. The Dil Pickle broadened Edgar's horizons, for anything was possible there. Gail Borden, writing in the *Chicago Times* in 1934, remembered the club as "filled with anarchism, bad poetry, soapbox orators, common-law wives, cardboard stages, bitter coffee, atheism, brilliant obscenities, disillusion, dirty collars, piles of manuscripts, unfinished paintings, colored lights, studio couches and passion—but never love."

Here Edgar could watch Clarence Darrow orate and hear Sherwood Anderson recite short stories or Carl Sandburg play "Frankie and Johnny" on his guitar. Besides showing art, the Dil Pickle presented plays in its Little Theatre and hosted lectures, the intellectual linchpin of the place, on Wednesday and Sunday nights. Magnus Hirschfeld filled the house with his speech "In Defense of Homosexuality," and Reitman gave a talk called "The Favorite Method of Suicide." Other lectures included "Sex Worship," "Does Love or Passion Rule Women in Marriage?" "Glands," "Is Free Love Possible?" and "Have Newspapers Degenerated Us?"

The Dil Pickle was at the fringe of what was considered an artistic renaissance during the first three decades of the twentieth century. Chicago was proclaimed the literary capital of the United States by none other than H. L. Mencken, the usually acerbic Sage of Baltimore, who in 1920 wrote that "in Chicago there is the mysterious something that makes for individuality, personality, charm; in Chicago a spirit broods upon the face of the waters."

Edgar also spent much of the decade establishing his career as a commercial artist, taking on all sorts of design work. His first jobs were small—detailed woodcuts for Christmas cards and personal announcements. He did woodcut illustrations for

MILLER'S POSTER TO PROMOTE A GALLERY WHERE ALL SERIOUS ARTISTS COULD SHOW THEIR WORK

GOUACHE STUDY BY MILLER FOR A PROMOTIONAL MAGAZINE, 1931

advertisements, too, often signing his work. "Years ago I did a lot of woodcut and wood engraving (it is a reverse process), also much lettering in woodcut, which runs opposite to the direction of our reading habit," he wrote.

From the woodcuts came pen-and-ink illustrations for ads and magazine covers. His files include a mockup of a cover for Chicago's famous *Poetry* magazine. He also worked on books, doing a hand-colored illustration for *The House of Endless Doors* by Mary Corse and the illustrations for *On Sweetwater Trail* by Sabra Connor. Starting in 1924, he produced ads for Chicago's Marshall Field and Company, illustrating its *Fashions of the Hour* seasonal magazine and making art for the store itself. A trade publication, *Modern Advertising on Display,* wrote: "During the early nineteen-twenties, Edgar Miller pioneered in the use of modern art in advertising. He developed a graphic style for the newspaper and direct mail advertising for Marshall Field & Company that would be advanced today."

The German magazine *Gebrauchsgraphik* devoted a four-page spread to Edgar's graphic work, and another publication called Edgar's work for Field's "as startling and original at that time as some of Picasso's techniques are today."

Edgar's status as a major Chicago artist was recognized in a 1923 advertisement titled "The Parade of the Chicago Artists" with an inscription that read: "The blond boy Michelangelo sculpts, paints, batiks, decorates china, makes drawings, woodcuts, etchings, lithographs. His fluency in manual expression is only equaled by the haltingness of his speech." It wouldn't take long for Edgar's hair color to change and his oratory to improve.

First Family

While Edgar's artistic life was ascending, his personal life was in shambles. His 1921 marriage to Dorothy Ann Wood, a fellow

bohemian, was threatened by Edgar's tireless devotion to his career. The marriage had little chance—Edgar's first love at that time was art.

It is unclear exactly how Edgar met Dorothy, a twenty-six-year-old from Michigan who came to Chicago in the hope of being a professional pianist. Dorothy, who ran in the same artistic circles as Edgar, was serious about music even after their marriage. This shared devotion to art brought them together and broke them apart.

Dorothy was a bit too heavyset to be considered a flapper, but she smoked stylish Melachrino cigarettes and was something of an undercover rebel. She grew up in Nara, Japan, the daughter of missionaries for the Methodist Episcopal Church, and probably followed her half sister, the social worker Iris Wood, to the big city. (Dorothy's other older sister, Elizabeth Wood, later became the first executive director of the Chicago Housing Authority.) In 1917, the *Chicago Tribune* noted that Miss Dorothy Wood played with the Chicago Symphony Orchestra as a soloist at Ravinia Park.

Edgar and Dorothy had three children: Iris Ann in 1921, Gisela in 1923 and David in 1925. "They were two people who should have never gotten married," Gisela said. "Both were strong willed—dad was art, mom was music—and the twain moved apart." Edgar bothered Dorothy when she practiced, and Dorothy disturbed Edgar when he worked. The spark, which burned bright at first, dulled in the mid-1920s, Gisela said. When Edgar's brother Frank moved to Chicago in 1929, he could see right away that the marriage was in shambles. "I was supposed to act as a balance, and help smooth things out somehow," he wrote. "When two people are as implacably incompatible, nothing short of separation can help."

Edgar left Dorothy and the three children around 1929. She refused his frequent requests for a divorce. The children, who loved their father, were devastated by the separation. Dorothy moved them to the western suburb of Batavia, where she rented apartments and later bought a house. Edgar supported the family sporadically. Dorothy joined the Episcopal Church and taught in churches and religious schools. "Dad was self absorbed when he was away from us; he didn't even think about sending money," Gisela said. Edgar visited Batavia several

times a year, and when the children occasionally came by train to Chicago, he took them to a double feature or introduced them to friends. "When he saw us, he loved us very much, but when we weren't in his sight, he didn't acknowledge us," Gisela remembered. Edgar sent handmade plates and cups to the children for their birthdays and Christmas, and he made a beautifully illustrated little book, *People to Remember,* for Iris Ann. He also painted a mural in the upstairs hallway of their Batavia home. Said Gisela: "It broke my heart when they painted over it."

Sunlight as a Medium

In the mid-1920s, Edgar turned his attention to architecture and interior design, for which he had long had an affection, and began experimenting with stained glass. Edgar instantly embraced the medium. "This was a great joy," recalled Edgar's sister Hester, who

MILLER'S SKETCH OF HIS FIRST WIFE, DOROTHY ANN WOOD, CIRCA 1925

43

joined him in Chicago during the 1920s and helped on early projects. To the pair, creating stained glass was magical. "It was like using sunlight as a medium to mix with color," she wrote. "The beautiful red was really created by molten gold caught in the glass; the blues, the greens and golden yellows."

In 1923, Edgar won his second Logan Medal for his early stained-glass work. Howard Van Doren Shaw, a judge in the competition, recognized Edgar's talent and gave him his first professional commissions. Shaw, a highly skilled architect who could create elegant buildings in any historical style, was a favorite of the Swifts, Ryersons, Donnelleys and Chicago's other moneyed elite, who hired him to build their country homes, clubs and commercial buildings. Edgar designed stained-glass windows for three Shaw buildings: a library for Warren David Owen in suburban Lake Forest, a home for A. D. Thomson in Duluth, Minnesota, and an executive office at the Lakeside Press Building south of the Loop. Around 1925, Shaw was commissioned to design a World War I naval monument in Brest, France, and a memorial chapel at Flanders Field in Belgium. He told Edgar they would collaborate. Edgar got his passport, but Shaw died in 1926.

In 1927, Edgar was given his biggest stained-glass project: the windows of Oakridge Abbey, a large mausoleum in the western suburb of Hillside, where he worked through the early 1930s. Within just a few years, stained glass had become the focus of Edgar's work and the basis for his reputation. Although his early stained glass was traditional, Edgar showed his modernist stripes in a 1928 letter to the *Bulletin of the Stained Glass Association of America*. Edgar urged American artists and architects to come up with new motifs and new ways of making stained glass. "Behind the curtain wall of the skyscraper grows an identity that is ours," he wrote. "In the backyards of the cities and in the intimate places in our homes it begins to make itself manifest. Until one day we wake up in a surrounding entirely different—our own."

Edgar's early architectural forays, including designing the interiors of the Vassar House and Russian Frock, two small restaurants on Chicago's North Side, spawned an urge to find his own design project. Like his mentors Alfonso Iannelli, Barry Byrne and Howard Van Doren Shaw, Edgar needed his

own project, one where he could control every detail. He wouldn't have to wait long.

The House on Carl Street

"In 1927, an opportunity presented itself," Edgar wrote. "The opportunity to create an environment that could include all the 'lesser' arts. Through enjoyment and curiosity, I had gathered most of the ingredients of my idea of an 'environment.' I had done work at the terra cotta factory; overglaze I had done in the school years. Stained glass and textiles I had investigated. I had a Logan Medal for both stained glass and batik by 1923. A long apprenticeship had given me experience in sculpture, casting, stone cutting, and woodcarving as well as mural painting. All I needed was a project."

The project came from Sol Kogen, Edgar's flamboyant friend from the Art Institute who had led the Independents revolt in 1919 and contributed to Edgar's decision to leave school. Eight years later, Kogen came up with what Edgar called "a damned good idea." Kogen reimagined city homes. He wondered what they would look like if artists designed them. His idea—of finding and rehabilitating old houses in an artistic manner—would define the lives of both Miller and Kogen and a Chicago neighborhood that would become known as Old Town.

Two distinct portraits emerge of Sol Kogen. One, painted by Edgar and supported by his brother Frank, shows a man overreaching his artistic and financial abilities. Another, painted by Kogen's relatives, shows a visionary who did everything possible to create a new type of home. The truth likely lies somewhere in between.

Sol Kogen was the favorite son of a Russian couple who immigrated to America during the late 1890s and opened a retail silk and fabric shop near Roosevelt Road and Halsted Street, by the old Maxwell Street Market, on Chicago's Near West Side. "He was the charmer, the heartbreaker of the family," said Llois Alpert Stein, his niece. Born in 1900, Kogen attended the Art Institute and took advanced drawing classes with Edgar. "Sol could sit down and turn out a fairly realistic portrait," Edgar later said. "He knew how to transfer the general sense of a form to paper."

Kogen's tenure at the Art Institute was marked by tension. "Sol got attention

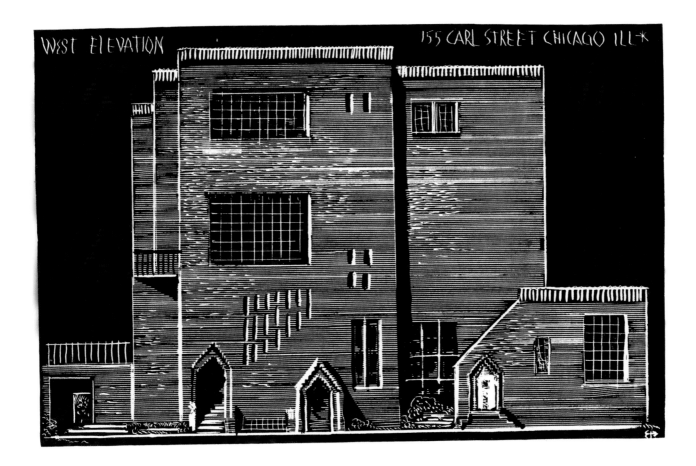

WEST ELEVATION 155 CARL STREET CHICAGO ILL

in drawing class by smashing a chair into splinters in one throw," Edgar said. "During breaks, he would fence. That was his ideal way to relax, by violent exercise." And it was his way to protest the authoritarian administration that ran the school. Said another student: "The new regime proceeded to run the place like a kindergarten, and this was particularly disturbing to Sol. He would lift up a chair, slam it to the floor, and break it in such a way that no pieces would stay together." It wasn't long before Kogen, Edgar, and seven others left the school to set up an independent studio at Hull House and pursue work on their own.

After leaving the Art Institute, Kogen also joined his family business. A born salesman with movie star looks, he brought a creative flair to selling silk. He could drape a mannequin with such style that the material sold almost instantly. By 1925, the family business expanded to four stores. Kogen made enough of a fortune that he considered retiring. "Sol knew how to make money," his brother Bernard said. Wrote Shirley Malkind in the *Chicago Reader:* "By this time he also had developed a reputation as a lady's man, a *bon vivant,* given to wear-

ing capes and throwing wild parties."

Instead of retiring, Kogen moved to Paris to restart his career as an artist. He sketched, painted and observed the changing city for two years, becoming particularly in-

terested in the picturesque studios that were being created in the Montmarte district in response to rent control laws enacted during the Great War. Apartments there were undergoing major renovation so that landlords could kick out tenants and raise rents. Kogen wrote an American friend that he wanted to remodel Chicago apartments in this spirit and create an artists' colony back home.

Towertown was a perfect place for Kogen to attempt this. Houses in this German neighborhood on Chicago's North Side were decaying, and prices were depressed. "The area was filled with old but soundly built buildings, on the edge of becoming a slum, and land was cheap," Edgar wrote. The Victorian homes, converted to rooming houses, could no longer be rented to anyone but the poorest of residents. Most buildings dated back to the 1880s, many to the Great Fire,

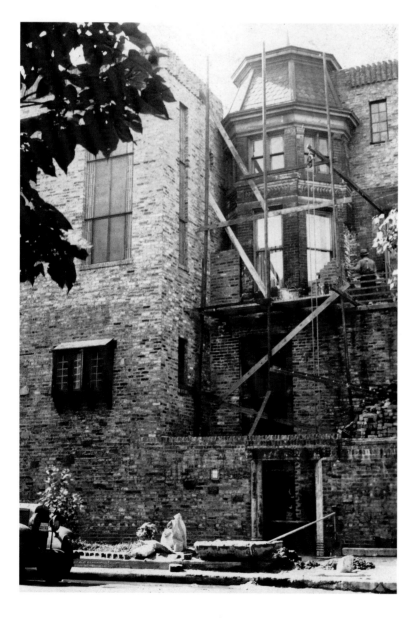

CONSTRUCTION OF CARL STREET STUDIOS, 1927 (CHICAGO HISTORY MUSEUM)

and landlords did not have the impetus to invest in or even repair homes because rents were so low. The neighborhood also had a charming, old-world feel, which made it ideal for rehabilitated artists' studios.

Kogen approached Edgar soon after his return. Besides having been his partner in the Independents, Edgar showed exceptional artistic talent and was an experienced rehabber. Since moving to Chicago in 1917, Edgar had remodeled several of his own apartments, as well as the homes of some friends, including Kogen's place. Kogen called Miller Last-Minute Edgar because he could work fast in any artistic medium. Kogen, who knew carpentry and how to lay brick, was an ideal developer and contractor because he had boundless energy and ideas—and was determined to complete every job as inexpensively as possible. Recalled the artist Taylor Poore, one of Edgar's friends: "I remember that he was trying to tear down a wall and he needed lots of help, so he got a bunch of kids together and told them there was a pirate treasure buried under the wall. He got it torn down."

Kogen showed Edgar "a pretentious, unimaginatively planned" three-story red-brick Victorian house and asked Edgar if he felt the building could be transformed.

"Sure," Edgar replied.

"What would you do?" Kogen asked.

"I said the first thing I would do is tear out and connect the first floor and the basement in order to make a larger room," wrote Edgar. "The next thing I would do is to tear out this ceremonial stairway, which was over twelve-feet wide including an extra vestibule, which was a good sized room, and take that stairway clear out of the house, and build a stairway outside."

Kogen knew he had his man. "Sol's bright idea was to make me his partner," Edgar wrote. "We would do this affair in a big way." And Edgar knew that he had his project. "From that building evolved an 'environment,'" he wrote.

The Victorian house was built on two lots at 155 West Carl Street in 1874 by Charles Emmerich, who owned the city's oldest and largest feather pillow company. It was sold in 1911 to Antonia Redieske, whose husband, Paul, had been forced to resign as the deputy commissioner of public works in scandal. She sold the house on August 8, 1927, to Kogen, who took out a mortgage the

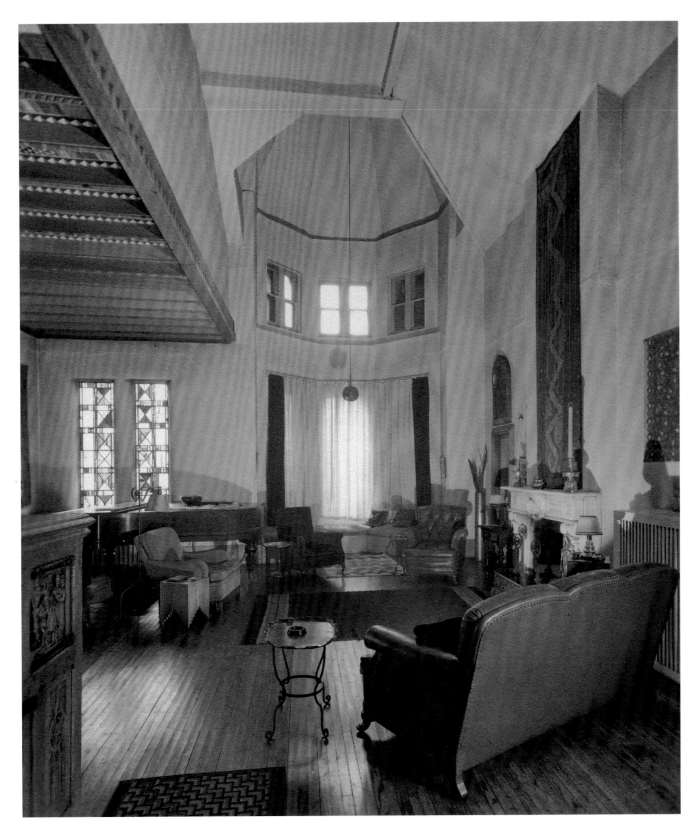

same day. Although no formal partnership was ever established on paper, Edgar said he was under the impression that he would split any profits evenly with Kogen.

Kogen served mostly as the contractor, hiring laborers to assist Edgar, purchasing materials and procuring work permits. (He would bribe building inspectors by drawing portraits. "You have a very interesting face. Do you mind if I make your portrait?" Kogen would ask. "With a pencil sketch, they left. No inspection," recalled Frank Miller.) Kogen soon realized that if he gave Edgar free rein and provided him the materials he needed,

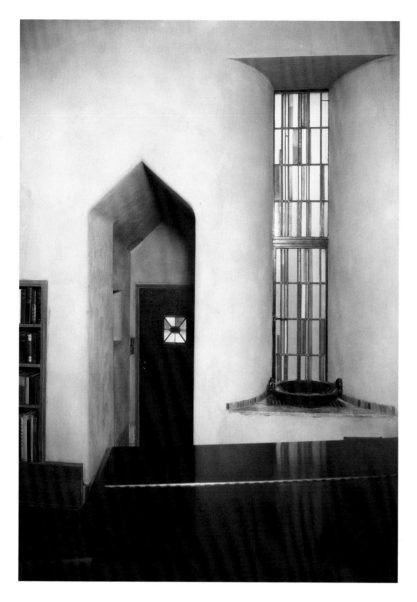

the Maxwell Street Market. "I was forever prowling around for bargains," he said. His trademark was a pocket full of silver dollars. "They all knew me and they loved it," he said. "They would look for things especially for me just to get those silver dollars. They thought I was the only source." His specialty was finding deluxe ceramic tiles. During the Depression, Kogen raided the abandoned studios of several bankrupt importers and bought tiles at a substantial discount, hoarding tens of thousands of them, including glazed Grueby tiles, in wooden cubbies in the Carl Street basement, where they remained for decades.

Edgar also embraced the concept of salvaging and picked up discarded items from local demolition sites. He had learned at an early age the value of conservation from his father in the apiary. As a young man, he had encountered hardships in Idaho and Australia that taught him resourcefulness. Now he combined his interest in reusing material with his artistic ability.

The rummaging didn't go unnoticed in Old Town. Soon others began to renovate their homes in the same manner, particularly on Carl Street and on Schiller Street, one block south. The idea would gain steam during the Depression, when money was tight but raw materials were plentiful.

Edgar served as the designer and artist of the Carl Street Studios. His friend Andrew Rebori, a licensed architect, was listed on official building records. "Yes," said Rebori, "I was the consulting architect, but only when I was consulted, which was damned little. Kogen had a way about him; he went ahead."

No drawings or architectural plans are known to exist of the Carl Street Studios, probably because none were ever made. Instead, Edgar worked room by room, creating new spaces with no overall plan for even individual items. In 1932, Earl Reed wrote in *Architecture* magazine about Edgar's work: "Few or no sketches are made unless others must be let into the secret. Then suddenly, it seems, the composition emerges full-blown, with superb finish, from the material itself. It is common for Miller to proceed boldly in lead and glass, for instance, without benefit of cartoon, matching colors and cutting forms in accordance with a vivid and compelling inner sight." This is how Edgar approached almost all of his work, no matter the medium.

Miller and Kogen converted the house

he could count on owning a masterpiece.

But to build a masterpiece, Kogen had to find the right material at the right price. Mostly, he salvaged building supplies from wrecking sites—not an easy feat during the 1920s, when builders generally hauled away debris to the West Side yards quickly because they were rewarded for speed. "The building contractors retaliated by saving nothing, bulldozing a building and hauling out the rubble of broken wood, plaster and bricks into the city dump," Edgar wrote. "By the unmerciful destruction of material enough time was 'saved' for a profit to be shown by the builder."

If he was lucky, Kogen could scavenge discarded common brick, copper washtubs, oak doors and beams, sheets of marble, wrought iron and even plumbing pipes and valves. He also bought discarded building materials from Chicago's great bazaar,

and the backyard coach house and stable to create "a Moderne fantasia unlike anything Chicagoans had ever seen," according to Paul A. Hochman, writing in a 1993 issue of the *New York Times Magazine.* They tore down partition walls, built entrance stairways outside to save space and removed floors so they could connect basements to first floors with huge vertical windows. They used common brick in the front to cover the Victorian facade, tore off a cupola and replaced double-hung windows with art glass to give a more modern look. "In this one structure, there's a touch of Moderne, Deco, Prairie, Tudor, Mission, a little English Country House and Arts and Crafts," Hochman wrote. "The whole thing is a poem, but it's free verse."

After exterior work was complete, Edgar went about creating what he called an "environment" for each studio unit. He painted frescoes and murals, carved wood doors, designed and built light fixtures and made bas-relief sculptures, tile friezes and iron railings, as well as built-in furniture and fireplaces, in nine original units. It was Edgar unbound.

The plan had been to rent unfinished apartments to artists, who would complete them in lieu of paying rent. Although many of the original units were occupied by prominent painters, Miller is the only artist to sign any art at Carl Street. "I did all the carving, stained glass, frescoes, and ceramics, and I used any legitimate architectural or design statement that made common sense," he wrote.

Edgar also built freestanding exterior walls to create a series of enclosed courtyards around the building. The yard became an extension of the intimate pattern of the house, Edgar said, and he brought "as much fine detail as possible" to the flagstone walks, mosaics, frescoes and murals that punctuated the courtyards. This was Edgar's way—along with the weasels, antelope and elk that he painted throughout the complex—of bringing his Idaho youth to Carl Street. But the walls also served a more practical purpose. "We started that idea in Old Town in order to enclose the yard and keep the place safe from kids running through the yard. At the time, there were neighborhood gangs. If you had a flower garden, they destroyed it."

A purist, Edgar wanted to build a perfect environment in which every detail was embellished like "polished stone," every vista was surprising and dramatic, windows filtered light and sent it in all directions, and the cool feel of iron railings soothed the palm. He saw the studios as a vindication of handicraft, where he could show that the lesser, or applied, arts were as important as the fine arts. He knew that "decoration" was considered a pejorative term and that industrialization was putting an end to the hand-built world. Like the British artist and visionary William Morris, one of Edgar's heroes, whose call for an arts and crafts movement grew fainter by the year, Edgar believed that he could marshal all his skills to create a total work of art.

"During this time I did not neglect the 'fine arts,' both in sculpture and painting," he wrote. "Although when I exhibited one painting, a local critic reporter on a newspaper condemned it as the work of a 'china painter,'

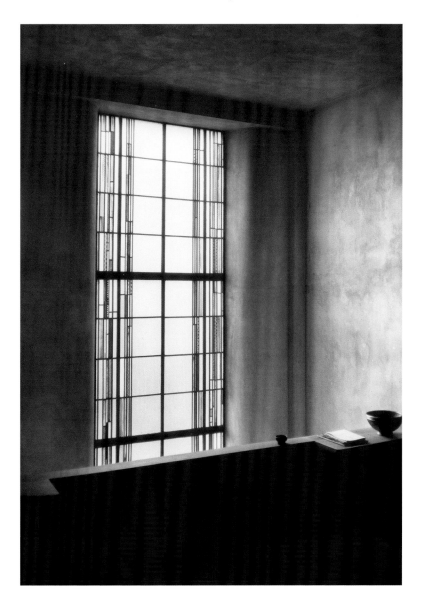

LEADED-GLASS WINDOW IN STUDIO 4 IN CARL STREET, 1931

and the jury awarded it a Logan Prize. The reporter could not believe that a craftsman could do 'fine art.' This is part of the weakness of our visual culture. We should be doing everything, then maybe our 'fine art' would amount to something."

Edgar firmly believed that the lesser arts and fine arts had a far greater impact when they were combined. "Nothing, to my mind, is so pathetic as a lonely easel picture, or an orphan piece of sculpture in a niche somewhere prepared for it. It is too reminiscent of the stuffed animal head trophy left to dust and the moth. On the other hand I have seen uncreative 'environments' so rigid in their fossilization that a chair could not be moved without destroying the 'composition,' and the big ashtray which was a focal point would become ineffective if an empty cigarette package was deposited in it. The decoration was of a fragile perfection that was lost when random people entered the room."

DOORWAY TO SUNROOM IN STUDIO 2 AT CARL STREET, 1931

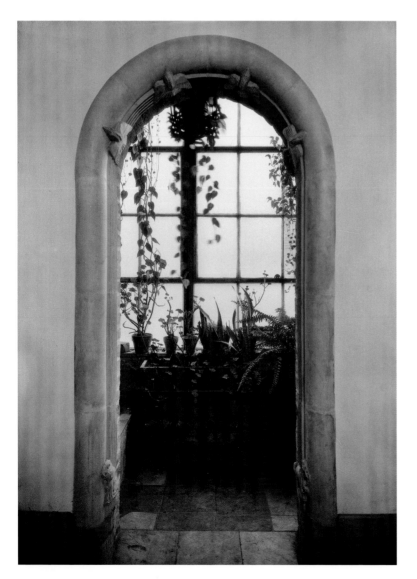

Edgar knew that his environment would live and change. He set it up and photographed it so that it remained immortal. He accepted the fact that the homes would evolve over the years with new owners. He spoke often of art that remains and art that passes. Both had value and impact. "A sound visual culture," he wrote, "should include the entire visual field, every object that can receive consideration, including the engineering to create a sound use, comfortable to touch and sight and permanent enough to deserve the affectionate use of more than one generation—except for the beauty made of the moment, the birthday cake, the Easter egg, the centerpiece of flowers or ice or aspic, this is the sacrificial art to be enjoyed and remembered."

To Edgar, even more important than the art—whether fleeting or permanent— was the act of creation. It didn't matter that vandals tore down Jo He's fence, because Jo He had had the chance to create it. It didn't matter that Edgar's World War I memorial with Howard Van Doren Shaw was never built, because he had had a chance to think about it and put it down on paper.

Jesus Torres, a talented artisan who became integral in the construction of Miller and Kogen's buildings, was Edgar's primary assistant on Carl Street. Torres, one year older than Edgar, left the Mexican city of Silao in 1924 to work road construction in Texas and the sugar beet fields of Minnesota. He soon migrated to Chicago, where he enrolled in English and art classes at Hull House. "With his first mound of clay, Torres sculpted a head that sold before it was fired," wrote Cheryl R. Ganz in *Pots of Promise: Mexicans and Pottery at Hull-House, 1920–40*. He quickly mastered woodcarving and copper making, and he was the only worker Edgar ever placed full confidence in.

Edgar's brother Frank, who came to Chicago to help, did rough carving for Edgar and worked with plumbers, steamfitters, carpenters, bricklayers, painters and tile setters. He also ran interference when Kogen wanted to take a more active role in the construction project. Frank was highly critical of Kogen, partly because he felt that Sol was paying him "depression wages." Frank wrote that Kogen, who insisted on hiring inexperienced workers, displayed shoddy building and contracting skills. Kogen forgot to fireproof new fireplaces and used brick walls that

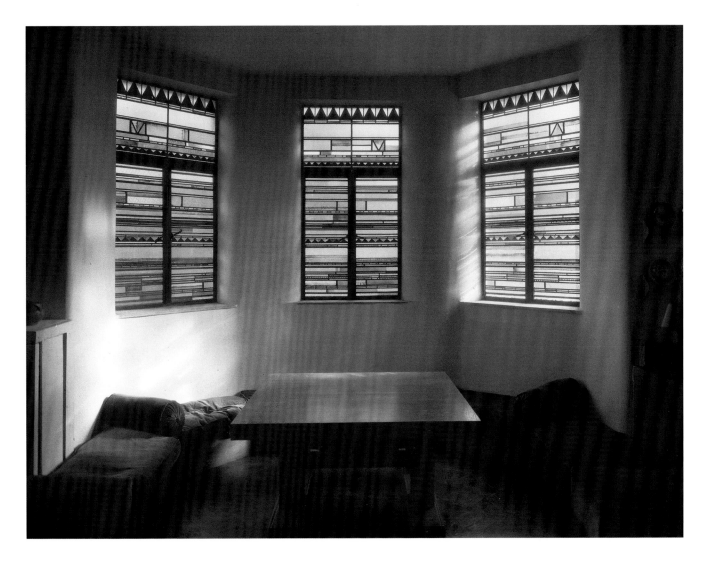

were thinner than the building code required. Once, he mistakenly connected hot water lines to the toilet.

Edgar agreed that Kogen had little structural sense. "I was always afraid he would build something that would collapse," Edgar said. "He had a tendency to doll everything up. Couldn't put enough schmaltz in it. I was always asking him to shore up things as he was tearing them out, and Kogen never did. But that was Sol."

Edgar finished work on the first nine units of the Carl Street Studios by 1935. (The street name was changed from Carl Street to Burton Place in 1936.) Kogen, who owned the building, lived there until his death in 1957. He occupied the largest unit and finished the final eight units with the help of Torres. Just before his death, Kogen attempted to take nearly full credit for the studios, then called the Burton Place Studios. In a March 1956 article in *Chicago* magazine, he portrayed Edgar as an early tenant in the coach house who only designed the stained

glass and murals. But his story is contradicted by all the articles that had been written about the complex during the previous years and by contemporary accounts. When a plaque was placed at the entrance proclaiming ORIGINAL CARL STREET STUDIOS. ERECTED 1927. SOL KOGEN, Edgar was livid, saying that both of their names should be on the sign. "Sol didn't have anything to do with designing anything," he told a reporter in 1979. "I designed the bricklaying. It was my idea to put the stairs on the outside to save space. Sol Kogen's name has no right to be on that building."

But Edgar later mellowed and acknowledged Kogen's contribution. "The true fact is it took both of us, with our peculiar, funny characteristics to make this kind of a thing," Edgar wrote. "It wouldn't have happened if I had been absent, or if Sol had been absent. I would have never done it alone. Sol was an indispensable help."

The studios were an instant success. "There was always a waiting list, even

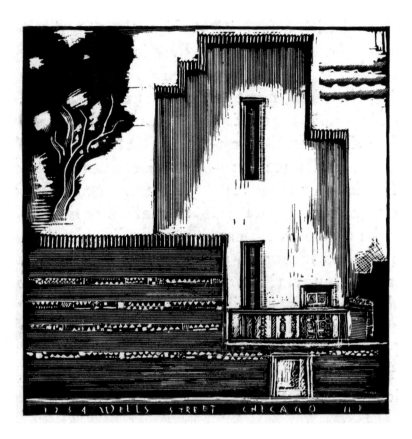

though the rent was much higher than the ordinary apartment," wrote Frank. Early tenants included the artists Edgar Britton, Taylor Poore, Edward Millman, Norma Brown, Boris Anisfeld and John Norton, as well as the jockey Willie Knapp and John Gihon, the dramatics editor at the National Broadcasting Company.

The complex won attention immediately. Bertha Fenberg, writing in 1928 in the *Chicago Daily News,* called the new artists' colony "a bizarre collection of one man and one woman studios." She wrote: "It isn't Paris, this walled in building with its tiled walks, its archways, its concealed gardens. It isn't Paris, but it isn't Chicago either."

Rich in Artistic Detail

Ten months after buying the Carl Street Studios, Kogen purchased a 40-foot-by-120-foot parcel at 1734 North Wells Street to build a second complex of artists' studios. On the property was a Victorian apartment building with a large stable out back. It was formally purchased by Sol Kogen, Edgar and Dorothy Miller, and another investor on June 5, 1928. That same day, according to Cook County records, the four new owners secured a mortgage. Edgar and Dorothy were likely

put on the original deed to make amends for not being given a financial stake in the Carl Street property.

But less than two weeks later, the *Tribune* ran a blurb announcing that the industrialist Max Woldenberg had purchased the Wells Street complex to build an art colony. "He will at once remodel old improvements on the land into duplex studios for artists. The studios are to have two and three rooms and will have all the conveniences of this modern day." The *Tribune* went on to state that Woldenberg had hired Sol Kogen, Edgar Miller and the artists Edgar Britton and Leo Bramson to design and build the new complex. "The interiors are to be simple in general arrangement, but they are to be rich in artistic detail; the artistic effect is to be supplied by tile, mosaic, leaded glass, carved wood and sculpture."

Once again, Edgar felt left out of ownership. "I very soon realized the so-called partnership with Sol was pure fiction," he wrote. But his enthusiasm for the new project did not wane. "I saw him make partners of two or three other acquaintances when he needed to borrow money, so I understood perfectly what the situation was. I wasn't a businessman, and I had plenty of jobs to do outside so I was not ever dependent on Sol for my living."

Despite the realization that he no longer had a financial stake in the Wells Street property, Edgar kept working on the two complexes, and he had to admire how Kogen kept them both afloat financially during the Depression. "Everything was going fine, until the Crash," Kogen said. Plat books in Chicago's City Hall are filled with mechanics' liens against Kogen, who transferred ownership of the two studios to friends and relatives several times in order to stay one step ahead of lawsuits. Kogen performed an amazing gymnastic feat of twisting and turning to keep the project standing during what he called "ten, terrible, wonderful years."

Financing was his biggest headache, he told a *Chicago* magazine reporter years later. "Banker after banker would come out to see what I was doing, and they all liked it. But loans? Not a chance. So I had to go to work in order to raise money. I'd decorate a nightclub, remodel a building, redesign it, run it after it was finished, sell a few pictures, anything. From six in the morning every day I was on the run—no time for meals or recre-

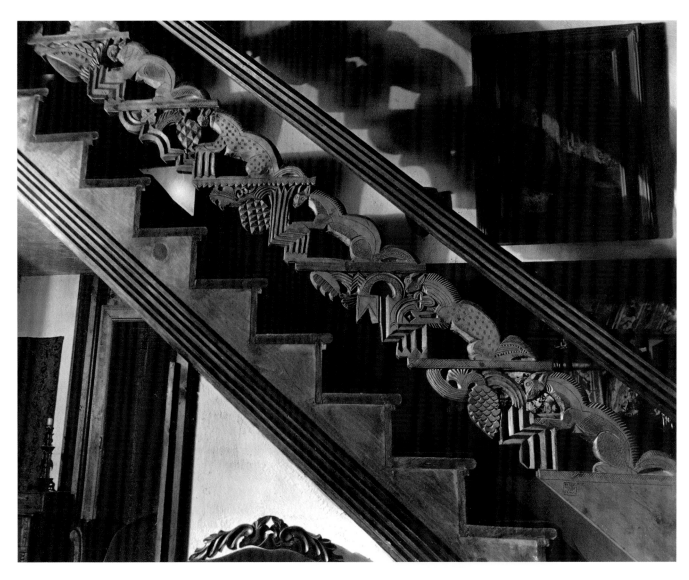

ation, just to get money so as to keep up with my building."

Ownership of the Wells Street property eventually reverted to Kogen, who leased the rear building to the industrialist Rudolph W. Glasner for construction of what Glasner called a "party house." Glasner, the financial powerhouse behind the Kogen-Miller Studios, immigrated to the United States from Vienna, Austria, around 1906 with pocket change and started a small tool and die shop in Chicago that became the Marquette Tool and Manufacturing Company. He sold that company and later organized the Clearing Machine Corporation, which made colossal machine presses used to manufacture such things as automobile body parts during the 1930s and tanks during World War II. Glasner, a patron of the Art Institute, met Miller and Kogen soon after construction began and became enamored by the idea of creating an artistic place to entertain friends.

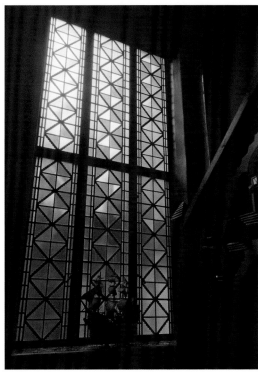

CARVED STAIR-CASES AT WELLS STREET STUDIOS. TOP STAIRCASE BY MILLER AND EDGAR BRITTON, 1929

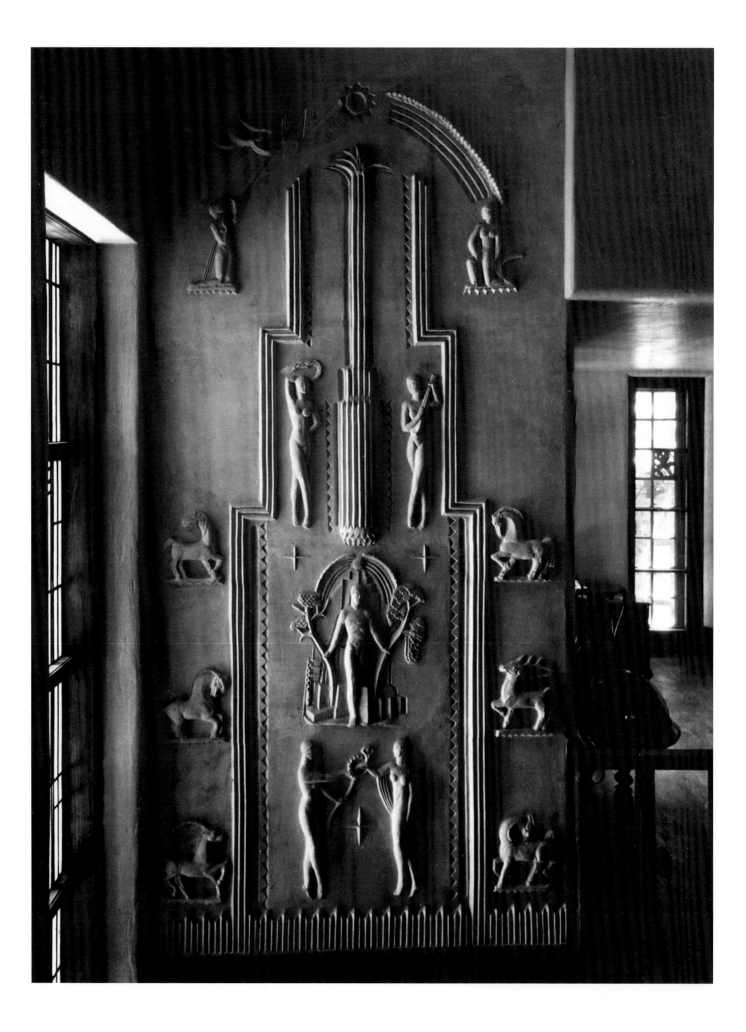

Miller and Kogen transformed the Victorian apartment house into six studios and constructed at the front of the property a building that contained two more. Most of Edgar's time and attention went into the stable, which was converted into the R. W. Glasner Studio. Work on this studio was paid for directly by Glasner.

As at the Carl Street Studios, the first thing Miller and Kogen did on Wells Street was create dramatic two-story rooms by removing floors, installing tall windows and building elegant stairs to connect the two levels. The nine units on Wells Street were completed around 1932, much quicker than the Carl Street Studios.

Once again, Edgar dressed the buildings with decorative tile and plaster bas-reliefs. He also attempted his first major woodcarving. Edgar had whittled as a boy but knew nothing about architectural carving. When he saw a hydrant-size block of wood, he thought, "Damn it, this should be carved." He purchased chisels from the hardware store and carved an eagle. "Your first act will tell you whether you are on the right track or not," Edgar wrote. "Everything is basically simple, and you get better as you go along." After he learned how to use different kinds of chisels, Edgar filled the Kogen-Miller Studios with woodcarvings.

He filled the house with art glass, too: classic colored stained glass that he painted, colorless grisaille glass for where light was needed, double-layered glass sandwiching lead figures that formed silhouettes, rustic and industrial glass that he used to bring in light but obscure the interior. Edgar's stained glass was revolutionary, wrote the artist Larry Zgoda. "These windows represent Edgar Miller's free hand in design and execution, after having determined placement and the design of the building in which they sit. There were no architects or committees constraining his creative impulses. This group of stained glass clearly shows a fresh approach to design, material application, placement and pictorial composition."

Most days, Miller, Kogen and their crew would arrive early at Glasner's studio. Kogen would tell Glasner what was to be done, but often they would instead spend the mornings at Carl Street, using the cement, plaster and metal lath that Rudolph Glasner had purchased. One day, Frank discovered another of Kogen's tricks. "I happened to find Sol's

little black book, that he dropped on the floor in Rudy's basement," Frank wrote. "The little book was very enlightening. Actually it was two books, one to show Rudy and the other showing what really happened to the money. Rudy's book listed six dollars a day for the help, but Sol paid us only five. In effect, Sol was stealing not only time and material from Rudy, but also a dollar a day from all the workers. He was highly disturbed as he frantically searched for his little book, and when I gave it to him without comment he was never sure whether I had inspected it or not."

Regardless, Edgar saved his best work for Glasner's studio. Like Frank Lloyd Wright's 1904 Dana-Thomas House in Springfield, Illinois, or Adler and Sullivan's 1892 Charnley House in Chicago, Edgar Miller's R. W. Glasner Studio shows the artist at his peak—from his intricate woodcarving to his tour de force stained-glass windows, known as *The Garden of Paradise*.

FOYER FRIEZE AND BILLIARDS ROOM IN R. W. GLASNER STUDIO

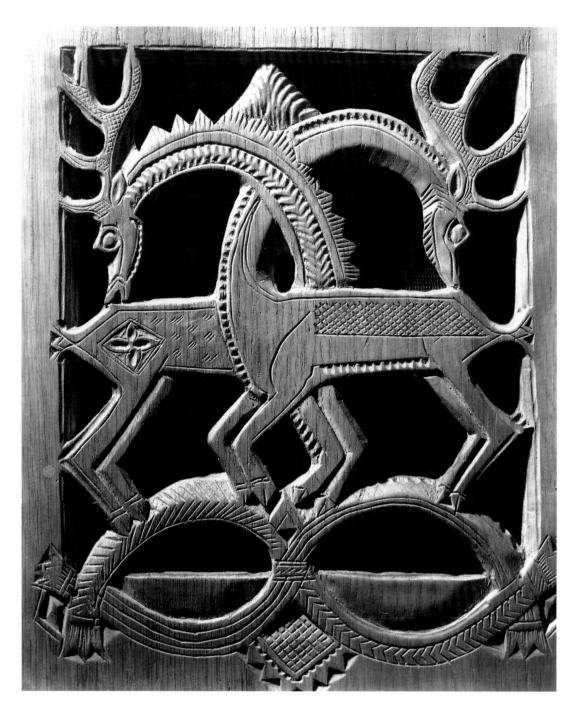

Edgar worked on the house on and off for fifty years. He returned in the 1940s to carve a history of science and technology in the ceiling above the foyer and to re-model the basement; in the 1970s, he added stained-glass windows.

Miller and Kogen will be forever linked by the work they did together. Nick J. Mat-soukas, in a December 1930 article in the *Western Architect*, called the two studios the "Kogen-Miller colony." Miller, he wrote, was "an artist who works in as many media as the world has made known." Kogen was "blessed with a feverish energy to accom-plish something on a grand scale." Together, they produced a building "as haphazard as is life, but just as purposeful."

The magazine published a detailed spread on the Wells Street complex, but Matsoukas missed the message of the Kogen-Miller colony. That was caught by Alice McKinstry, who wrote "Chicago's Art Colony Modern" in the August 1930 issue of the *Woman Athletic*. "A place to live is a place to live," she said. "Walls, ceiling, stair-way, kitchen, porch—mankind has to have them if he is to continue his ordered habits. Sometimes it makes no difference whether

they are beautiful or not. There is a kind of decent comeliness that suffices very well for many homes—the clean cheap rug, the comfortable chairs, the uninspired covering of a wall with loopings or bedraggled flowers. If you feel that a home should be only this, and a springboard to leap lightly toward movie or baseball game, stay away from the Edgar Miller studios on Carl Street and Wells Street. For they will fill you with the haunting surety that you are missing something remarkable and lovely in this world.

"Here are homes wrought by an artist, for artists; homes marvelously made from brick, stone, tile, glass, steel and wood—with eloquent care and without the slightest trace of regard for the neat little rules that prevail in suburbia. Here are homes that will cause your maiden aunt to return to Dubuque with the ultimatum that Chicago people are crazy and live in some kind of filling-stations; and that will provide your small son aged six with a valid model for fairy castles in the wood; homes that you have no right to live in unless you understand, and like, Debussy's music and Roerich's paintings and Dudley Poore's poetry and Anton Bruehl's photographs and the dynamic folly of Adolf Bolm's ju-ju dance. [Bolm, the artistic director of what was called the "Negro ballet," had a studio in Carl Street.]

"It is probably that Edgar Miller asked himself for many years why the beauty of glass, of metal, of carving and bas-relief, of tile and marquetry, should be confined solely to churches and public buildings, and finding no answer, began to plan a group of studio buildings which should employ them all to his satisfaction." McKinstry predicted the studios would greatly influence domestic architecture. "In the next decade there may be many who will profit from Edgar Miller's simple and revolutionary tenets of home design," she wrote. "That a small apartment needs not be a 'one-story' affair: that every beautiful material has as much right in a dwelling-place as in a public library or a college hall; that repetition dulls individual loveliness; that a stairway, a window, an arch are all inherently graceful and that structural lines should never be concealed."

His reputation growing, Edgar was hired by an admirer, Walter Guest, to convert a three-story Victorian-era house at 2150 North Cleveland Avenue into three duplex apartments and two studios. The apartment house is the most cohesive of Edgar's renovations. Guest, a salesman whom Edgar met during the 1920s, assumed Kogen's role as contractor. Edgar's sister Hester helped paint the entrance fresco, cut lead for the front windows, and complete art-glass windows in the back apartments. Jesus Torres, Edgar's assistant on the Carl Street Studios, added tiny highlights such as the punched-brass shutters overlooking interior windows. And Frank, as usual, assisted throughout the house. Edgar created everything else: frescoes, cut-lead and stained-glass windows and tile mosaics.

The Walter Guest apartments are quiet and elegant. Edgar worked on them for only about a year, instead of the nearly eight it took to complete the two projects with Kogen. The apartment complex on Cleveland

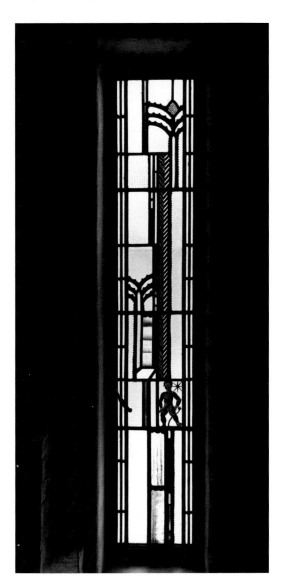

GRISAILLE GLASS
IN R. W. GLASNER
STUDIO

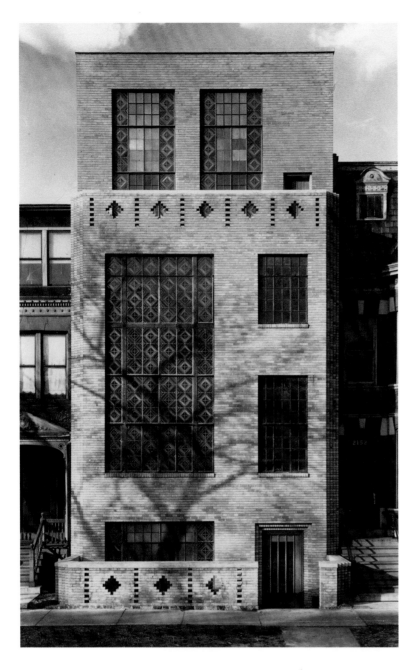

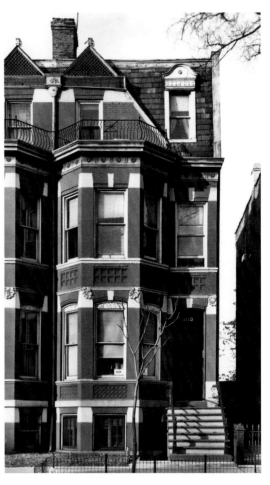

Avenue, less than a mile north of Old Town, was not beset by mechanics' liens or by financial drama. Here, Edgar served as the orchestra leader, directing his trusted crew. A single structure, the apartments possess a simplicity that was impossible to create in the Old Town complexes.

By 1935, Edgar was weary of renovating old homes. Kogen went on to work with Torres on at least four other studio projects in the neighborhood. The pair worked in the Miller style, and Kogen even used some of Edgar's old plaster molds and artwork—without his permission, according to Edgar—to dress up the new studios. The counterfeit studios saddened Edgar for the rest of his life. His relationship with Kogen was over,

and he sought new ways to extend his artistic vision. As usual, he was unstoppable.

Magical Years

By the 1930s, Edgar could do no wrong. One of Chicago's most prominent artists, he knew many of the city's wealthiest and most powerful people and was a frequent subject in the daily newspapers. The plaster plaques he created for the remodeled Punch and Judy Theatre, at 62-66 East Van Buren Street, won praise in 1930 from the *Western Architect*. "In some respects I consider these among the most clever things done by Miller," a critic for the magazine wrote of the bas-relief sculptures when the theater opened. "They are beautifully composed in diagonal compositions, perfectly done. Edgar Miller has, with his usual fine sense of fitness, captured something characteristically theatrical of the old time theatre."

Edgar filled the two-story lobby of the Trustees System Service Building, at 182 West Lake Street, with lead figures of men at work that he and his sister Hester cut by hand. At Kelvyn Park High School on

the North Side, at 4343 West Wrightwood Avenue, Edgar designed a stained-glass installation depicting great leaders in history, which was paid for by the 1933 graduating class.

Edgar owned Chicago, at least artistically, but Chicago never became the main subject of his art or his life. He painted few cityscapes. Most of Edgar's art was firmly rooted in his rural childhood. Of the hundreds of stained-glass windows he did during the first dozen years of his professional career, only one—an abstract view of skyscrapers for Kogen—firmly connected Edgar to Chicago.

Edgar never quite fit in with his urban surroundings. He was bewildered by troubles he frequently faced. For decades, he was challenged by union members who could not accept his insistence on having a hand in every phase of his art. He was bullied when he attempted to install a stained-glass window in the men's lounge of the Medinah Athletic Club on North Michigan Avenue. "I remember the threat of the union to 'put a ladder through it' if I didn't come up with twenty bucks for the putty glaziers' union," Edgar said. That same year, Edgar quarreled with union members while completing glass panels in the Diana Court rotunda of the nearby Michigan Square Building. "I could have sandblasted the glass panels perfectly, but a stupid workman who couldn't read a drawing did the panels with minor mistakes." The union, Edgar wrote, "killed the stained glass industry."

During the 1930s, Edgar had also developed a reputation as Chicago's busiest artist. A reporter for the *Hotel Belmont* magazine wrote that Miller's studio at 155 Carl Street was full of projects and noted that the photograph accompanying her article was "an informal pose of Edgar Miller snapped during working hours (that's most any time, day or night)." The architect Earl H. Reed Jr. described the work that filled Edgar's studio. "Hundreds of objects, newly made and in process, are in sight," Reed wrote. "Gorgeous painted ceramics, etched glass, clay animal grotesques, a great church window with sober saints, panels of engraved polychrome wood, drawings of things imagined and things to be made, book illustrations, carvings in wood and stone, plaster reliefs, elegant or humorous—a delectable confusion to which strength or delicacy of color

and form have been bountifully brought."

Edgar loved the challenge of new work and could not turn down a job. He designed restaurant interiors in the Loop, mausoleum doors in suburban Evanston, linoleum floor patterns, advertisements, books and even menus. "Edgar was so immersed in art that he was not a very good parent," wrote Frank, who would drive Edgar out to Batavia to visit Dorothy and their three children after the separation. "This was brought home to me one day when we were playing ball in the yard. Edgar would call instructions to David, and the little boy would pay no attention for he was partially deaf and did not hear his father. Edgar got mad and shouted to David, who became completely confused because he did not know why his father was so upset. I hurt, too, for I had great empathy for the unhappy child who tried so hard to please. As time passed these children realized they would have to fashion their own lives without their father's help, which they have done and very well."

In 1932, Edgar was hired by Andrew Rebori to design scenery for the Architects' Ball. The city's top architects had been asked to paint scenes of Paris's Left Bank, decorating a ballroom in the Drake Hotel to raise money for an architects' relief fund, but one painter dropped out at the last moment. "The ball was to begin on the next day in about twelve hours time," Edgar wrote. "It

CUT-LEAD WINDOWS FOR PALMOLIVE BUILD-ING EXECUTIVE OFFICES, 1931

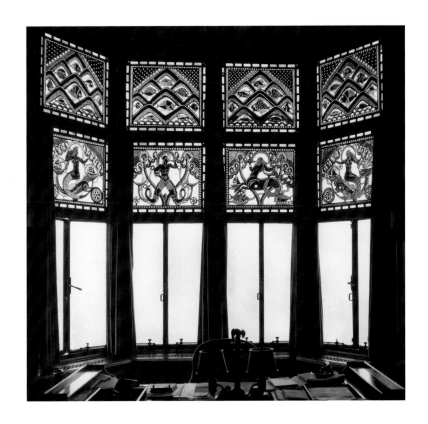

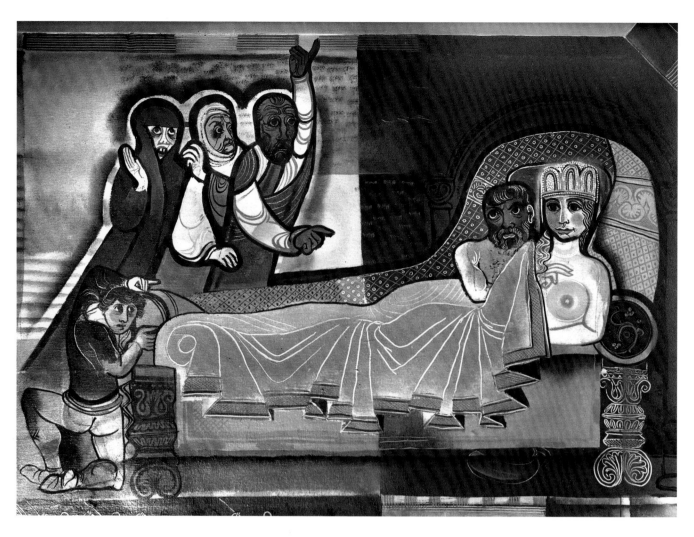

had been suggested that the beaverboard wall could receive a casual jungle pattern for decoration, and a Seminole Indian would be hired to wrestle with an alligator. I was asked to 'sketch a few palm trees.' I agreed to paint the room in my own design."

Edgar decided he would poke fun at all the Chicago architects who did not think he had enough "historic background" to work on their Gothic shrines around town. "People didn't realize that I had been teaching historical art at the Art Institute, and they were scared to death that I was a modernist." From late morning until the opening of the show the next evening, actually closer to thirty hours, Edgar painted historic and humorous scenes between men and women. *Love Through the Ages,* drying when the guests arrived, was one of the smash hits of the ball. "I did this thing mostly as a joke," Edgar said of his history lesson that started with the early Egyptians and ended with Henry VIII and his many wives.

Love Through the Ages lasted only a night at the Architects' Ball, but it was resur-

rected two years later in a new mural at the Tavern Club, on the twenty-sixth floor of 333 North Michigan Avenue. The club, a place for "witty ineffectuals as well as taciturn successesmen," was Edgar's dining and drinking headquarters. There he met top business and cultural leaders, connections that greatly helped his confidence and his career. He was a loyal member of the Tavern Club for more than fifty years, but no night was as special as the June 1935 evening when *Love Through the Ages* made its second debut—an event of "social and artistic consequence," according to the Tavern Club history.

Costumed lovers celebrated the new mural series at a party that commenced with a flourish of trumpets and the Hymn to Apollo. Then a goddess clothed only in a veil dropped it, announcing the start of what the club called "a night of ancient and deathless rapture." In a room described by a club brochure as having "more angles than a used-car dealer," Edgar's panels sketched a history of amour, beginning with amoebas and protozoa and advancing to the Neander-

thals, the Egyptians, the Greeks and Romans, Henry VIII (of course), and Cortés and the conquistadors. Edgar then examined the love life of America, from the Puritans through Brigham Young to the mademoiselles from Armentières, the Frenchwomen who welcomed doughboys during the Great War. What began as a comical romp concluded with a serious look at contemporary life. In the final panel, *The Rape of Peace,* Edgar drew a woman being assaulted by Hitler, Mussolini, Stalin and others. The mural was eerily prophetic.

The debut of the murals was viewed as an art event. Eleanor Jewett, of the *Chicago Daily Tribune,* called them "neatly precise and concise" but criticized Miller for not delving deep enough. "Neither physical nor sentimental love really is illustrated in his work," she wrote. "There is a tiny bedroom scene, but with participants so lacking in charm, guile, beauty and allure that no one need turn from it in alarm."

Inez Cunningham, a critic with the *Chicago Herald and Examiner,* lauded the murals, saying that they were one of the "finest things of its kind ever done in the city" and had been designed with the same skill as his two studio apartments. "If Edgar Miller were less casual about his work, if he were more convinced of its authenticity, he would already have attained world fame," she said. "But instead of being interested in becoming either—famous or rich—he is occupied each day with learning a new craft and developing the ideas that come to him, one a second."

She concluded: "I should like to think that one day he will have the opportunity of making something on a scale worthy of his talent, a civic project or a house that would do him entire credit. Aside from Frank Lloyd Wright I know of no man in America who more fittingly deserves the title artist."

THE RAPE OF PEACE AT THE TAVERN CLUB, 1935

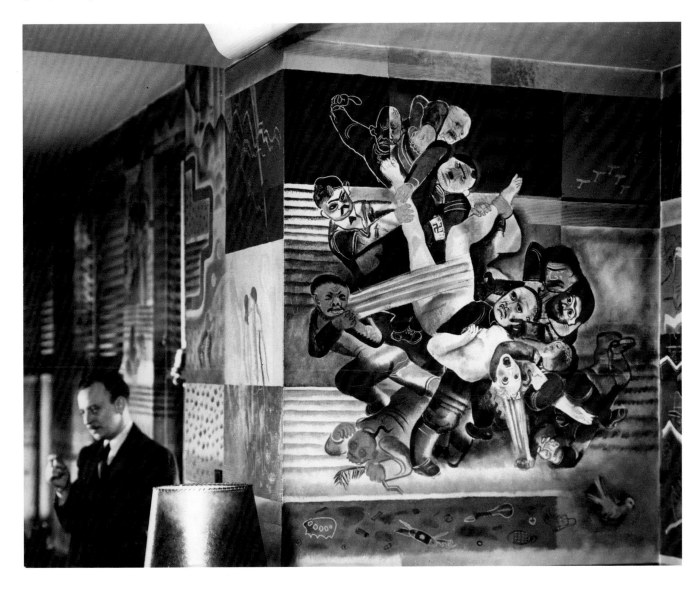

More Triumphs

In 1933, Edgar and Frank left Chicago for a long trip out west. It was the first trip they had taken since their days in Australia, and it helped Edgar reconnect with his brother. "Frank, a little boy, and I—sitting, wise cracking under the green tamarind growth," Edgar wrote in his notebook. It also helped him reconnect with nature. "Ecstasy, like grief, is belittled by words." The brothers camped on a cattle range and slept under the ponderosa pine of the Grand Canyon, looking down at its "inconceivable depths." Edgar savored almost every part of the trip: the vibrant paloverde trees, Frank's accordion playing at night, the warm river waters of Texas, even the silence. But it was not the West he knew as a boy. Driving past a Hopi village, Edgar wrote: "I am almost shamed to look an Indian in the face. Such rank injustice—struggle against unnecessary handicaps." The Millers returned renewed, "anxious to take the many

waiting commissions," Frank wrote. "Edgar's artistic drive seemed limitless."

Despite the Depression, the 1930s were Edgar's most productive decade. He took jobs based not on how much they paid but on how challenging and interesting they were to him. He sculpted a seven-foot-tall ice palace on the twenty-fifth-floor terrace outside the Tavern Club for a children's Christmas party and executed a huge painting of the northern lights for the taproom of the Great Northern Hotel in the Loop. Edgar also did murals for Fred Harvey restaurants in Los Angeles, Gallup, New Mexico, and Kansas City, Missouri.

Back in Chicago, he designed animal posters for the Brookfield Zoo, as well as a colossal mural of the African veldt for its giraffe house. He also had a hand in the design of Monkey Island, a revolutionary rock and cave habitat surrounded by a moat.

Edgar's biggest architectural job was designing exterior and interior decoration for North Dakota's new capitol, the Skyscraper on the Prairie, in Bismarck. The firm of Holabird and Root hired Edgar in the early thirties to cloak the sleek nineteen-story tower with traditional bronze bas-reliefs, plaques and friezes to temper the avant-gardism of the building. He designed five bas-relief figures of cowboys and Indians, hunters and trappers, and mothers to tell the history of the state in bronze above the oversize Memorial Hall window, and two bas-relief tablets representing industry and agriculture above the main entrances. Inside, he designed pioneer scenes for the sculptured elevator doors. The building's only ornamentation, his work softened the skyscraper's modern feel.

Edgar's 1933 visit to Bismarck to check out the capitol was big news, covered by three papers. The *Bismarck Tribune* and *Fargo Forum* quoted Edgar as saying that the new capitol would be a symbol of the strength and idealism of the early pioneers, a statement probably made to soothe critics of the new building. "Such intelligent selection of public buildings is found only in the West," he said. The *Tribune* assured readers that Edgar was the man for the job: "Son of a pioneer Idaho family, Miller is familiar with the traditions of the West. It is his belief that in the not far distant future the West will advance a culture truly American." The *Bismarck Capitol* followed suit, quoting the state's librarian, Mrs. Florence Davis: "Mr.

Miller is of splendid American stock. His family on both sides date back to the Revolutionary period, and the young man himself is filled with the spirit of the pioneers as his parents were among the early settlers in Idaho." Edgar told reporters that he would fly back to Chicago and start sketching.

Despite the accolades, Edgar was hypersensitive to any criticism, and he carried a lifelong disdain for critics and art juries. That is surprising, for critics almost universally gave Edgar high marks. Douglas Hardy, writing in the *Chicago Daily News,* called Miller a "master of mediums" after Edgar exhibited work at the Cinema Art Theater on the North Side in 1930. "He should hang up a shingle with that line printed on it in all black letters," Hardy wrote. "He would not, of course; Edgar Miller's approach to his art does not permit noise or fanfare; he works, and that is all there is to it. But it is hard to believe that any other creative artist in Chicago can work in so many fields with so much surety and so much success."

In the summer of 1931, Edgar exhibited a wide variety of his work, including carved chairs and benches, glazed pottery and decorations, mosaics and terra-cotta columns, at the Art Institute of Chicago's summer show. The pieces, Edgar said, were found in his studio by the Art Institute's director, Robert Harshe, who suggested the show. Critics were astounded. One reviewer, Edna Wright, wrote in the *Chicago Times* that it did not seem possible the work could have come from a single artist. "All will surely agree that it marks the emergence of Edgar Miller as a contemporary giant," wrote Irwin St. John Tucker in the *Chicago Herald and Examiner.* "The only phrase to describe Miller is that of Napoleon's, who said one of his generals marched off in six directions at once. The difference is that Edgar Miller seems miraculously to arrive in good order at all six of his destinations." Eleanor Jewett, of the *Daily Tribune,* agreed, lauding his "strange beasts of curious ornamental beauty"—his "gorgeous" chairs and his benches—"down to the last bit of exquisite carving."

The reviews amused Edgar, who said that practically all the pieces in the show had been at one time or another refused by Art Institute juries for previous exhibitions.

The most glowing critique of the 1931

CERAMIC HORSE
BY MILLER (PAUL
HANSEN)

Art Institute show came from C. J. Bulliet, in the *New York Times.* "Miller is a craftsman who carves heavy oak chairs, designs stained-glass windows and makes them himself, paints china, glazes pottery, does sculpture in the round or in relief, paints oils and watercolors, makes lithographs—in fact, an old Florentine master come to life in this machine age," Bulliet wrote. "Everything Miller does he does not only well but with distinction. He has gathered 'motifs' from all primitive sources—from the caves of Spain, from the Mayans, from the ancient Hebrews, from the Byzantine, from the Greeks, the Persians, the Chinese and the African sculptors."

But three years later, Bulliet wrote an article surprisingly critical of a watercolor of Edgar's that had won a top prize at the Art Institute's International Watercolor Exhibition. Bulliet, in the *Chicago Daily News,* said the painting, called *Chickens,* was "a good piece of commercial work" that would look at home in a poultry supply catalog. "It has about the same relation to art that a highly colored exceedingly accurate flower composition on spring garden pamphlets now visible in the seed-store windows has to a Redon," Bulliet wrote.

Edgar dwelled on criticism of his work. In a biographical sketch he prepared for the Art Institute's Ryerson Library in 1936, Edgar said that he had received "consistent unpleasant references from Bulliet and Eleanor Jewett" and "countless rejections" in his attempts to exhibit his work. After writing about his wife and children, Edgar concluded the cryptic sketch: "Just barely beginning now to find myself."

The Streets of Paris

Andrew Rebori brought cosmopolitan Paris to Chicago in 1933 at the world's fair, A Century of Progress. Rebori convinced architect John Root, of Holabird and Root, to construct a three-acre replica of the Latin Quarter, complete with an entrance gangplank that led to a "passport office," where visitors paid their twenty-five cents, and a giant "ocean liner" to Rebori's Streets of Paris. From opening night, the Streets of Paris concession was a spectacular success because of its naughty nature. "The idea for it came from a man who should have run a brothel, but it was all done in fun," said Edgar of Rebori. It was a

honky-tonk—with a Folies Bergère, a Nudiste Colonie, slot machines and fifteen-cent peep shows that the columnist Westbrook Pegler called "little skin operas." For women, Rebori hired what he called "gigolos" to dine and dance the evenings away.

Rebori, gregarious, irreverent, and of a like mind with Edgar, designed significant buildings all over town, but he stood out for the high jinks he brought to every project. He always had a surprise up his sleeve. In 1927, Rebori had invited a nude Lady Godiva to enliven the Arts Ball at the Stevens Hotel, and he repeated the stunt at the Streets of Paris. "His personality could be humorous with mischief or definite with scientific accuracy," Edgar wrote about his friend. Of the dozens of architects Edgar worked with during his career, he believed Rebori was by far the most talented.

Edgar designed huge murals at the world's fair for the Rock Island Railroad and Southern Pacific Railroad and was given an award as one of the nation's foremost

LEFT: MILLER'S SANCTUARY CARVINGS AT FIRST PRESBYTERIAN CHURCH OF EVANSTON, CIRCA 1930

MILLER THE PORTRAITIST IN HIS STUDIO, CIRCA 1945 (PAUL HANSEN)

portrait artists, but the thing from the fair he talked about the rest of his life was the Streets of Paris. Rebori enlisted Edgar to be its "art director." Edgar and many out-of-work artists and architects ran the fair's concessions. Edgar painted the interiors of a lot of the faux Paris shops and studios, including murals in the Sleeping Beauty—or La Belle au Bois Dormant, as it was called—concession, where patrons tossed baseballs at a target in the hope of tipping scantily clad women out of bed.

Edgar owned the Life Class concession, where for a quarter visitors of both sexes were given crayons and paper to sketch nearly naked women. The *Chicago Tribune's* James O'Donnell Bennett reported that the women, who were experienced life models at the Art Institute, "posed without any self-consciousness or non-sense" and sat "wholly nude" before the police warned of a crackdown.

Edgar also helped operate Visions d'Art, an exhibit that depended on technology to beat the censors. "The idea was that two or three good looking girls would appear on the stage practically nude," he said. "There would be a film projected—with fancy crinoline skirts like the French aristocracy—on their bodies. This was the Streets of Paris connection. People paid to see these girls. The act implied they were dressed, which they were not."

The star of the Streets of Paris was the actress Sally Rand. She made her entrance to the fair as Rebori's Lady Godiva, and she performed several dances a day covered only by ostrich feathers. Thanks to Rand, concessionaires took in more than a million dollars a week. A petition to shut down the "lewd and lascivious" dances at the Streets of Paris was quashed midsummer by Superior Judge Joseph Bradley Davis, who knew better than to upset the apple cart. "Lots of people in

this community would like to put pants on horses," he told the attorneys attempting to stop the dancing.

When attorneys took aim at Edgar's art classes, the judge said: "The human form is a beautiful thing. If the officials of A Century of Progress want to encourage art or if a woman wiggles about with a fan it is not the business of this court." The ruling meant that Rebori and Miller were in business at least through the end of the year. A Century of Progress was revived in 1934, and the Streets of Paris was as popular as ever.

Flush with success and cash, Rebori enlisted Edgar in 1934 to become a partner in what was advertised as the "Sensation of the Century" and the world's largest theater restaurant. Rebori wanted to create a place for late-night entertainment. Called the Cascades, the magnificent cabaret was built in the Auditorium Theatre, the monumental space designed by Louis Sullivan and Dank-

mar Adler in 1889. Rebori, who served as the architect, impresario and general manager of the Cascades, tore out all the seats on the main floor and constructed a large terraced main room with café tables. Box seats around the lower balcony were transformed into private dining rooms. Working as the decorator, Edgar built scenery, including a giant waterfall modeled after the fountains of Versailles.

The Cascades opening was a wonderful success, with six hundred socialites filling the hall for a hospital fundraiser. Patrons could dine, dance to two jazz bands (one white and one black) and watch an assortment of stage shows—from ballet to tap, singing quartets to operatic arias—all for two bucks. But after just a few weeks, problems set in. Rebori reorganized, announcing that Lottie Mayer's Disappearing Water Ballet, "a bevy of beautiful mermaids and a huge diving chorus," would be the main attraction.

MILLER'S LA BELLE AU BOIS DORMANT MURAL AT STREETS OF PARIS, 1933 (CHICAGO ARCHITECTURAL PHOTOGRAPHING COMPANY/CHICAGO HISTORY MUSEUM)

But the diving girls couldn't save the Cascades. The nightclub closed in early July, less than two months after it opened. Edgar blamed the closure on a fight between Rebori and the unions. Within months, Rebori and Miller lost all the money they had made from the Streets of Paris, and Rebori filed for bankruptcy, declaring assets of $18,000 and liabilities of about $80,000. But it didn't take long for both to make a comeback.

Depression Art

In late 1933, Edgar was put in charge of the "technical committee" that chose artists for the Public Works of Art Project in Illinois, Wisconsin and Minnesota. The Chicago regional office was directed by a woman named Increase Robinson, who had sold Edgar's art at her gallery in the Michigan Square Building near Diana Court and was one of many who thought they "discovered" Edgar.

"Miss Robinson demanded one painting every week, subject matter 'American Scene,'" wrote the artist George Josimovich. "The story went round the project that she rejected Ivan Albright's canvas of a football game as not being American Scene. Sometime in January we were asked to bring our canvas 'as is' to the downtown project office for review. I'll never forget taking my rather large composition, just started, down to cold, windy Chicago. When I got there I ran into Edgar Miller, whom I knew very well, and was one of the project committee members. He said, 'What the hell are you doing here with that canvas?' I showed him the card I received from Robinson: he shook his head and said, 'George, take it home and paint and take your time.'"

Created in 1933, the Public Works of Art Project was Franklin Delano Roosevelt's first attempt to help needy artists all over the country by commissioning art for government buildings. When the Chicago office opened, scores of painters and sculptors lined up to find work. One of the artists, Avery Johnson, wrote: "In December, a musical friend, Mrs. Edgar Miller, told me that her ex-husband was organizing a new art project and wished to get artists who could be depended upon for quality paintings. I submitted some of my water colors and was put on the payroll."

By late December, more than a thousand artists had applied for jobs. Edgar and eight other committee members chose 174 artists (the government quota) to work full-time over the next four months. More than 500 oils, 700 watercolors and drawings, 73 murals and 56 sculptures were completed during the program's six months. Despite economic guidelines on the hiring process, the *Tribune* critic Eleanor Jewett declared, the program was an artistic success. "Much brilliant and fine painting is finding its way into headquarters," she wrote during its height. In May 1934, when the project was complete, she raved of the "grand job" done by government artists. "Proof of the excellence of their work may be found in the current exhibit on the eleventh floor of 135 South LaSalle Street."

C. J. Bulliet, the art critic who had praised Edgar's work in the past, disagreed. He wrote that Miller's poor taste in art explained why many of Chicago's finest artists refused to participate. (Actually, some of the city's top artists did not qualify for the program because it was designed for artists with no other means of support.)

Soon after, Edgar was hired by the federal government to design a series of animal sculptures that would double as a playground at Chicago's first public housing project, the Jane Addams Homes on the West Side. The project, called Animal Court, consisted of a several-ton main climbing sculpture of fanciful animals plus six seven-hundred-pound individual creatures. (The sculptor Emmanuel Viviano designed the bear.)

In 1939, Edgar returned briefly to administration when he was asked to serve as one of five jurors in the government's Forty-Eight States Competition. His job was to pick the best mural design for a post office in each state. Some three thousand entries were received, and winners were exhibited around the country and in *Life* magazine. Edgar enjoyed the work in Washington, D.C., and was honored to be appointed to this national panel.

Organic Architecture

Much of Edgar's architectural work during the late 1930s was with Andy Rebori. In 1935, Miller and Rebori redesigned and rebuilt the 885 Club, a restaurant and nightclub on Rush Street at Delaware Place. Edgar

painted several murals for the club, including a history of important generals for its West Point Bar. Historical murals were becoming a favorite for Edgar, who loved research. In 1936, Edgar created a stained-glass window and carved the front door and sculpture for the Rebori-designed Ernest Kuhn House in suburban Wilmette. The house is correctly attributed only to Rebori because Edgar simply added details. But in typical Rebori-Miller fashion, Edgar put a nude woman in a niche above the front door, and Rebori rouged her cheeks and painted parts of her breasts vermilion. Neighbors complained; city officials became alarmed. "The upshot was that the lady was repainted—this time a chaste and chilly white," the *Tribune* reported. "She looks out upon Greenwood Avenue and recalls her lurid past. All the neighbors are happy, and so is Mr. Kuhn."

Near the end of the decade, Edgar

MILLER'S ANIMAL COURT
SCULPTURES AT THE JANE
ADDAMS HOMES, 1938

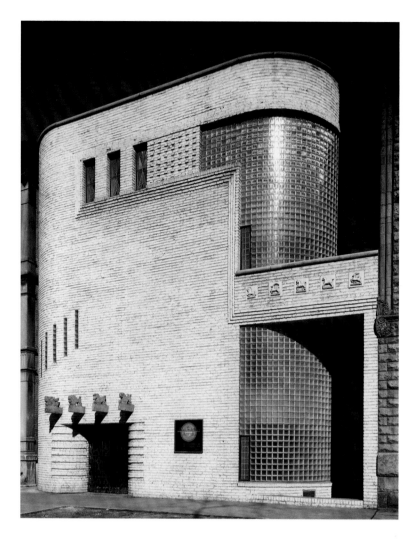

helped Rebori by designing the rose window above the entrance and the mosaics in the crypt of the Madonna della Strada Chapel on the Lake Shore campus of Loyola University, and by sculpting two Alsatians for the tomb of the *Tribune* editor and publisher Robert McCormick and his first wife, Amy. ("They are the only friends I got," said McCormick of the dogs.) Edgar was not paid for his work until the tomb was actually built following McCormick's death in the mid-1950s. "They said I would get a million dollars of publicity; my name was never mentioned," Edgar wrote. When he was finally paid, Edgar said, it was at Depression rates. "That was the colonel."

In 1936, Edgar joined Rebori in designing the thirteen-unit Frank F. Fisher Apartments, at 1209 North State Parkway, about a mile north of the Loop just off the city's luxurious Gold Coast. This was Edgar's final house, and the only one he built from scratch. "Miller and Rebori broke the mold when they designed that building," wrote the artist Larry Zgoda. It was their organic

house.

"Home life, whether in an apartment house or residence, is not a mass-production process but a social adventure which demands the leavening influence of grace and beauty," wrote Rebori and Miller in *Architectural Record.* Each unit, they said, must encourage and sustain pleasurable living. "The design of the modern small apartment house at 1209 North State Street, Chicago, presented us with an unusually interesting opportunity to work toward a conception of how an organic modern architecture can achieve compact, livable, light housekeeping units in minimum workable space, with added factors of comfort and beauty."

On a thin lot near a noisy streetcar on State, Miller and Rebori built a curvy moderne facade. "Nobody else could have designed the front of the Fisher Building but me," Edgar wrote years later. Above the entrance were four pieces of oak with Edgar's carvings of a horse, a buffalo, a mountain lion and a whale. "In terms of humanistic logic, they mark the entrance with statements of life and vitality which can be enjoyed more than a purely mechanical marker ever could be enjoyed."

Behind the facade, Miller and Rebori turned the four-story complex on its side to create a quiet, enclosed courtyard. Pivoting the building away from the street kept apartments from noise and gave more light. The house was divided horizontally into two sections, upper and lower duplexes, so no elevator was needed.

"The plan developed with some familiarity: an outside stairway to studios that were two stories with large windows," Edgar wrote. "In this case, of glass brick rather than leaded glass that was used in Burton Place and in other buildings in Old Town. In the metal sash of the second floor, the windows were leaded and some small addition of color or enamel in an animal or two. The doors had leaded glass panels, which have entirely disappeared. There were some sculptural details around the doors—and the facade of the building on State Street was a complete concealment with some carved beam ends above the entrance and the common brick of the wall carried the slit windows of the outside curved stair. I included some terra cotta tiles that had animal figures. The windows of the two floors were in curved forms of glass brick."

Inside the units, a glass wall separated the kitchen from the main room, which connected to several smaller rooms. As at Edgar's other apartments, walls and ceilings had rounded corners, and each unit had a wood-burning fireplace. "The general character of such an interior should be both restful and stimulating," Miller and Rebori wrote. "By varying ceiling height in the duplex unit there is achieved a feeling of release." The interiors connected to the exterior by the use of enormous vertical glass block windows. "Privacy becomes a problem in the crowded city," they wrote. "By adopting the large glass block opening and windows of obscure glass, we eliminate the need for curtaining which can give privacy only at the sacrifice of light."

The Fisher Apartments was a complete collaboration, and both men were credited as architects of the studio houses. "The Fisher building was an entirely different kind of building than a skyscraper or an office building," Edgar wrote. "Andy saw it as the same kind of building that I had done on Burton Place." Rebori made Edgar's ideas work, and he changed the mood on the upper floors into that of the International style. In the *New York Times* decades later, Ada Louise Huxtable said that Rebori combined Russian constructivism with art moderne. Wrote Edgar: "He did something with the structure on that second floor that I simply couldn't have imagined. In Andy I was aware of an architect that I never encountered anywhere else."

Built for the Marshall Field executive Frank Fisher, the building was advertised as the first air-conditioned apartment house in Chicago and one of the first in the nation. It garnered attention as soon as it opened in May 1937. "It would be hard to carry romantic eclecticism any farther than has been done in this most unusual apartment house," noted *Architectural Forum*. "Built in no recognizable style, the structure combines glass brick, stained glass, medieval brickwork, and woodcarving in the Swedish manner, and displays an equally individualistic approach on the interior."

Edgar, as usual, had trouble accepting even a favorable critique. He took offense at the term "romantic eclecticism," writing: "A typical academic remark of an uncertain idiot to whom it is inconceivable that any creation is possible. It must be copied or influenced by something made in the past! 'Eclectic' is a word that brands its user as the slavish academic that 'knows everything original happened in the past.'"

Decades later, in 1978, Edgar looked back at the Fisher Apartments and his three other homes with fondness. "I got an enormous amount of enjoyment out of doing these things," he said. "But I have never taken them with great seriousness. They were for people who were interested in living in dramatic, charming surroundings, that's all. So much art is so damn serious and deadly and dignified that you can easily go too far in that direction, cutting out an enormous number of the human race. I always felt that humor reaches more people than dignity."

The Normandy House

In 1937, Edgar found another chance to create a total environment when he was approached by Richard Tallman and his wife, Grace Holverscheid, to help develop a restaurant in the nineteenth-century mansion built by Levi Z. Leiter, one of Marshall Field's

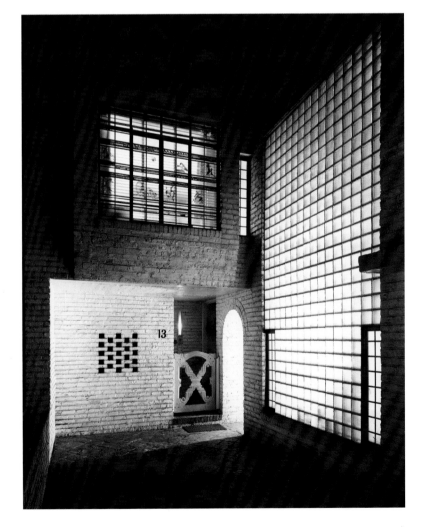

CARVED GATE AND LEADED WINDOWS BY MILLER AT FISHER APARTMENTS, 1937 (HEDRICH BLESSING/CHICAGO HISTORY MUSEUM)

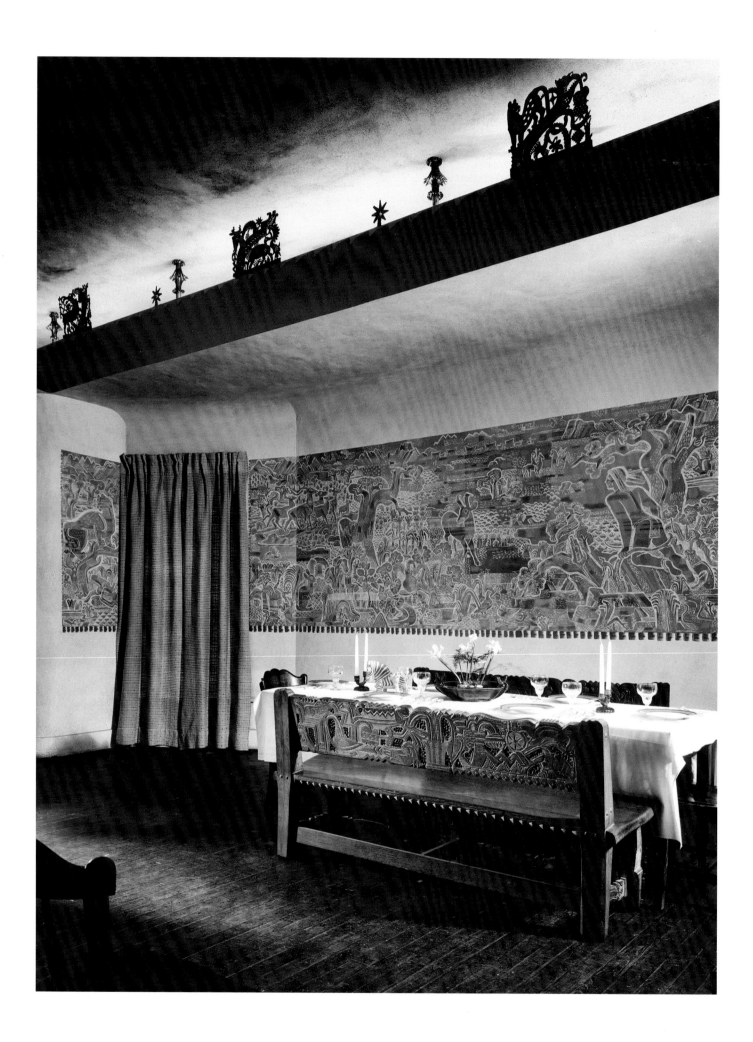

original partners. Directly west of the Water Tower, Leiter's stone house, at 800 North Tower Court, changed hands many times over the years and was remodeled in 1931 as a restaurant called the Charm House.

Tallman, a composer, and his wife, a concert soprano, and their business partner, the accompanist Helen Wing, were an unlikely trio to run a restaurant. Their goal was to create an artistic abode that specialized in healthy, home-cooked meals. They had bought a restaurant, Little Normandy, in 1932 and expanded to the old Leiter mansion when they couldn't keep up with demand. "For fifteen years, the Tallmans and Mrs. Wing have fought and won the daily battle for good food," wrote Patricia Bronte in her 1952 book *Vittles and Vice.* "Their high-quality menus and deliciously prepared dishes have brought them the steadiest and most faithful clientele in the area. Some customers—Jascha Heifetz, Lily Pons, and Victor Borge—are old friends from their musical-world days."

Edgar and Frank had helped the restaurateurs create Little Normandy, which was housed in the Edgar-designed Vassar House just off North Michigan Avenue. After their success, the threesome told Edgar they would not consider opening a larger place unless he was its artistic director. Edgar agreed, and he designed every detail of the Normandy House, a two-story restaurant and basement bar. "The name Normandy House set the theme for decoration, and Edgar's creative imagination had free reign, an artist's dream," wrote Frank. Edgar embellished the front door to greet visitors and filled the first-floor dining room with painted plaster scenes, carved wood, custom-made furniture and stained-glass windows. A row of his china dinner plates rimmed the room. The Normandy's walls became a tableau of French life as Edgar painted fishing villages, farms, wheat fields, cattle pastures, waterfalls, hills and swamps—often populated by singing, dancing and picnicking young men and women. Edgar also designed the waitresses' costumes, the place mats, the matchbook covers and the menu.

Downstairs at the Black Sheep Cocktail Lounge, Edgar covered the pillars, walls and fireplace with portraits of famous black sheep: Jesse James, Frankie and Johnny, Barnacle Bill the Sailor, the Daring Young Man on the Flying Trapeze and many others.

"Customers sitting at the bar always marveled when what they saw in the mirror differed from what they saw from the outside," wrote Frank. "Edgar said repeating the same thing took the fun out of creating."

The Normandy House became a sensation for its food, its ambiance and its environment. Many regulars ate there three or four times a week, and the Art Institute sent students over to see Edgar's work. "The building sparkled with fine artistic humor," wrote Frank.

Because he was not timid about taking small jobs or jobs that didn't pay at all, Edgar never wanted for work during the 1930s. "The days and weeks passed quickly for we were so busy," Frank wrote. "Edgar still designed and made things for the studios, plus many things that struck his fancy. Ceramic vases, bowls, or tiles, painted dishes, seals, Christmas cards, sketches or pictures that piled up in his studio."

But Edgar had no system for saving money. "As he could pay his bills and alimony he did not seem to be concerned one way or another," Frank wrote. "Accumulation was not in his nature." Frank was no better. He lived with Edgar during much of the decade and assisted him daily by stretching canvases, painting backgrounds and doing heavy carving. But he never asked for money. "It seemed like bumming," Frank said. Although he did not pay his brother on a regular basis, Edgar bought Frank suits, shoes and meals, and made his car payments. "These were very productive years, and I dedicated myself to helping what I knew to be an unusually unique and important talent," Frank wrote.

By the end of the 1930s, work had slowed for Edgar and Frank. Their lives were changing. Their mother died in 1934, and their father in 1938. Near the end of the decade, Edgar wrote his brother Eugene, who had taken over their father's optometry business in Idaho, thanking him for the eyeglasses that he sent to Chicago: "Frank and I have been scraping out the bottom for a number of months now, and I have been wearing glasses of a still earlier prescription so these were a great relief." But the Miller brothers were getting by as happy, productive bachelors. They lived on the third floor of the Normandy House, in two bedrooms provided free by the restaurant owners, and converted upstairs space into a large workshop.

MILLER'S FRESCO, PAINTED CHINA, CARVED BENCHES AND CEILING FIXTURES IN NORMANDY HOUSE DINING ROOM

without him. Edgar, who had steadily employed Frank for more than a decade, cut him off from work and money. "That was like hitting me over the head with a sledge hammer," Frank wrote. "A blow I shall remember to my dying day." Despite his bitterness, Frank, who always thought of Edgar first, excused his brother's rash decision. "He had been so deeply engrossed and busy in art work, and I'm sure he was not thinking when he so casually dismissed his slave."

The two brothers separated. Frank and Josephine moved to Arizona and then North Carolina in an attempt to get away from Edgar and Dale. Years later they moved back to Chicago, where Frank got a job as the bar manager of the Normandy House, but he did not reconcile with Edgar for several decades. Edgar and Dale stayed at 800 Tower Court, on the fourth floor of the Normandy House, where they started a family.

In Demand

The 1940s meant bigger jobs for Edgar. He was paid $7,200 in 1940 to design bas-reliefs for Northwestern University's Technological Institute, a massive $5 million structure at 2145 Sheridan Road in suburban Evanston. Edgar loved the job because the firm Holabird, Root and Burgee handed him a roll of blueprints with areas marked for sculpture and turned him loose. Edgar decided to tell the whole history of applied science, with the goal of educating and inspiring engineers at work on the war effort.

Few people who enter the Technological Institute ever realize how Edgar used much of the building's exterior to symbolize exactly what was going on inside. He employed a series of symbols around the parapet to show man's simplest idea of his physical world: mass, motion, time and space. The three main entrances show pure physical sciences—mechanics, chemistry and electricity—and two small entrances signify civil engineering and physics. In the back, Edgar expressed the sources of power and material: electricity, coal and oil, ferrous and nonferrous metals, plastics and chemistry, glass and ceramics.

The most outstanding sculptures in the building are the bas-reliefs in the lead spandrels between the first and second floors. "I wanted to express the synthesis of science from the very beginning, so I used the four

All that changed in 1940, when Frank married Josephine Michaels. Edgar gave Frank money for his honeymoon, and the newlyweds headed to New Orleans. A few weeks later, Edgar finally got a divorce from Dorothy and married Dale Holcomb, a textile designer eight years his junior whom he had met while she was working as a sketch artist at the Streets of Paris. Dale was hired to do at least one mural for the Works Progress Administration. Frank disliked Dale from the first time he met her at what he called a "Depression dinner." Frank wrote: "Dale's high, loud mirthless laugh warned me off immediately. Everybody liked her, so I thought maybe there was something wrong with me, and put it out of my mind." A few months later, Edgar started dating Dale.

Soon after they married, Dale tried to separate Edgar from his family and friends. "I was the first casualty," Frank wrote. When he complained about Dale, Edgar told his brother that he and Dale could get along

spandrels to illustrate the four elements—earth, air, fire and water," Edgar wrote. Above the doors, he did low-relief sculptures of preeminent scientists, including Archimedes, Lavoisier and Benjamin Franklin.

In 1943, Edgar told another story—the history of brewing—in fresco on the walls of the huge Sternewirt taproom for the Pabst Brewing Company, at 915 West Juneau Avenue in downtown Milwaukee. Free freshly brewed beer was offered in the Sternewirt to guests who took the brewery tour. It was a taste of heaven.

Edgar's work was chronicled in the *Milwaukee Journal,* which proclaimed: "History of Brewing in Murals, Done in Record Time by Miller." The pub was pure Edgar. *The Journal's* Frances Stover reported that Edgar told beer's story "from grain to foam" and portrayed all the trades associated with brewing. Edgar worked from memory and from study. "Pictures he had looked at and books he had read had long since given him a perfectly clear idea of what an old braumeister looked like as he stirred the mixture in a big, round vat while a varlet stoked the fires underneath," Stover wrote, noting that no detail was used without care. "Every episode painting, every costume, every pose of a figure brought interesting explanations and comment from the artist."

By the mid-1940s, Edgar was in demand by some of America's top designers. He created a series of wallpapers, called the Tower Court Collection, for the leading-edge Chicago firm of Bassett and Vollum. The architect Samuel Marx, who designed Chicago's Pump Room restaurant, hired Edgar to create a history of eating for New York's Pierre Hotel, across the street from Central Park. Edgar's murals for the foyer of the Pierre Grill depicted such food events as Montezuma's feast for Cortés, a Roman banquet and the first Thanksgiving. He also did lush sgraffito, or scratch work, on the restaurant's columns; six layers of color that he cut away to make gilt-edged designs covered each.

In Washington, D.C., Edgar designed murals and an immense plaster bas-relief of an eagle in the Presidential Ballroom of the Statler Hotel, now known as the Capital Hilton, four blocks north of the White House, at 1001 Sixteenth Street Northwest. Edgar, hired by the firm Holabird and Root, was also commissioned to do a mural in the hotel's South American Ballroom. The architect and designer told Edgar that South Americans loved heroic art and mentioned that nudity was seen in the major parks and plazas of Brazil and Argentina. Taking the hint, Edgar painted two giant nudes on the wall, but the racy murals mortified the conservative Sons of the Revolution, the first ballroom guests. In front of Edgar, the rattled conventioneers taped giant sheets of craft paper across the naked women. "In order not to embarrass the architects, I painted out one of the best things I had done, and I decided not to be caught dead as a Son of the Revolution," Edgar wrote.

Life with the Millers

Frank Miller was incorrect about Dale. She proved to be the perfect wife for Edgar. Their first son, Norman, was born in 1941, and their second, Ladd, in 1946. "I married a woman

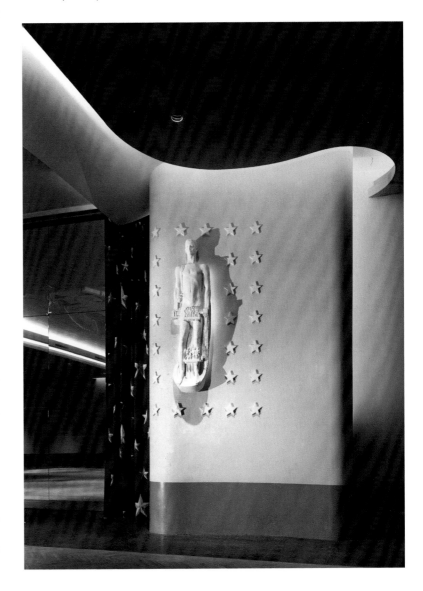

BAS-RELIEF SCULPTURE IN PRESIDENTIAL BALLROOM OF STATLER HOTEL, WASHINGTON, D.C., CIRCA 1945

who was my friend and we had a nice life together," Edgar told a reporter. It was the closest he ever came to talking of love. "We used to give parties and I enjoyed that more than anything. We made gingerbread cookies and decorated them, and I painted dishes to give as gifts to our guests. Everything I've done was because I enjoyed doing it."

The family they created was most unusual and was the subject of frequent articles in Chicago newspapers. In 1951, the *Chicago Tribune's* Kermit Holt wrote an article titled "Miller Family at Home Is Four Ring Art Circus." More than a decade into their marriage, Edgar and Dale still lived in the fourth-floor apartment above the Normandy House with their two sons, a rabbit named Bunny, a cat named Kitty, a pigeon named Pidgy and a Javanese rice sparrow with no name. On the rainy night that Holt visited, the Millers had nine buckets catching leaking water all over the house.

"You have to pass the cashier to reach the Edgar Miller family apartment in the Near North side's Bohemian art colony, but there's no admission charge," Holt wrote. "Perhaps there ought to be. An evening with the talented Millers and their menagerie is so entertaining and stimulating that a visitor feels a little guilty he got it for free." The apartment had no TV, no radio and no telephone, Holt noted. It was short on gadgets but long on "friends and cleverness and accomplishments and happiness."

Holt admired the Millers. He described Edgar as an artist, a scholar and a "topnotch conversationalist"; Dale as a prizewinning portraitist who did silk-screen printing; and Norman, known as Skippy, as a genius artist who spoke Chinese, Malay, Bengali and Spanish and played the piano, violin and Hungarian cimbalom. "The Millers are artists, completely creative in almost every art form, even the little lad named Ladd, who, come to think of it, is an artist at taking things apart with a screwdriver," Holt wrote.

Skippy later recalled the years at 800 Tower Court as his happiest. He began making pencil sketches at six months and using a paintbrush a month later. His father, astounded by his son's work, let Skippy draw in his precious sketchbooks and held art exhibitions for the boy starting at age two. Among Skippy's admirers was the Finnish composer Jean Sibelius, who wrote Skippy a fan letter.

Skippy's first memory was of his father working in the fourth-floor apartment. "When father painted a mural at home he put up a two-by-four scaffolding, which was seven or eight feet high, and depending how long it was the scaffold wound around our bedroom, living room, third floor hall, dining room and carving and workroom area," he wrote. "Sometimes it even went through the kitchen into the clay and casting room. It was a shocking experience to visitors."

When Edgar was away, he would send Dale and the boys illustrated letters, cards and booklets, Skippy recalled. "When he was home, he would surprise us with some new design for wallpaper, or a hand-illustrated book for me with my name on it. And late after one or two o'clock in the morning, we might all go out unexpectedly for a snack, where we had a chocolate sundae or something nice. Nobody ever went to bed before two o'clock. Besides, company would often turn up at that time, and then we might stay up for a surprise party, with chocolate cake or apple pies baked on the spur of the moment by mother."

Ladd agreed that childhood in the Miller house was idyllic. "We seldom took vacations as such since we enjoyed life all the time," he wrote. "We never felt it was necessary to run away from stresses." Ladd thought Edgar gave his children the proper attention. "I remember father was very loving to me and to my brother, Norman. He was sometimes pretty stern, but also very interested in what we did and thought. Norman was more the artist. . . . I was more scientifically inclined. Father was interested in both."

During the early 1950s, the Millers moved to an eighteen-room mansion on the North Side overlooking Lake Michigan. Even from the outside—with the globe thistles and common mullein weeds surrounding the house and the windows whitewashed with Bon Ami cleanser—it was clear that the family inside bucked the regimentation of the era.

"If you've ever driven or ridden past 5754 Sheridan Road, you've seen the big brick house with Mexican designs painted on its windows," George Murray wrote in 1957 in the Pictorial Living section of the *Chicago American.* "That's where the family of Edgar Miller lives and works in a crazy-quilt pattern incomprehensible to ordinary mortals. They are artists, the whole family of them. Edgar and his wife and their two sons and his

DALE AND EDGAR IN THEIR HOME ON SHERIDAN ROAD, CIRCA 1955 (PAUL HANSEN)

'BUCOLIC SCENE,' ONE OF MILLER'S SEVEN PAINTED-OVER POST-CARD VIEWS OF CHICAGO, CIRCA 1960

mother-in-law and their teacher of Chinese. Yes, they all study Chinese together. And Malayan and Bengalese. While the boys hook rugs and the elders print textiles."

The description was accurate, Ladd confirmed. He recalled the dining room table as the center of activity—Edgar sketching, Dale studying Chinese, Skippy studying math, and Ladd electronics. The sunroom was an aviary with a tile floor, but birds flew all around the house.

When *American Artist* profiled Edgar in 1963, it reported that the house on Sheridan Avenue was a key to his work as an artist: "To understand why Edgar Miller's talent is sought by architects and interior designers all over the country, you must see him in his everyday surroundings. The stylized designs of clear glass in the opaque windows on the first floor look as if they have been sandblasted. Instead, the effect was achieved with whitewash, with the design area rubbed clear, thus making it possible to change the decoration from time to time. Inside, a mynah bird emits a wolf whistle and a mother cat walks by with six kittens. The cat motif appears in gay colors on built-in cabinet doors. The radiator cover is an open woodcarving of prancing horses, and

similar shields of plaster shade the wall light fixtures. Miller also painted the ceiling decorations, designed and fired the tiles framing the doorways and topping the coffee table, decorated the soup bowls and frieze of plates in the dining room, and carved the wooden dining benches."

Although no photographs exist that inventory the contents of the house, there is little doubt that the Sheridan Avenue mansion was another total art environment. Edgar's oil portraits and watercolor landscapes lined the walls. He designed and executed stained-glass panels in the living room and worked with Dale to produce silk-screen wall hangings. For Dale's birthday one year, he created a mural that filled the back staircase.

"This is a home where ideas, however unorthodox, are received with enthusiasm, where conversation is never trivial, and where there is laughter, camaraderie, and curiosity, but no inhibitions about trying an experiment for fear of making a mess or failing," *American Artist* noted. "This may sound like an assembly of merry madcaps, but this is only superficially true. Actually, the Millers' way of life is an expression of their sense of values. For them, ideas are all-important.

It also explains the unique qualities in Edgar Miller's art."

The family's lifestyle was certainly a reflection of Dale, who was fearless and outgoing, but it also expressed the artistic communalism Edgar favored. He enjoyed working with his family around him and used the entire house as a giant studio. His output was "staggering," the magazine reported. "He often started work at one in the afternoon and continued until eight or nine the next morning."

Although Edgar was the darling of designers in the 1950s, his work did not show the same innovation it had in earlier years. Edgar would dispute that statement; he believed he was always doing his best work. In 1950, Edgar was hired by the Container Corporation of America to do a poster of Aristotle for its Great Ideas of Western Man series. The company hired the best designers of the age—Paul Rand, Herbert Bayer, Ben Shahn, Leo Lionni, Hans Erni—to illustrate quotes from inspiring thinkers.

Then followed a series of commercial jobs: murals depicting Chicago history for the Chicago Title and Trust Company, barbecue scenes for a new Fred Harvey restaurant off Michigan Avenue, foyer and bar murals for the Palmer House hotel, a company history of the Hudson Pulp and Paper Corporation for its New York office and a number of projects for Jo Mead Designs, a company that made large-scale decorative sculptures for homes, restaurants and hotels.

Through Samuel Marx and the designer Raymond Loewy, Edgar was hired to paint murals at five May department stores in the Midwest and at a Famous-Barr store in St. Louis. At the May store in University Heights, east of Cleveland, Edgar and Dale spent months painting murals: three kings above the giftware department, storm clouds above the rainwear department and a knight in shining armor (actually a boy with a tooth missing) in the juniors' department.

Loewy hired Edgar to design and hand-paint a map and an illustration depicting the Lewis and Clark expedition on six of Northern Pacific Railway's Traveller's Rest buffet lounge cars on the Vista-Dome North Coast Limited from Chicago to Seattle. When he arrived at the railroad shops in St. Paul, Minnesota, he was met by a group of Swedish American mechanics nudging each other and snickering at the tenderfoot from Chicago. Edgar couldn't figure out why, but he soon learned that they knew from experience that ordinary oil paint would simply roll off the vinyl surface he was to paint. "This is what the workmen expected to witness as I finished my mural—and they expected to enjoy my embarrassment."

But Edgar knew better. He had tested the vinyl and figured out how to do the job. He brought his own paint and solvent and quickly covered the upper walls and ceiling of the railroad cars with his work. "To paint on vinyl demands a special technique," he said. "The paint dries so rapidly in the brush that it must be applied instantly to the vinyl surface or it dries on the brush. This requires a direct application, no sketchy hesitation on

'SWEET ARE THE USES OF THE CANTILEVER,' MILLER'S UPSIDE-DOWN VIEW OF THE PRUDENTIAL BUILDING, CIRCA 1960

MILLER'S
PORTRAIT OF THE
WIFE OF A
BRAZILIAN
CONSULATE
MEMBER IN
CHICAGO, 1962

soley on the fire, Edgar showed the looks on people's faces.

Work fell off in the late fifties and early sixties. This may have been a consequence of the recession of 1958 or because many designers who employed Edgar were approaching retirement. In 1959, Donald Deskey, who designed the interior of Radio City Music Hall, hired Edgar to produce murals for the ultraexclusive Marco Polo Club off the lobby of the Waldorf-Astoria Hotel in New York City. Edgar painted Marco Polo's galleon behind the back bar and a large map he called *The World of Marco Polo* in the restaurant. Back in Chicago, Edgar designed sculpture for the lobby of the new United States Gypsum Building and returned to ecclesiastical work, doing stained-glass windows and the black walnut crucifix for St. David's Episcopal Church in suburban Aurora, bronze saints for St. Mary's Cemetery in suburban Evergreen Park, carved doors and glasswork for a chapel inside Michael Reese Hospital on the South Side and a Holy Ark "Tree of Life" for Temple Emanuel on the North Side.

Work in churches and synagogues required a high standard of craftsmanship. "Although I couldn't possibly feel the reverence that a devoted Catholic has for the virgin, or the wounds caused by the nails of the cross, El Greco gives me access to the emotions he experiences and I am emotionally enriched as I am by some of the sculptured heads of Buddha," Edgar wrote. He enjoyed the work but never got too firmly connected. "One time when I was in a church with the idea of making some stained glass, the father accompanying me noted my polite genuflection and said 'None of that, I know you have your own religion as an artist.'" Wrote Edgar: "Perceptive man."

In 1961, Edgar returned to the Tavern Club to redo his *Love Through the Ages* mural. The celebrated original had been taken down and cut into eighty paintings, which were sold at auction to benefit the club. Edgar repainted *Love Through the Ages,* updating it to add a scene with beatniks and one in the space age. The panels were considered witty and delightful, but there was little doubt that they did not match the quality or verve of the original. Times and styles had changed, and Edgar was no longer as fresh and bright as he was in the 1930s. For the first time, Edgar's skill seemed limited and dated. His time had come. Or so it seemed.

your dry brush." The men were shocked by Edgar's success. At the end of the job, they presented him with a pocketknife of Swedish origin with their finest compliment: "You are a mechanic."

In 1954, Edgar was hired by the Standard Club to design two sets of glass doors and four murals. He used stencils and sandblasting tools for the doors, a throwback to the panels he did in 1929 in Diana Court, and a straight-edged razor for the murals, which were actually large black linoleum panels in the club's cocktail lounge. The intricate panels illustrate the Great Chicago Fire of 1871. Edgar made no preliminary sketches; he just started work on a surface that could not be corrected. When an onlooker suggested that Edgar use a utility knife, he responded, "Nah, I'm fine with a razor blade." The murals show Mrs. O'Leary's barn, horse-drawn fire teams, city dwellers escaping the fire and the rebuilding of Chicago. Instead of focusing

Edgar the Innkeeper

In 1967, Edgar and Dale sold their spacious house on North Sheridan Road to a developer who demolished it to build an apartment complex. "Down goes the Edgar Miller home. Out goes an amazing variety of original art works," Edgar wrote on a flyer announcing the sale. "Your once-in-a-lifetime opportunity . . . if you hurry!"

On something of a whim, Edgar and Dale moved to Florida. With the help of the attorney Rick Nelson, Edgar raised about $500,000 by selling the Sheridan Road house and twenty-nine acres of undeveloped woods on Lake Michigan south of Castle Park, near Holland, Michigan. Edgar had purchased the property in the late 1930s for $12,000 and sold it for more than $400,000.

With the money, Edgar and Dale bought several pieces of property in Florida, including the nine-unit Roxy Motel, at 14464 Sixty-sixth Street North, in the heart of Clearwater, and a beach house on the northern end of Clearwater Beach Island, at 978 Bay Esplanade. Edgar and Dale, who moved in June 1967, had many plans, from expanding the old motel to creating a small art colony there. None came to fruition. "I expected to go into building—houses, hotels, things like that," Edgar told reporters years later. "I did a lot of preparatory work, but couldn't get a permit." So instead Edgar stuck to art. He carved two cypress doors and a long panel for a Palm Beach condominium, put up a large metal Morton building as a studio out back and worked as an innkeeper. "I wish you could see this place, and I'd like to sketch out what can be done with it," he wrote a friend during his first winter.

Edgar liked the warmth, the palmettos and even the alligators that lived in the nearby swamps. Best of all, he wrote, "there are fewer people in Florida than in Chicago!" Florida brought Edgar back to nature; he enjoyed Clearwater even during the worst of weather. "Everything under water and the chorus of frogs almost deafening," he wrote after one storm. "Dale and I in a state of suspended animation. The house on the beach—one rug soaked and water at the doorsteps but subsiding. All the animals and plants love it."

Edgar loved it, too. Dale invited family and friends to the motel, and the couple hosted many parties in Edgar's studio. At Christmas, Edgar designed giant gingerbread cookies. Their younger son, Ladd, got

PAINTING OF
MILLER'S LAND
IN MICHIGAN

married and opened a hardware store in town. Edgar showed his art wherever possible, from the Red Carpet Gallery to a local art museum. "Anyone who goes to Miller's one-man exhibit at the Florida Gulf Coast Art Center opening today and continuing until Nov. 1 will be awed that one man could accomplish such a variety of work," wrote Christina K. Cosdon of the *St. Petersburg Times* in 1972. After the opening, the museum's director, Dorothy A. Edmunds, wrote Edgar: "All of us connected with the Florida Gulf Coast Art Center are very happy that you have moved to this area. We feel we are fortunate to have a man of your stature as a permanent resident!"

In 1975, Pamela Peters, the *Pinellas*

TWENTY-STORY OCTAGON APARTMENTS, DESIGNED BY ANDREW REBORI AND MILLER IN 1961 TO REPLACE THE SHERIDAN ROAD HOME. IT WAS NEVER BUILT.

Times correspondent for the *St. Petersburg Times*, wrote a piece that offers a good look at Edgar in retirement. "It was a long time before I knew Edgar Miller as more than the proprietor of the Roxy Motel," she said. "You wouldn't notice the small place if you were going at more than reasonable speed down 66th Street N. You'd only stay there if you were one of the aging couples who return each winter to spend the season." Peters stopped every month or so because she also worked as a saleswoman and the Roxy was on her route. She wrote:

If it was an incongruous atmosphere for an artist, I didn't realize that. I didn't bother to see him as more than an account and an elderly man.

He occupied a woodlined cave of an office strewn with the ordinary that had somehow alighted there and with the exquisite and exotic that seemed to belong there by right. Reader's Digest condensed books leaned against wood carvings. Screen prints were mixed in with rent receipts.

Perhaps I'd never really have known him as more than a motel manager if it hadn't been for noticing the handwriting on the checks he paid me with and for Chopin swirling though the air one fall evening.

The writing had a bold, deliberate Mandarin beauty. The music came from a room behind the room we were in. If it were out of place at the Roxy Motel it did coincide with the autumn twilight.

When the reporter asked Edgar about the carved and painted animals in the office, he took her into a room where he lived. "I would return again to lunch with black bean soup and brandy and talk," Peters wrote. "Sometimes just to talk." She went on:

My errand the last time I talked to him wasn't to review his life and works. He says I'm utterly ignorant of art. I tell him he doesn't really appreciate literature. He's right, and I'm not all that right.

This time I went to interview the Artist as Aging Person.

I went armed with 12 intelligent questions, six books on gerontology, three humanities courses and a camera

in a black bag.

As usual in our continued argument, he maintained that my liberal arts background was useless. He refused to answer my "intelligent questions prepared ahead of time." He would not talk about the Artist and Aging. He hates photography.

For example, he's been described repeatedly as a Renaissance type because of his successful use of nearly every medium from oils to stained glass. He snuffs abruptly: "I think the Renaissance is very much overrated. Phony, definitely phony."

Well, that gives you some idea.

Edgar then told Peters of his Idaho past and talked about what he was working on and the book he was writing on the structural organization of art.

Desperate to get something more personal, I beg to go to the studio. After a visit to a family of wild dogs he has adopted and after a brief check on the horse, we enter that huge metal barn with its entirely orderly confusion of styles and material. I visit all my favorite paintings, checking on the stained glass window propped in the corner and stopping in front of the wallpaper design series.

The dog in the picture has ragged whiskers and a wart on its jowl. It cocks what is obviously a flea-bitten ear projecting both life and tenderness in spite of its defects.

The dog possesses a quality that most of Miller's work seems to have. When I tried to define it for myself once, he said what he was aiming for was "the sweet ugliness of reality."

Edgar explained:

"An artist falls in love with a particular pattern of the universe making harmony of it. Love. That's the basis of it. There's a kind of love for the work one is doing that one never outgrows. Age doesn't dim this enthusiasm.

"Then there's the precious ability to communicate that is the proof of our humanity, the means of expressing our love of the world to each other. The world as it really is."

Peters added, "With the sweet ugliness of reality." She concluded her profile of Edgar

with the following scene:

> Back again in the motel office, he looks up at a deceptively simple painting he's done for a children's book.
>
> A young cock pheasant perches on a log in a field, throat full, crowing out to a summer afternoon. A butterfly wings in the foreground while a rusty strand of barbed wire twists across the painting, tearing it in two.
>
> Miller smiles gently at that odd note of violence in the work. "You see, the butterfly thinks it's going to be summer afternoon forever. Well, life is short. Art is long."

San Francisco Years

In 1977, at the age of seventy, Dale died after a two-year struggle with dementia. For a while, Edgar could not talk about her without breaking into tears. She was his true love—who accepted him, propped him up and made his personal life special. Then he went on with his life and hardly mentioned her again.

All of a sudden, Florida seemed like hell to Edgar. For the first time, Edgar was no longer working and had time on his hands. Vandals broke into an auxiliary house on his property and scattered his sketchbooks. Lonely, he watched too much TV, which saddened him. "The thing I most resent about television is that it is most oriented to the evil in the world," he wrote. "It gives you as companionship the convict, the murderer The company I keep by means of television is the dregs of the social order. Thank God I don't accept it as a picture of our social order—and that I know people like our yardman Ed, people I run into in the trip to the supermarket and on the road in one way or another. Once in awhile, a crook undoubtedly follows his own devious path that he hopes few notice. But there is a preponderance of simple well-intentioned people. To hell with all television."

The next year, Edgar traveled to Chicago for an extended visit with Frank and his wife, Josephine. Frank and Edgar went to see the Kogen-Miller Studios, where they met the new owner, Lucy Montgomery, the ex-wife of a successful Chicago lawyer and heir to the Post cereal fortune. Montgomery made Rudolph Glasner, the liberal industrialist who first lived there, seem moder-

ate. Often referred to as a "white socialite" in newspaper accounts, Montgomery had long ago given up her spot in the society pages for one on watch lists. She bankrolled the Students for a Democratic Society and Eugene McCarthy's failed 1968 presidential bid and famously attended a conference of the Student Nonviolent Coordinating Committee in a Christian Dior coat. Montgomery bailed out Black Power advocates after the 1968 Martin Luther King riots, and she transformed her home—described as a "Moorish-style townhouse" by one columnist—into a think tank and safe house for radicals such as Eldridge Cleaver, Angela Davis, David Dellinger and Tom Hayden. Meeting Montgomery was fortuitous. Edgar agreed to create two new stained-glass windows for the top floor. When he arrived for work, Montgomery announced: "Boys, this is Edgar Miller." The first words out of his mouth: "I never made a penny on this place."

Edgar returned to Clearwater and was faced with the results of a seventeen-inch rain. "Miller Lake, two feet deep, next to the studio," he wrote. Edgar was finished with Florida. He packed during the summer and flew to San Francisco to live with his son Ladd, who had relocated. "Moving from Chicago to Florida and then to San Francisco has scattered and broken a lot of stuff and a lot has been lost," he wrote. "I have no idea of what is even in existence."

Edgar liked San Francisco. His son Norman, who was having psychological problems, soon joined Ladd and his father. They lived many places: near Twin Peaks (129 Idora Avenue), south of downtown near Bernal Heights (24 Colby Street), and on Nob Hill (1348 Sacramento Street). "The consideration for art here is so much more than Chicago," Edgar wrote in August 1979. "The standard of craftsmanship is higher than in any place I have been. The one thing I expect to do that I seem to know more about is stained glass. The glass I have seen, so far, is very low grade."

Edgar's priority was to finish a book on the meaning of art. He started thinking about the book's content in 1919, when the painter George Bellows told Edgar his theories of art, opening Edgar's eyes to basic principles and spurring him to think intellectually. Edgar became serious about gathering his thoughts on paper when he moved to Florida. "I have gotten to the point where I comprehend

it," he said. "Now the job of it is that other people will comprehend it. It was one hell of a job to comprehend it." Edgar believed that the book would be his most substantial original creation and had high hopes that it might bring about a rebirth in the visual arts by helping people finally understand art in the same way they did music.

Although Edgar was highly learned in the history of art, his book was nearly incomprehensible. Sentences, paragraphs and small sections made sense, but the book in total never came together in any coherent manner. He admitted in 1984 that after decades of work it was still unorganized. Edgar thought about the book daily during the last two decades of his life, and he talked about it to friends and strangers by the minute. But most everybody found the conversation unpleasant, because somewhere along the way they got hopelessly lost in Edgar's words.

One of Edgar's major points was that the basic structure of art is a line. For thousands of years, art was simply lines scratched from one stone to another. "A really good drawing," he wrote, "has every line in the right place—as in a good musical composition, there is an inevitable 'rightness' of each note—that marks the music of a good composer."

He also argued that children and apes start painting in the same manner: by making abstract forms that please them in a personal way. At the age of five or six, he said, a child begins to use recognizable forms, for he or she has started to become a social animal. The ape never outgrows the personal state.

A third point was that the road to abstract art, considered modern by many, was actually a return to ancient art. "Some of the bison paintings in the caves have an abstract structure that makes Mondrian's inventions look puerile," Edgar wrote. "Rembrandt, El Greco, and Vermeer make Kline and the abstract painters today look like children. We are in a period of cultural confusion that is complete. Thousands of young painters start in by counterfeiting the end product of artists like Picasso without sharing his pains of growth and development or submitting themselves to his discipline. In their innocent fervor of ignorance, they are converts to a religion they don't understand. One of the greatest illusions about abstract art is that it expresses 'our time.' At the level of the personal subconscious, no one is conscious of

'his time'; he is only conscious of himself. He has nothing of value to communicate, and, in fact, no conception of communication. He, like the ape, is only expressing himself."

Edgar believed that his single most important contribution was a theory he developed about extending every line found in a painting. He determined that the lines would all converge in a couple of key areas. Edgar was obsessed with this idea. He drew lines over reproductions of hundreds of famous paintings, but he could never put his theory into understandable words.

STAINED-GLASS WINDOWS FOR R. W. GLASNER STUDIO, 1979

85

The several rejections he received from book publishers and magazine editors did not stop him. Instead, he continually rewrote his book, paying a typist to put his handwritten words into manuscript form. The book was constantly evolving. "It has had to be practically rewritten," he wrote. "New ideas and realizations have made whole areas in need of redoing."

He submitted two hundred pages of text and thirty examples of art to Harper and Row under the tentative title *Art, the Intuitive Control of Space by a Modular System*. "This can be changed if considered too formidable, although it is justified by the content," Edgar told the editors. "The writing of this book has been a most rewarding adventure. I cannot convey to the readers the thrills I have experienced in realizing the material that has been uncovered of 30,000 years of human

awareness of life and this attempt to comprehend and express it. It has more than paid for itself. Also, I am satisfied that whatever the reality in the things I have written, it will be only a matter of time before these ideas are seen by others, because the principles are on the surface of ordinary experience."

A few days later, the publisher of Harper and Row wrote Edgar a kind letter of rejection: "Thank you very much for your most interesting—and beautifully penned— letter of October 26, as well as the drawing which arrived a few days later. I have now had a chance to carefully consider your proposal and to discuss it with my colleagues. Our consensus is that while we find your project fascinating, we believe that your work requires a specialty form of publishing that university presses are best set up to accomplish."

Edgar's early years in San Francisco also revolved around reconnecting with his first family. In 1980, he flew to Acapulco with his son David, who had become an industrial designer. David gave Edgar a snorkel and fins and was pleased to spend time with the man who left him as a boy. But disappointment crept in when Edgar continued to put art before their relationship. Instead of focusing on his son, Edgar became entranced by Acapulco's artists' markets. "I'm going to see if some person in the market will allow me to decorate some pieces," Edgar wrote from Mexico. "This is a powerful temptation."

Edgar also visited the Michigan home of his oldest daughter, Iris Ann Evertsen, who had become a postmaster, and met up in 1983 with his daughter Gisela Titman, a librarian. Their letters indicate a desire by both to establish a relationship. In April, Gisela wrote Edgar in San Francisco to call collect anytime: "We certainly do not want to lose contact after all these years." Edgar responded: "Pay no attention to my political ramblings. They can be turned on or off like a spigot. Please call."

By the early 1980s, life was catching up with Edgar. One year, he was shaken up by a fall he took trying to catch a bus. Another year, he told Frank that he was constantly depressed. In 1982, Edgar wrote: "I'm coming to life in a small way on injections of B12. Also I found that my last operation shows a mild presence of malignancy. Nothing to worry about, but after all I'm eighty-two."

Complete Naiveté

Edgar was anonymous to most people in San Francisco, but in 1984 he was invited to speak about his career by the Academy of Art College (now the Academy of Art University), which had installed a show on his work. At the talk, students asked Edgar to assess his status in the art world ("I haven't any idea"), where to find his work ("I have painted murals many places. I do not know if they exist or not") and to pick a favorite art form ("I would hate to have to make a choice"). Then a student asked Edgar if he wanted to be remembered as one of the masters of art. "I would want to be remembered by the fact that I was interested in art enough to try to find out what stuck it together and what you accomplished by doing it," Edgar said. Art is a language far removed from much of our low-level communication, he continued, "so an artist must be a special person—needs something to say."

Later that year, Edgar was approached by a computer consultant named Rodney E. Harrill about establishing a not-for-profit organization to catalog Edgar's work, create a museum, publish his manuscript and limited-edition prints and promote the "inspired insight" of other artists. "I entered this idea of a foundation with complete naiveté," Edgar wrote, "depending upon the reality of its professed ideals which, as they were sold to me, consisted of the intent to help those interested in art by possible scholarships as well as stimulation through instruction and information; works of art, not only mine but any other arts, would be conserved and exhibited—etc."

The Edgar Miller Foundation for the Advancement of the Creative Arts was incorporated in 1984, with Harrill as the executive director. He brought Edgar's son Ladd on board, as well as Ladd's friend Charles Jarrell and a man named Jeff Biggs, who was to market and sell Edgar's artwork. Jarrell, who was Harrill's partner, was the link that bonded the nefarious group. As a boy, he had spent a great deal of time at the Millers' Sheridan Road home, and had later convinced Ladd to move to San Francisco. But now, Jarrell was up to no good. For seed money, Harrill and Jarrell contacted Edgar's friends, people like Lucy Montgomery and the designer Jo Mead, as well as institutions such as the Tavern Club, Brookfield

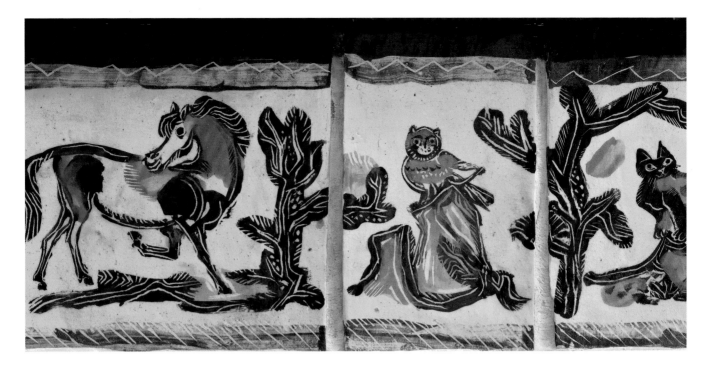

Zoo and Pierre Hotel. Their intent, to take advantage of Edgar's connections and fame, was clear.

Edgar must have been flattered by the idea of a foundation based on his work, but he soon grew suspicious. The foundation quickly fractured Edgar's strained relationships with his sons. Ladd was in favor of the new organization, but Skippy was wary of it. By the 1980s, Skippy had been diagnosed with schizophrenia, but he had the good sense to be distrustful of Harrill. The scattered letters that remain do not tell the whole story, but they certainly point toward Harrill's attempt to manipulate Edgar in his old age—and Edgar's surprising ability to stand up for himself. On September 30, 1984, Harrill wrote to Edgar:

> I wanted to take this opportunity to respond to you concerning this most recent round of trouble.
>
> I am outraged at the ease by which you can allow your sons, Norman and Ladd, to affect your judgment in such a manner as to completely try to destroy your work.
>
> You made a statement to me several months ago: "I am entrusting this to your hands." You charged me with your care and feeding, and support, and gave written and verbal consent to this. Then, out of the clear blue sky, you accuse me of "trying to be the boss."

Now, I am sure you see my confusion: First, you charge me with the day-to-day running of the affairs of your life, then you say the problem is mine, because I am "in charge!" This erratic behavior of yours is why I have protected this work, even from you.

I have been fair, honest, and self sacrificing to the extent that your own sons could never be, and have proven this time and again. Yet you try to betray this affiliation for no apparent reason. To accuse me of theft is, of course, outrageous. We have entered into agreements that transcend personality problems, for your benefit, as well as for mine and others.

I have reached the limit of my patience with you and your behavior and am taking the necessary steps to protect myself, and our business agreements. I have not broken our contract, but I want to let you know that if you persist in this manner that you are exposing yourself, and your sons, Norman and Ladd, to a high degree of liability from myself and from Jeff Biggs, Argus Design Association, and the Edgar Miller Foundation, all at the same time! Jeff Biggs, by the way, has been a major contributor to the success of our venture and has kept you alive.

Harrill's language was intimidating. "Do not

open yourself up to any liability," he concluded. "You cannot possibly 'win,' and why entertain the idea in the first place. Your confusion can cost you more than you know."

The next day, Harrill wrote a note saying that Edgar and Norman would no longer have access to the foundation's headquarters, at 2565 Third Street, and demanded that they return their keys.

"I am eighty-five years of age," Edgar wrote back, "and for the remainder of my life I require only the peace of mind necessary to finish my writing of observations I have made concerning art." Edgar admonished Harrill against using any of his art in the foundation's newsletter without his permission. "It should not be difficult to understand why, in the future, I cannot associate myself with the Edgar Miller Foundation."

Four days later, Edgar wrote a friend: "I cannot relate to the so called Foundation, that's the end of it." But he was far from through. Harrill refused to return Edgar's manuscript, paintings and photographs, and shadowed Edgar for the rest of his life. "The stress of this experience I will not forget in a hurry," Edgar wrote near the end of 1984. Just as he had in his youth, he needed a project to channel his energy. He would find that in Chicago.

Bound for Chicago—Again

In 1986, Edgar was visited by three Chicago admirers—Jannine Aldinger, who lived in the Wells Street Studios, Mark Mamolen, who lived in the Carl Street Studios, and their friend Fleming Wilson, an artist and antiques dealer—who flew to San Francisco to talk about Miller's work. Upon arriving, they were shocked by the condition of the tiny apartment Edgar shared with Skippy. Edgar was silent and aloof. "The place was smelly and in disarray, artwork was strewn on the floor, a couch stood upright on its side, and Edgar was barely talking," Aldinger later told a reporter. "To tell you the truth, at first we thought he was an artist gone mad." But in a short while, Edgar started regaling his visitors with memories of Chicago. When they left the next day, they invited Edgar to Chicago for the summer to tell his stories on videotape. Edgar needed no coaxing. Just a few weeks later, he was on a plane. "I am going to Chicago on Friday," he wrote Charles Jarrell, "and what develops I do not know."

For most of the next year, Edgar lived in the studios on Carl and Wells streets that he had designed five decades earlier. The apartments were owned by Jannine Aldinger and her physician husband, Glenn, and the businessman Mark Mamolen. They paid for Edgar's trip and saw him almost every day. "He talked about everything," recalled Glenn Aldinger. "The meaning of art, the history of the world. He had an opinion about everything. When the first Middle East war broke out he lectured everyone on the history of Arabs." Recalled Mamolen: "He told us we didn't understand the big picture unless we read both sides."

A few weeks after his arrival, Jannine and Glenn Aldinger, and Mark Mamolen hired a professional film crew to record Edgar. They wanted him to talk about his life and his work, which he did, but he also spent several hours explaining his art theories. From eight hours of footage, they produced a twenty-minute tape called *Edgar Miller: Portrait of an Artist.*

Edgar felt very much at home in Chicago—and decided to stay. "I never could have dreamed this would happen, and yet I fit right in," he said. When his son Ladd called from San Francisco, he put him off. Edgar basked in the attention of his new friends and started working again, painting plates (he was rusty at first) and fireplace

MILLER CARVING A FRAME IN CARL STREET COURTYARD (JANNINE ALDINGER)

tiles, as well as carving wood doors and casting ornamental plaster columns for both the Kogen-Miller and Carl Street studios. "You know I may live to be ninety if I have something to do, to keep me busy," he told Jannine. A few years later, he told a reporter: "Jannine and Mark just came to get me. No notice or anything. Brought me back to my roots, you might say."

Mamolen had lived in five of Edgar's studios since he first rented one of them on Wells Street in 1975. He purchased the entire seventeen-unit Carl Street complex in 1984 and took over Sol Kogen's old place. "I decided that this building needed a patron," he told a reporter. Owning the complex presented day-to-day joys and challenges. "It's kind of a cross between a Picasso and the Black Hole of Calcutta," he said.

Within a few months, Edgar moved to Mamolen's apartment. He was given his own bedroom and a work area—and thrived. Mamolen was out of town often on business trips, but when he was in Chicago, he and Edgar spent quite a bit of time together. They would go to dinner or invite people over. Edgar enjoyed squiring people. Mamolen didn't push Edgar to work, but it was apparent that Edgar desperately wanted to get back to art. He painted plates, carved doors and executed several stained-glass windows in Mamolen's apartment.

Edgar, approaching ninety, was back after two decades of inactivity, sometimes making art that matched his best work. He would spend up to twelve hours working, seldom taking a break. An early riser, he would put on a hand-painted bow tie, a clean white shirt, a suit or sports jacket and an artist's beret and take in a long breakfast at Nookies or another restaurant in the neighborhood, greeting old and new acquaintances and defending his theories on art. He was cantankerous and feisty—annoyed if he was interrupted while he was thinking. But he never tired of going on long walks, often talking to the squirrels on the street or the fish in the Burton Place pond. Edgar started sketching more frequently, and his books from the late eighties are filled with animals he encountered or remembered. On many of these sketches, he would write, "Our friends, bless them."

During his last years, Edgar completed twenty-six stained-glass projects with the assistance of the artist Larry Zgoda. Edgar designed the windows and selected and painted the glass, and then Zgoda cut, fired, fabricated and installed the windows. Edgar also produced at least eight panels, four carved and painted doors and a huge oak balustrade that he somehow completed with his brother Frank. Most of the work was for the Carl Street and Kogen-Miller studios, but he produced work for churches, offices and other studios, too.

In 1987, Edgar created a carved jungle scene that is as good as any in his long career. Horn recalled that Edgar did not lay out a design; he simply placed spots of gold and silver leaf on a cherry door panel and painted red splotches like in a Hans Hofmann abstract painting. Then he started carving, working in the second-floor sunroom of Mamolen's apartment. "I remem-

bered looking at this thing and thinking, My God, that's going to be horrible," Mamolen said. "Not only is it going to be horrible, but I have to hang it. And I'm going to have to keep it up until Edgar dies." Edgar worked on it for weeks, pulling it together at the end. "When I paid him, I said, 'You know, Edgar, to tell you the truth, when I saw you starting on that door, I was afraid it was going to be horrible. I didn't see where you were headed.' He said, 'Neither did I.'"

Edgar enjoyed the role of honored elder. In 1987, he was declared one of the founders of Old Town when he received an award from two Old Town organizations. "Edgar Miller was responsible for a renaissance in this area," said Ferd Isserman, president of the Old Town Chamber of Commerce. "He embodies the spirit of the people here in that he is very creative. He is an individual." Edgar thanked the 125 guests and announced: "While I have something to do, I will stay in Chicago."

Two years later, the Graham Foundation for Advanced Studies in the Fine Arts presented an exhibition of his work. In 1990, Mayor Richard M. Daley inducted him into the Chicago Senior Citizens Hall of Fame. When a reporter asked Edgar on live TV if he would categorize his work as art deco, he responded, "You're an idiot," and walked off camera.

Although he kept his working studio at Mamolen's, Edgar moved in with Frank in 1987, arriving at his North Side home with two wrinkled suits, a few shirts, a pair of Reebok black leather shoes and a bag of his own hand-painted bow ties. "He gave the impression of having been on welfare," Frank wrote, "an indication of how he must have looked and how he was living in San Francisco." Frank's wife, Josephine, took over Edgar's finances, which he had ignored most of his life, opened a bank account for her brother-in-law, paid his medical bills, cleaned his clothes and welcomed Edgar back into their lives.

Frank and Edgar would take out the TV trays at dinner, watch *The MacNeil/ Lehrer NewsHour* and talk. "We enjoyed endless conversations, and as free thinkers discussed every subject imaginable," Frank wrote. Their favorite thinkers were Paul R. Ehrlich, author of *The Population Bomb,* and Rachel Carson. Said Frank's son, Paul Miller, of the two brothers: "They became cranks."

But they were happy cranks. "These I'm sure were the happiest days he had seen for many years," Frank wrote. "He would get up early and leave for the studios, have breakfast in a restaurant nearby, and spend the day painting tiles and dishes. This was his routine seven days a week." Frank and Josephine took Edgar to the movies, the circus, and the zoo. "We expected him to stay with us for the rest of his life."

Edgar had found happiness back where it all started.

The Last Act

In 1990, Edgar moved back to Old Town because Josephine was fighting cancer. She died later that year. Around 1991, the inevitable happened: Edgar fell on the stairs in his apartment at the Carl Street Studios. He convinced himself that he had injured the retina in one eye, rendering it blind, but doctors could find no physical damage. Glenn Aldinger, Edgar's friend and occasional physician, said Edgar's eye troubles were caused by old age. He was starting to suffer ministrokes that made it impossible for him to process what he was seeing, and he couldn't read or paint anymore. The accident "really stopped him in his tracks," Frank wrote. "This destroyed his depth perception

NEW STAINED-GLASS WINDOW AT ERNEST KUHN HOUSE IN WIL-METTE, 1987

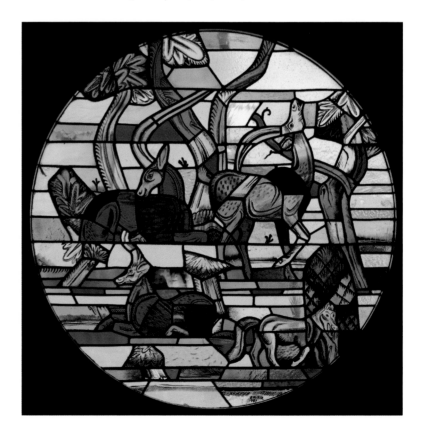

and of course his ability to continue creating. When that happened he lost his desire to live. Life without creating meant nothing. He hoped the end would come soon."

The accident made work "very difficult," Edgar wrote. "I am so disorganized physically that I can't control space in composition very easily anymore and I can't carve or paint." Edgar wrote in a journal: "From here on everything is crazy. . . . I'm going blind. It will be gradual—I hope." Later in the entry, he wrote: "The end of my life is a nightmare. It is broken into thousands of separate reactions—and each one is out of my control. I lose my balance, and before I am fully conscious of it, I'm staggering into an unintended explosion of impulse not very far . . . from ordinary insanity. I have no orderly control of my legs."

Edgar moved back into the Wells Street studio so he could receive more help. Jannine Aldinger or her sister visited him daily and made sure he had enough food. A woman was hired to bathe him. Another friend, Kristine Lang, took him on car rides. "As he grew older, he was so sweet, so soft, so gentle, so full of love," she said. "All the ego left him." Mamolen remembered a slightly different Edgar on rides in his turbocharged Porsche. "He'd always say, 'Floor it,'" said Mamolen. "'You sure, Edgar?' I'd ask. 'I'm sure,' he'd say."

Back in Old Town, Edgar continued to make it to Nookies many mornings, but most of his day was spent alone with his two Siamese cats. In December 1992, he wandered out of his apartment and got lost. When he became combative with police, he was taken in leather handcuffs to Northwestern Memorial Hospital's psychiatric unit for older adults. Doctors there said he needed full-time care.

The Aldingers and Mark Mamolen hired the artist Karen Flowers to live with Edgar on Wells Street, but that arrangement became complicated and she soon took him to live at her apartment in the North Side neighborhood of Uptown. Flowers developed a fondness for Edgar and became ultrapossessive. "From now on," she said, "wherever Edgar goes, I go, and vice versa." She took him to dinners, to art openings and back to see friends in Old Town. Frank visited his brother at least once a week and brought groceries, but Edgar lapsed into episodic dementia.

Miller did not fear death. "The end has never been accompanied with any terror, for me," he wrote. "It has rather been a moment in which I might get a glimpse of that of which I am a part, something of enormous size, stretching endlessly through time."

To Edgar, a life filled with creativity was a life well led. "Time stretches out very long before the uncreative person," he once wrote in a letter. "He looks uncomprehendingly at Michelangelo, who went to bed without taking off his shoes. He cannot comprehend the degree of physical exhaustion that this indicates." But Michelangelo did not have the time or energy to prepare himself for sleep, Edgar wrote. He always had more profitable work to do. "The uncreative mind sees such creative people as 'dismal failures as human beings': yet we would be gathering seeds and robbing birds' nests if it were not for them. Everything we have—fire, language and ideas—we owe to these people."

In late May 1993, Jannine Aldinger gave the noontime lecture on Edgar's life and career at the Chicago Architecture Foundation that roused him one last time. Friends brought Edgar downtown out of respect; they did not expect him to comprehend the event. But when he heard someone ask, "Why not let Edgar speak?" he snapped to attention. The stirring of emotions coupled with surging adrenaline permitted his blood to flow freely and his brain to function normally, according to Glenn Aldinger, his physician friend. Cerebral connections restored, suddenly and miraculously, the Edgar Miller of old was back.

"Regrettably, his heart's fast and irregular rhythm was too much for his aging body to withstand," said Aldinger. "Edgar's heart became hyperdynamic, beating too hard and mobilizing the clots, which otherwise sit dormant."

Edgar went to lunch with friends and stayed lucid for a time after the talk, but that night a blood clot travelled to his brain, resulting in a massive stroke that rendered him unconscious. He was taken to St. Francis Hospital in suburban Evanston but never woke or responded. He died on June 1, 1993.

"It's four a.m., and I have not been able to sleep since three," wrote Frank Miller the year after Edgar's death. "This has be-

come the pattern of my life for the last few months. I will be ninety-four next month and feel I must record the last few years of my brother's life while it is still fresh in my memory. I am the only one left who knows most of the history. His end was classic for truly great artists."

Edgar had remarkable gifts, Frank said. "These treasures are given at random to only a few, and many of those fortunate few are diminished or destroyed by an overzealous, ignorant, insensitive, or unfeeling parent. Even those precious few who manage to

survive have many obstacles to surmount on their way to full development. This requires a degree of self-discipline and drive for perfection, rare and unusual. The artist must run the gamut of greedy manipulators, con men, jealous rivals, flattery, or the wrong partner. All these tragedies happen more often than we know, and the artist just usually disappears."

Edgar Miller never disappeared. His work and his ideas—about nature, recycling, the act of creation and the place of art in our lives—all survive in his handmade homes.

ONE OF THE LAST FORMAL PORTRAITS OF MILLER, TAKEN AT THE CARL STREET STUDIOS (PHOTOGRAPH © 1992 WAYNE CABLE)

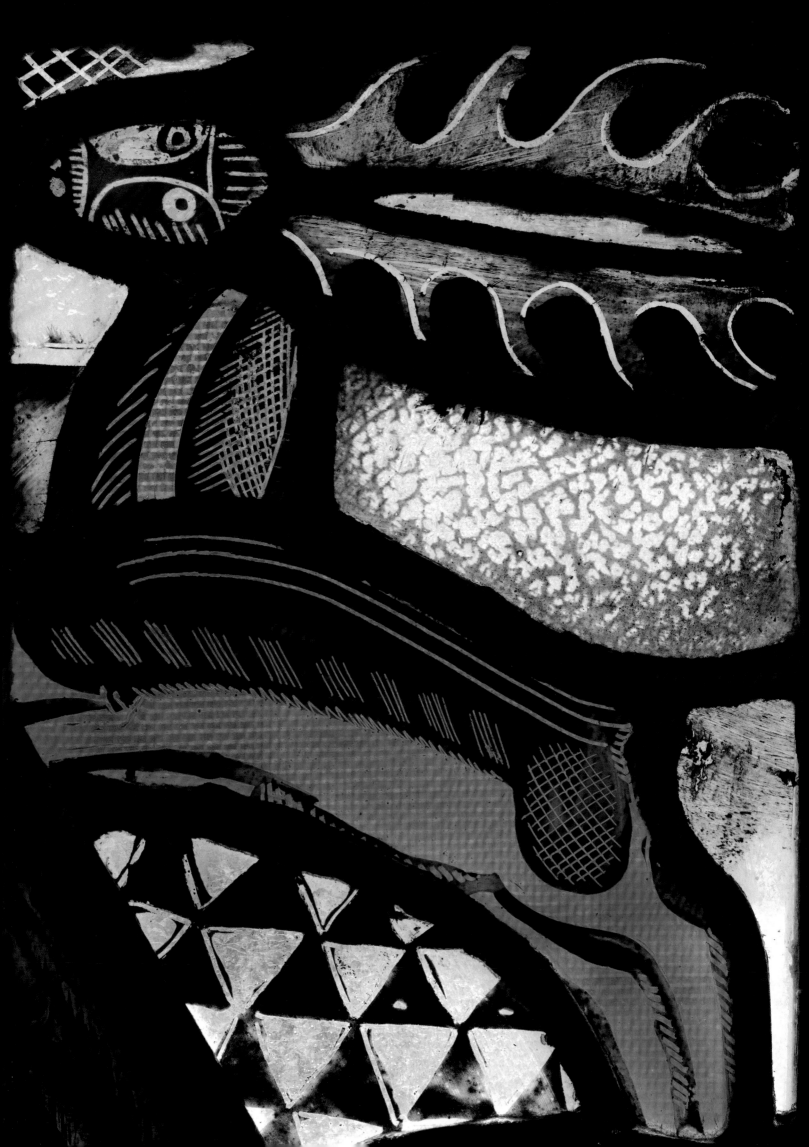

The Handmade Homes

The primitive world is no mystery to me; I knew the inside of a teepee with its acrid sagebrush smoke. Primitive art was an honest, often mystical communication, not a sophisticated posturing, however "sincere."

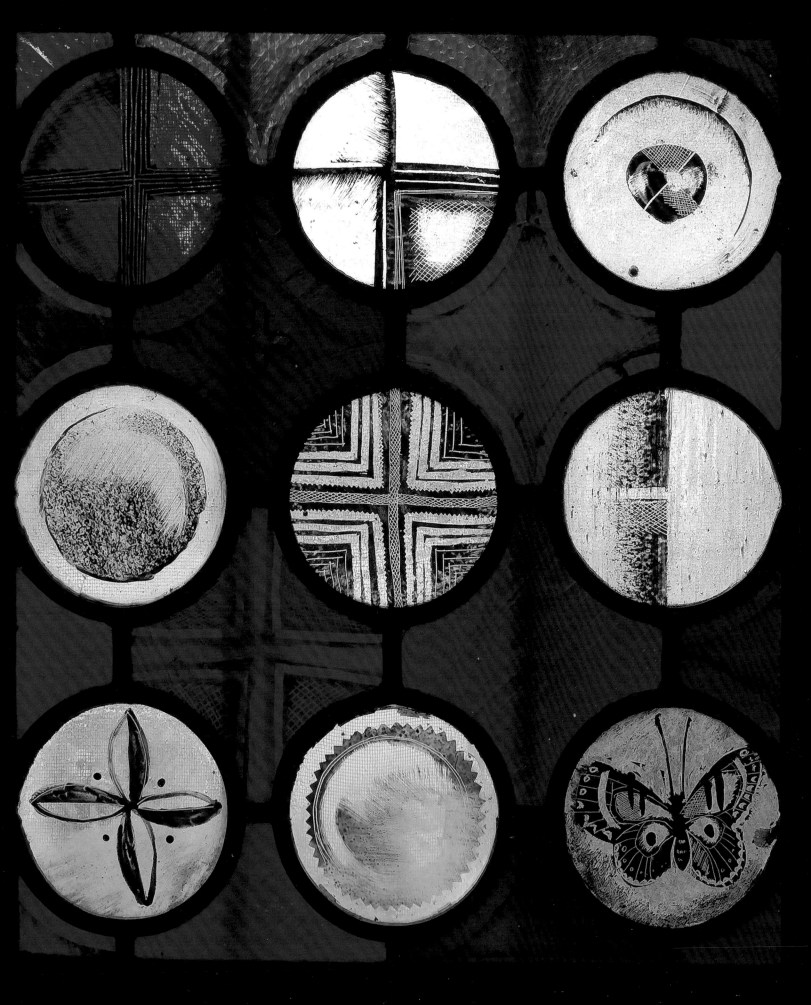

KOGEN-MILLER STUDIOS

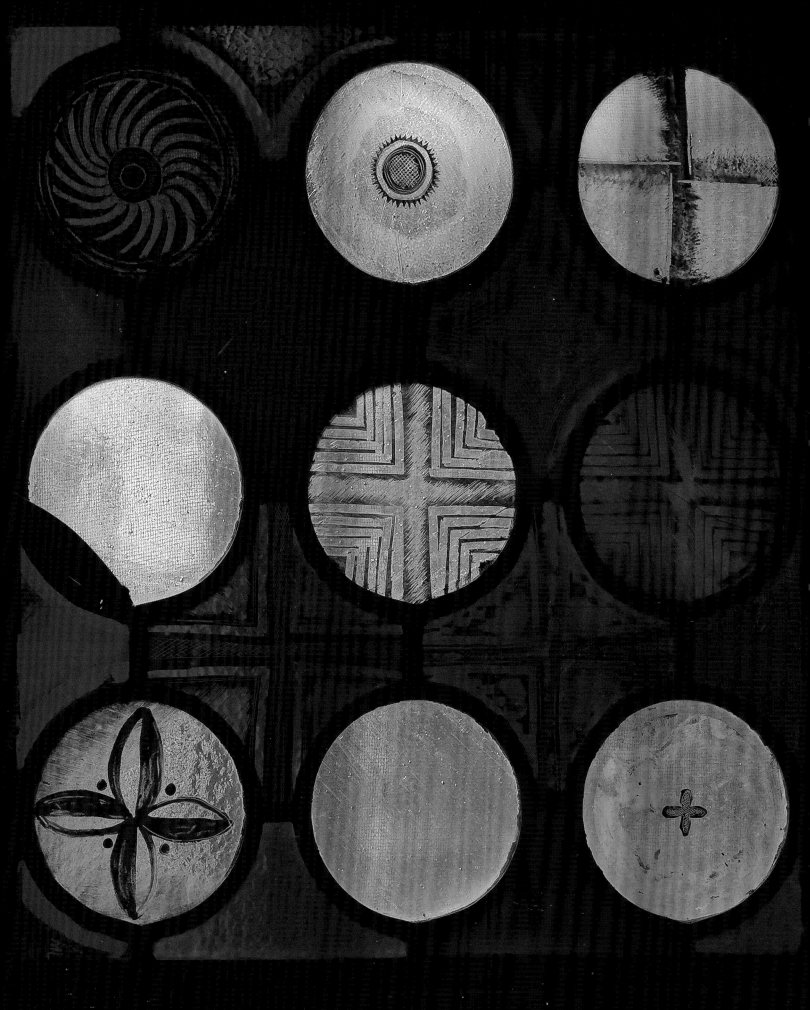

1734 NORTH WELLS STREET 1928

Edgar Miller crafted handmade living spaces for himself ever since he arrived in Chicago in 1917. "Every studio I moved into I remodeled," he recalled. "Any creative person learns what he knows by doing." So when Sol Kogen approached him in 1927 with his concept of building an artists' colony on Chicago's Near North Side, Edgar was ready, visualizing dramatic spaces filled with art that he would make. Edgar's plan went beyond just living spaces; he wanted to create an "environment" where artists could live and work in an inspirational setting.

Within a year of that meeting, Kogen and Miller were busy working at two different sites: the Carl Street Studios and the Kogen-Miller Studios on Wells Street. While work on Carl Street began earlier, the Wells Street complex was completed first and today remains closest to Edgar's original vision.

Two structures sat on the Wells Street site: an 1880s apartment building and a two-story stable at the back of the long, narrow lot. Miller and Kogen eventually conceived a plan to rebuild the apartment house as six duplex studios, to build a new structure with two duplex studios up front and to convert the stable into a huge studio. The remaining open space would be used for a courtyard.

To save money, Kogen and Miller used materials from the existing buildings as well as salvaged materials—bricks, tiles, doors, pipes and the like—from nearby demolition sites, flea markets and failing businesses.

A small crew of laborers worked at the site, including Edgar's brother Frank. With tradesmen transforming the structure of the old house and building the new one, Edgar could focus on the overall design and create art for the complex—such things as stained- or leaded-glass windows, tile work, light fixtures and woodcarvings.

He focused most of his attention on the stable. He kept its footprint but designed an art-filled "party house" for the industrialist Rudolph Glasner, who was interested in the innovative architecture of Kogen and Miller. Freed from worrying about day-to-day living considerations, Edgar was at his best in the R. W. Glasner Studio, and it is regarded as his masterpiece.

KOGEN-MILLER STUDIOS, AT 1734 NORTH WELLS STREET, ON CHICAGO'S NEAR NORTH SIDE.

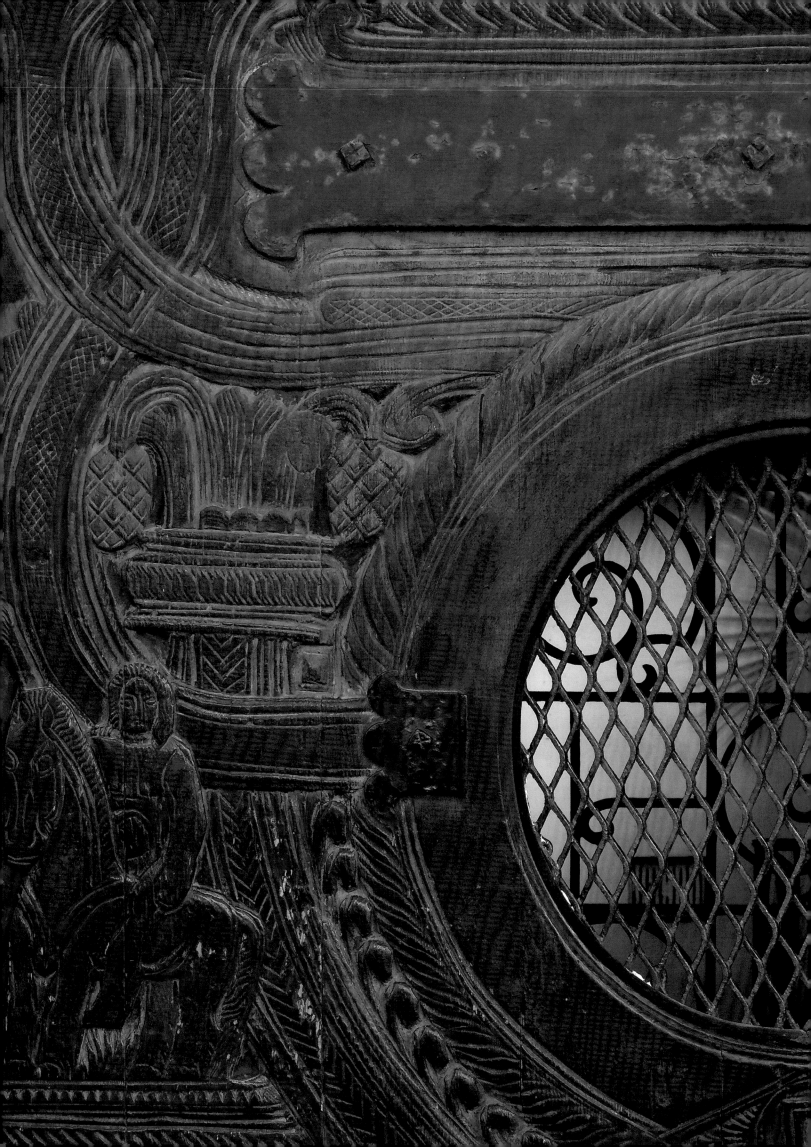

LEFT: RESIDENTS ENTER THE COM-
PLEX THROUGH A CARVED DOOR
MILLER LAYERED WITH HIS CHARAC-
TERISTIC ANIMALS AND NATURAL
ABSTRACTIONS.

RIGHT: A BARCELONA-STYLE ROOF
OF HUNDREDS OF BROKEN TILES,
MANY OF WHICH WERE SALVAGED
FROM RAZED BUILDINGS, COVERS
THE VESTIBULE.

BELOW: THE COURTYARD WALLS ARE
DECORATED WITH RECLAIMED TILES
IN A DESIGN DOMINATED BY REPEAT-
ING TRIANGLES, A SYMBOL OF LIFE
FOUND THROUGHOUT MILLER'S
BUILDINGS. MILLER SOMETIMES
USED THE BACK OF A TILE IF HE
THOUGHT IT MORE INTERESTING
THAN THE FRONT.

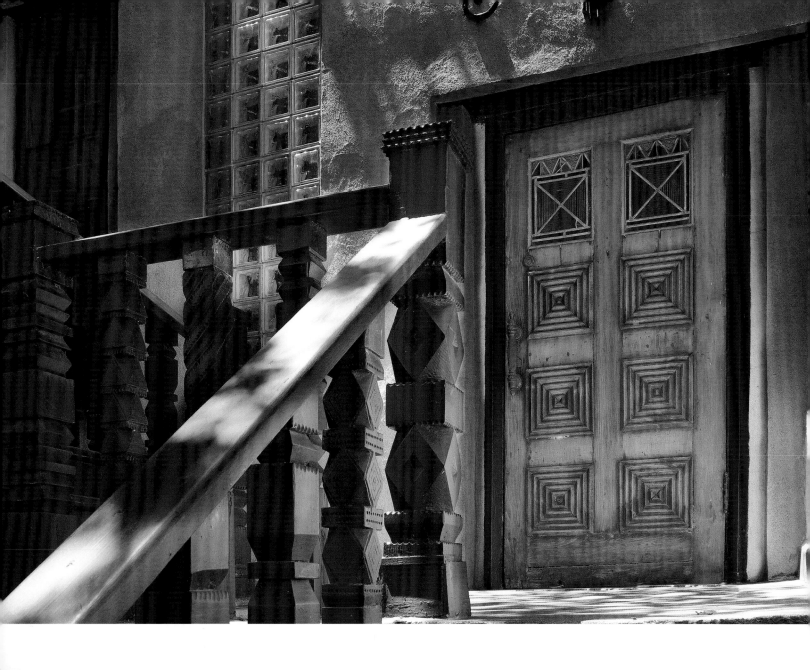

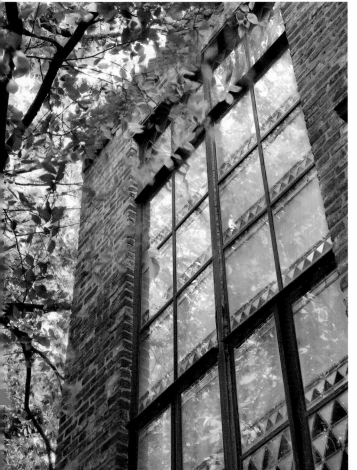

MILLER CARVED A DOOR, EACH
WITH A UNIQUE DESIGN, FOR NINE
STUDIOS ON WELLS STREET. HE ALSO
CARVED MANY OF THE BALUSTRADES
AND HANDRAILS IN THE COURTYARD.

LEFT: A TWO-STORY WINDOW OVER-
LOOKS THE COURTYARD.

RIGHT: BRICK WALLS CREATE A
HIDDEN GARDEN. "I BUILT A WALL
AROUND THE YARD SO THAT IT
BECAME AN EXTENSION OF THE
IMPRINT PATTERN OF THE HOUSE,"
MILLER SAID. "IT BECAME MORE
PRIVATE IN USE AND MORE ATTRAC-
TIVE TO THE PEOPLE LIVING THERE."

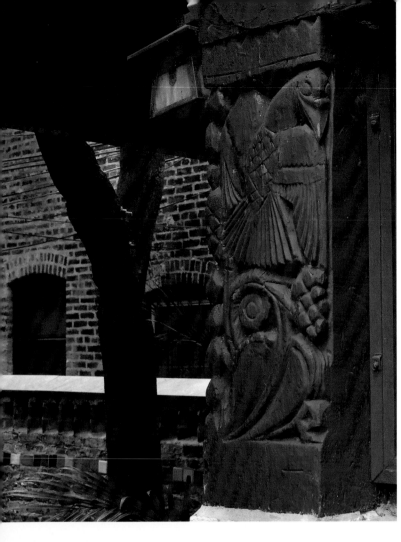

LEFT: MILLER ATTEMPTED HIS FIRST LARGE-SCALE CARVING IN THE COURTYARD, A PRIMITIVE EAGLE WITH LEAVES AND FRUIT.

RIGHT: MOST OF THE STUDIOS HAVE AN ENTRANCE THAT FACES THE COURTYARD, ALLOWING ACCESS TO A FISHPOND, TREES AND OTHER LANDSCAPING.

BELOW: OVER THE YEARS, NEW DECORATIVE ELEMENTS HAVE BEEN ADDED—INCLUDING HANDRAILS WITH A DRAGON MOTIF—THAT MAINTAIN THE SPIRIT OF MILLER'S ORIGINAL DESIGN.

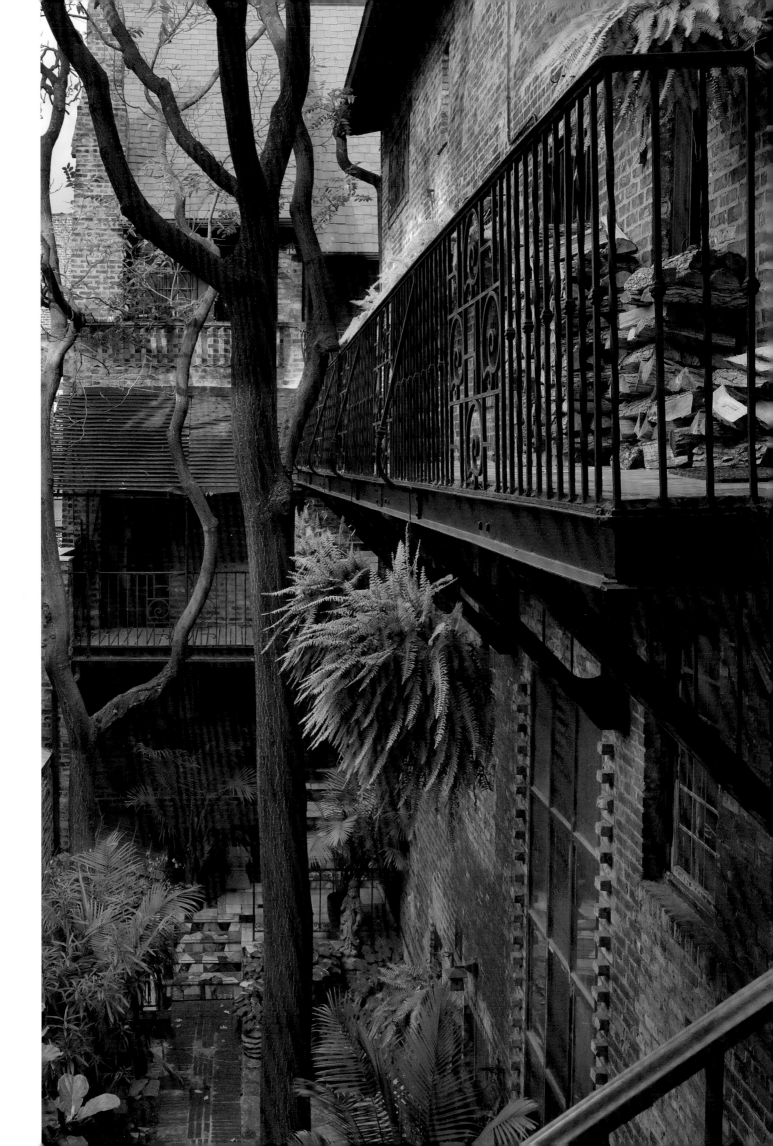

R.W. GLASNER STUDIO

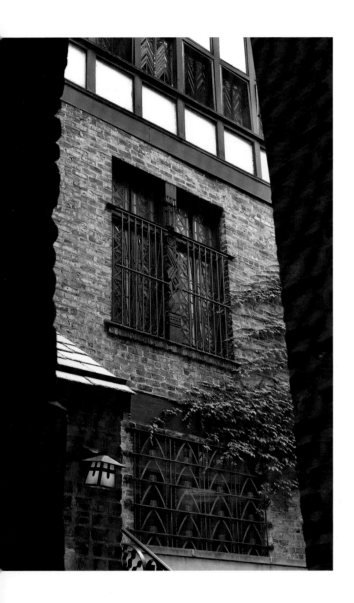

A visionary designer and a willing client are both needed to build an ethereal home. The R. W. Glasner Studio at the rear of the Wells Street complex had both. In Rudolph Glasner, Edgar Miller found his perfect patron—a wealthy man who recognized Edgar's genius and gave him the time and money to realize his ideas.

Glasner was an Austrian immigrant who came to America at nineteen with only a few dollars in his pocket. After a short while in New York City, he settled in Chicago, where he began a highly successful career as a manufacturer. The company he owned, Marquette Tool and Manufacturing, prospered during the economic boom of the 1920s, making him enough money to become a patron of the Art Institute of Chicago and to commission Miller and Kogen to build his dream house.

Miller gave Glasner a home that defies easy description. Each of the building's four major levels has a distinct feel, from art deco to English Tudor. But the disparate spaces never feel in competition. They are linked by common themes and the single hand that created them all.

Glasner was charmed with his home, but his wife, Ann, never got used to the unusual design or the rough neighborhood. "Glasner wanted to use the house primarily for entertaining," Edgar wrote. "It was not big enough for good living." The couple sold the building in the late 1930s.

Over the next fifty years, Miller would return to the home occasionally to create new work. He renovated the basement and added new woodcarving in the 1940s, and he fabricated new stained-glass windows in the late 1970s. Speaking about his work in Chicago, Edgar said: "My modest architectural experience—remodeling and rebuilding in a new shape—it was the greatest experience. One lifetime isn't enough."

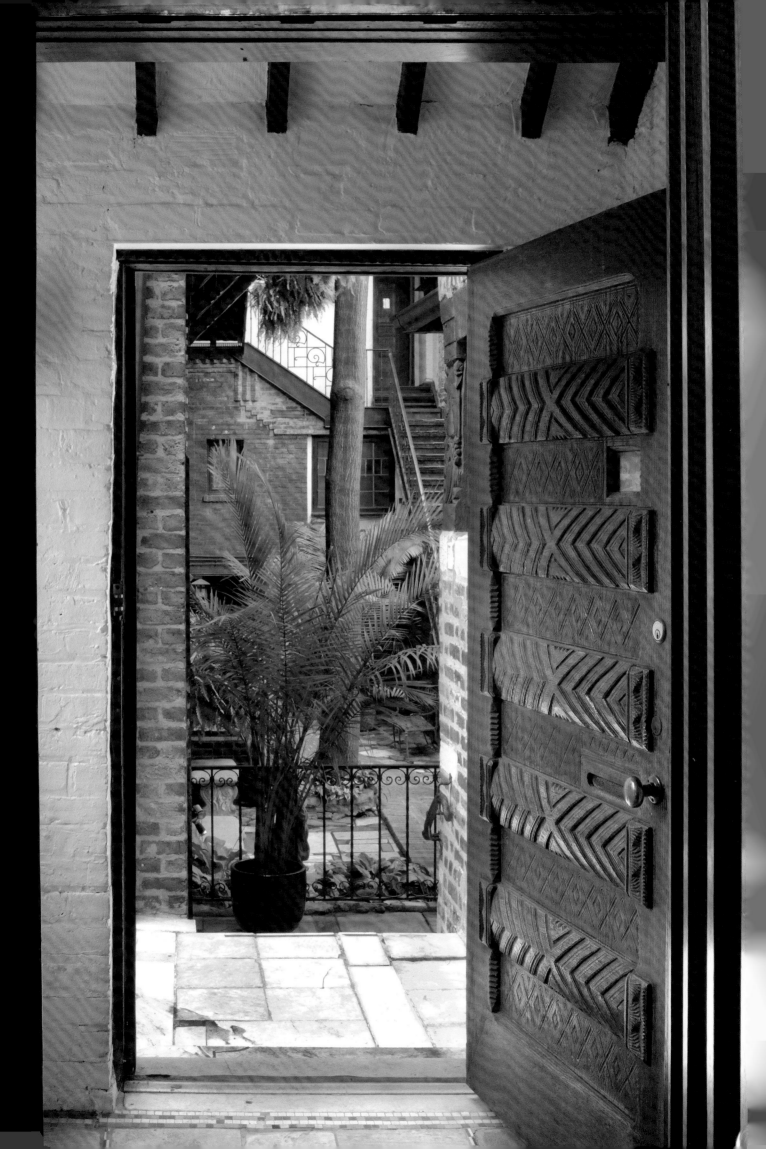

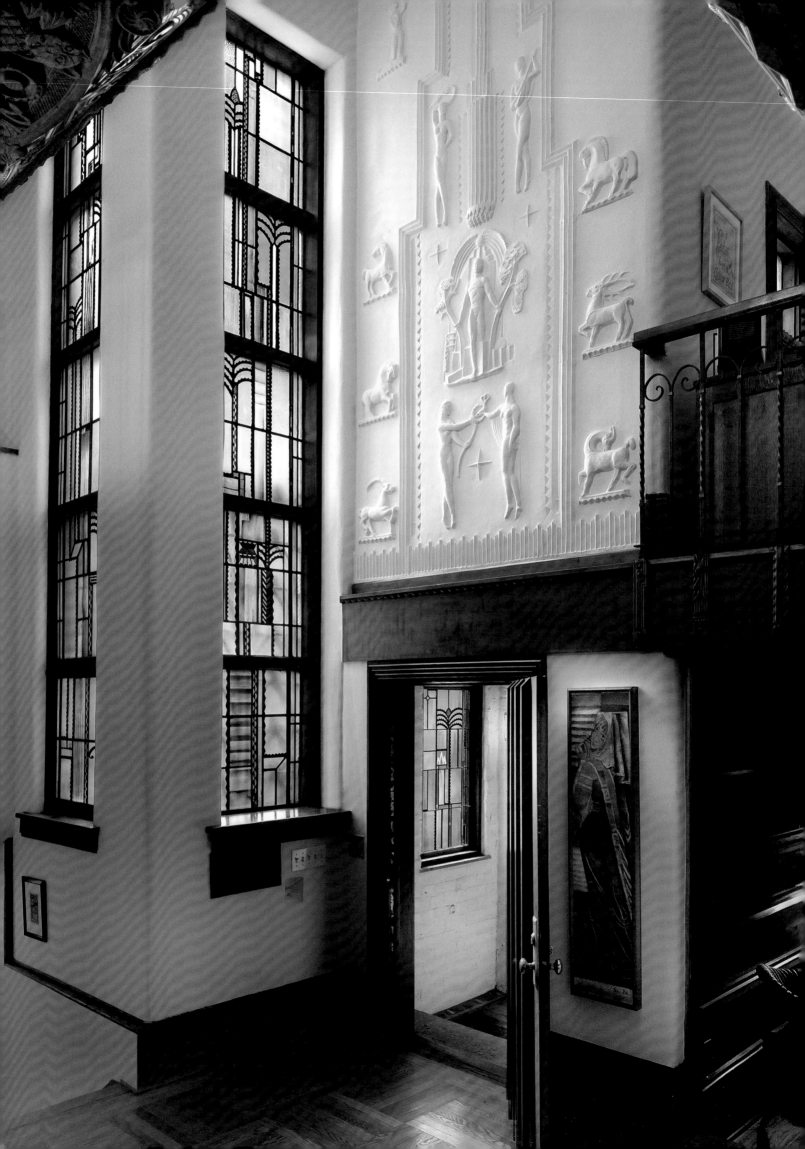

MILLER DID NOT ADD THE ORNATE
PLASTER FRIEZE ABOVE THE ENTRY
DOOR ON THE EAST WALL UNTIL
AROUND 1930. "I HAD A NOTION
OF DOING SOMETHING THAT WAS
HIGHLY DRAMATIC," HE SAID. HIS
DESIGN, A CELEBRATION OF THE
ARTS, REQUIRED MULTIPLE CLAY
MODELS AND PLASTER CASTINGS
BEFORE THE PIECE WAS SET IN
CONCRETE. THE TOP FIGURES
REPRESENT MUSIC AND DANCE,
THE CENTRAL FIGURE ARCHITEC-
TURE, AND THE BOTTOM FIGURES
DRAMA AND ART. LIGHTNING AND
A RAINBOW REPRESENT THE ACT
OF CREATIVITY—OR, AS MILLER
DESCRIBED IT, "THE VIOLENCE
OF INSPIRATION AS WELL AS THE
QUIETUDE OF INSPIRATION."

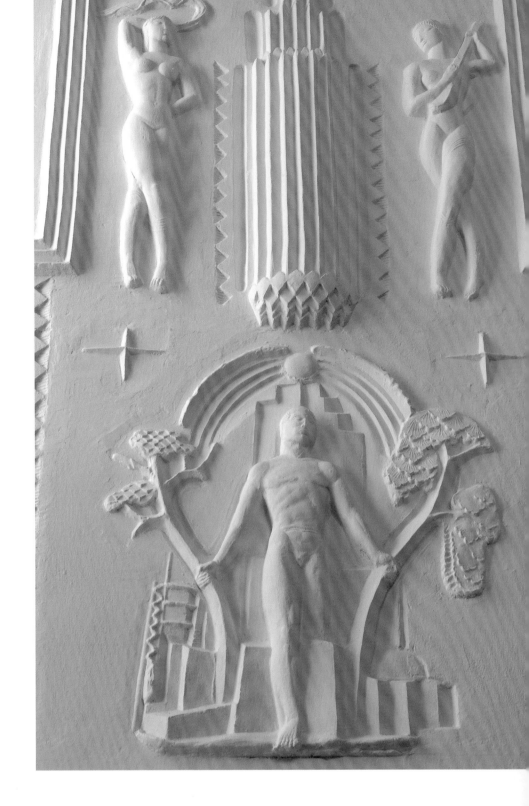

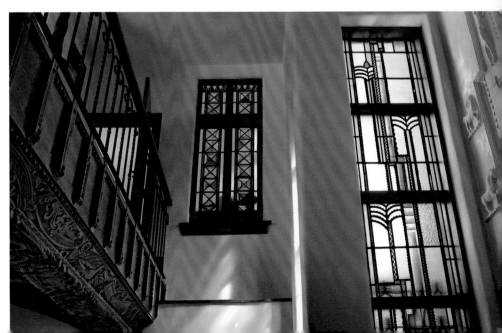

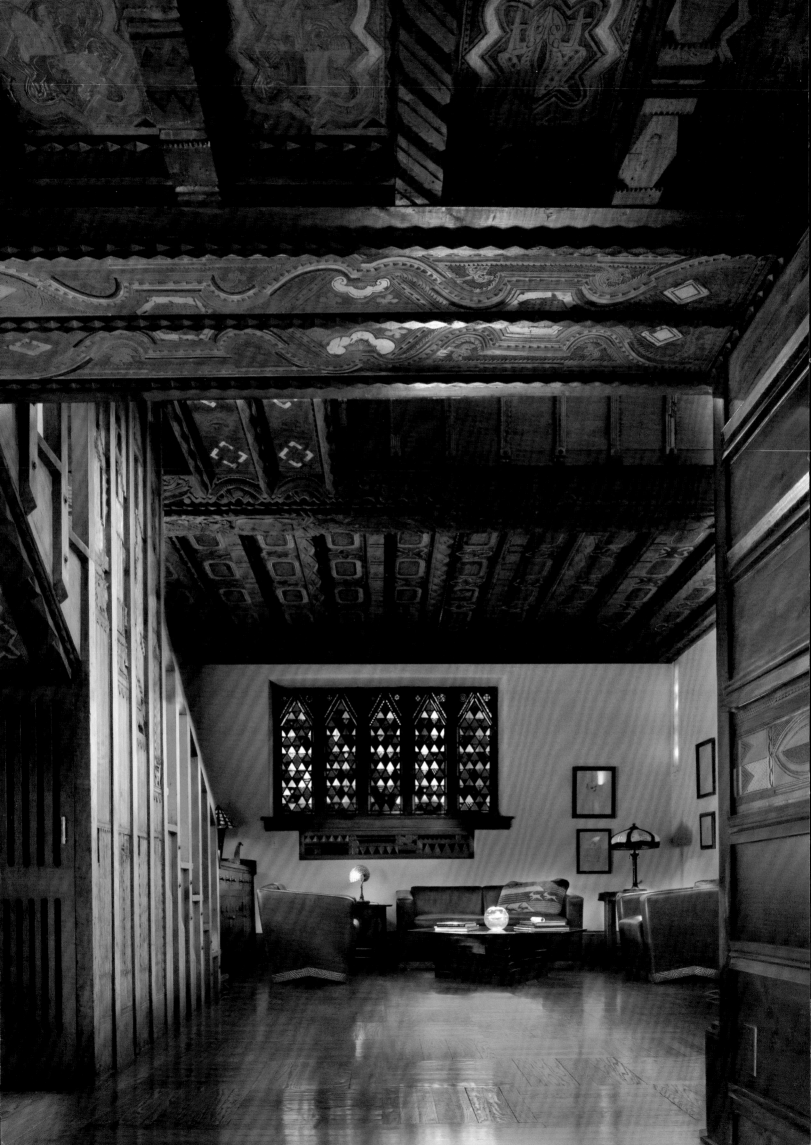

A DINNER PLATE FOR MILLER'S YOUNGEST SON, LADD. MILLER MADE HUNDREDS OF PLATES, WHICH HE GAVE TO CELEBRATE BIRTHDAYS, HOLIDAYS OR SIMPLY DINNER TOGETHER. HE LEARNED CHINA PAINTING AT AGE THIRTEEN FROM A NEIGHBOR IN IDAHO FALLS. "SHE WANTED ME TO PAINT FLOWERS, AND I WANTED TO PAINT COWBOYS AND INDIANS."

LEFT: THE FIRST-FLOOR LIVING ROOM VIEWED FROM THE FOYER. MILLER WANTED TO SURROUND THE OWNERS OF HIS HOMES WITH ALL TYPES OF ART.

RIGHT: MILLER WROTE THAT HE HAD TO UNDERSTAND COLOR ALL OVER AGAIN WHEN HE STARTED MAKING STAINED GLASS. "COLORED LIGHT HAD ENTIRELY DIFFERENT PRINCIPLES THAT HAD TO BE SEPARATELY LEARNED."

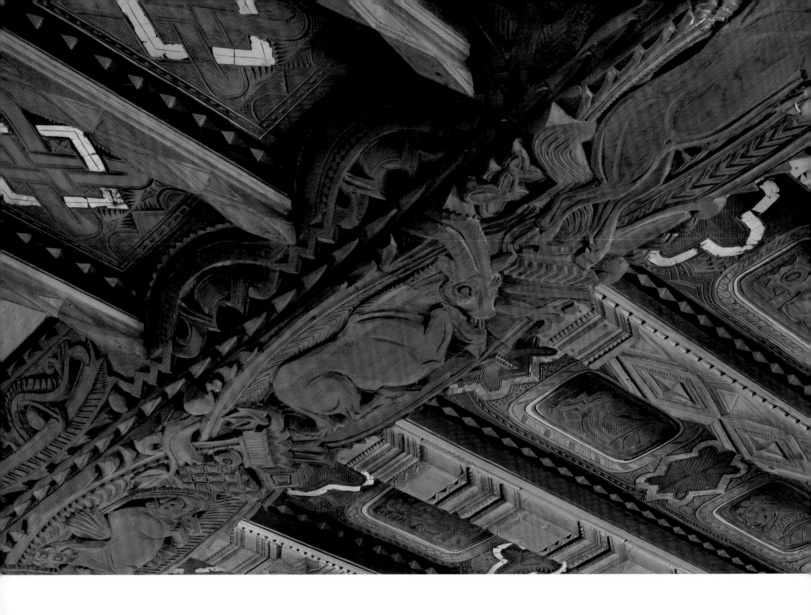

IN THE MID-1940S, FRANK FUREDY COMMISSIONED MILLER TO CREATE A CARVED CEILING DEPICTING THE WORLD'S GREATEST SCIENTISTS AND INVENTORS. FUREDY, WHO PURCHASED THE KOGEN-MILLER STUDIOS AFTER GLASNER, HELD A NUMBER OF PATENTS, INCLUDING FOR THE SELF-INKING FOUNTAIN PEN, AND OWNED SUN-KRAFT, WHICH MANUFACTURED POPULAR SUNLAMPS FOR TANNING. MILLER CARVED THE NAMES AND IMAGES OF FORTY INVENTORS INTO THE CEILING, PEOPLE SUCH AS GUGLIELMO MARCONI (RADIO), VLADI-MIR ZWORYKIN (TELEVISION), LEE DE FOREST (MOTION-PICTURE SOUND) AND WILHELM RÖNTGEN (X-RAYS). AND TO THAT GROUP MILLER ADDED FRANK FUREDY HIMSELF. THE PANEL WAS FINISHED JUST AFTER THE EXPLOSION OF THE FIRST ATOMIC BOMBS.

114

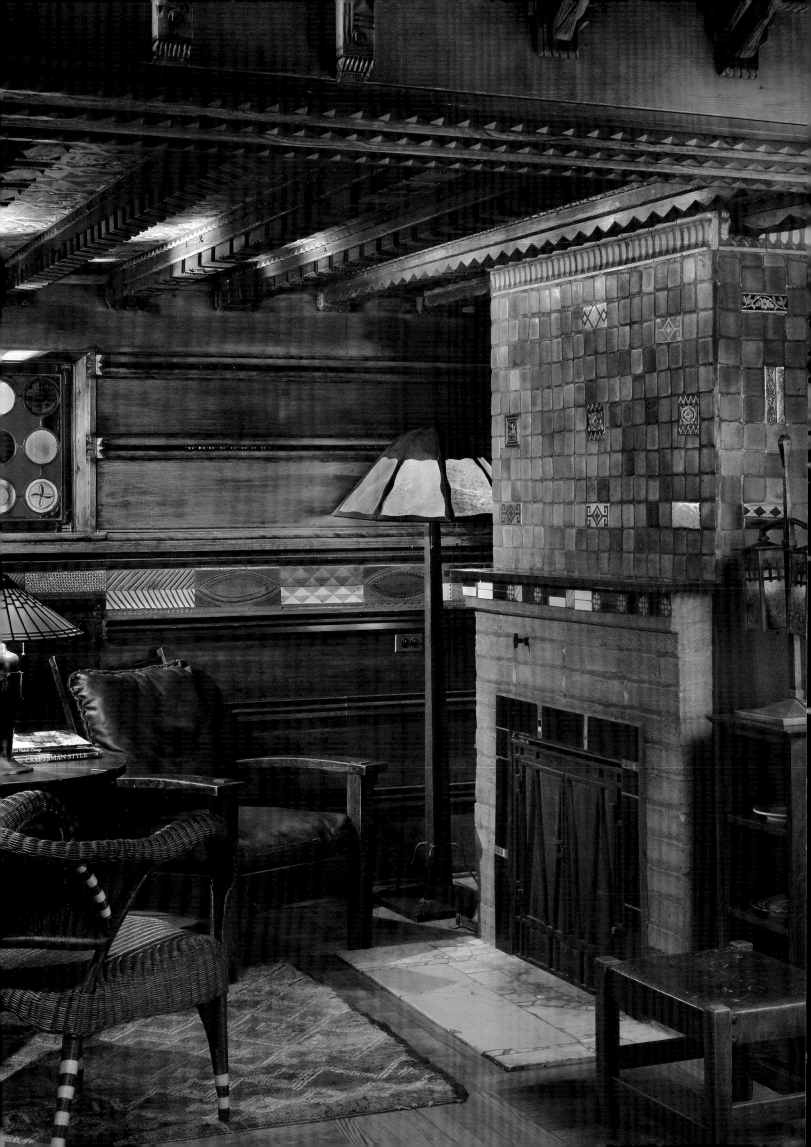

A SMALL STUDY INCORPORATES
ANOTHER CARVED CEILING BY
MILLER. THE LACK OF LIGHT IN THE
SPACE WAS A CHALLENGE. "IN
ORDER TO HAVE IT REMAIN RED IN
LOW LIGHT, I CAREFULLY ADDED
ENOUGH WHITE TO ALLOW IT TO
STAND UP AND BE READ," HE
WROTE. MILLER ALSO CARVED AND
PAINTED THE PRIMITIVE DESIGN
IN THE PANELING. THE GLASNER
STUDIO, LIKE WILLIAM MORRIS'S
RED HOUSE IN ENGLAND, WAS
MEDIEVAL IN SPIRIT.

RIGHT: FROM MILLER'S 1935
LOVE THROUGH THE AGES.
PANELS FROM THE MURAL WERE
SOLD WHEN THE ORIGINAL WAS
REMOVED IN 1959 FROM THE
DOWNTOWN TAVERN CLUB.

IN THE FIRST-FLOOR BEDROOM,
MILLER CREATED A ROMAN-
INSPIRED WINDOW AND A MOSAIC
OF HUNDREDS OF IRREGULARLY
SHAPED TILE FRAGMENTS. THE
BEDROOM COLUMNS ARE FORMED
FROM PLASTER OR CEMENT THAT
WAS CARVED WHILE WET. THE
PLATE COMMEMORATES THE 1939
INVASION OF POLAND. "THIS WAS
DONE IN RECOGNITION OF THE
CRAZY COURAGE OF THE POLES
WHO MET HITLER'S TANKS ON
HORSEBACK WITH SWORDS AND
LANCES," MILLER WROTE.

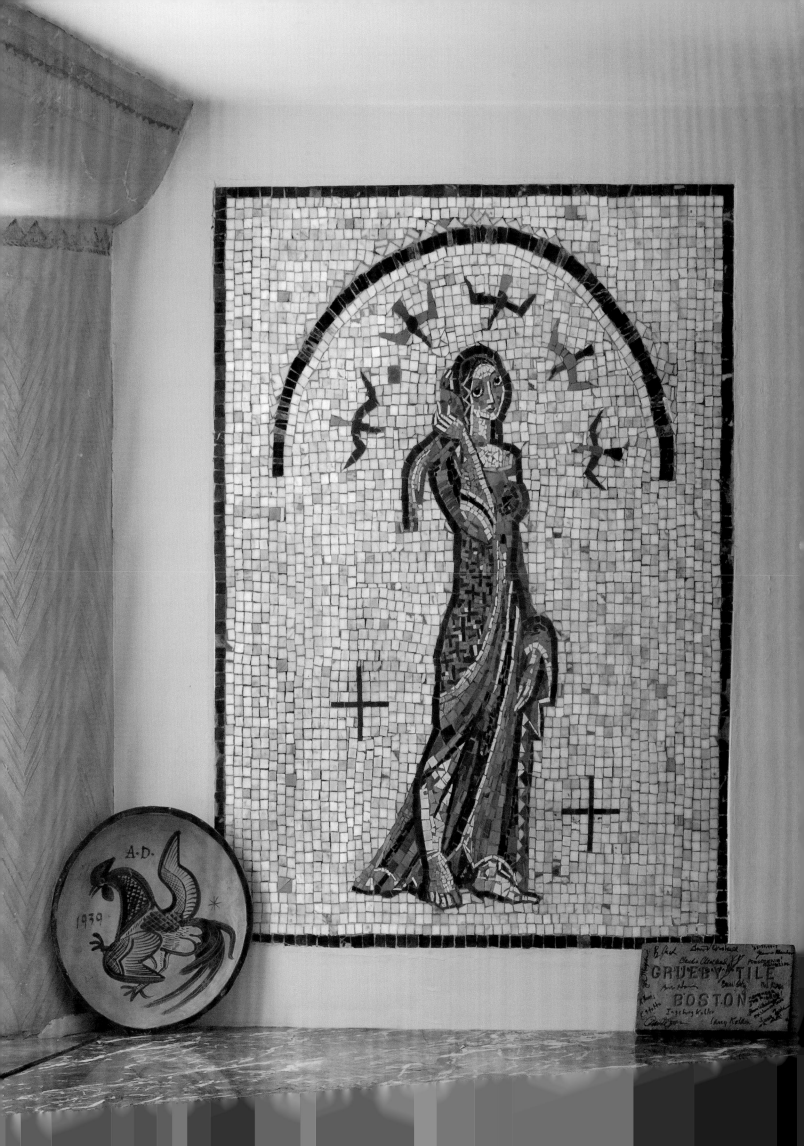

RTG
BY
Edgar
Miller
and
Sam
Kogen
1932

MILLER'S TILE WORK IN THE FIRST-
FLOOR BATHROOM WAS AMONG HIS
FAVORITES. FRIENDS RECALL THAT HE
"JUST BEAMED" WHEN HE RETURNED
TO THE GLASNER STUDIO IN HIS LATER
YEARS. EARL H. REED JR. WROTE OF
MILLER IN A 1932 ISSUE OF ARCHI-
TECTURE: "MEMORIES OF VIGOROUS
AND LOVELY FORMS ARE STORED IN HIS
MIND, WHICH WILL BE CALLED FORTH
TO COLORFULLY GLORIFY THE BUILD-
INGS HE WILL DECORATE."

LEFT: MILLER SIGNED AND DATED THE
TILE WORK FOR RUDOLPH GLASNER,
THE ORIGINAL OWNER.

MILLER CARVED ANIMALS INTO THE GRILLES, STAIRCASES AND EVEN THE HEADER JOIST IN THE FIRST-FLOOR LIVING ROOM. "I INDULGED MY ENJOYMENT OF ANIMALS—ANIMALS IN ACTION—ALL DIFFERENT KINDS OF ANIMALS," HE SAID. "THE INCREDIBLE RICHNESS OF THE EARTH IS TO BLAME FOR ALL OF THESE PLANTS AND ANIMALS."

LEFT: VISITORS ARE CHALLENGED BY MILLER TO LOOK CLOSELY AT EVERY DETAIL, LIKE THESE WROUGHT-IRON BALUSTERS WITH INCISED DESIGNS.

RIGHT: MILLER CARVED THE WOOD PANELS THAT ENCLOSE THE STAIRCASE BETWEEN THE FIRST AND THIRD FLOORS.

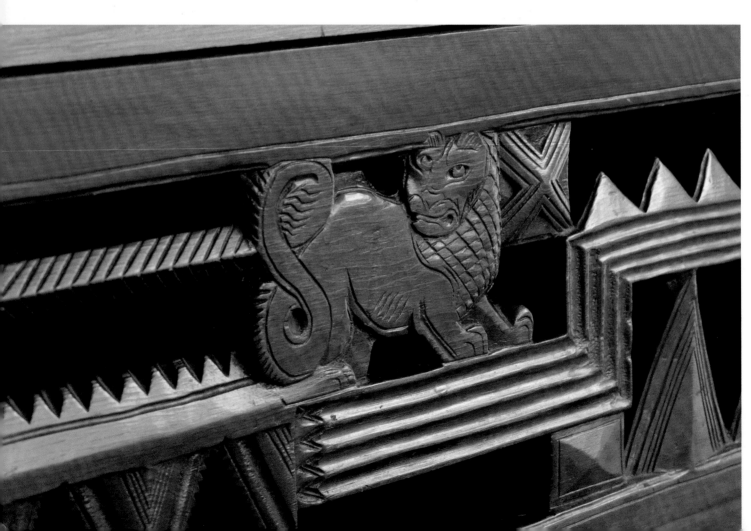

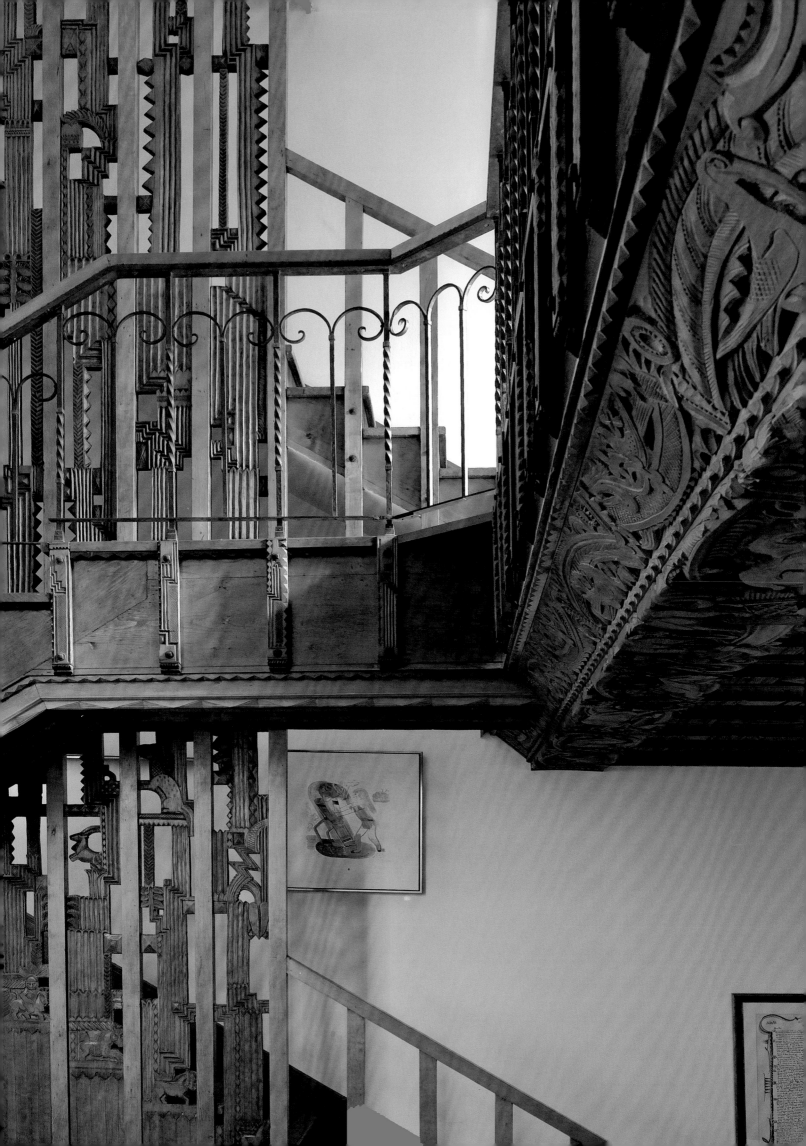

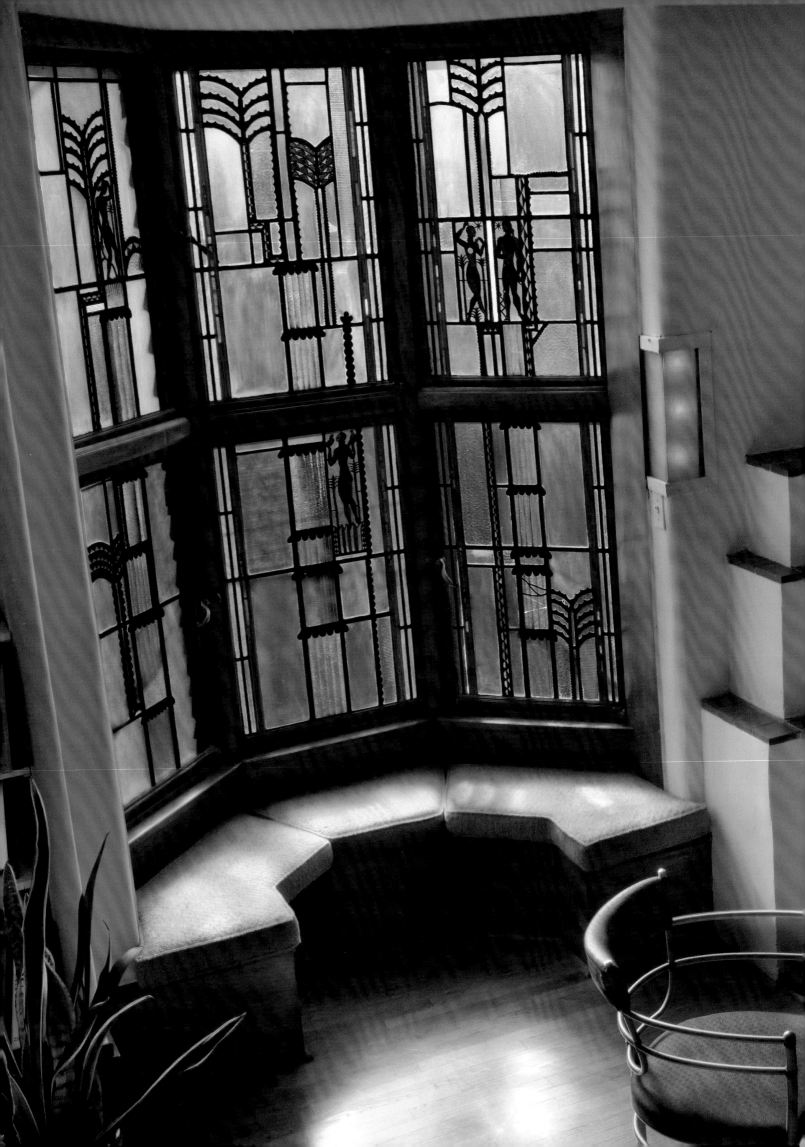

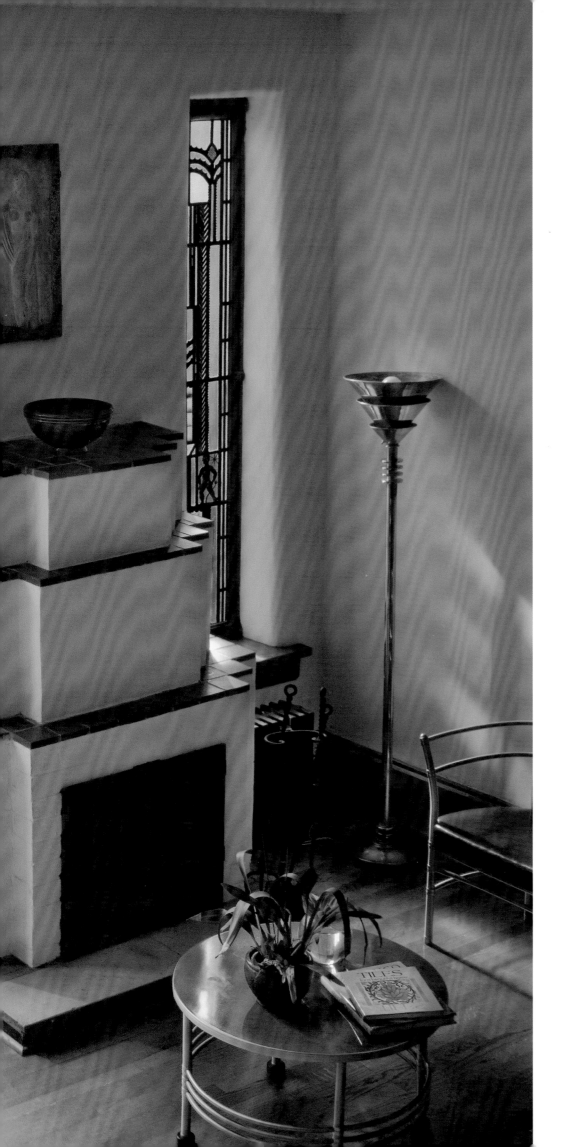

"IN THIS ROOM I
WANTED TO GET A LOT
OF LIGHT," MILLER SAID,
"SO I MADE THE GLASS
ALMOST ENTIRELY WHITE
OBSCURE GLASS."

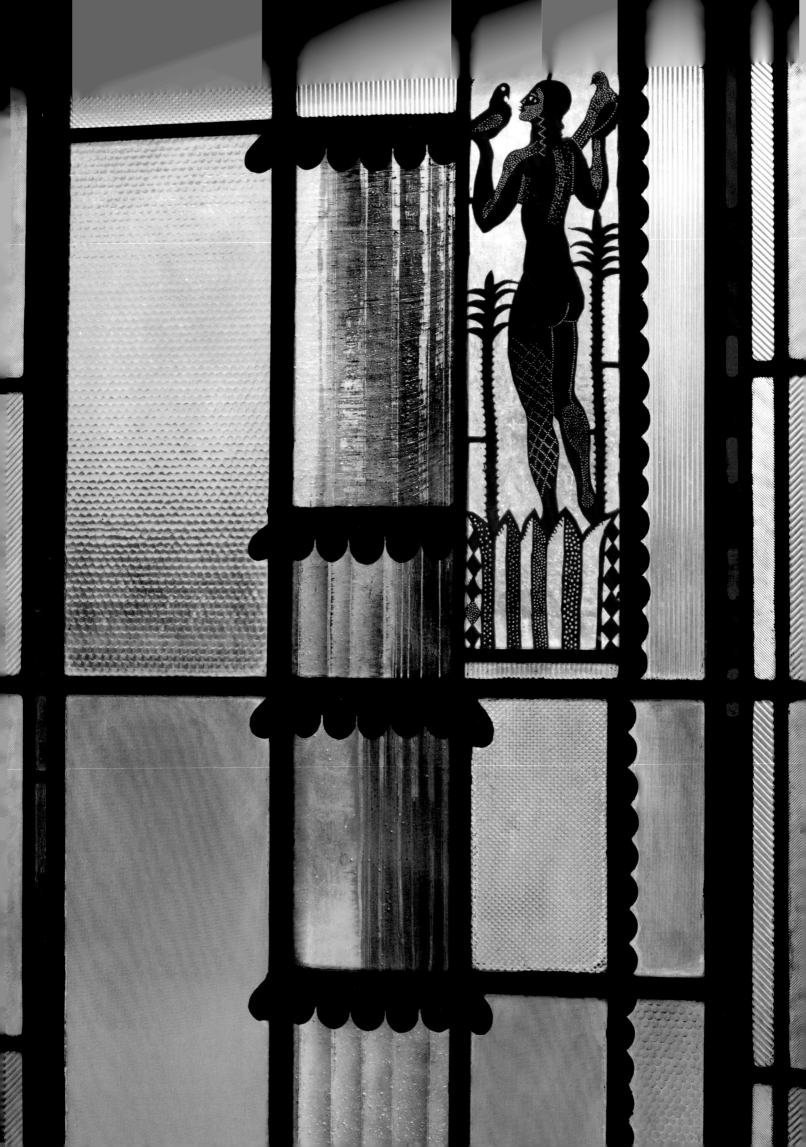

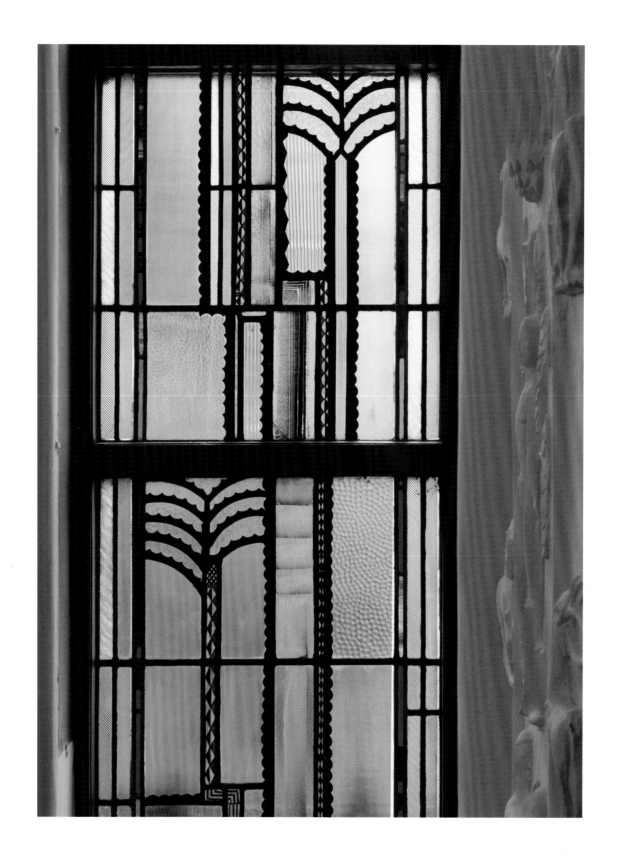

THE WINDOWS MILLER CREATED ON THE SECOND FLOOR WERE INSPIRED BY TENTH-CENTURY
EUROPEAN MONKS WHO WERE NOT ALLOWED TO USE COLORED GLASS. HE ADDED A BIT OF
COLOR TO TRANSLUCENT GLASS TO UPDATE THE MONKS' MONOCHROMATIC STYLE, KNOWN
AS GRISAILLE. "I HAVE USED THE PATTERN OF THE OBSCURE GLASS IN FRAGMENTS TO MAKE
A UNIQUE PATTERN, AND I DON'T THINK THAT GLASS HAD BEEN USED FOR THAT PURPOSE
EVER BEFORE," MILLER WROTE. HE PAINTED THE GLASS WITH IRON OXIDE, WHICH ADDED A
DASH OF COLOR.

THE CLIMAX AT THE TOP OF THE STAIRS: THE GARDEN OF PARADISE ROOM.

EVERY ONE OF US HAS HAD THE EXPERIENCE OF REALIZING
THAT SUDDENLY ONE HAD, FOR AN INSTANT, SEEN BEYOND
THE BOUNDARIES OF THE 'ORDINARY.'

SUCH IS THE SUDDEN REALIZATION THAT 'I AM ALIVE.'

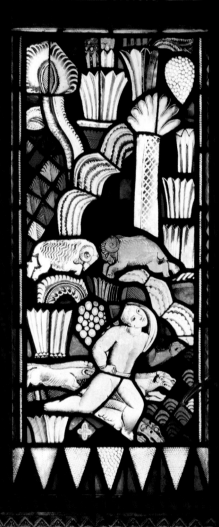

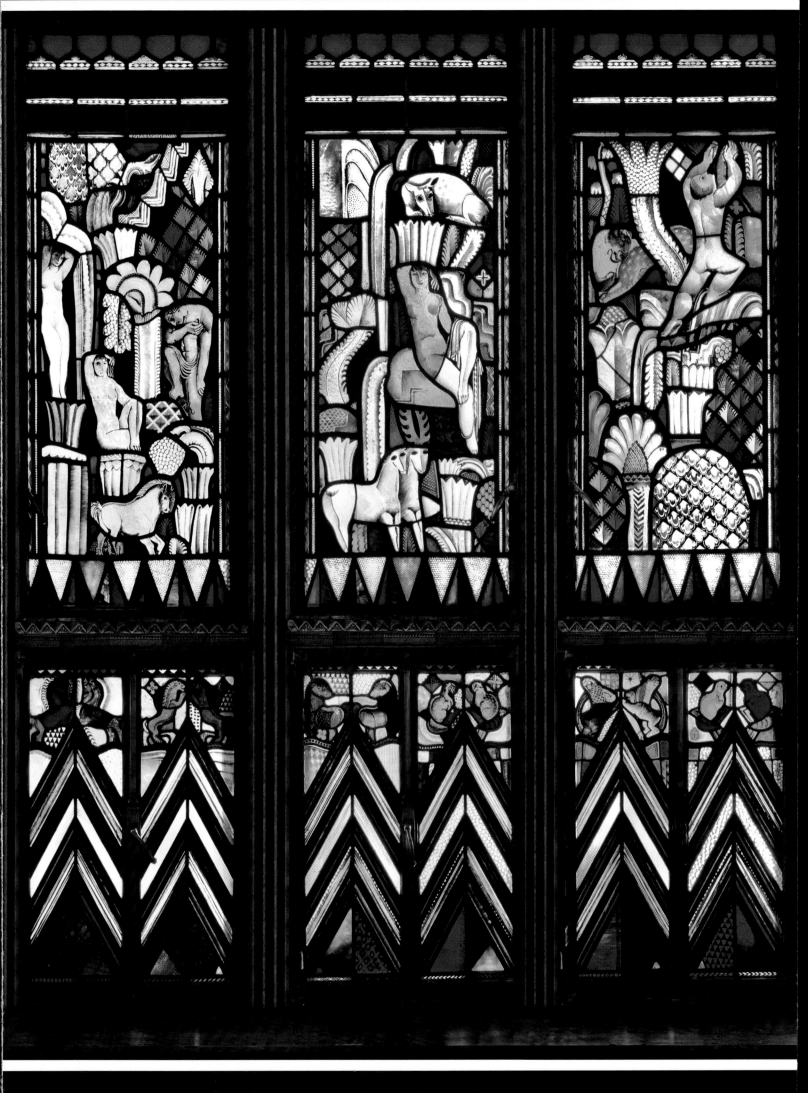

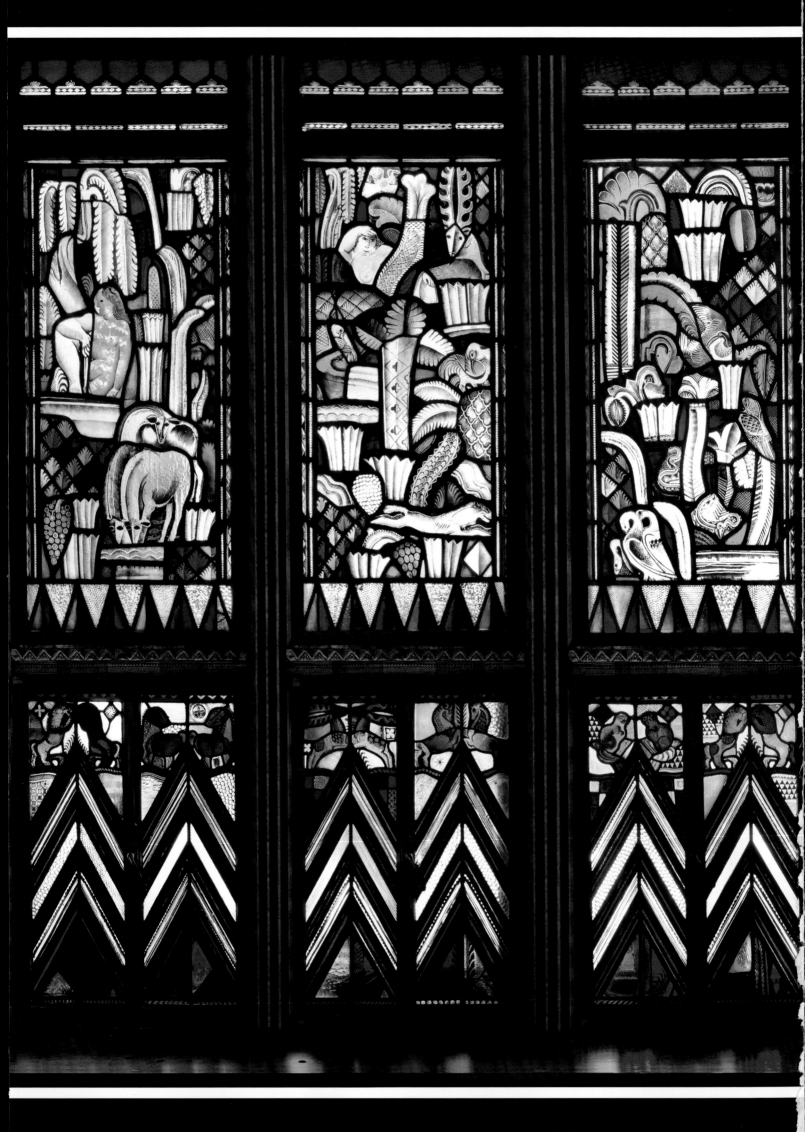

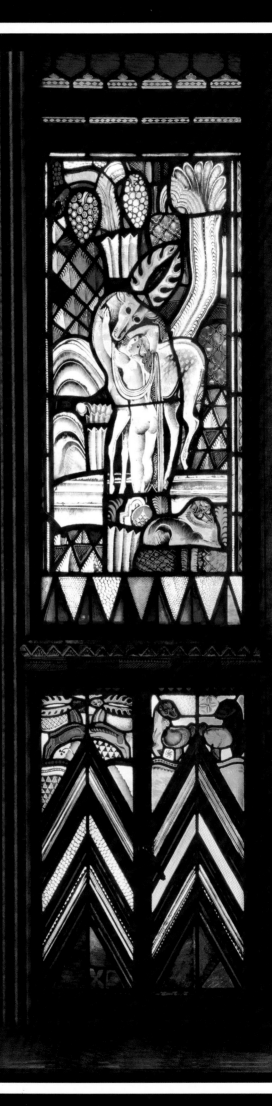

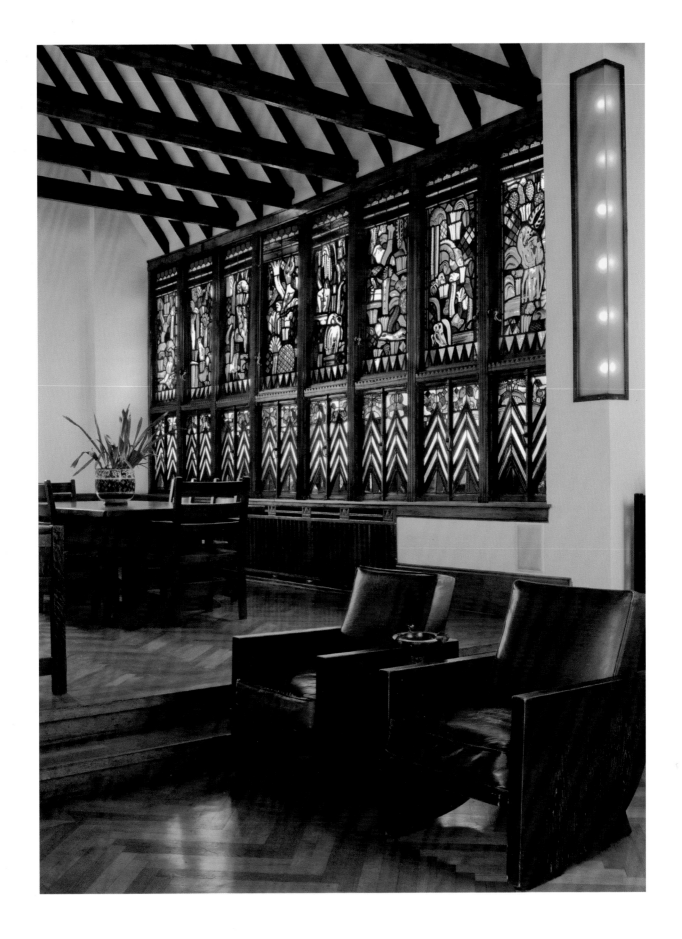

EDGAR INCLUDED EVERYTHING THAT WAS IMPORTANT TO HIM IN THE ROOM: THE BEAUTY OF NATURE, COLOR, ANIMALS AND THE FEMALE FORM.

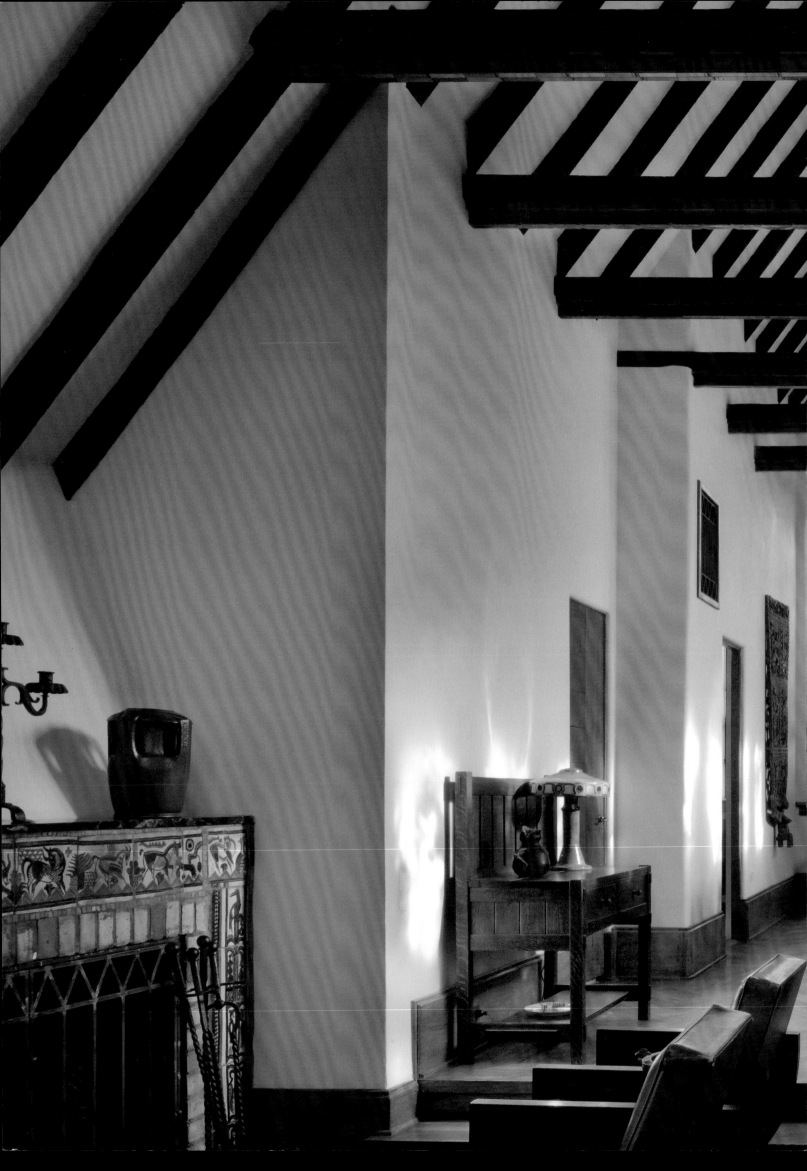

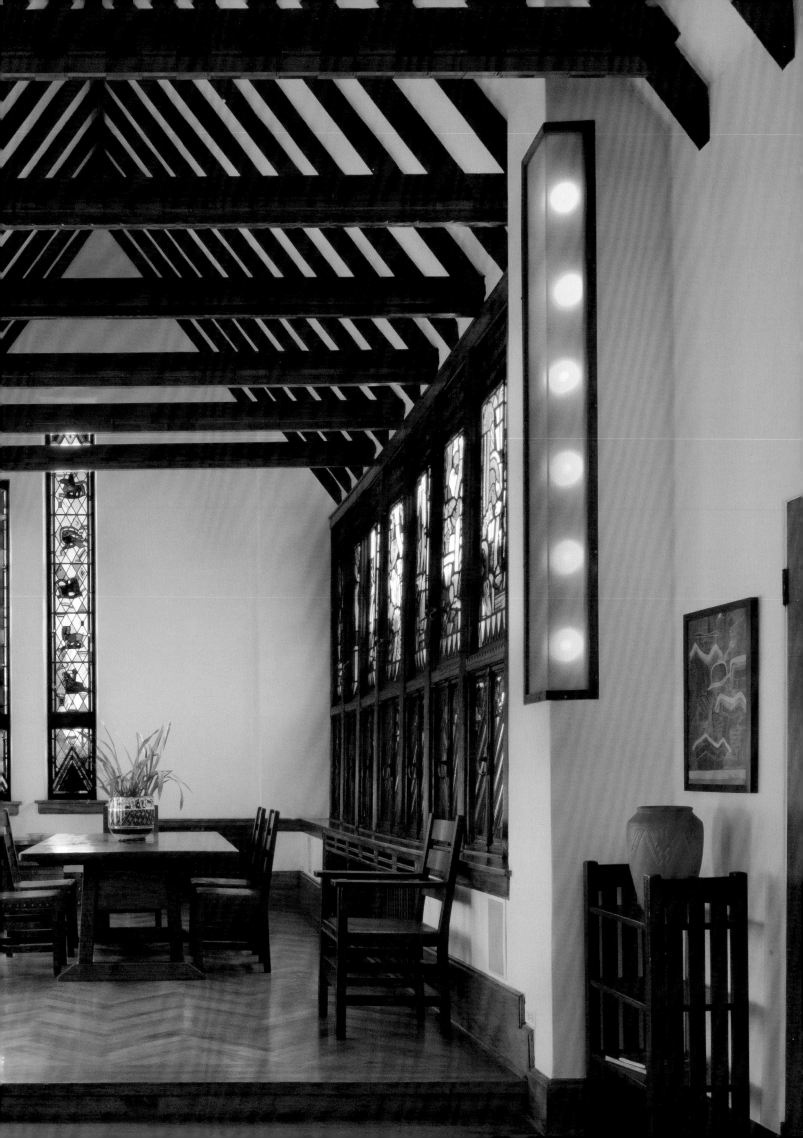

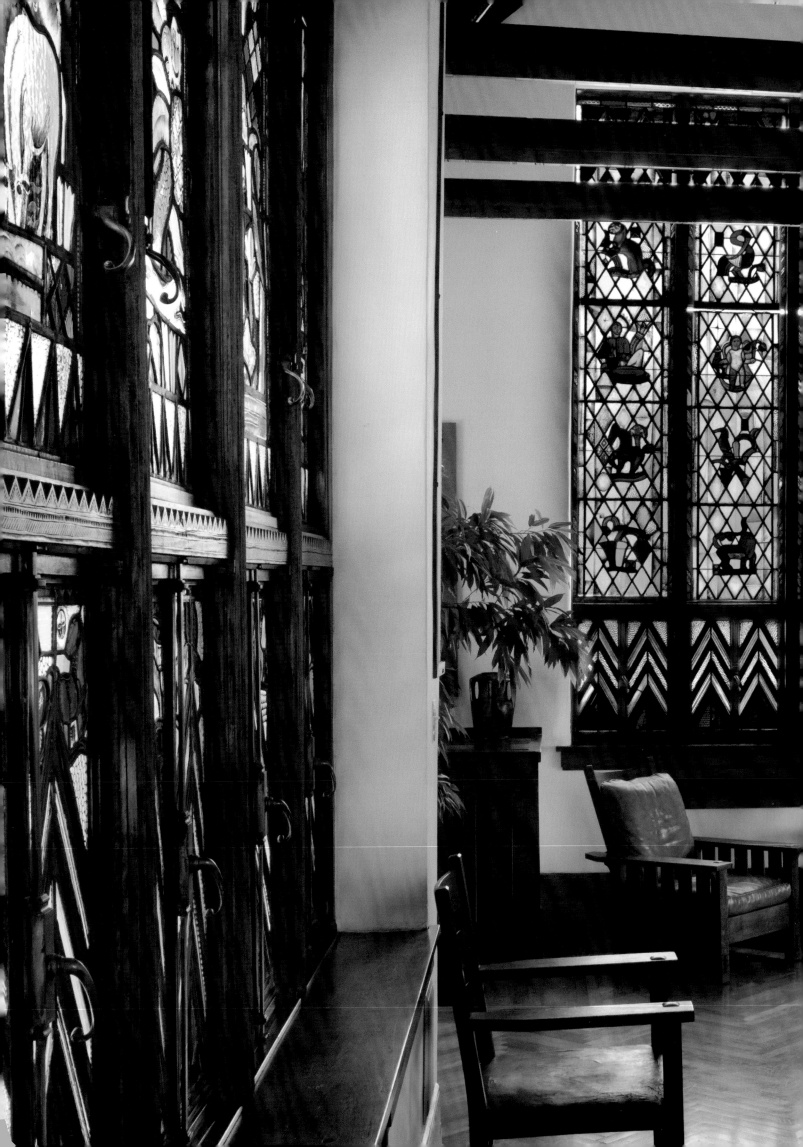

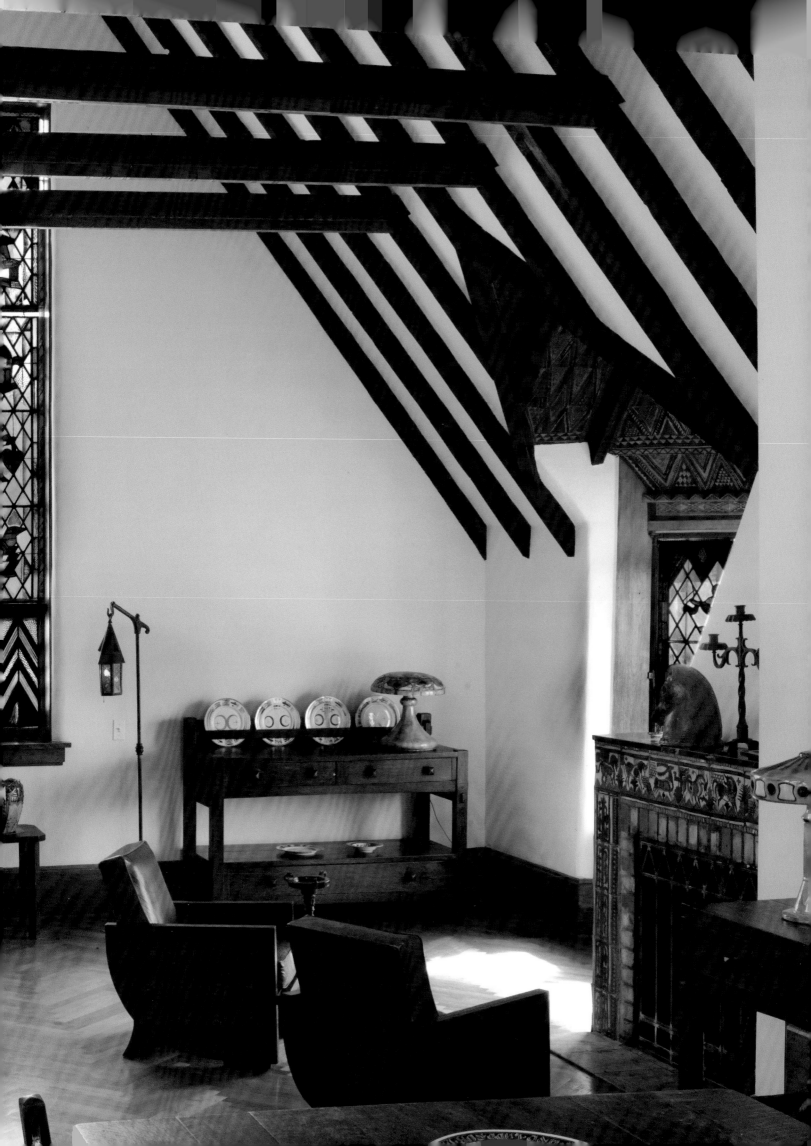

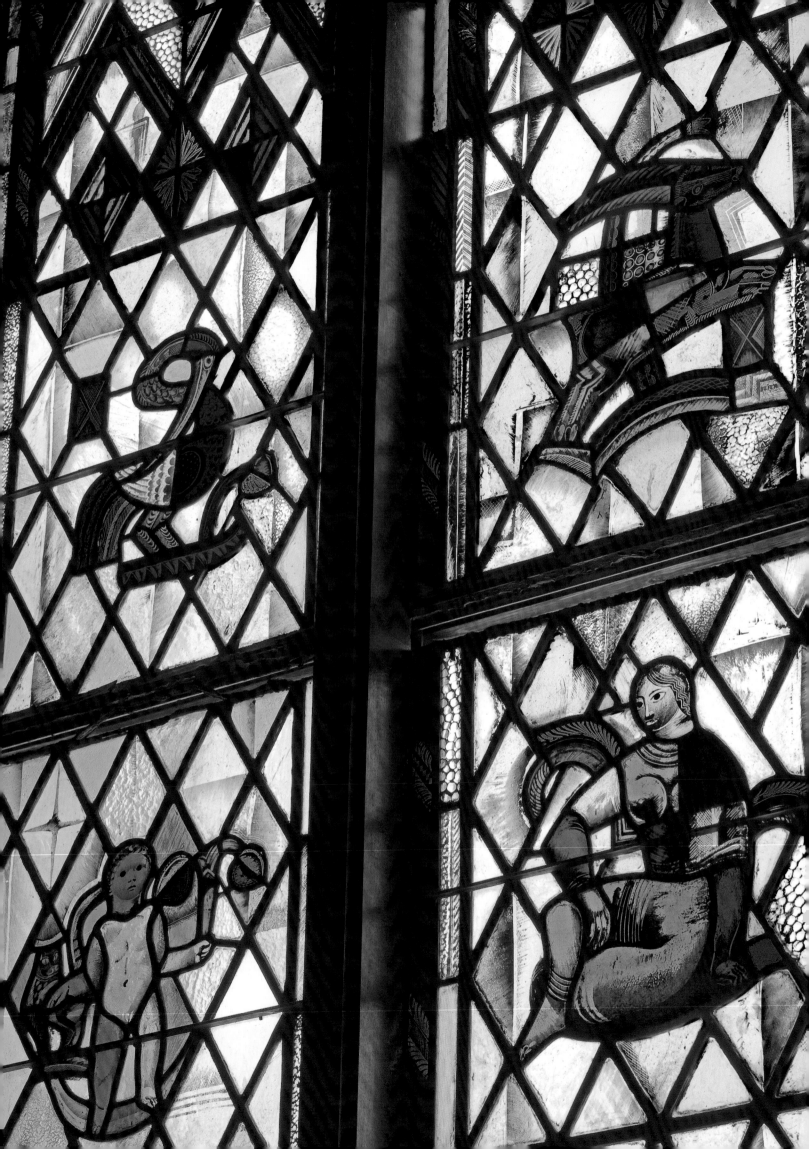

MILLER NEVER STOPPED WORKING
ON OTHER PROJECTS, LIKE THIS
SMALL PAINTED BOX AND CERAMIC
BOWL. "I WOULD BE WORKING ON
NORMAL COMMISSIONS ANYTIME—
NIGHT OR DAY. ANYTIME I FELT LIKE
IT," HE SAID.

LEFT: MILLER CARRIED THE
MEDIEVAL-INSPIRED THEME OF THE
TOP-FLOOR ROOM TO THIS TWELVE-
FOOT-TALL WINDOW. EARLY IN HIS
CAREER, MILLER WAS FASCINATED BY
MEDIEVAL AND GOTHIC DESIGN, AND
HE INCORPORATED THE STYLE INTO
MUCH OF THE ART IN THE GLASNER
STUDIO.

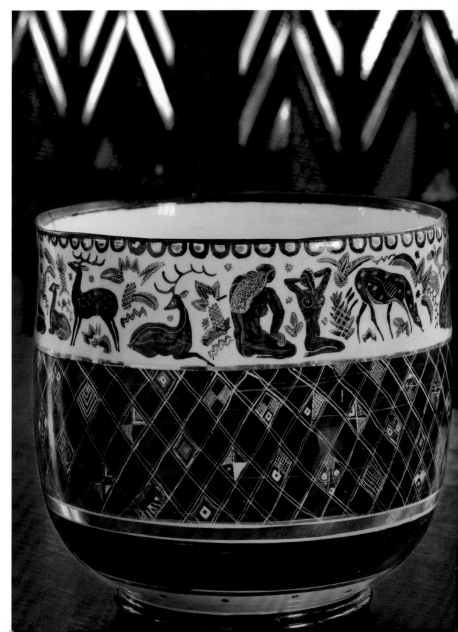

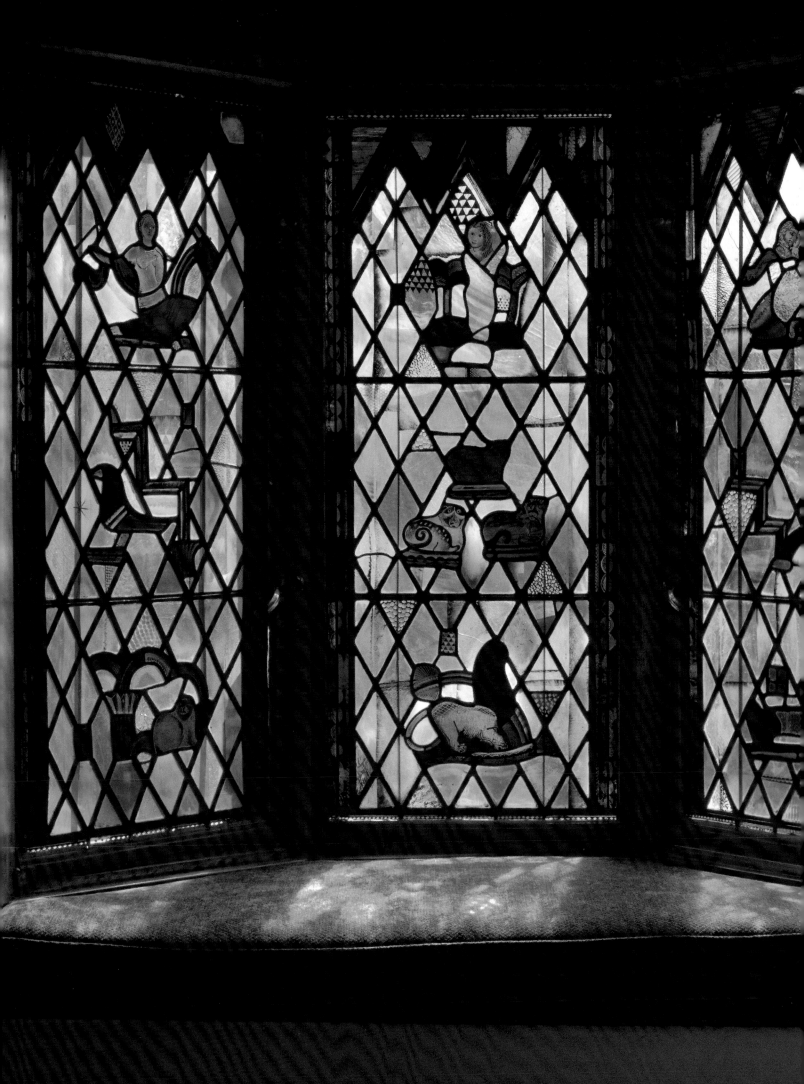

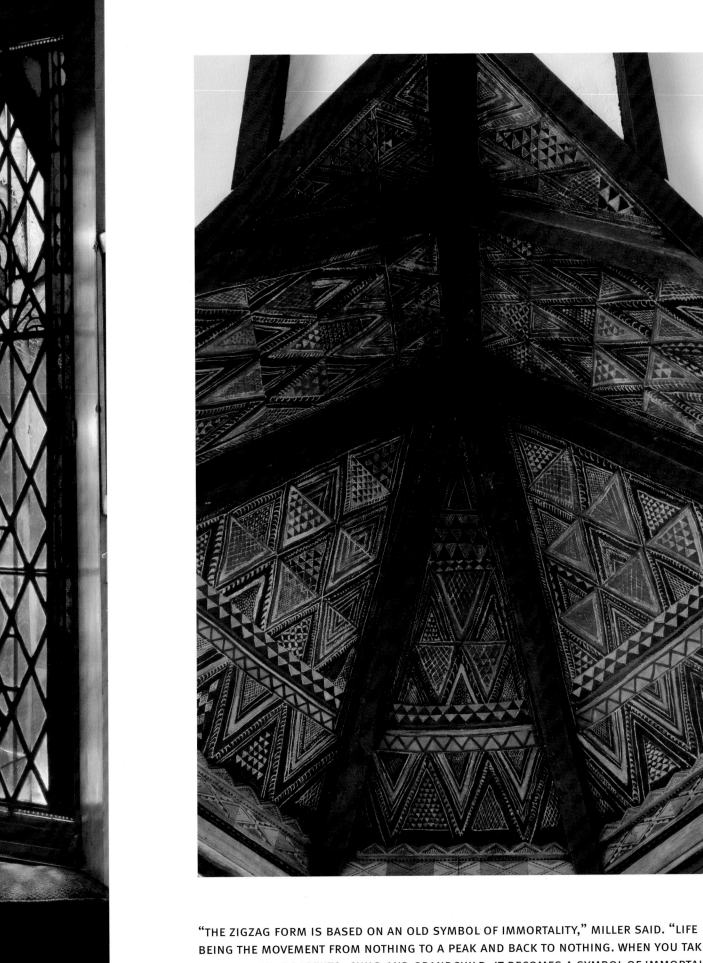

"THE ZIGZAG FORM IS BASED ON AN OLD SYMBOL OF IMMORTALITY," MILLER SAID. "LIFE BEING THE MOVEMENT FROM NOTHING TO A PEAK AND BACK TO NOTHING. WHEN YOU TAKE THE LIFE OF THE PARENTS, CHILD AND GRANDCHILD, IT BECOMES A SYMBOL OF IMMORTALITY TO GENERATIONS."

MILLER BEGAN MAKING
SERIOUS CERAMIC WORK
IN THE EARLY 1920S,
USING THE KILNS AT
HULL HOUSE, AND
WOULD CONTINUE THE
CRAFT THROUGHOUT
HIS LIFE. HE MOLDED
AND FIRED THE TILES
THAT SURROUND THIS
FIREPLACE, DECORATING
THEM WITH IMAGERY
THAT HAS THE FEEL
OF PREHISTORIC CAVE
PAINTING.

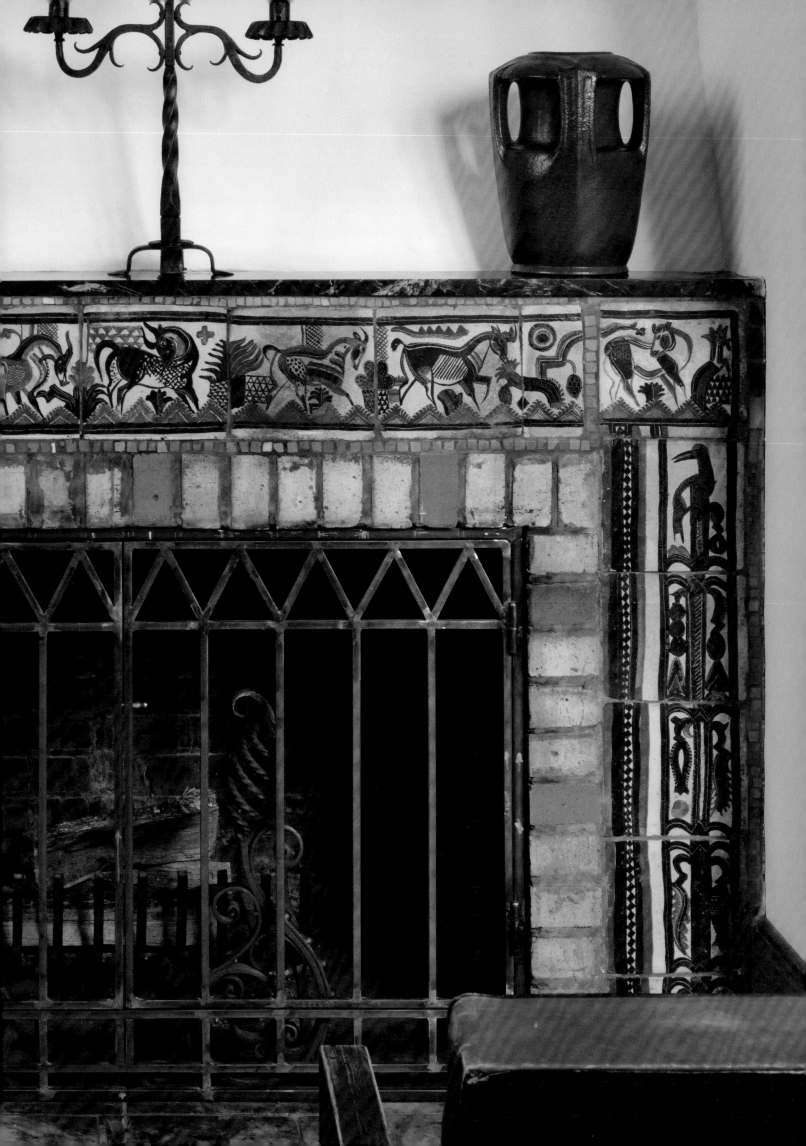

DESPITE BEING NEARLY IMPOSSIBLE TO SEE FROM BELOW, THE RAFTERS ARE DECORATED WITH CARVED AND PAINTED ANIMALS, EACH ONE UNIQUE.

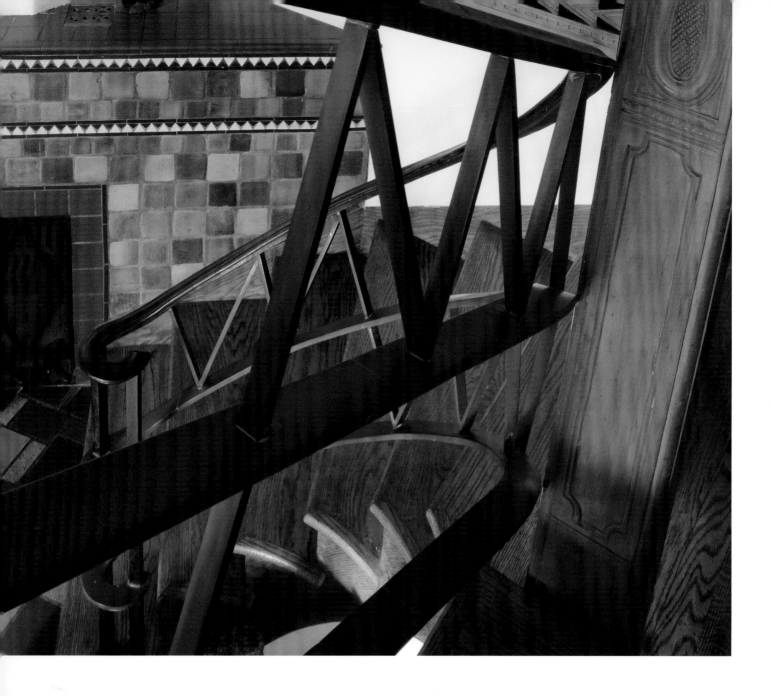

MILLER RENOVATED THE FIRST
FLOOR FOR FRANK FUREDY IN
1946. HE CARVED THE CEIL-
ING BEAMS, STAIRCASE AND
RADIATOR GRILLES, TILED THE
FLOOR AND FIREPLACE MANTEL
AND ADDED STAINED-GLASS
WINDOWS.

LEFT: MILLER HAMMERED THIS
COPPER CHARGER IN THE 1920S,
THE ONLY KNOWN EXAMPLE OF
HIS WORK IN THIS MEDIUM.
"I WAS NEVER STOPPED BY A
MEDIUM," HE ONCE TOLD A
REPORTER. "I LEARNED THAT IF
YOU WANT TO DO IT, GO AHEAD."

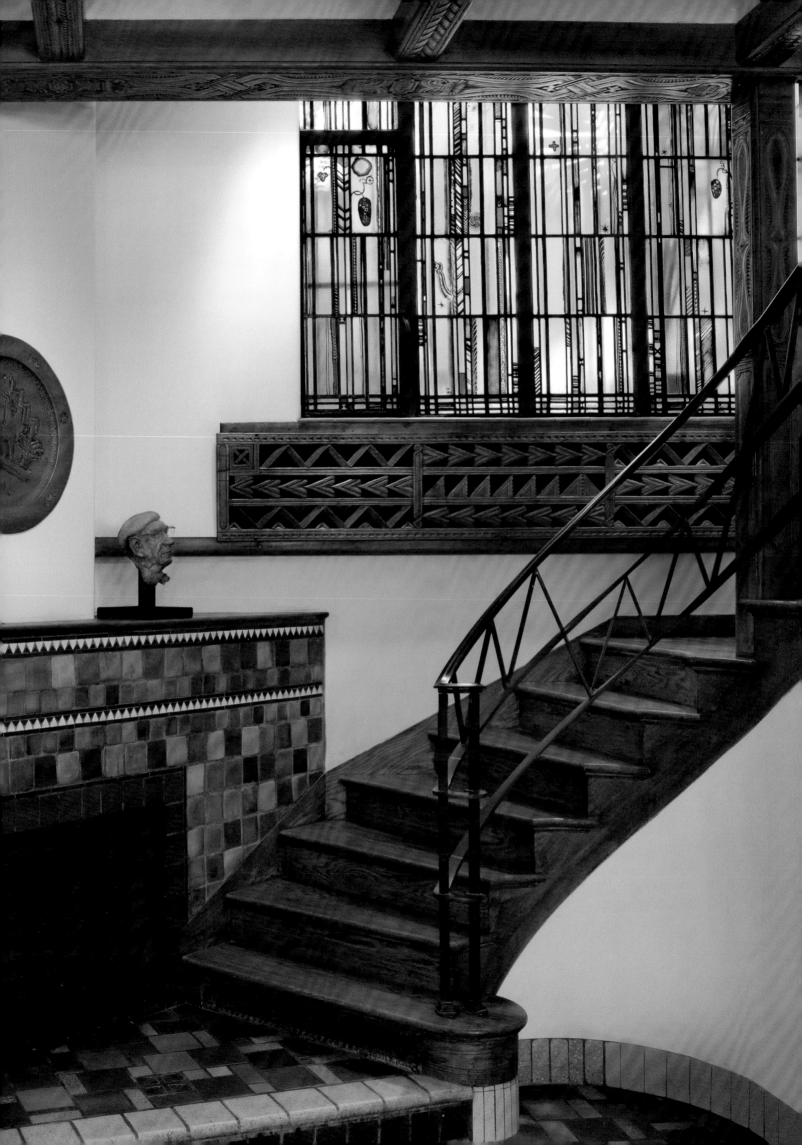

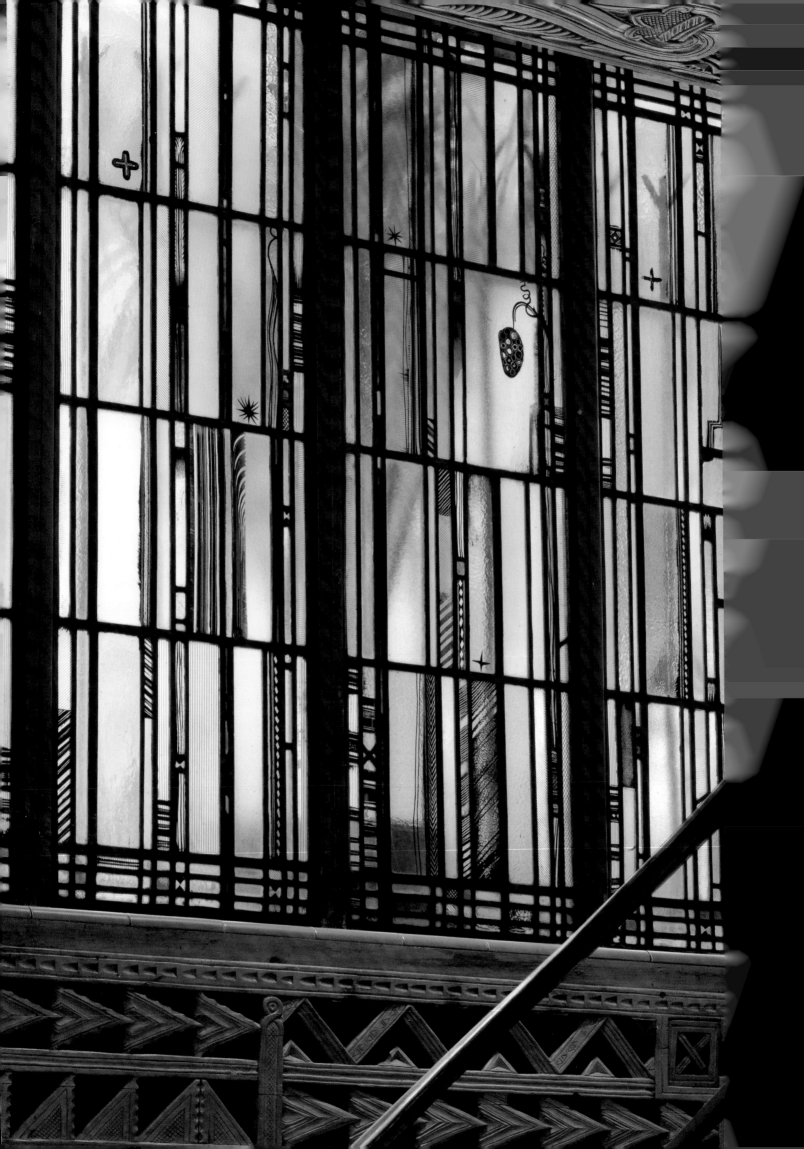

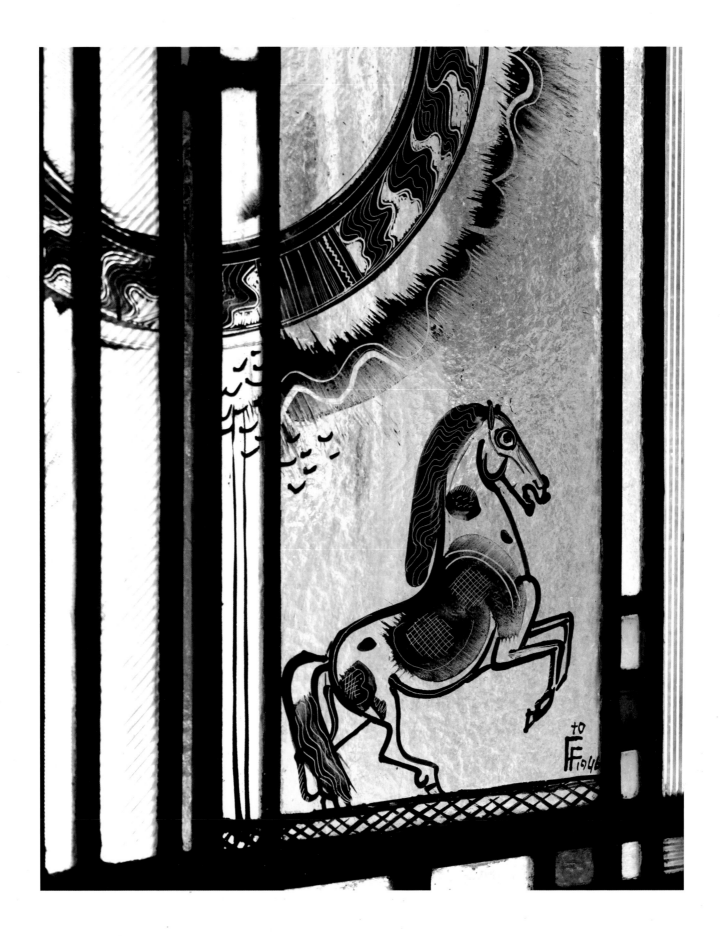

MILLER'S EVOLUTION AS AN ARTIST IS EVIDENT ON THE LOWER LEVEL. HIS WORK IN THE GLASNER STUDIO, INFLU-
ENCED EARLY ON BY MEDIEVAL TRADITIONS, HAD TAKEN A MORE ABSTRACT DIRECTION BY THE MID-1940S.

STUDIO 1

EXAMPLES OF MILLER GLASS FROM 1920S (RIGHT) AND THE 1980S (ABOVE).

FOLLOWING PAGES: STAIRCASE TILES, LIKELY DESIGNED BY MILLER AND JESUS TORRES, SWEEP UP FROM THE FIRST-FLOOR LIVING ROOM.

Studio 1 was new construction. Neither Sol Kogen nor Edgar Miller was an architect, but all accounts indicate they designed the new building on their own. Andrew Rebori, the architect officially listed at the Kogen-Miller and Carl Street studios, joked many times over the years that he was the consulting architect who was seldom consulted.

Miller originally designed Studio 1 in 1928 as a single-story dwelling, but in 1932 a second story was added to accommodate an additional studio.

Miller's design of Studio 1 follows the pattern he set for the rest of the complex: a duplex unit containing a large, bright living room and tiny kitchen on the first floor and a single bedroom and bathroom on the second. While small in overall square footage, the studios feel larger because of the nearly sixteen-foot-tall windows that illuminate most of them.

Salvaged materials abound—from tiles on the stairs to recycled bricks on the fireplace. "Practically all of the materials were reclaimed, because when a building was demolished, the good wood, tile and marble was saved," Miller wrote. "So here was secondhand material that didn't cost much, but was distinguished as hell. To use it, you just had to have taste and a sense of space."

The wood-burning fireplace in the living room is an element that all studios share, though Miller most likely painted the one pictured at right white. Opposite the fireplace, a tile stairway leads to the second floor. Original to the studio, the tile work appears to be a collaboration between Miller and his assistant Jesus Torres.

When Miller returned to Chicago in the 1980s, he designed a new stained-glass window for the second floor.

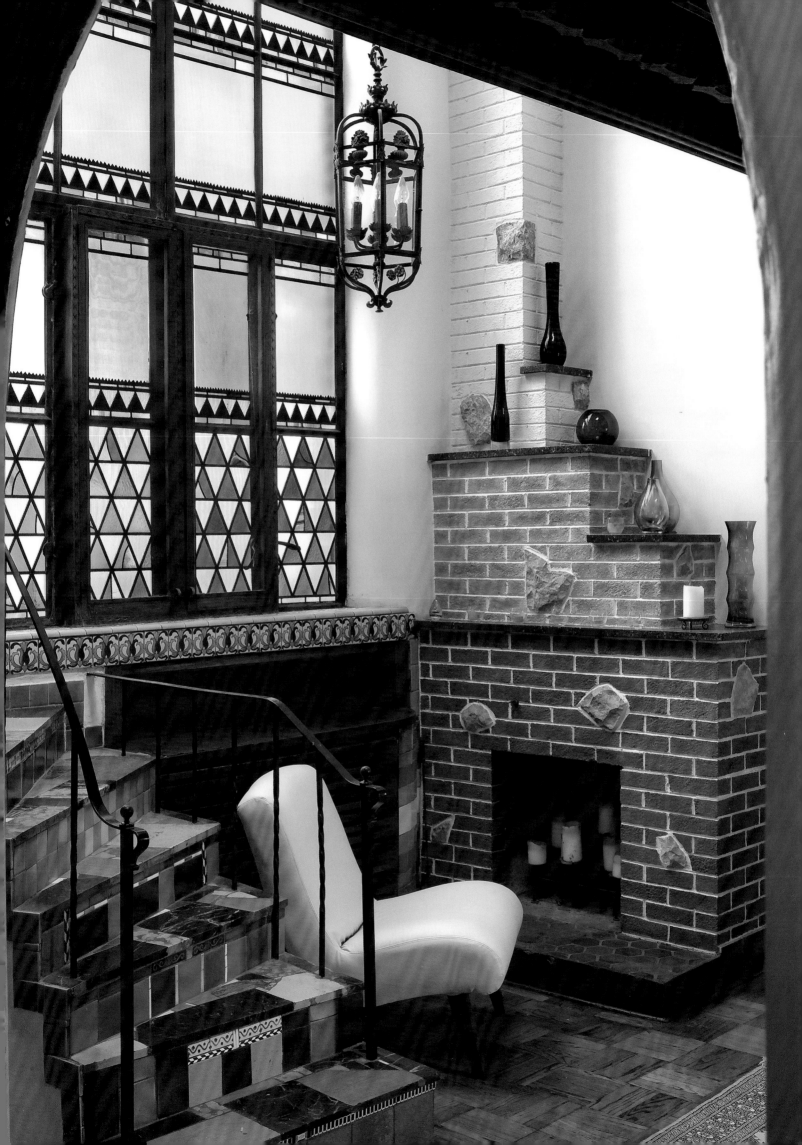

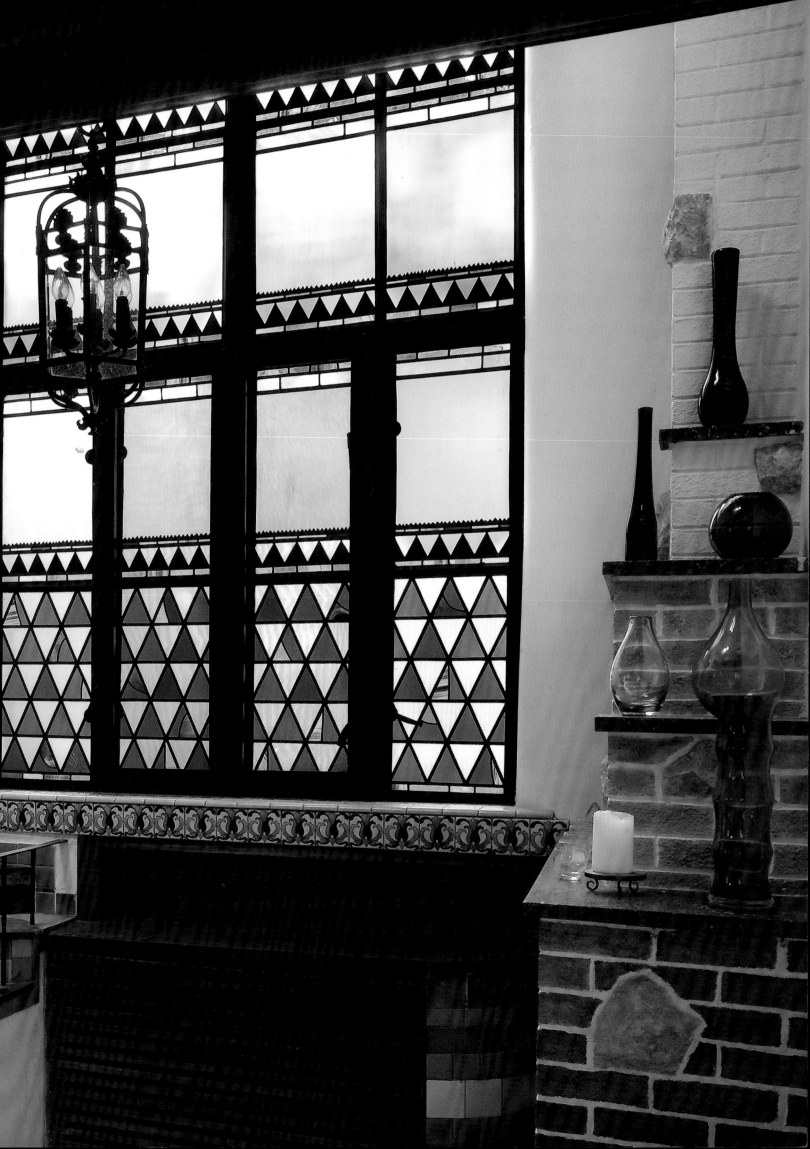

LOOKING UP AT THE CARVED AND PAINTED CEILING UNDER THE SECOND FLOOR. THE DESIGN IS UNCHARAC-TERISTIC OF MILLER, SO IT MAY HAVE BEEN DONE BY AN ASSISTANT.

RIGHT: FOR THE MAIN WINDOW, MILLER USED ONE OF HIS FAVORITE MOTIFS—A REPEATING TRIANGLE—WHICH DOMINATES THE GLASS DESIGN AND HARMONIZES WITH THE COURTYARD.

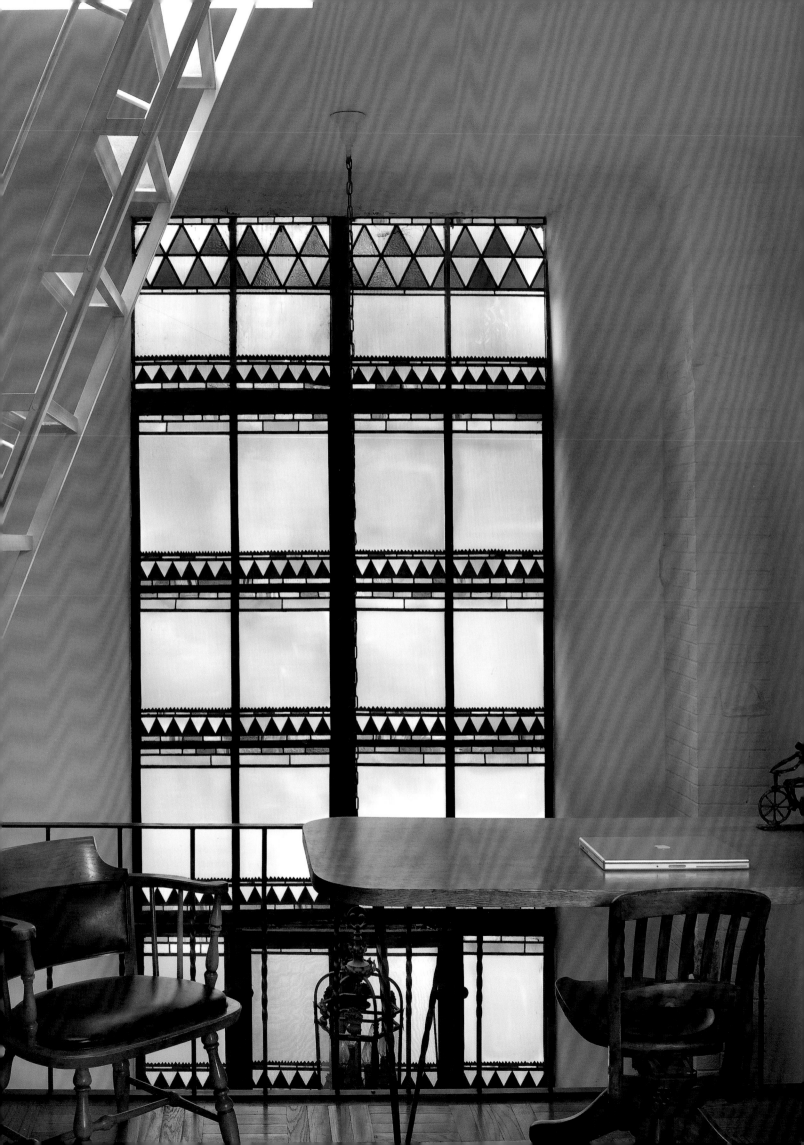

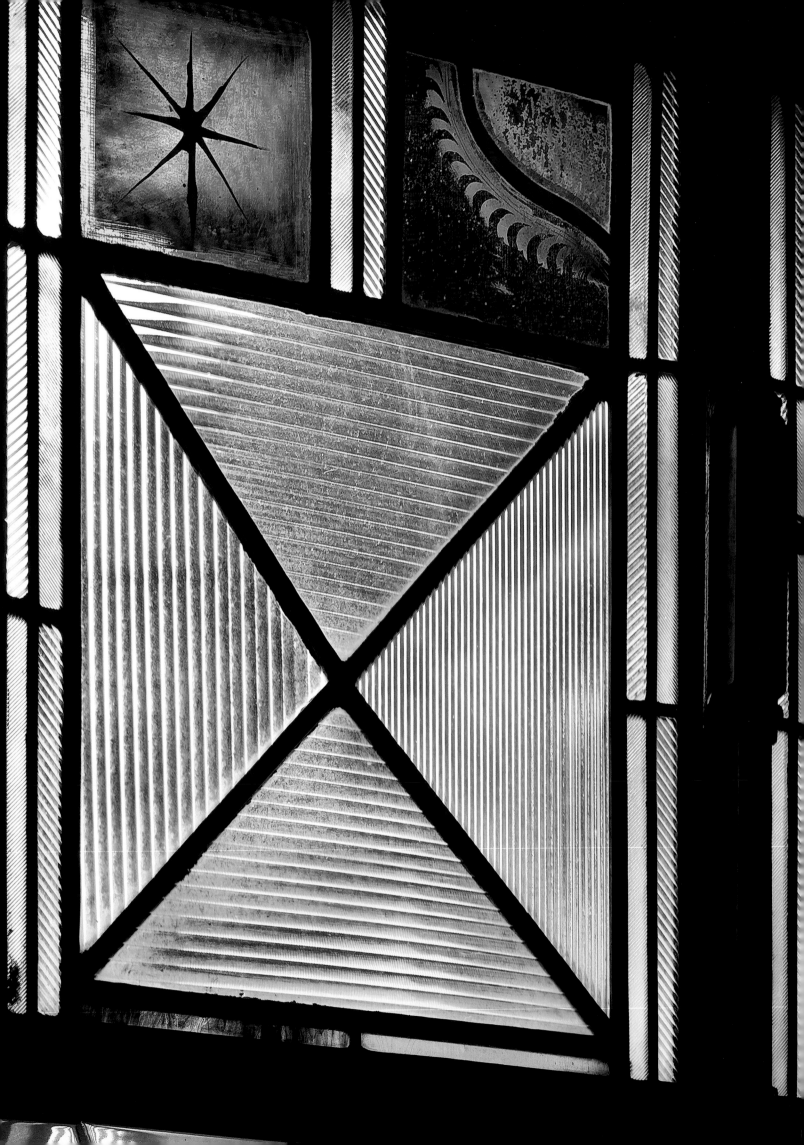

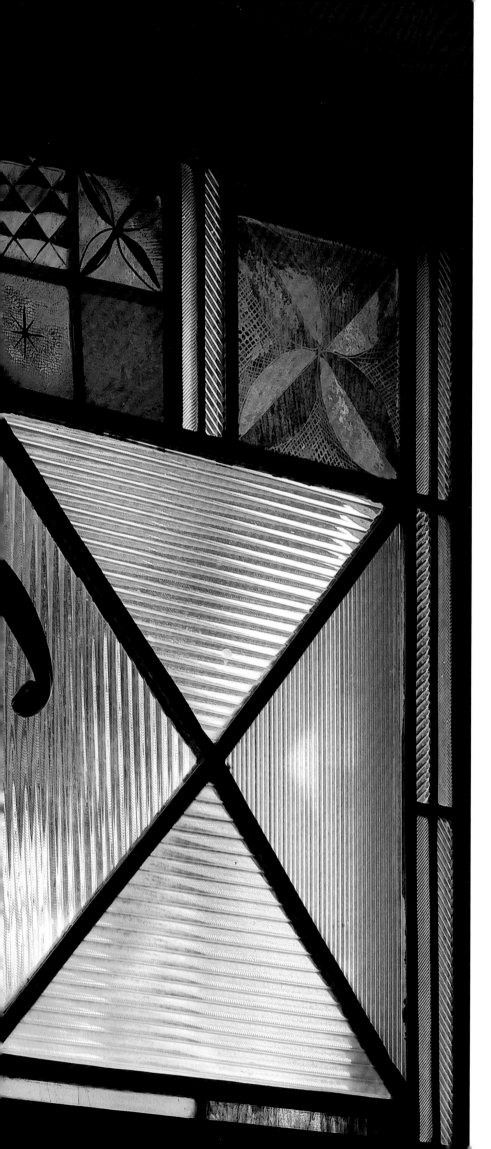

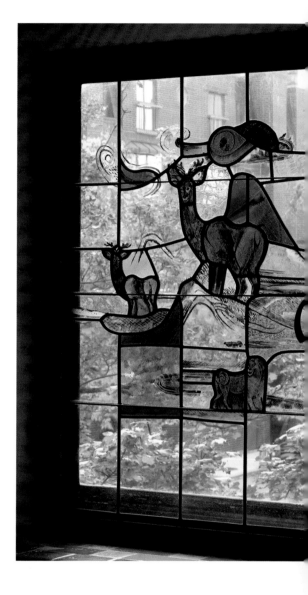

A STAINED-GLASS WINDOW MADE
BY MILLER IN 1988.

LEFT: THE TEXTURED GLASS USED
IN THIS DESIGN WAS INTENDED
FOR A COMMERCIAL APPLICATION
LIKE A BANK TELLER'S WINDOW.
MILLER WAS ONE OF THE FIRST
TO USE INDUSTRIAL GLASS FOR
AESTHETIC REASONS.

STUDIO 2

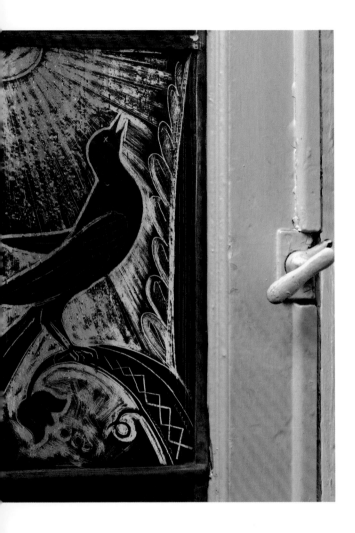

Of all the units on Wells Street, Studio 2 has the least amount of Miller's artwork. Not part of Miller's original plan, the studio dates to 1932, when a second floor was added above an existing one. It is unknown if Miller had any say in the decision, but the dearth of his art in the unit is likely an indication of his feelings.

Miller and Kogen purchased the Wells Street complex together in 1928, but Miller sold his share within a year after a series of disagreements. "I very soon realized that the partnership with Sol was pure fiction," Edgar wrote. "He never made it a legal reality, and I knew that he never intended to." Edgar watched as Sol brought other friends and family members in as partners when he needed to borrow money. "So I understood perfectly what the situation was," Edgar wrote.

Kogen was a dreamer who wanted to bring Montmarte to Chicago. He saw Edgar as the man who could make that happen and was smart enough to let him work unencumbered. Edgar saw Kogen as a builder, somebody who would run interference and provide an opportunity to test out his theories on hand-built homes. Their relationship soured in the early 1930s, but that did not affect Miller's enthusiasm for the Wells Street complex—though Studio 2 might be the exception.

In the end, the two made a fragile peace. Edgar was free to make the art; Sol was free to make the deal. "In general, I didn't get any pay," Miller wrote. "I did it all in my spare time and I enjoyed doing it. It was opportunity to do something where I didn't have to buy materials, or worry about even the wood that I carved, which was furnished for me. That was a good deal as far as I was concerned."

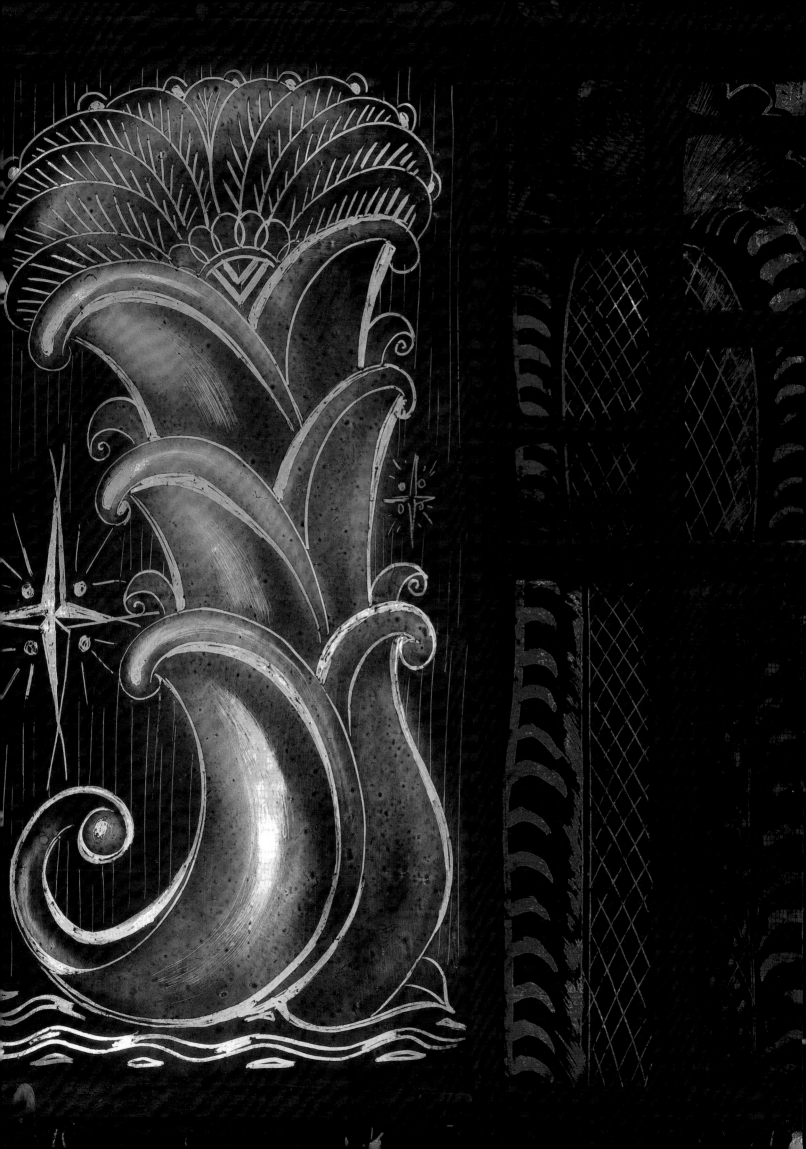

A FIREPLACE RISES FROM A TILE BASE. "I REALIZED THAT THE BRICKLAYERS DID NOT HAVE ANY SECRET," MILLER WROTE. "ALL YOU NEEDED TO DO WAS TO UNDERSTAND WHAT WAS REQUIRED OF YOUR MORTAR. IT IS A TRICK ANYBODY CAN DO."

RIGHT: THE HIGHLIGHT OF THE STUDIO IS A LARGE MULTIPANEL WINDOW, WHICH DEMONSTRATES MILLER'S ABILITY TO PAINT DIRECTLY ON GLASS. THESE SELF-CONTAINED ILLUSTRATIONS ARE AN HOMAGE TO BIRDS AND OTHER NATURAL WONDERS.

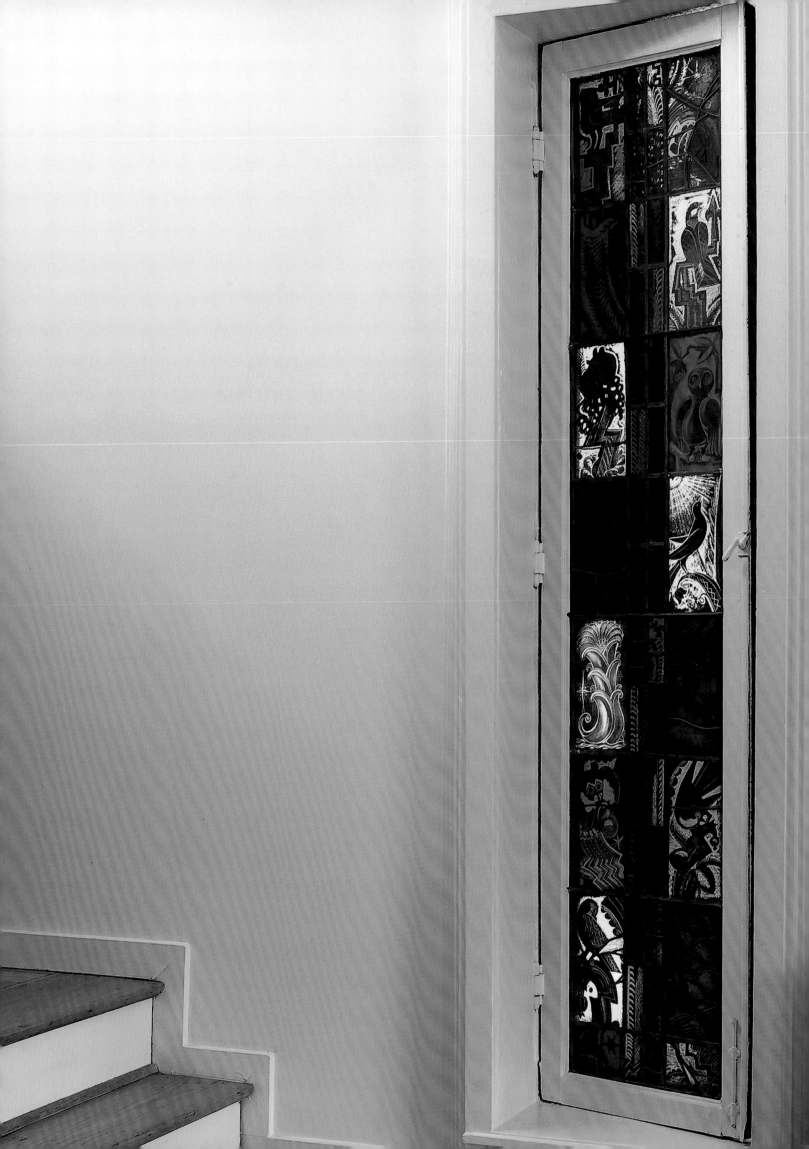

STUDIO 3

**MILLER USED STAINED-GLASS AND
CURVED WALLS IN THE STUDIO.**

Edgar Miller gets most of the credit for the beauty of the Kogen-Miller Studios—and deservedly so. But there was also a small group of tradesmen who worked under Miller, quietly making his job easier and bringing his ideas to life.

Among them were Jesus Torres, a Mexican immigrant who primarily did tile and copper work, and Edgar's brother Frank, who gathered materials, did preliminary carving and set tiles. Another unsung hero was Charles Smith, the man responsible for Studio 3's remarkable plasterwork.

Frank worked side by side with Smith on Wells and Carl streets and singled him out for his substantial contributions to both complexes. "Charley made an art of plastering, and to watch him at work was like viewing a graceful ballet dancer, as he fashioned soaring arches with feathered edges, and charming symmetrical curves," Frank wrote. "He was the only plasterer that could do justice to Edgar's designs."

Sol Kogen paid Smith well for his artistry. Wrote Frank: "Sol always kicked at having to pay top union wages, but he also knew that Charley was a bargain at that. Charley always insisted on mixing the final coat himself and strove for perfection as any true artist as he completed each lovely curve and featheredge."

Edgar often declared that he worked on the Kogen-Miller and Carl Street studios for free. But Kogen did give him an apartment and a large work studio on Wells Street, in addition to the payment he received from Rudoph Glasner. Ironically, Charley Smith might have been the top earner of all.

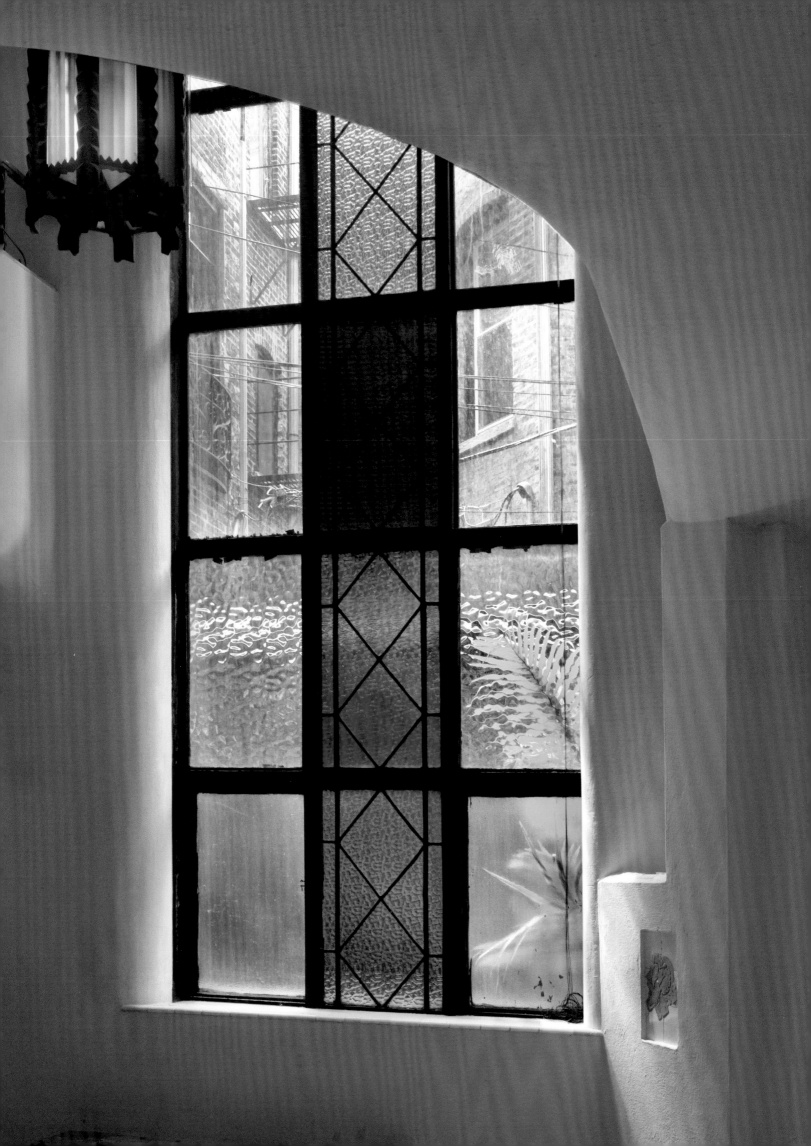

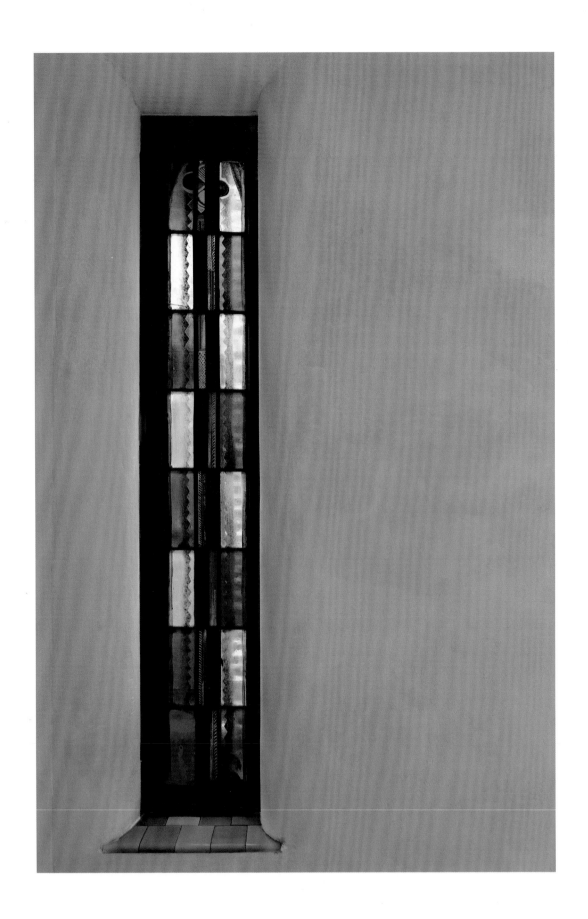

MILLER CREATED BLACK-AND-WHITE ABSTRACT DESIGNS ON GLASS IN TWO WAYS: PAINTING
DIRECTLY ON THE GLASS OR FLOODING AN AREA WITH PAINT AND THEN SCRAPING IT OFF TO
CREATE AN IMAGE.

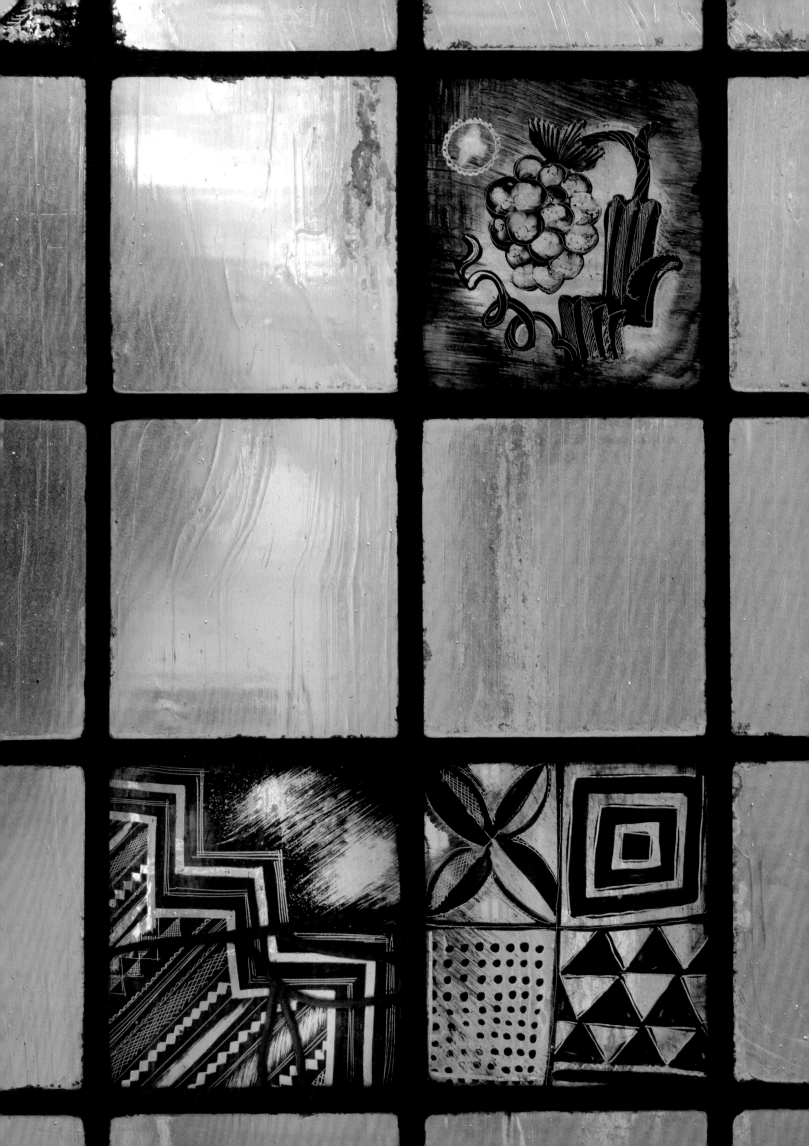

STUDIO 5

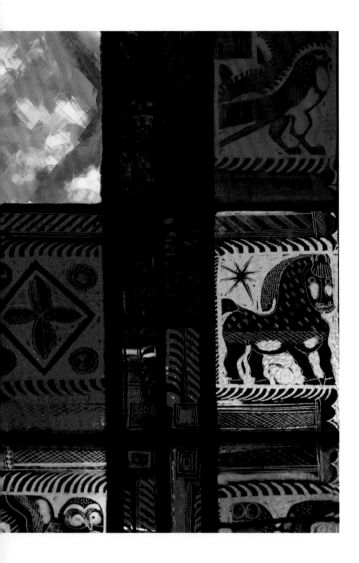

The Kogen-Miller and Carl Street studios attracted many prominent Chicago artists during the 1920s and '30s, including the painter and theater designer Boris Anisfeld and the muralists Edward Millman and John W. Norton. But Edgar Britton was the only tenant to have created for them a signed piece of art.

Britton and Edgar Miller had much in common: both worked in many mediums and both took a special interest in architectural art. The carved staircase they produced in Studio 5 is signed EDGARS MILLER AND BRITTON 1929. Filled with animals, it looks like Miller's style. But there is also a window in the studio that is reminiscent of Britton's work.

The two Edgars would go on to serve together in the Federal Art Project in Illinois during the Depression; Britton was the director of the mural division, and Miller worked in the sculpture division. Britton left Chicago permanently in 1941 after being diagnosed with tuberculosis and lived a long life in Colorado.

Miller produced a variety of stained glass in Studio 5. In a large casement window on the second floor, birds, flowers and abstractions are painted on red, blue, yellow and orange glass.

The large window in the living room is a mystery. While there are individual panels within the window that are by Miller, it is unlikely that the overall design was his. Instead, it was probably created more recently, using small samples of vintage Miller glass found elsewhere in the complex.

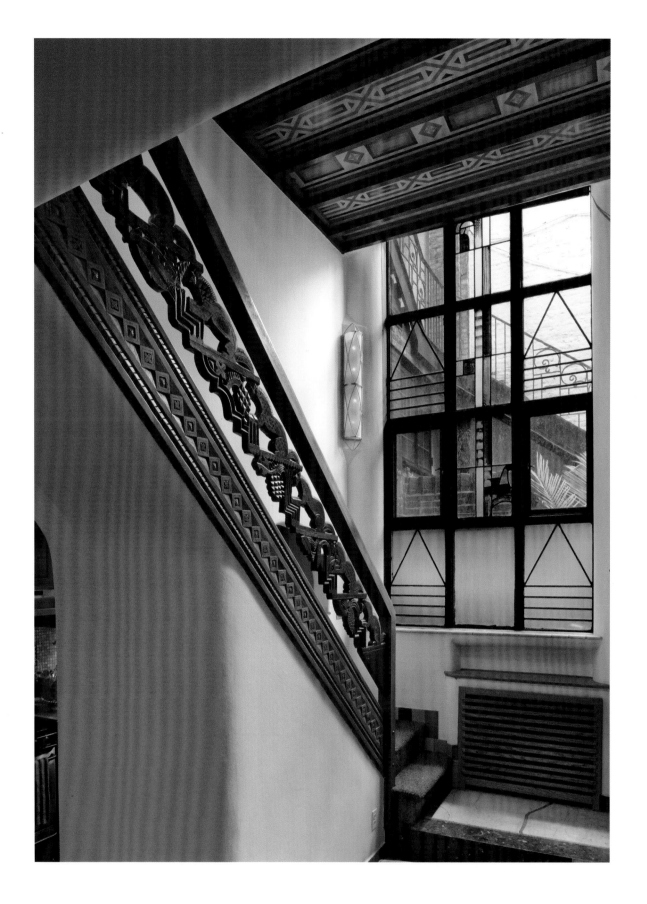

A STAIRWAY CARVED BY EDGAR BRITTON AND EDGAR MILLER LEADS TO THE SECOND FLOOR. THE CEIL-ING HAS BEEN REPAINTED, BUT THE DESIGN IS ORIGINAL.

FOLLOWING PAGES: THE BEDROOM LOFT.

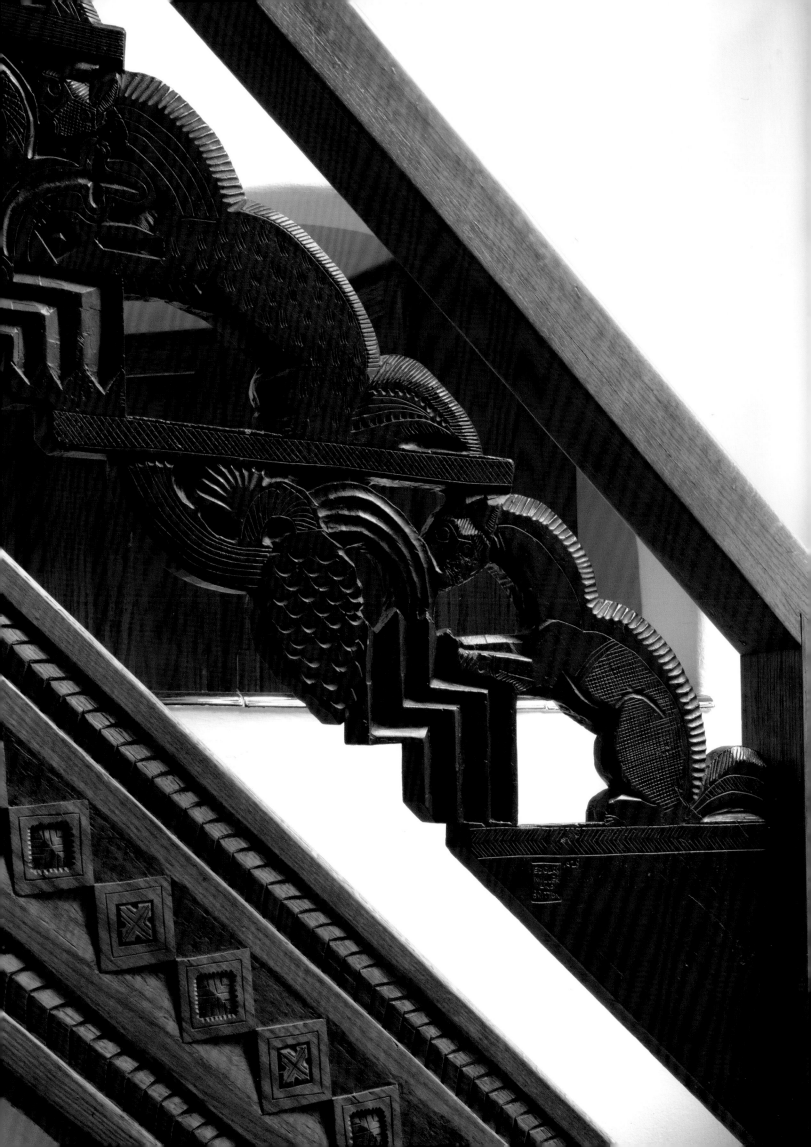

STUDIO 6

Edgar Miller learned and mastered many mediums while working on the Kogen-Miller Studios. But his distinct personal style is felt in all of his work. That's because he had a calligraphic approach and the ability to translate his fundamental drawing style to wood, glass, ceramics, lead—virtually any material.

This skill is evident in Studio 6. The light fixture that hangs from the living room ceiling—one of two surviving fixtures that Miller created during his studio years—features Edgar's favorite geometric abstractions painted on sheets of glass. When the fixture is on, Miller's bold designs are backlit by a warm glow, giving the feel of an illuminated woodblock print.

Miller's calligraphic approach is again on display in a row of carved balusters bordering the sleeping loft directly across from the fixture. Each section contains a single animal or natural abstraction. As he had for his fixture design, Miller looked to his drawings and woodblock prints for inspiration. This time, each line he carved represents a corresponding line he might have drawn or printed in his graphic work. He added a light stain to the wood to enhance the effect.

The perpetually restless Miller didn't stop his carving when he completed the fronts of his balusters. Look closely at the following pictures: Miller made his task more challenging by creating a completely different design on the backs, turning the shapes he created on one side into a new form on the other.

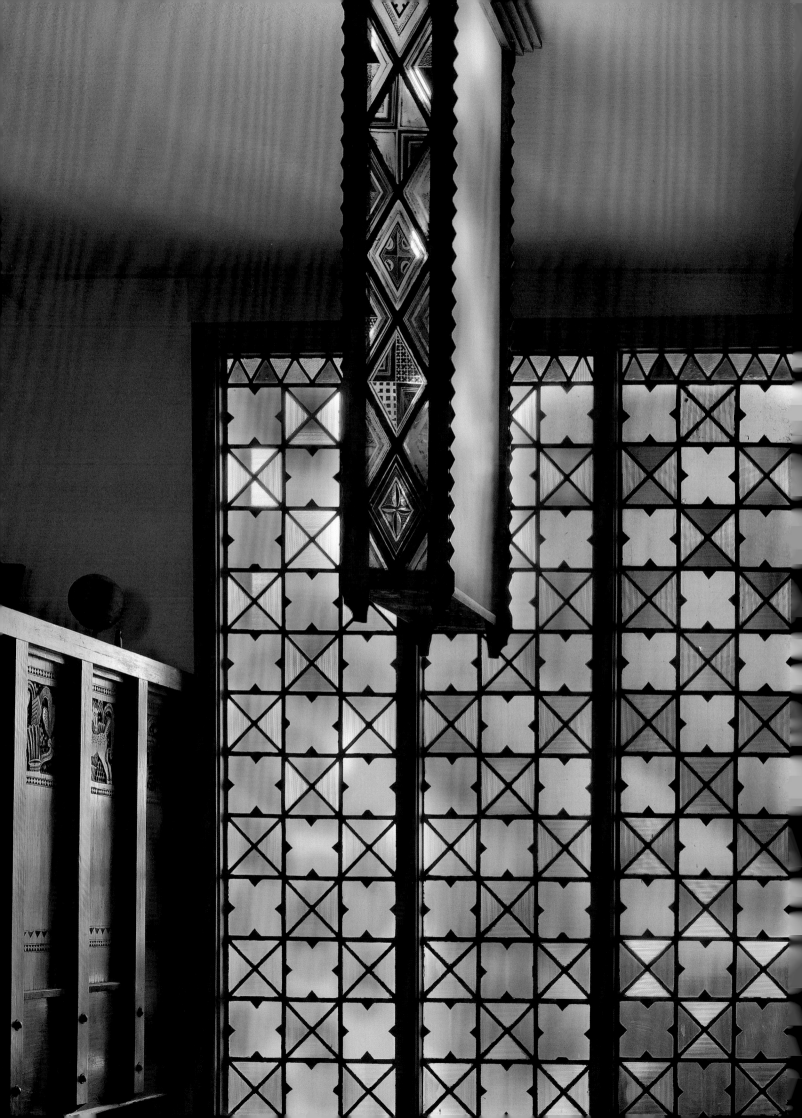

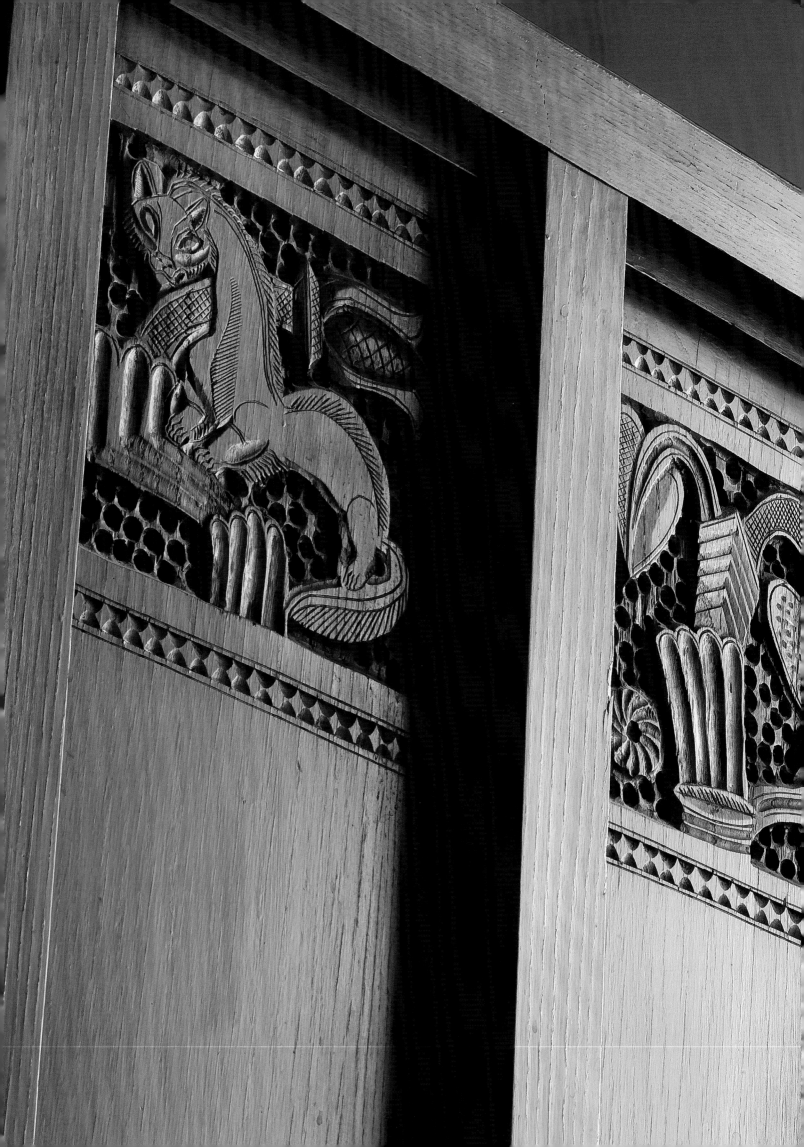

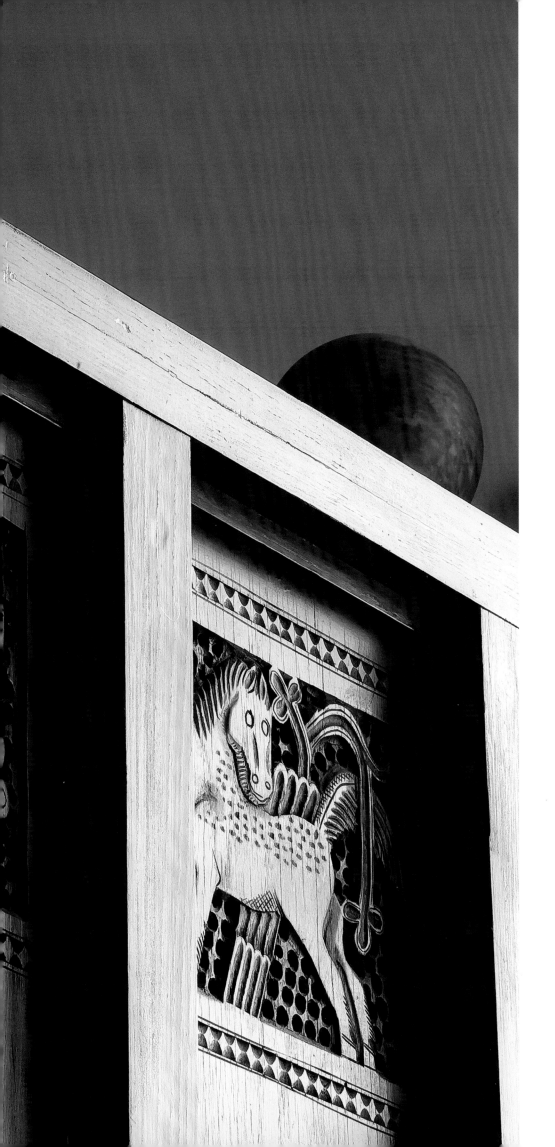

MILLER DISLIKED REPETI-
TION; IT WAS THE MARK
OF AN UNCREATIVE ARTIST.
SO HE CARVED UNIQUE
DESIGNS ON EITHER SIDE
OF THIS BALCONY RAIL-
ING. THE OPPOSITE SIDE
CAN BE SEEN ON THE
FOLLOWING PAGES.

STUDIO 7
NOW INCLUDING STUDIOS THREE AND FOUR

A HALF-TIMBERED BAY AND THE ENTRANCE TO THE STUDIO.

Studio 7 is filled with Edgar Miller's art, including carvings, paintings, furniture—even a ceramic dinosaur. It's also a veritable museum of his stained glass, with work from the 1920s to the 1980s.

Helping Edgar execute many of the studio's windows during the last decade of Miller's life, the stained-glass artist Larry Zgoda developed an insight into Edgar's work. Zgoda began corresponding with Miller during the early 1980s when Edgar was still in San Francisco, and he convinced Edgar to come to Chicago in 1984 to collaborate on a church window.

"Miller's earliest work looked very much like his drawings and woodcuts," Zgoda said. "He was impressed by the work of Charles J. Connick, who worked in a medieval style and greatly influenced Miller early in his career." Connick opened a studio in Boston in 1913 that created bold stained-glass windows for churches and libraries around the country.

Before long, Miller's work veered from the archaic to take on a bolder, modern look, as seen in the two-story cut-lead window spanning the main level of Studio 7. "The variety of geometric shapes and sizes reflect light from different directions during the day," said Zgoda.

When Miller was in his late eighties, Zgoda helped him fabricate windows on the top level. "Edgar drew inspiration from nature his entire life," Zgoda said, "and he loved everything about it. I remember how he would pick up a flower, or even a small sprig, and wear it on his lapel."

MILLER PAINTED A
PORTRAIT OF DEVI
DJA, A BALINESE
DANCER WHOSE TROUPE
PERFORMED IN CHICAGO,
IN 1945. HE ALSO
CARVED THE FRAME.
FRIENDS SAY HE WAS
SMITTEN BY THE DANCER,
WHO LIVED WITH THE
MILLERS FOR SEVERAL
YEARS. IN 1933, MILLER
WAS GIVEN AN AWARD
AS ONE OF THE NATION'S
BEST PORTRAITISTS. HE
SAID: "BEFORE MODERN
ART DECREED THAT
PORTRAIT PAINTING
WASN'T ART, THE MOST
PROFOUND STATEMENTS
IN ART WERE PORTRAITS."

STAIRS LEAD TO A SMALL SLEEPING LOFT, NOW USED AS A STUDY, OVER THE FOYER. MILLER CARVED AND PAINTED THE CEILING THAT FORMS THE BASE OF THE LOFT.

FOLLOWING PAGES: LOOKING UP AT THE CEILING. MILLER WOULD CARVE AND PAINT PIECES LIKE THIS IN HIS STUDIO AND INSTALL THEM LATER.

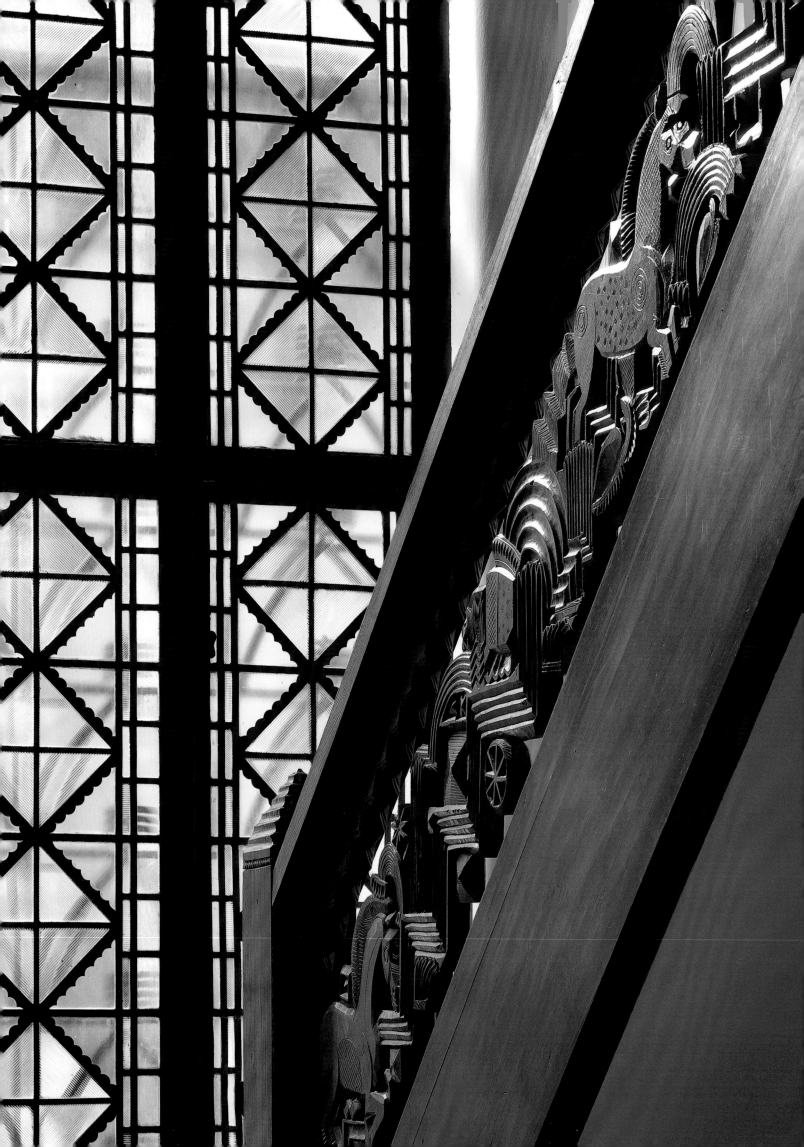

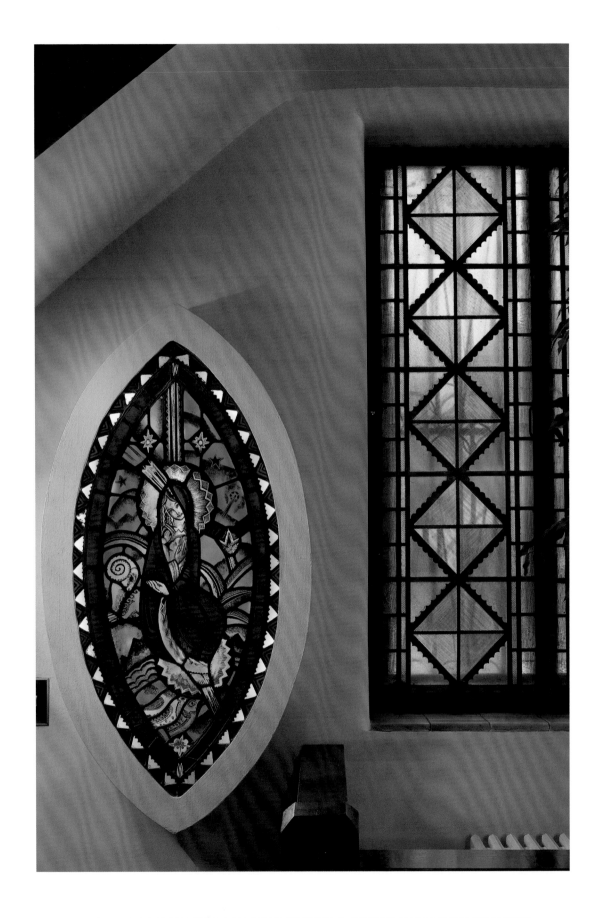

A LIGHT BOX BUILT BY MILLER'S SON DAVID FRAMES A STAINED-GLASS WINDOW OF THE MADONNA AND CHILD THAT MILLER MADE IN THE 1920S.

LEFT: A STAIRCASE CARVED BY MILLER AROUND 1930 LEADS TO THE GROUND LEVEL.

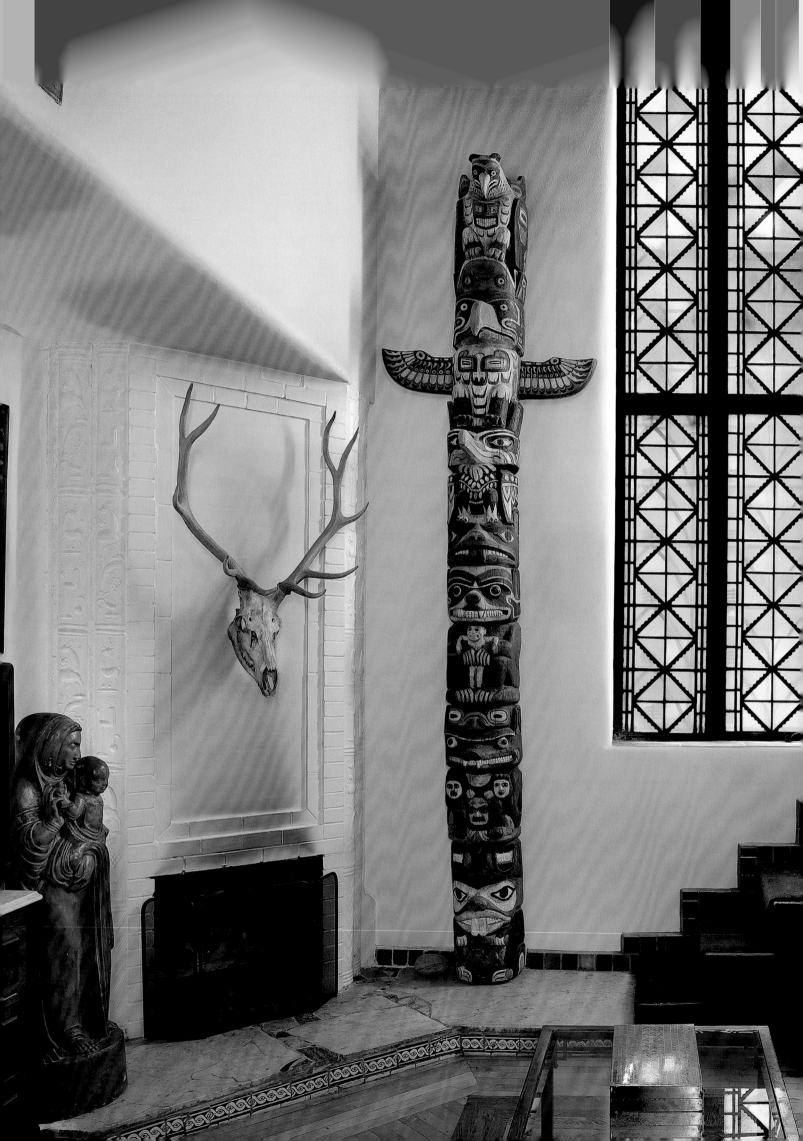

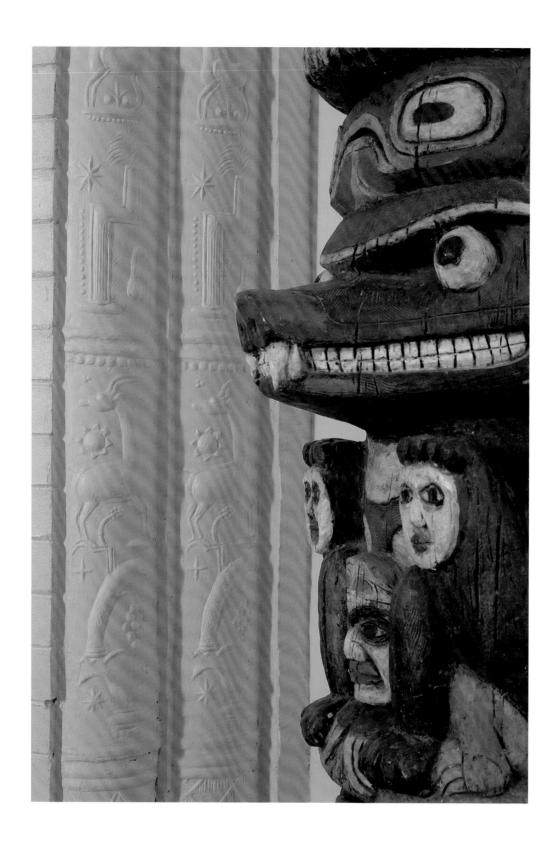

MILLER CREATED SEVERAL MASS-PRODUCED PIECES FOR JO MEAD DESIGNS. THIS TOTEM POLE, OF A REINFORCED COMPOSITION, WAS CAST FROM AN ORIGINAL MILLER CARVING.

LEFT: IN THE FOREGROUND IS A PLASTER CASTING OF A LIFE-SIZE MADONNA AND CHILD CREATED IN THE EARLY 1940S FOR THE MADONNA DELLA STRADA CHAPEL OVERLOOKING LAKE MICHIGAN. THE STATUE WAS NEVER CAST IN METAL DUE TO WAR RESTRICTIONS.

FOLLOWING PAGES: MILLER CARVED THIS STAIRCASE WITH HIS BROTHER FRANK IN 1987. HE CREATED THE STAINED GLASS IN THE 1920S.

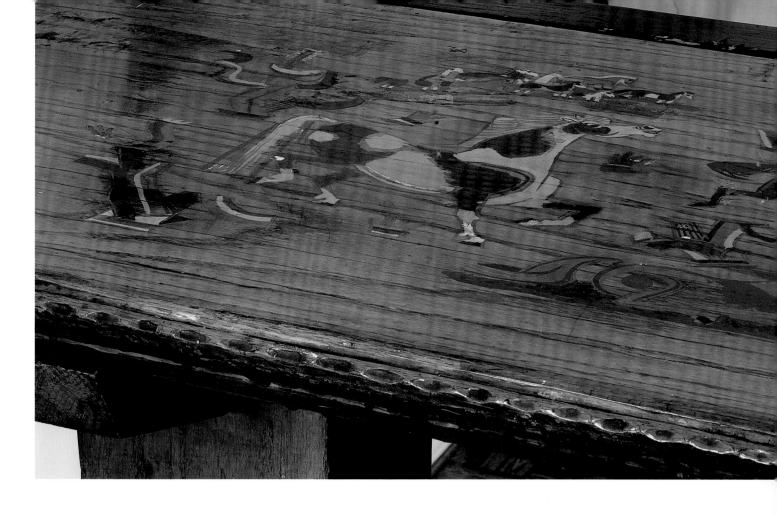

A DESK CARVED AND PAINTED BY MILLER IN THE 1940S.

LEFT AND RIGHT: MILLER RETURNED TO THE STUDIO IN THE 1980S TO CREATE THESE CARVED, PAINTED AND GILDED DOORS. MILLER RELISHED THE OPPORTUNITY TO WORK AGAIN. BOB HORN, WHO WITNESSED MILLER AT WORK ON HIS LATE-1980S DOORS, DESCRIBED THE NEARLY NINETY-YEAR-OLD ARTIST AS A MAN POSSESSED: "HE STARTED AND JUST KEPT GOING. A PAINTER WORKS A LITTLE BIT, GOES BACK TO HIS STOOL, LOOKS AT HIS PAINTING FOR A WHILE AND JUST STARES. EDGAR KNEW HOW HIS WORK WAS GOING TO COME OUT. HE WAS SO FOCUSED HE DIDN'T WANT TO TAKE BREAKS."

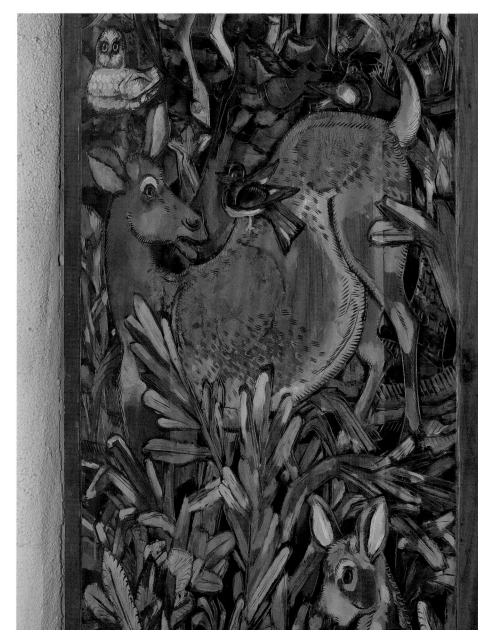

189

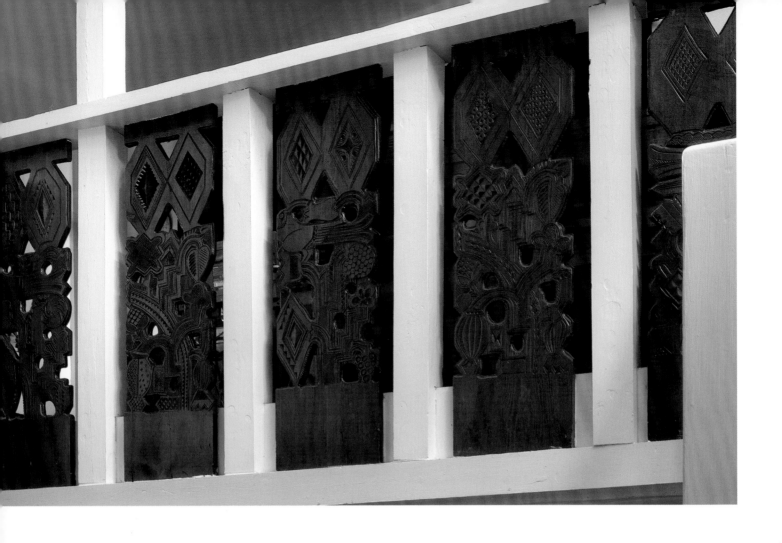

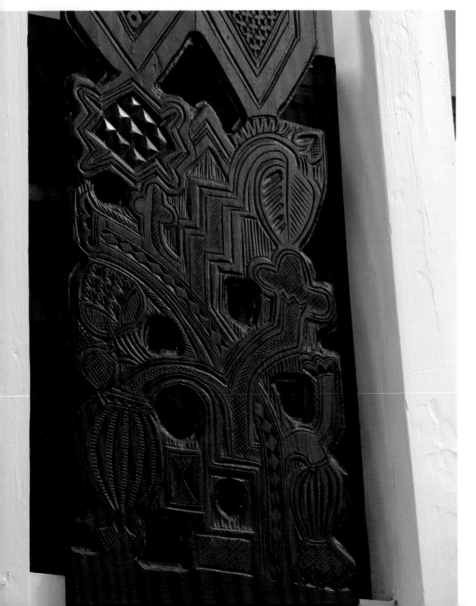

MILLER CARVED UNIQUE DESIGNS ON BOTH SIDES OF THESE BALUSTRADES IN THE 1930S.

RIGHT: A PLATE RAIL CARVED BY FRANK MILLER IN THE 1980S HOLDS PHOTOGRAPHS OF BRONZE STATUES THAT EDGAR COMPLETED FOR ST. MARY'S CEMETERY IN SUBURBAN EVERGREEN PARK. FRANK WAS A TALENTED CARVER IN HIS OWN RIGHT, BUT ASSISTING HIS BROTHER ALWAYS REMAINED HIS PRIORITY. FRANK STRETCHED EDGAR'S CANVASES, HAULED HIS MATERIALS AND DID MUCH OF HIS ROUGH CARVING. "THIS ARRANGEMENT WAS BOTH SUCCESSFUL AND PLEASANT," FRANK WROTE. "IDEAL FOR EDGAR, WHO WAS RELIEVED OF THE TEDIOUS, UNPLEASANT, HEAVY AND THE TIME CONSUMING PART OF THE WORK."

MILLER'S CERAMIC WORK
INCLUDES A TEA SET AND
DINNER PLATES. AS USUAL,
ANIMALS WERE HIS MAIN
SUBJECT.

WINDOWS WITH STAINED GLASS MADE BY MILLER AND LARRY ZGODA IN THE 1980S. THROUGHOUT HIS CAREER, MILLER WOULD PAINT PANELS HIMSELF AND THEN WORK WITH AN ASSISTANT TO FABRICATE AND INSTALL THE WINDOWS. THE ABOVE WINDOW WAS SIGNED TO JANNINE ALDINGER, WHO HELPED BRING MILLER BACK TO CHICAGO IN THE 1980S.

CARL STREET STUDIOS

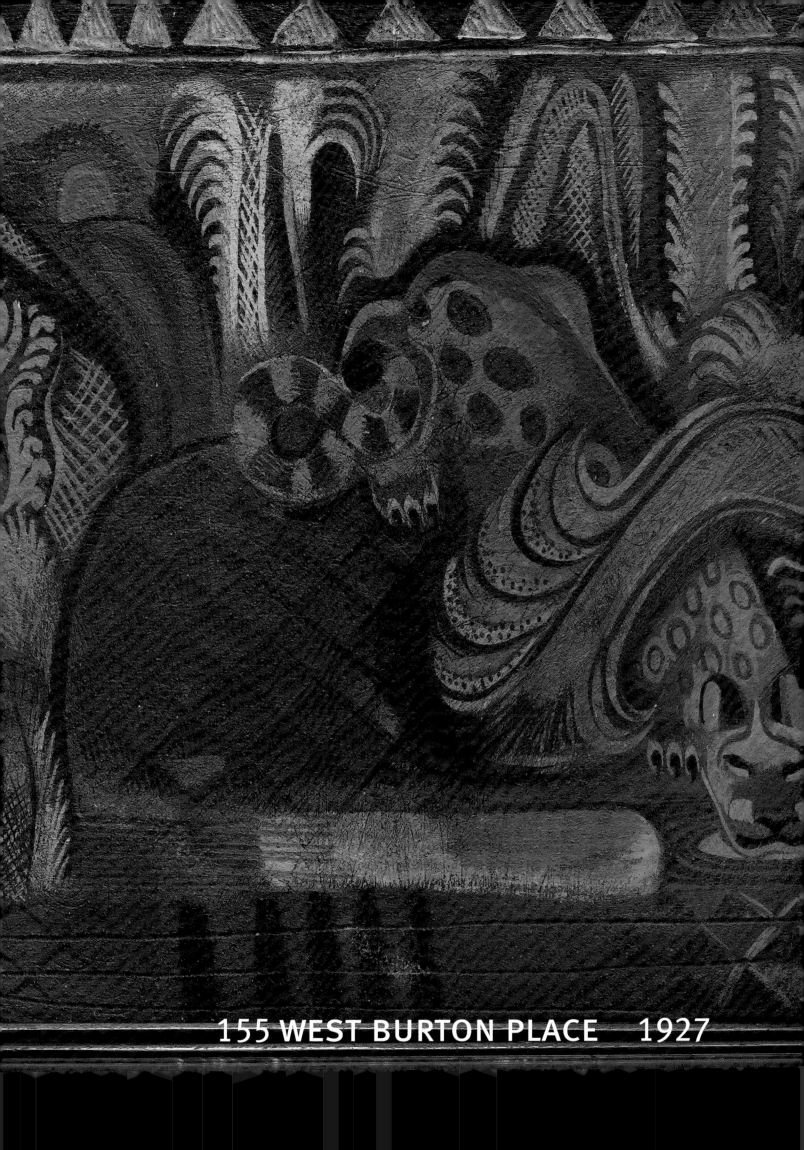

155 WEST BURTON PLACE 1927

When asked what he designed at the Carl Street Studios, Edgar Miller's answer was simple: "The whole thing." But he later added: "The only things I didn't do took place after I left there."

While it was clearly Sol Kogen's concept to create the studios, it was Miller's artistic vision that drove the project from the beginning. Without Kogen, the Carl Street Studios would not have been built. Without Miller, the Carl Street Studios would not have been so special. Their collaboration was instrumental in the creation of both the Kogen-Miller and Carl Street studios.

The pair replaced much of the existing 1874 structure on Carl Street. New walls built on the exterior swallowed a lot of the original facade, and new staircases and entrances were created that allowed for the removal of the old ones. Artifacts do remain from the old structures, offering tantalizing clues to the buildings' transformation over the years.

Seeing the old Victorian house, coach house and stable on Carl Street for the first time in 1927, Miller told Kogen he wanted to create dramatic vertical studios. That is exactly what he did. Miller and Kogen gutted the main house, turning it into six studios, each with two-story living spaces that led off to kitchens, bedrooms and bathrooms. Three additional studios were soon created in new construction.

The collaboration lasted through 1935. After Miller left Kogen, seven new studios were built. Jesus Torres, Miller's assistant, became the primary artist, and Kogen directed the building design himself. The post-Miller work took on a markedly different look, with Kogen creating even more drama with his designs.

Returning to the Carl Street Studios years later, a cantankerous Miller was not impressed by the work done in his absence, saying, "Sol had a tendency to do too much. He didn't know when to stop."

TILE WORK FILLS BOTH COURTYARDS AND SPILLS ONTO THE SIDEWALK ALONG 155 WEST CARL STREET (NOW BURTON PLACE). SOME OF MILLER'S ORIGINAL DESIGNS HAVE BEEN ALTERED DUE TO TILE DAMAGE AND DETERIORATION.

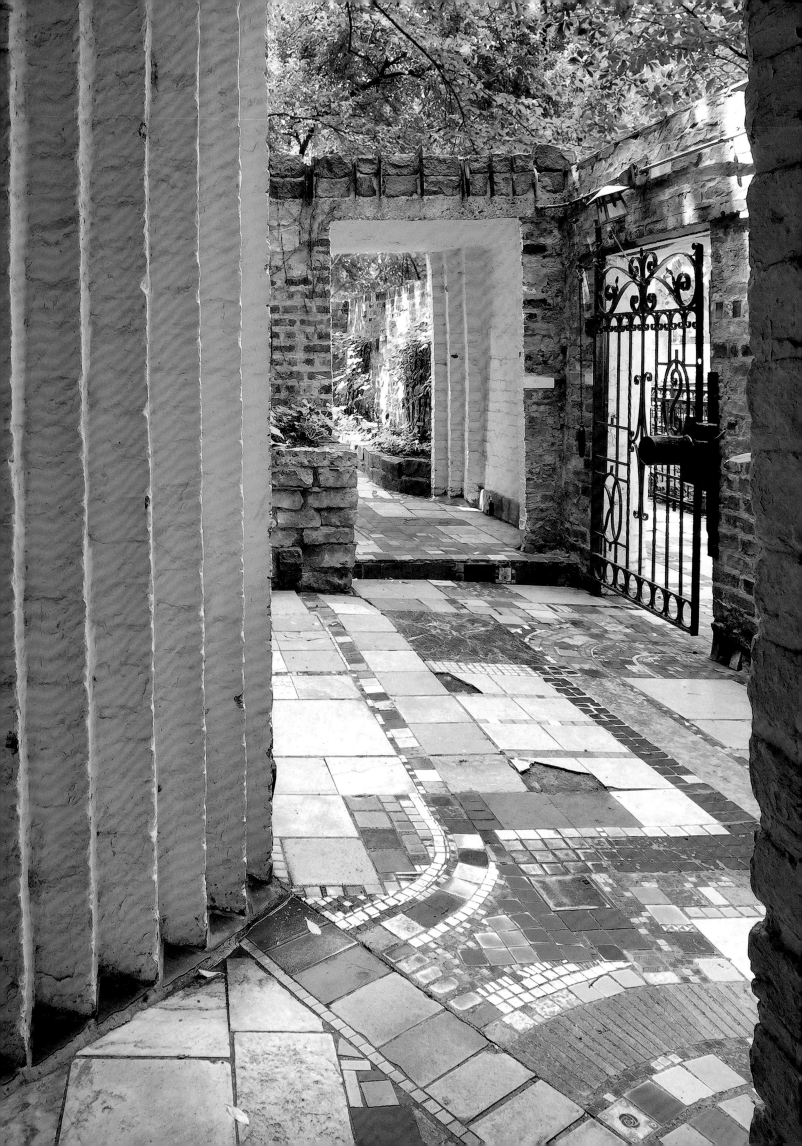

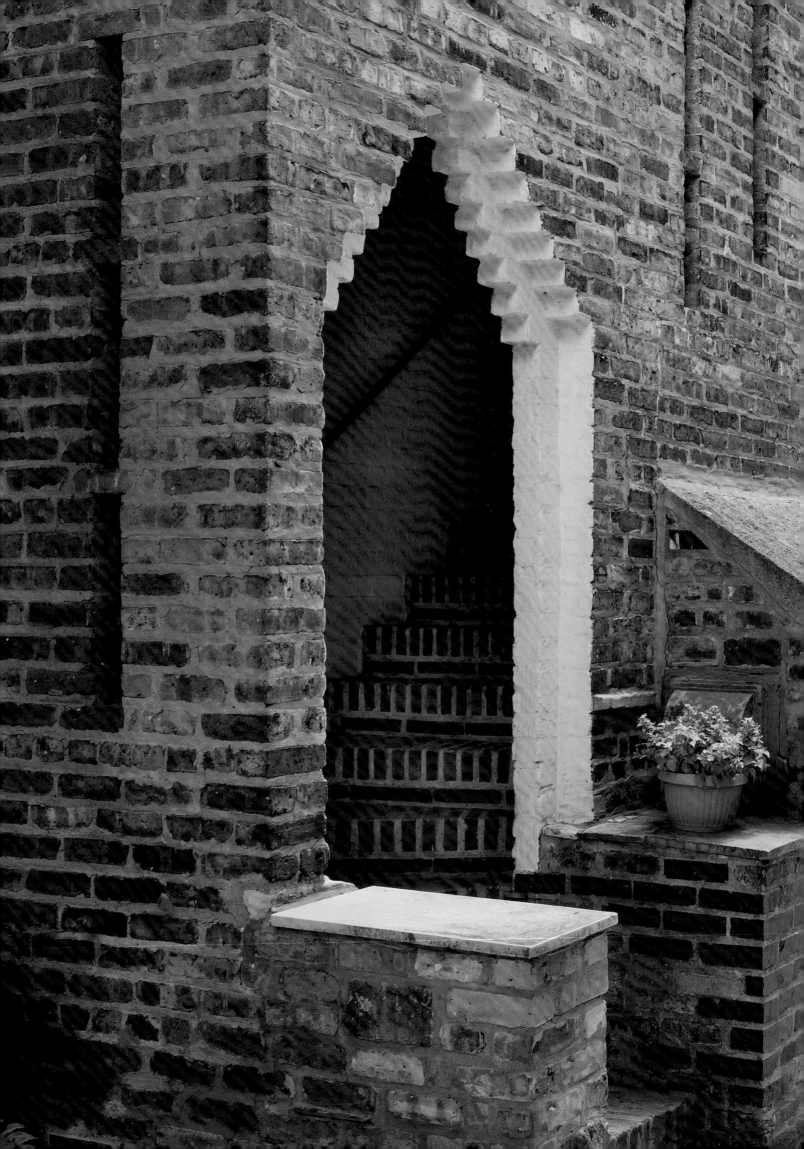

THE ORIGINAL VICTO-
RIAN HOME JOINS THE
EXPANDED ORIGINAL
COACH HOUSE IN THE
WEST COURTYARD. NEW
WALLS WERE BUILT,
AND NEW STAIRCASES
AND ENTRANCES WERE
ADDED.

A BAY FROM THE ORIGI-
NAL HOUSE IN THE EAST
COURTYARD. THE BAY
AND SURROUNDING
WALL ARE SOME OF THE
FEW EXTERIOR FEATURES
THAT WERE KEPT FROM
THE VICTORIAN HOME.
NEW WINDOW OPEN-
INGS WERE PUNCHED
THROUGH THE WALL
TO ACCOMMODATE
MILLER'S SIGNATURE
TWO-STORY WINDOWS.

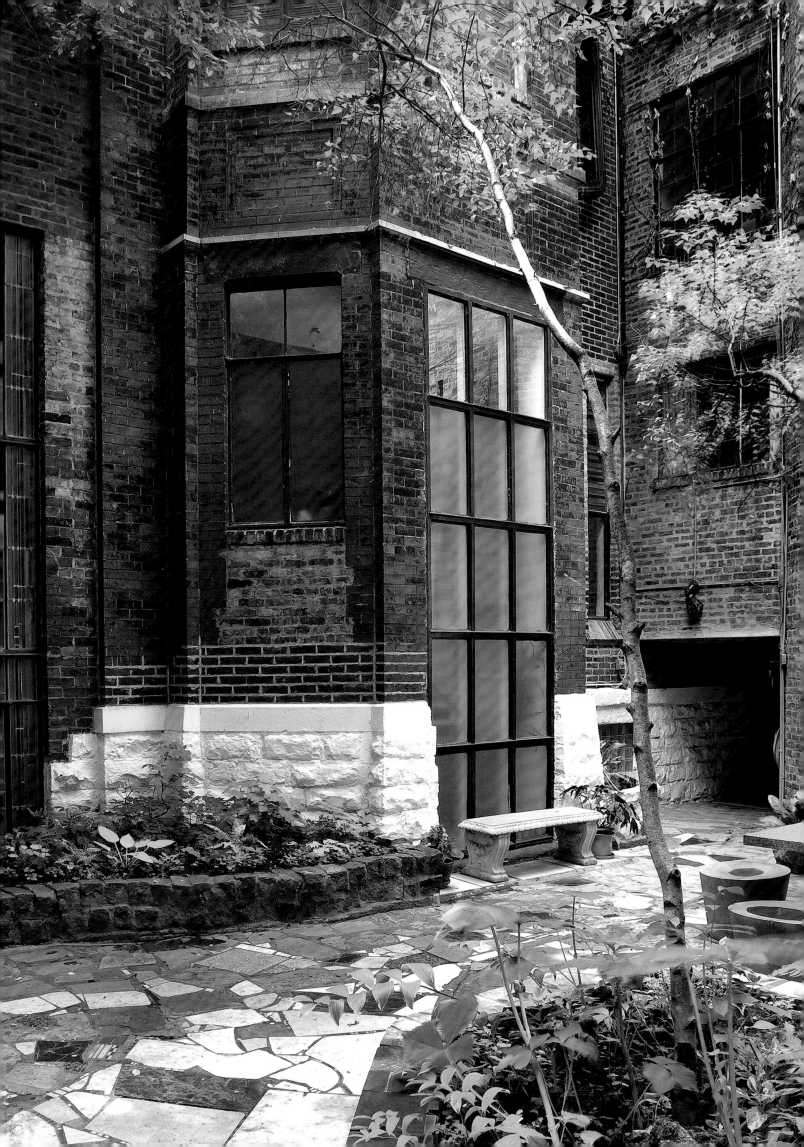

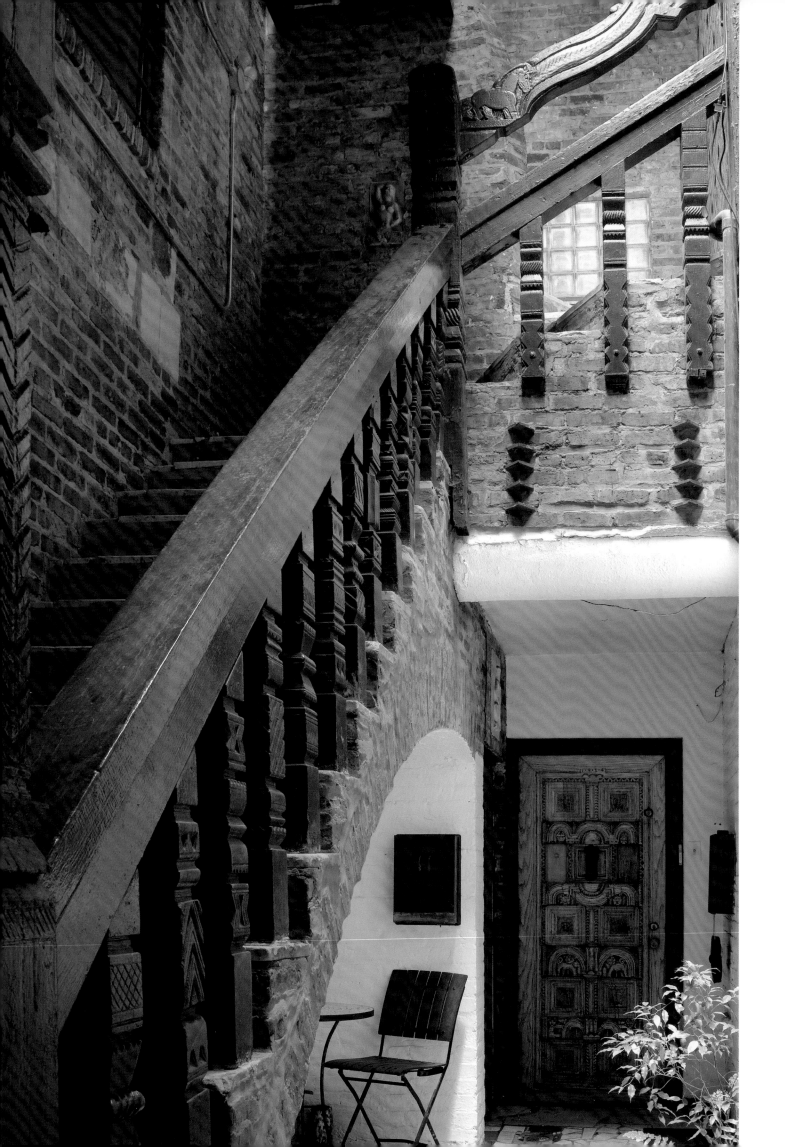

ONE OF MILLER'S INNOVATIONS WAS
TO MOVE STAIRCASES OUTSIDE,
FREEING UP SPACE AND CREATING
MANY NOOKS AND ALCOVES. THE
CRUDE MOSAIC UNDERNEATH THE
STAIRCASE AT RIGHT IS MILLER'S
FIRST, AND HE WAS SURPRISED TO
SEE IT INSTALLED IN THE COURT-
YARD. "I DIDN'T KNOW WHAT I WAS
DOING," HE LATER SAID.

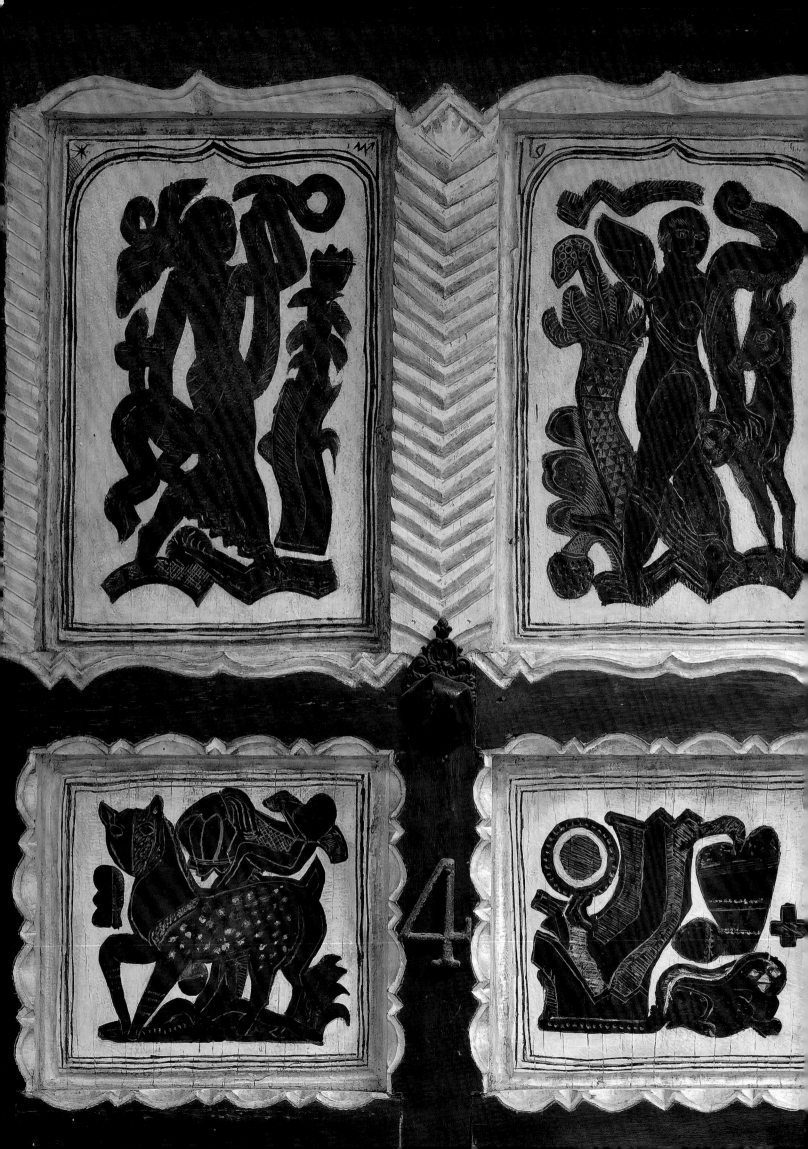

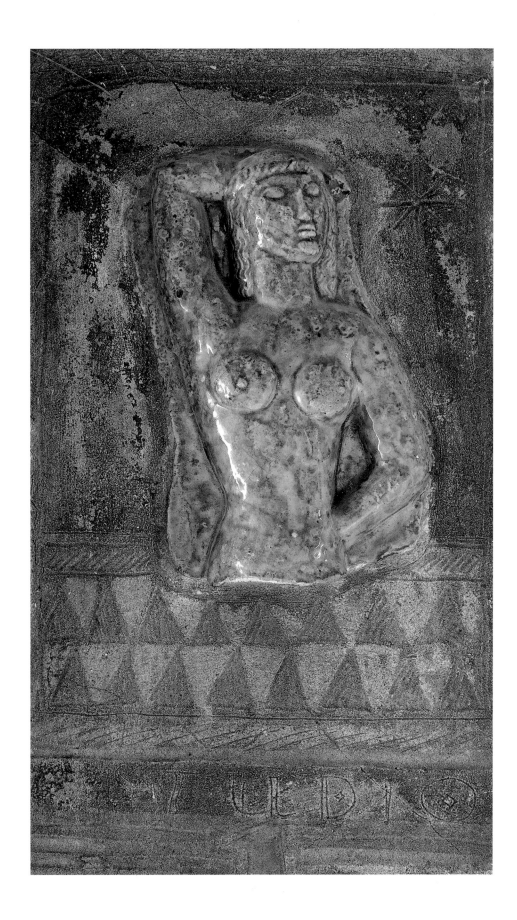

THE CARL STREET COURTYARDS ARE FILLED WITH ART, INCLUDING CARVED DOORS, FRESCOES, STAINED GLASS, MOSAICS AND CERAMICS. MILLER BELIEVED ART SHOULD BE PLACED WHERE PEOPLE WOULD ENJOY IT MOST—IN THEIR HOMES.

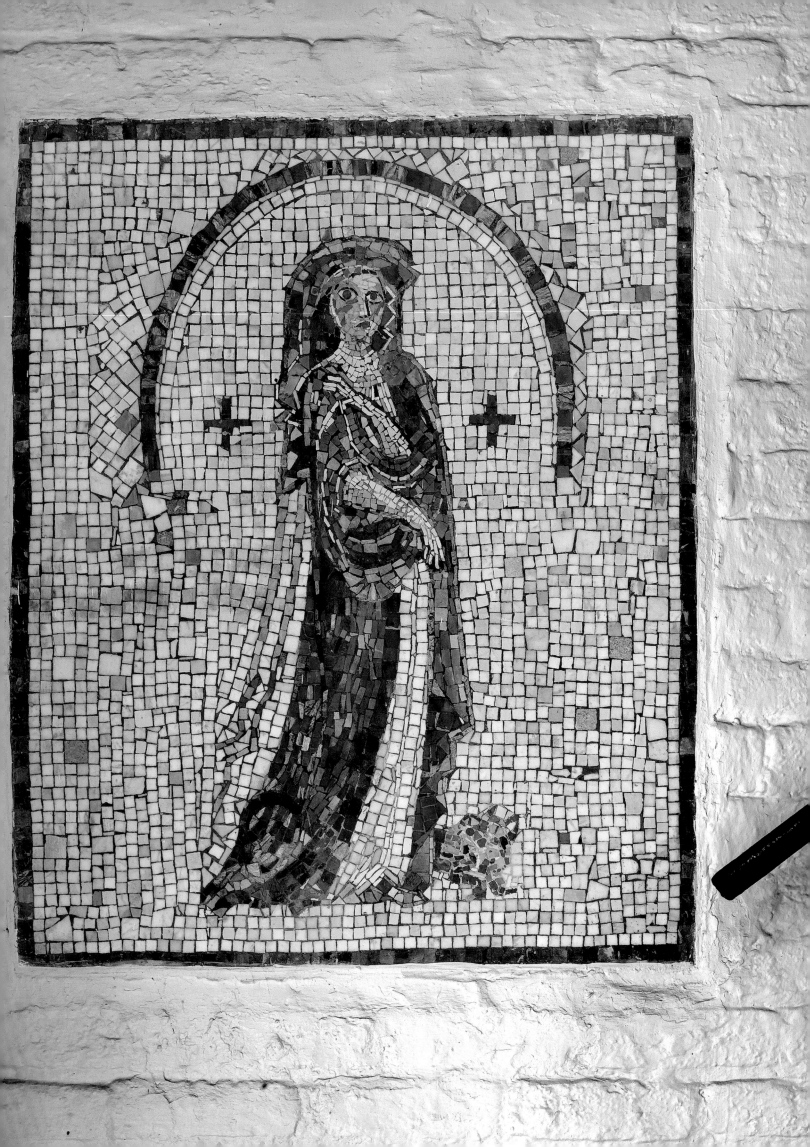

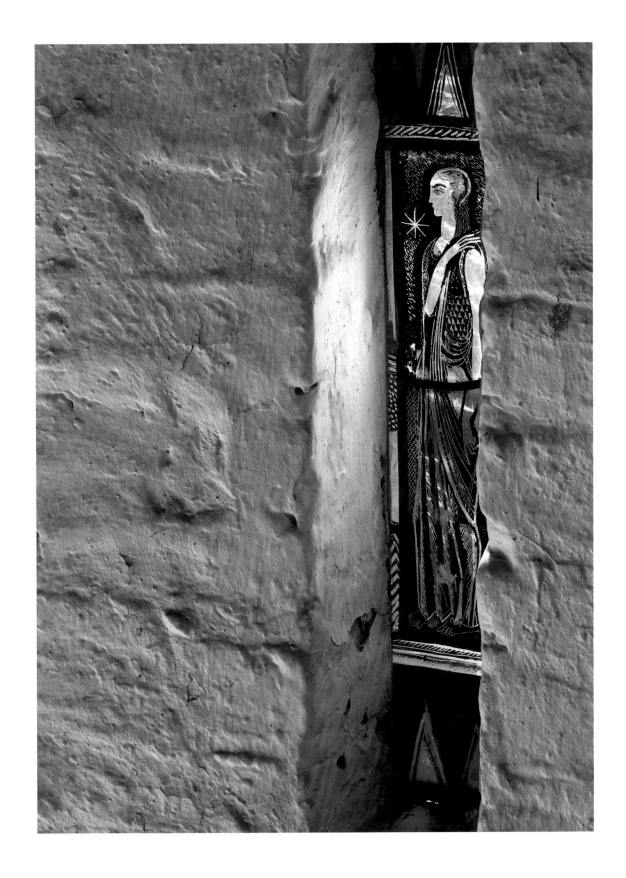

MILLER'S FASCINATION WITH ANCIENT HISTORY IS EVIDENT IN THIS TILE MOSAIC AND STAINED-GLASS WINDOW IN THE COURTYARD. THE MOSAIC IS EDGAR'S SECOND. HE CREATED A SIMILAR BUT MORE REFINED VERSION IN THE R. W. GLASNER STUDIO ON WELLS STREET.

FOLLOWING PAGES: TENS OF THOUSANDS OF CERAMIC TILES, INCLUDING RARE GRUEBY AND BATCHELDER TILES, WERE STORED IN THE BASEMENT OF THE CARL STREET STUDIOS FOR DECADES.

THE VIEW FROM THE
WOODEN DECKS
THAT WERE LATER
ADDED ON THE
ROOFTOP. THESE
STUDIOS WERE
COMPLETED BY SOL
KOGEN AND JESUS
TORRES AFTER
MILLER LEFT THE
PROJECT.

SOL KOGEN STUDIO

A 1928 BIRTHDAY GIFT FROM MILLER
TO SOL KOGEN, AND A STAIRCASE
DESIGNED BY JESUS TORRES.

FOLLOWING PAGES: THE LIVING AND
DINING ROOMS.

The largest of the Carl Street units, the Sol Kogen Studio is filled with four thousand square feet of Edgar Miller's work created over fifty years and demonstrating the full range of his talents. But the apartment, also known as Studio 2, holds the best examples of the work of another artist, too: Jesus Torres, Miller's assistant and successor at Carl Street.

Born a year earlier than Miller, Torres and his wife left Mexico in 1924. After working road construction in Texas and picking beets in Minnesota, Torres came to Chicago and began taking art classes at Hull House. Under the guidance of Morris Topchevsky, a leading Chicago modernist painter, Torres quickly excelled at pottery, woodcarving and metalwork. It's likely that Miller, who also participated in many Hull House activities, met Torres during this period.

Described by his niece as "patient, quiet, introspective and humble about his work," Torres worked under Miller at Carl Street, but he slowly developed a following of his own and eventually opened a studio on Chicago Avenue and exhibited work at the Art Institute. His patrons included Dave Garroway, a Carl Street resident who would go on to become the first host of NBC's Today show, and Frank Logan, whose Logan Medal was one of Chicago's most prestigious art awards.

After Miller and Kogen parted ways, Torres worked with Kogen as the lead craftsman on several other rehabbed buildings in Old Town. Torres died in 1948, and Kogen died in 1957.

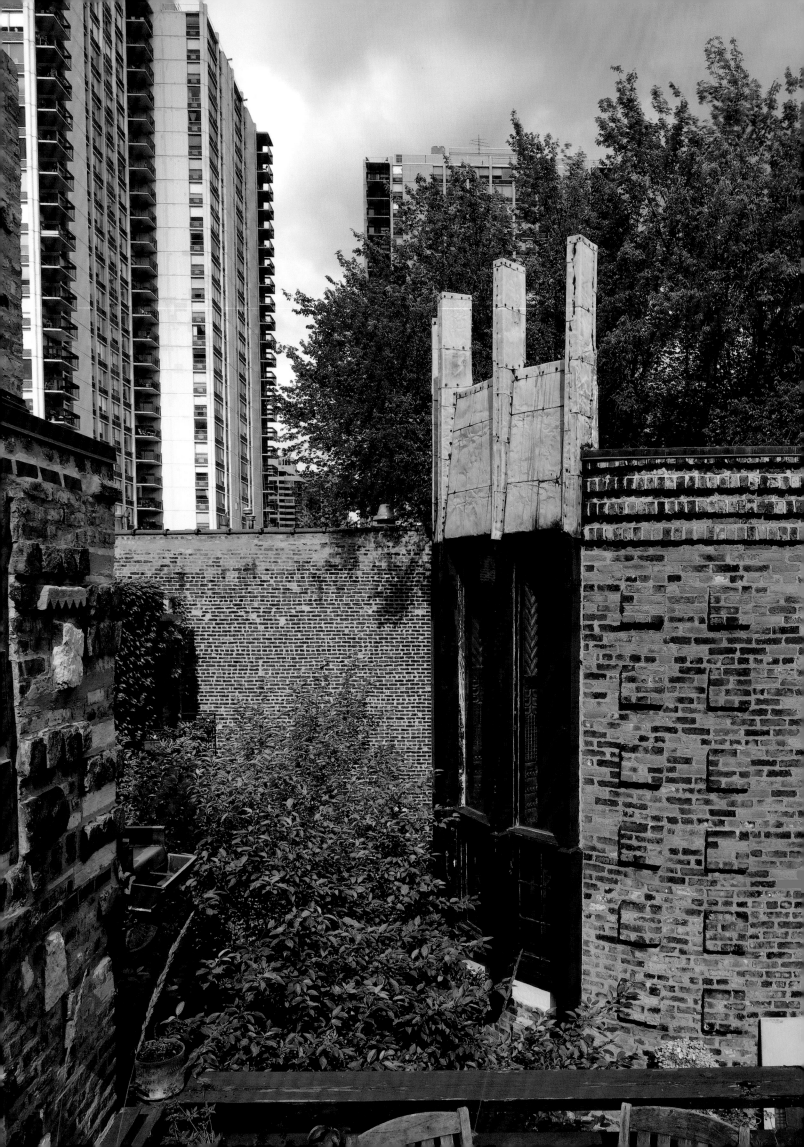

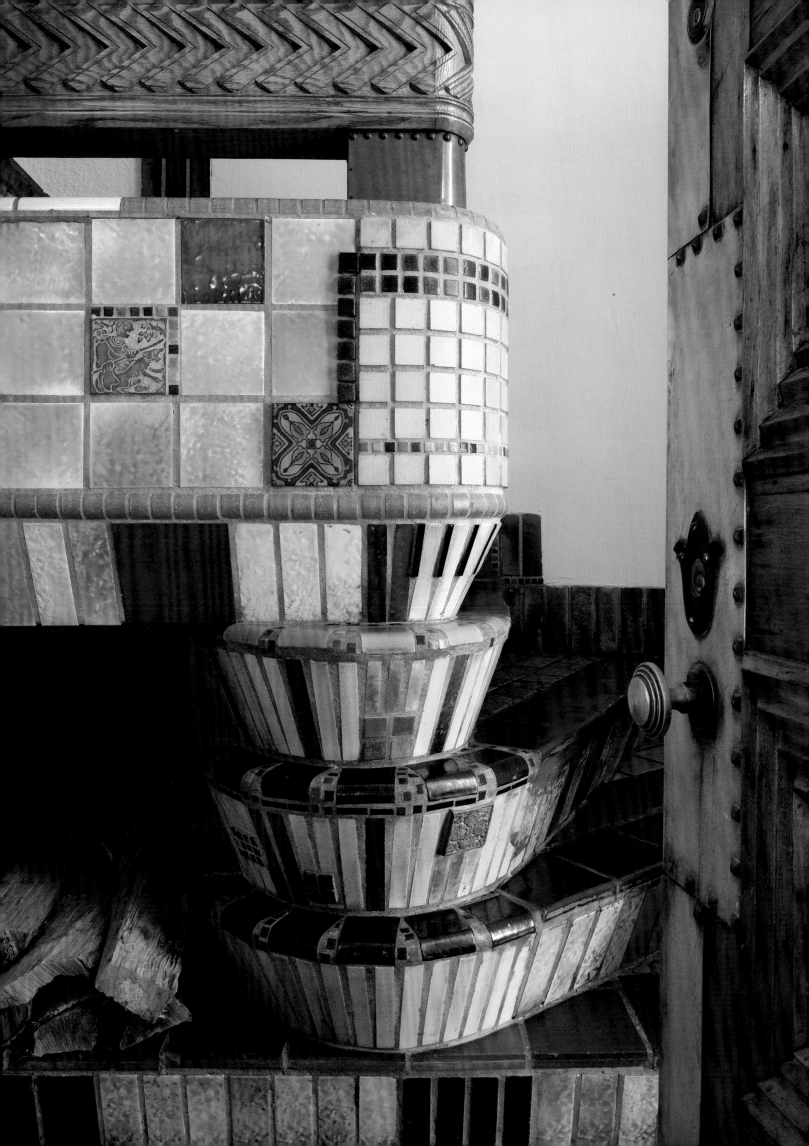

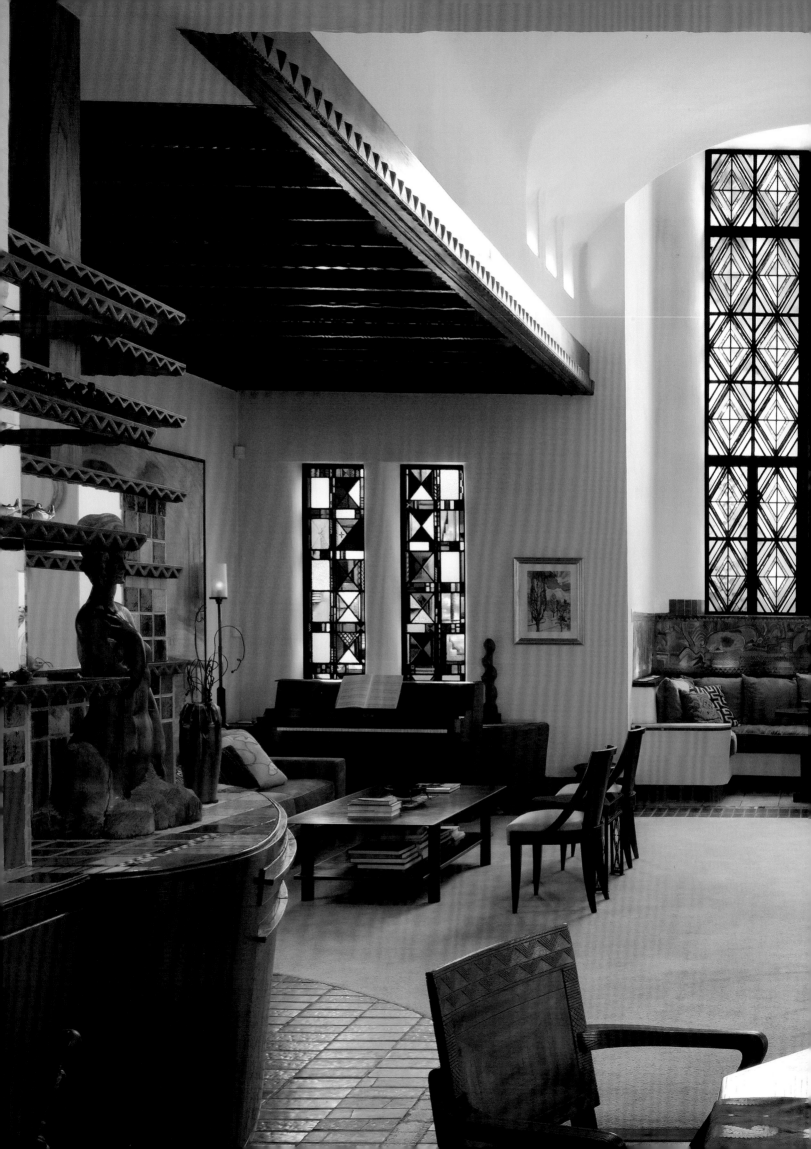

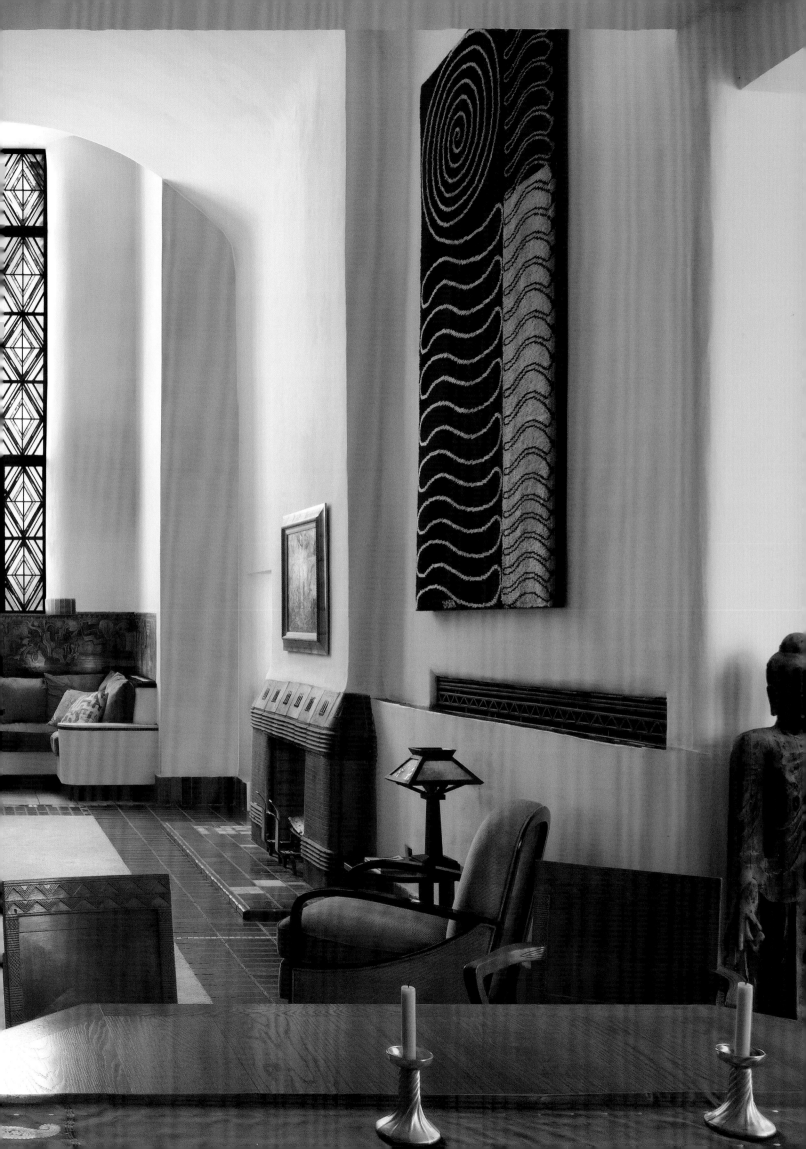

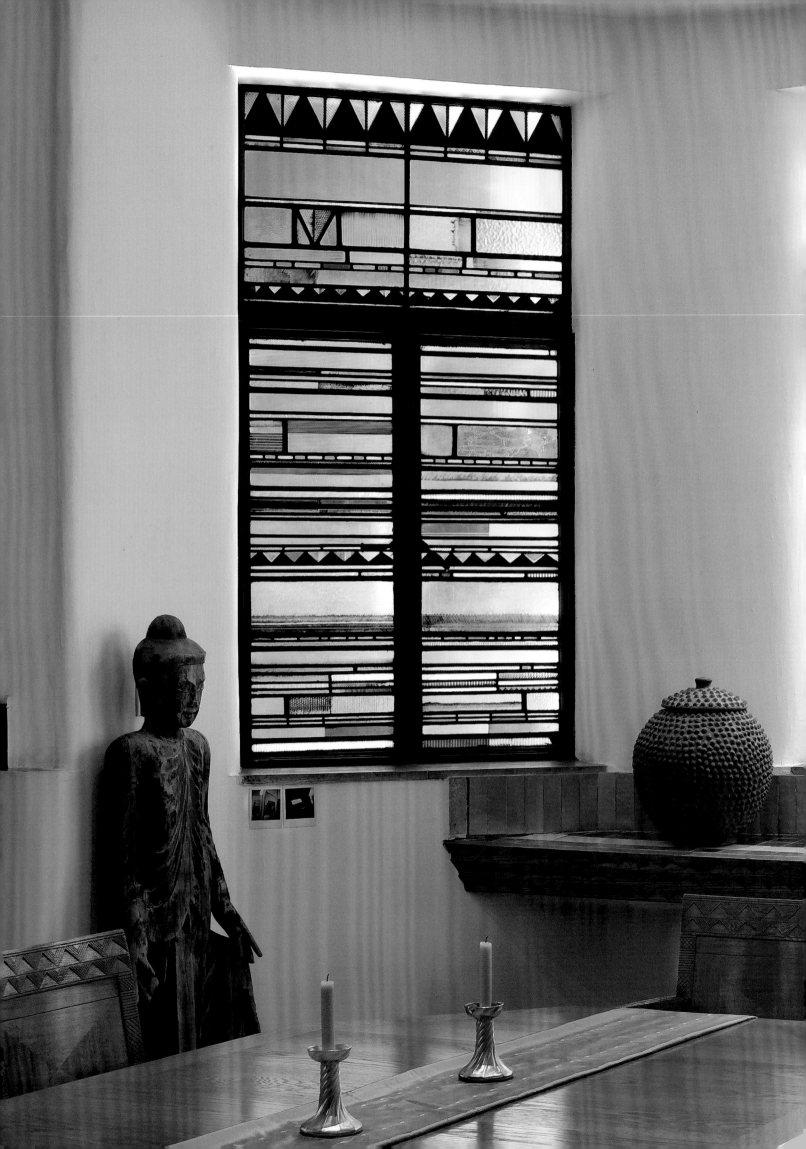

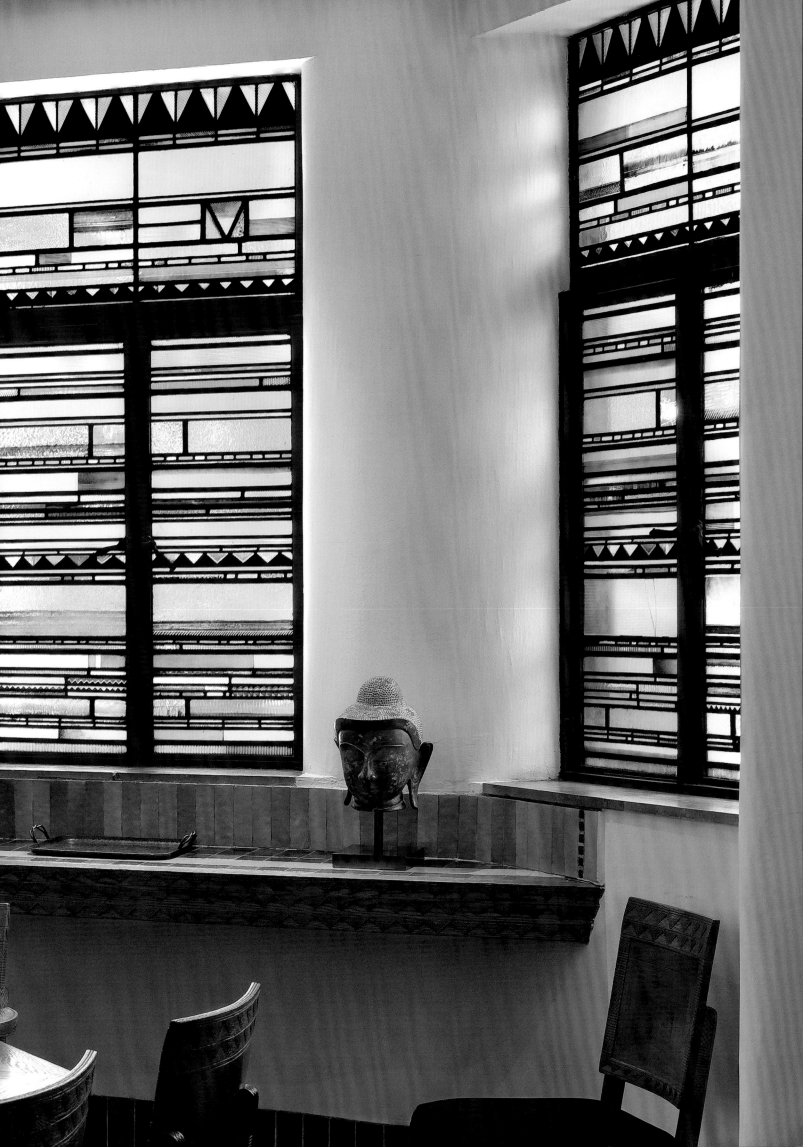

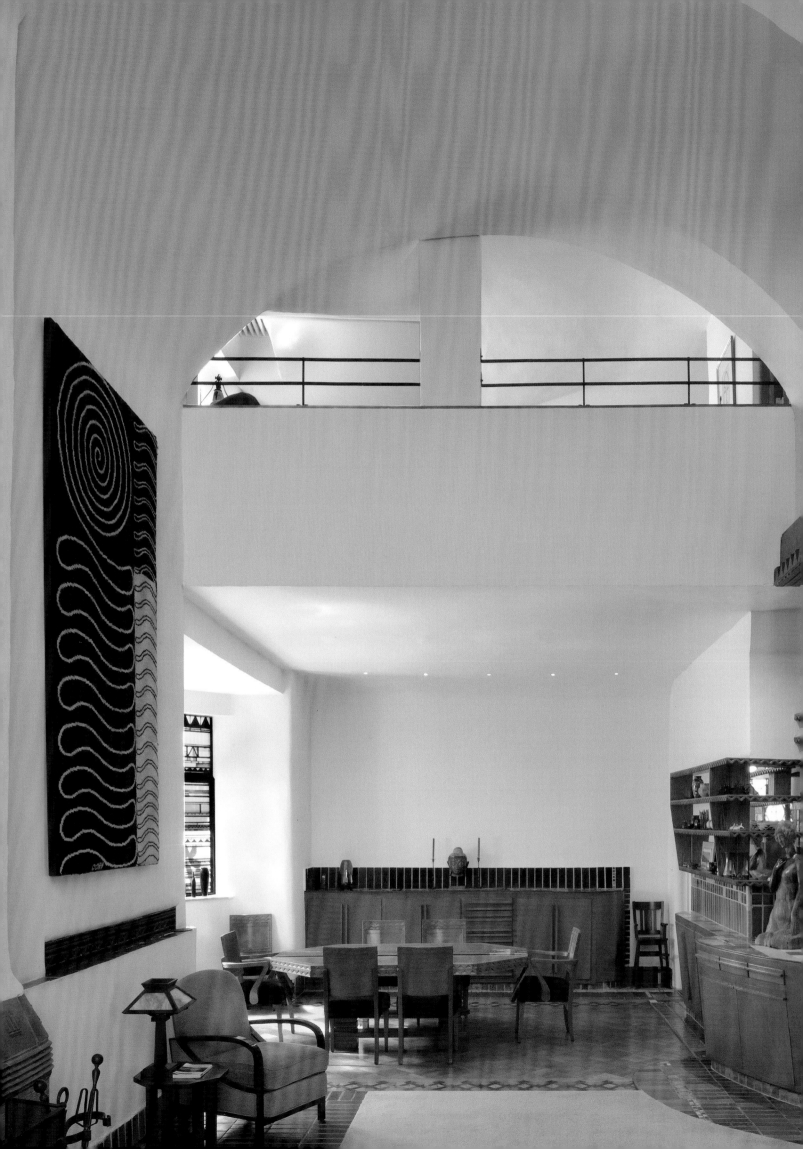

THE DINING ROOM IN THE SOL
KOGEN STUDIO USES THE SAME
SPACE AS THE ORIGINAL VICTORIAN
ROOM. JESUS TORRES ADDED THE
SIDEBOARD AND SURROUNDING
TILE WORK IN THE 1940S. THE
PARQUET FLOOR, A REMNANT FROM
THE 1880S, CONTRASTS WITH
TORRES'S FLAMBOYANT ART DECO
TILE WORK.

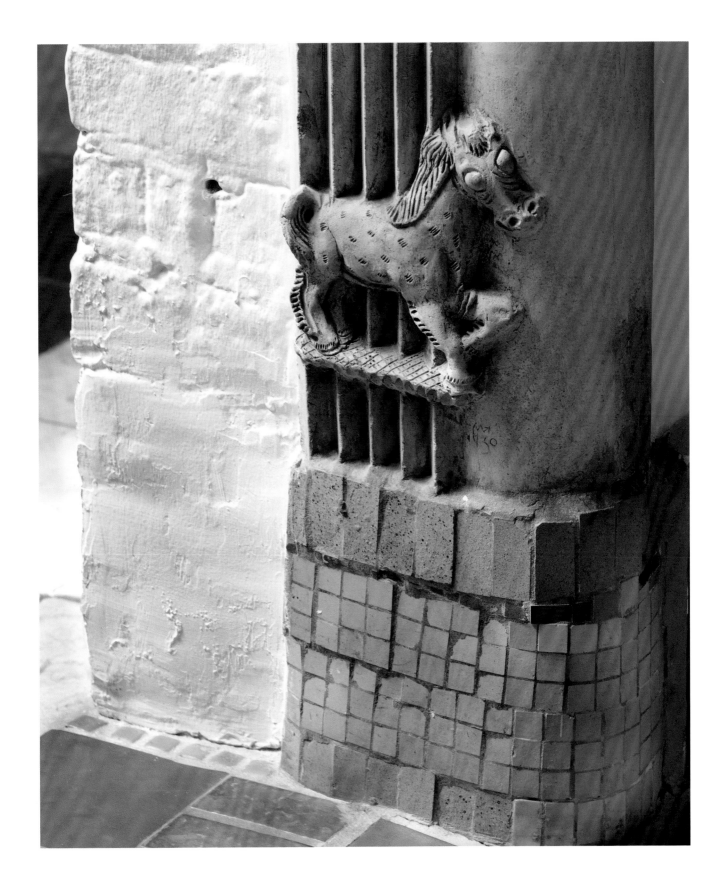

MILLER ADDED SMALL TERRA-COTTA ANIMALS TO THE BASE OF THE LIVING ROOM ARCHWAY IN 1930. HE ALSO CARVED AND PAINTED THE LIVING ROOM CEILING.

FOLLOWING PAGES: TERRA-COTTA BIRDS PEEK THROUGH THE LIVING ROOM ARCH. MILLER MADE EACH ONE UNIQUE.

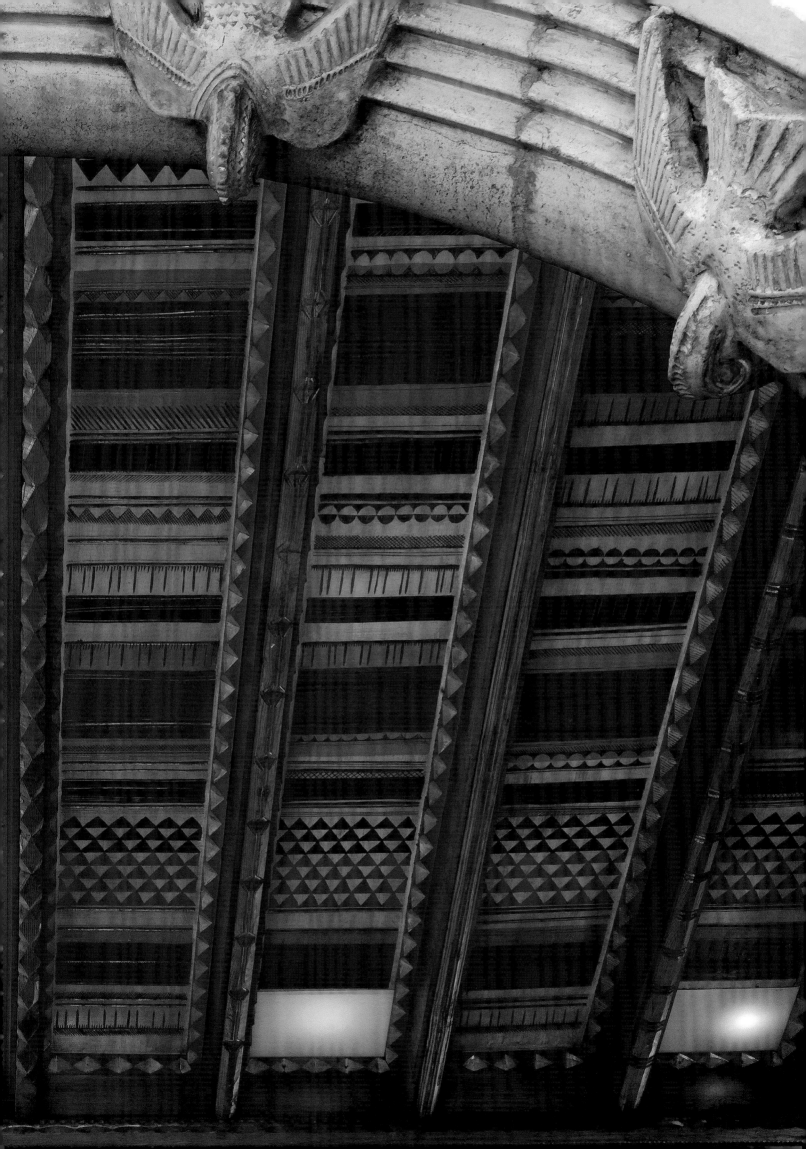

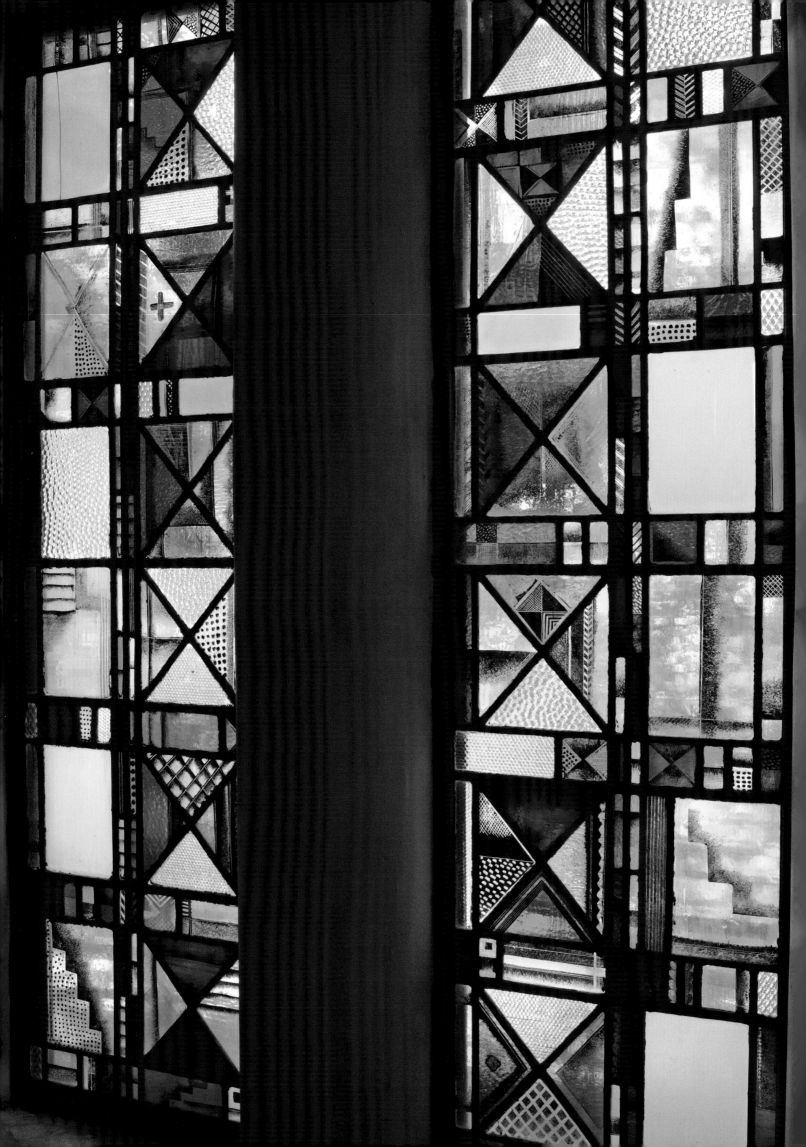

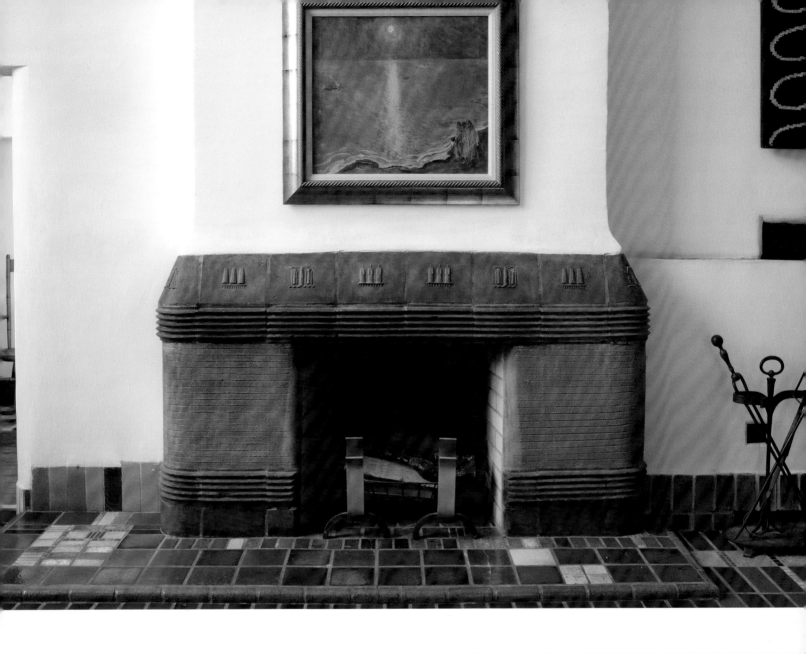

THE FIREPLACE DATES TO THE 1930S, BUT MILLER DID NOT HAVE A HAND IN DESIGNING IT. A PAINTING BY BORIS ANISFELD, WHO LIVED IN THE STUDIOS FOR FOUR DECADES AND SOMETIMES PAID HIS RENT WITH ART, HANGS ABOVE.

LEFT: MILLER'S BIRTHDAY GIFT TO SOL KOGEN IN 1928 WAS THIS PAIR OF STAINED-GLASS WINDOWS. THE DESIGN WAS UNUSUAL FOR MILLER, WHO RARELY USED SKYSCRAPERS AND OTHER URBAN IMAGERY.

RIGHT: UNDER THE HUGE LEADED-GLASS WINDOW IN THE LIVING ROOM, MILLER PAINTED A FRESCO FILLED WITH ANIMALS. HE WROTE THAT IT TOOK HIM LESS THAN SIX HOURS TO CREATE THE ELABORATE SCENE, THOUGH HE HAD THOUGHT ABOUT THE DESIGN FOR "ABOUT A WEEK."

FOLLOWING PAGES: DETAILS FROM THE FRESCO.

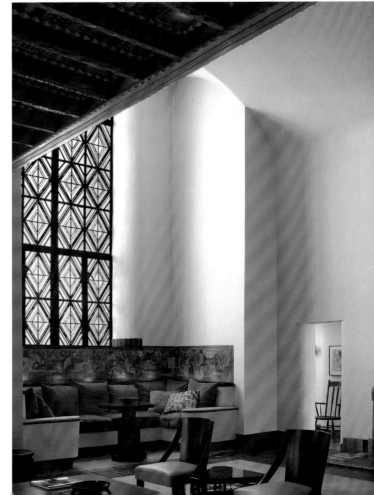

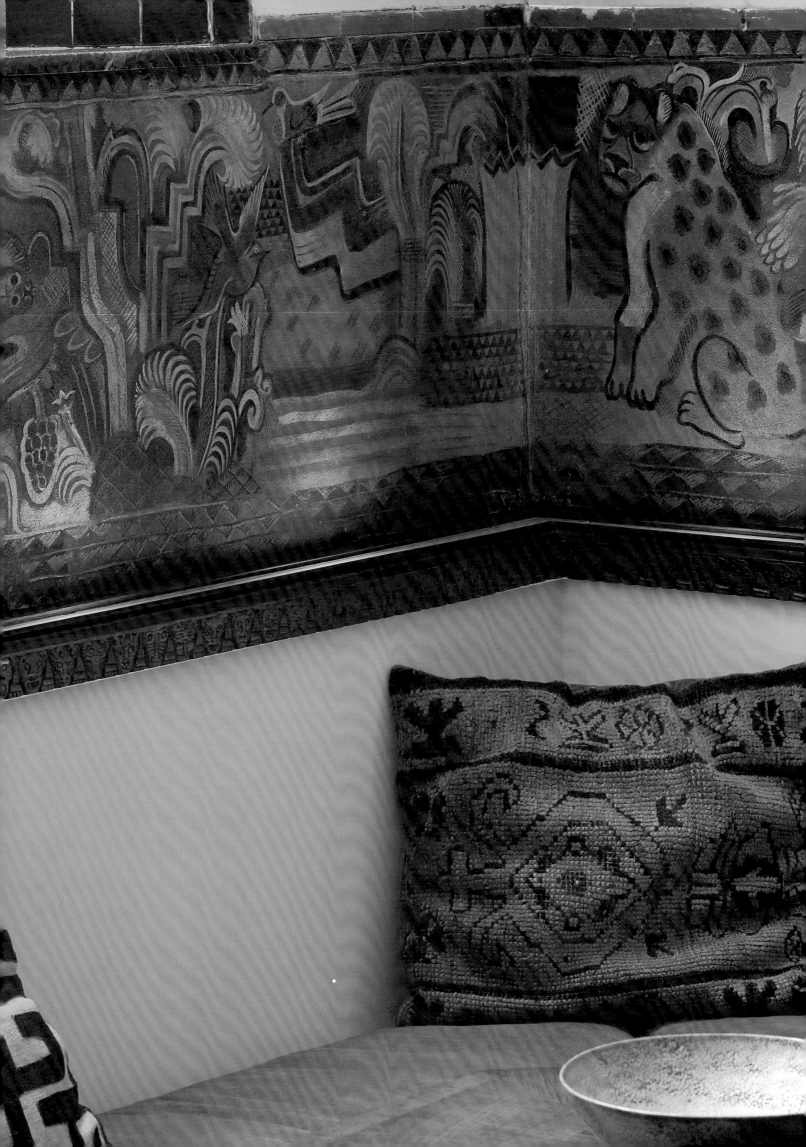

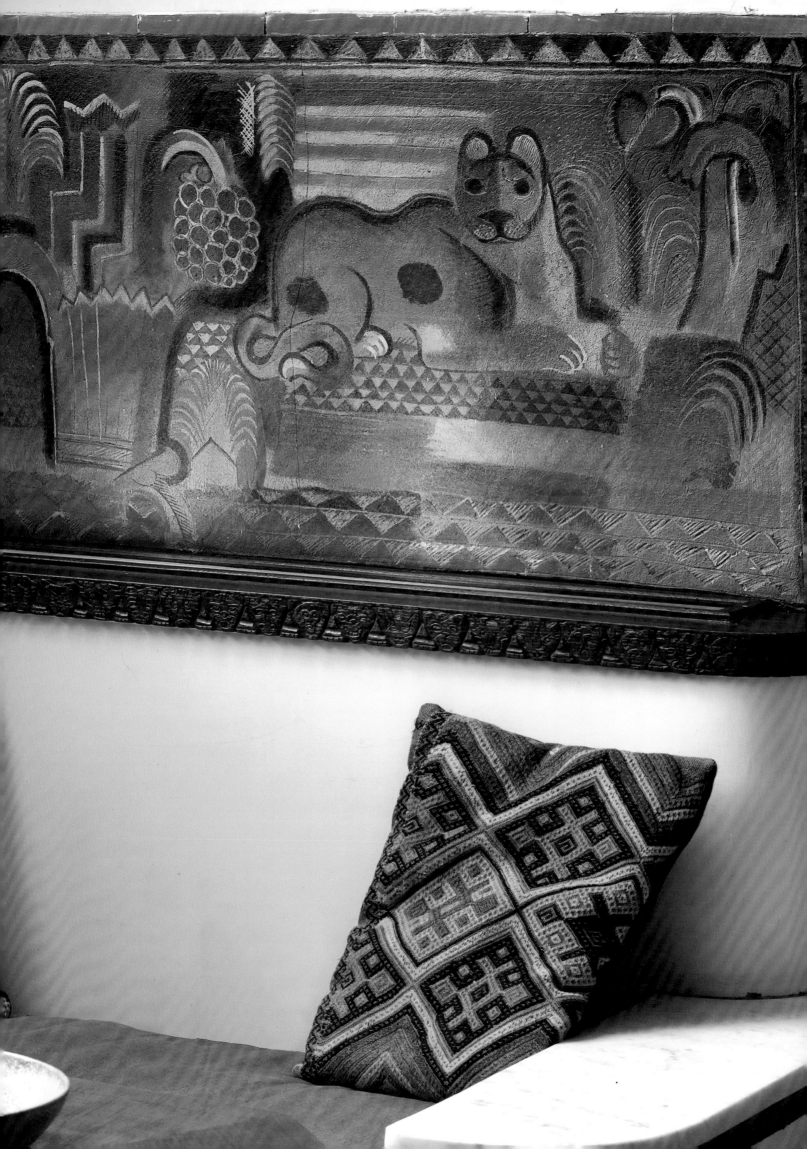

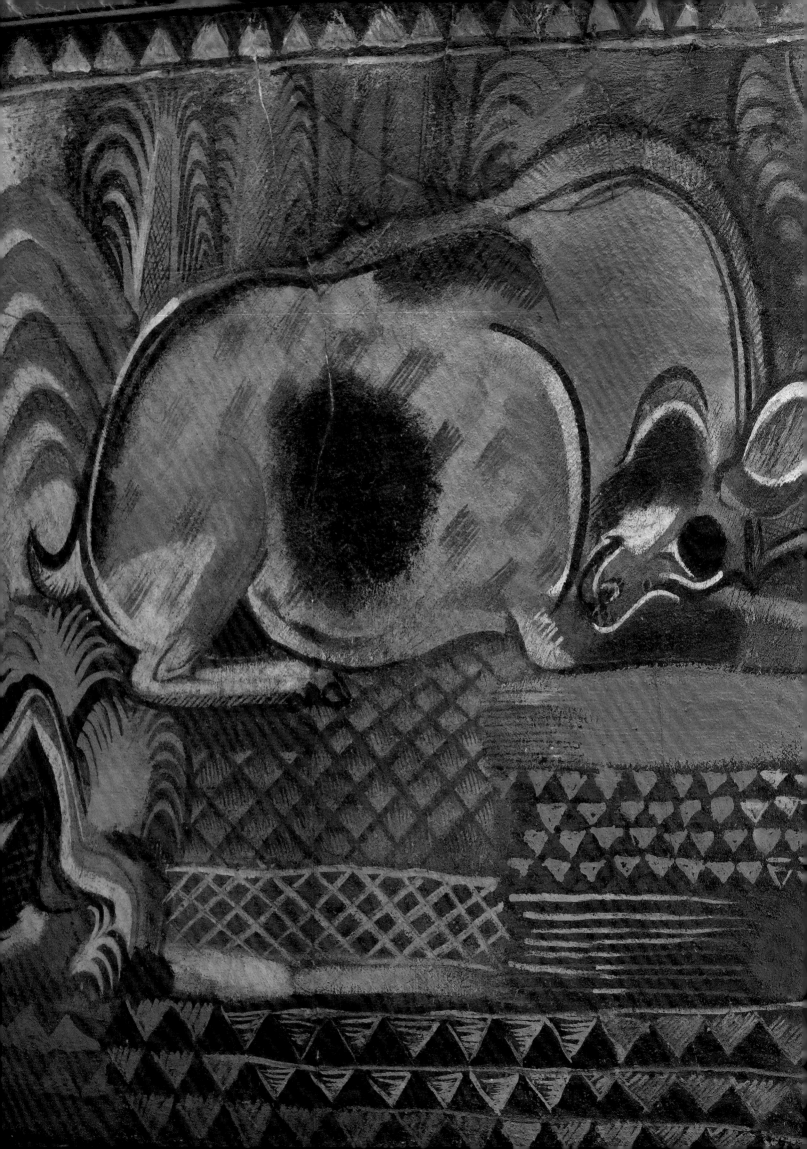

MODERN ADDITIONS. THE SOL KOGEN STUDIO HAS BEEN EXPANDED IN STAGES DURING THE PAST DECADE. THE ORIGINAL FOYER LEADS TO WHAT WAS ONCE STUDIO 18, NOW USED AS A BREAKFAST ROOM. THE ROOM, REMODELED SEVERAL TIMES, IS ANCHORED BY A TILE FLOOR BY JESUS TORRES.

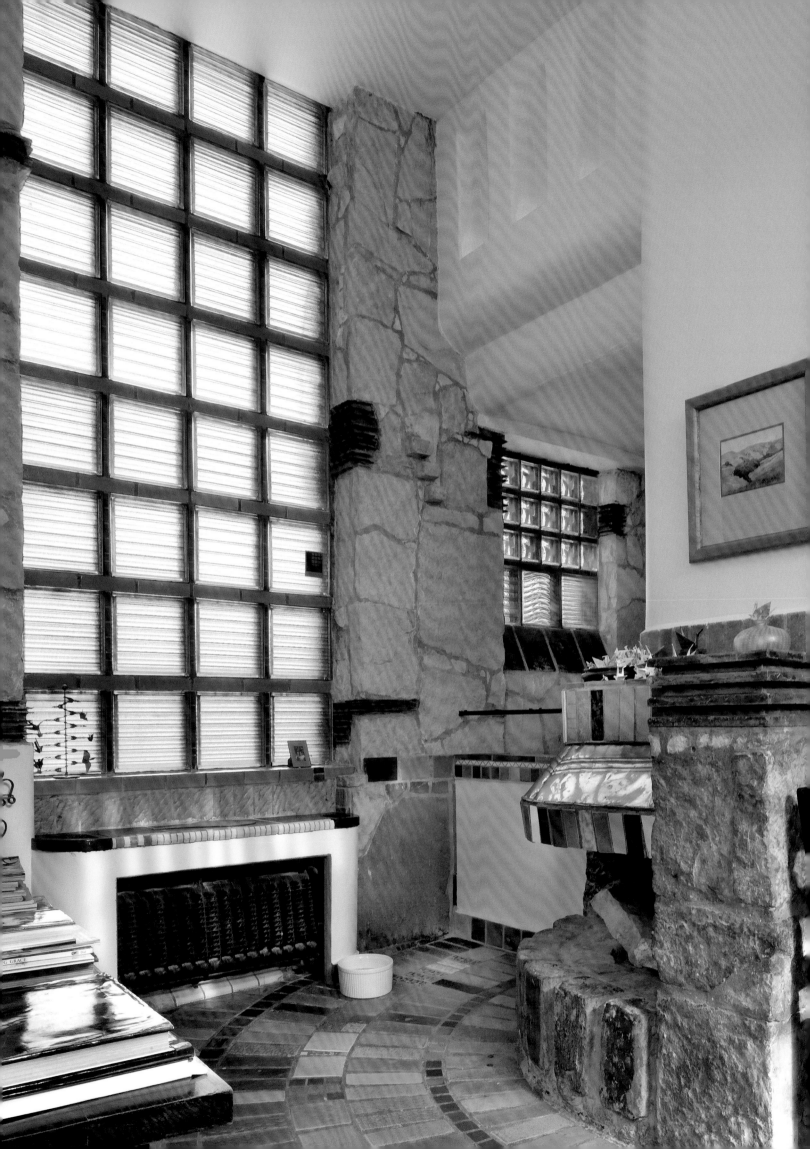

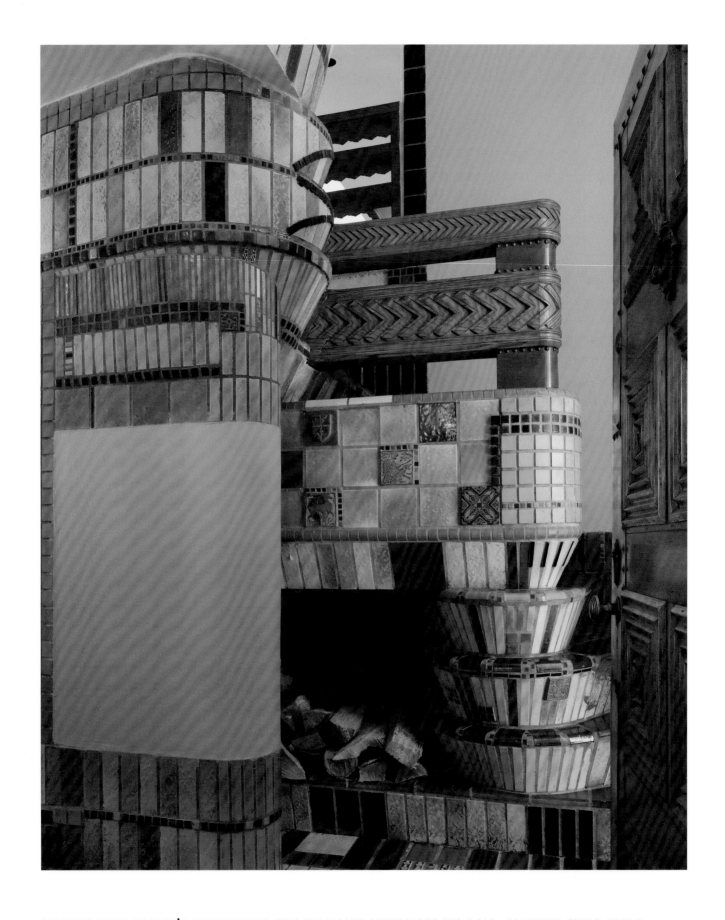

PERHAPS JESUS TORRES'S FINEST WORK, THIS STAIRCASE SHOWCASES HIS BOLD, COLORFUL STYLE. WHILE MILLER HAD A MORE SUBDUED APPROACH TO HIS TILE WORK, TORRES WAS FEARLESS, CHOOSING TILES THAT EXPRESSED BOTH HIS INTEREST IN ART DECO AND HIS CULTURAL IDENTITY.

WHEN MILLER WAS EIGHTY-NINE, HE CREATED THIS DOOR FOR THE MASTER BEDROOM. EDGAR SET UP A SOLID CHERRY DOOR ON SAWHORSES AND WORKED WITHOUT A SKETCH FOR UP TO THIRTEEN HOURS A DAY FOR ABOUT TEN DAYS. BOB HORN, AN ARTIST WHO ASSISTED MILLER, RECALLED THAT HE "SEEMINGLY PUT RANDOM SPLOTCHES DOWN ALL OVER THE PLACE—LIKE A HANS HOFMANN ABSTRACT PAINTING. IT JUST GREW."

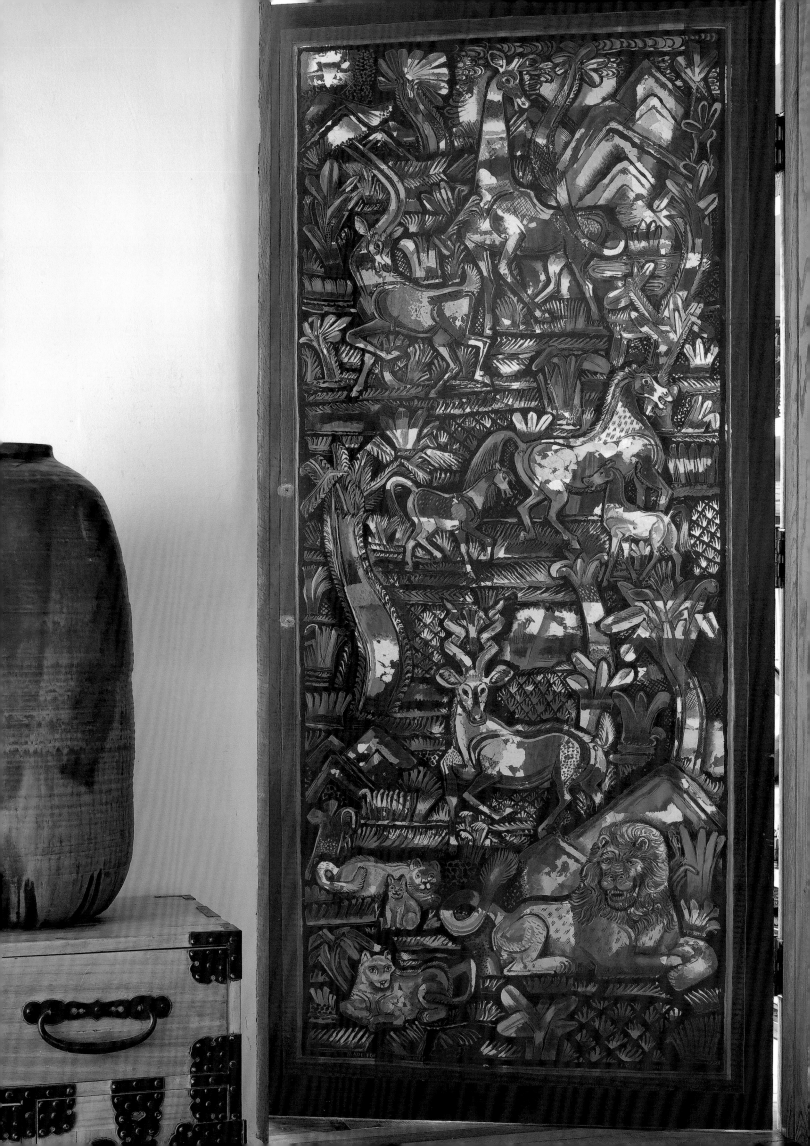

MILLER MADE THIS BEDROOM
WINDOW, THE WORLD, FOR
MARK MAMOLEN, WHO HAD
LIVED IN SIX OF HIS APART-
MENTS AT THE CARL STREET
AND KOGEN-MILLER STUDIOS.
THE WINDOW WAS COMPLETED
IN 1988 WITH THE ASSIS-
TANCE OF LARRY ZGODA, WHO
SAID THAT MILLER WOULD
MAKE FULL-SIZE DRAWINGS
OF HIS DESIGNS TO START.
"FROM THERE," ZGODA SAID,
"I WOULD CREATE A TEMPLATE
SHOWING WHERE LEAD LINES
GO. AFTER EDGAR SELECTED
THE COLOR OF THE GLASS TO
BE USED, I CUT THE SHAPES
FOR HIM, WHICH HE WOULD
THEN PAINT. IT WAS THEN
FIRED TO MAKE IT PERMANENT.
I WOULD PUT IT ALL TOGETHER
WITH LEAD CHANNEL, SOLDER
IT, WASH IT, CEMENT IT, REBAR
IT, AND INSTALL IT."

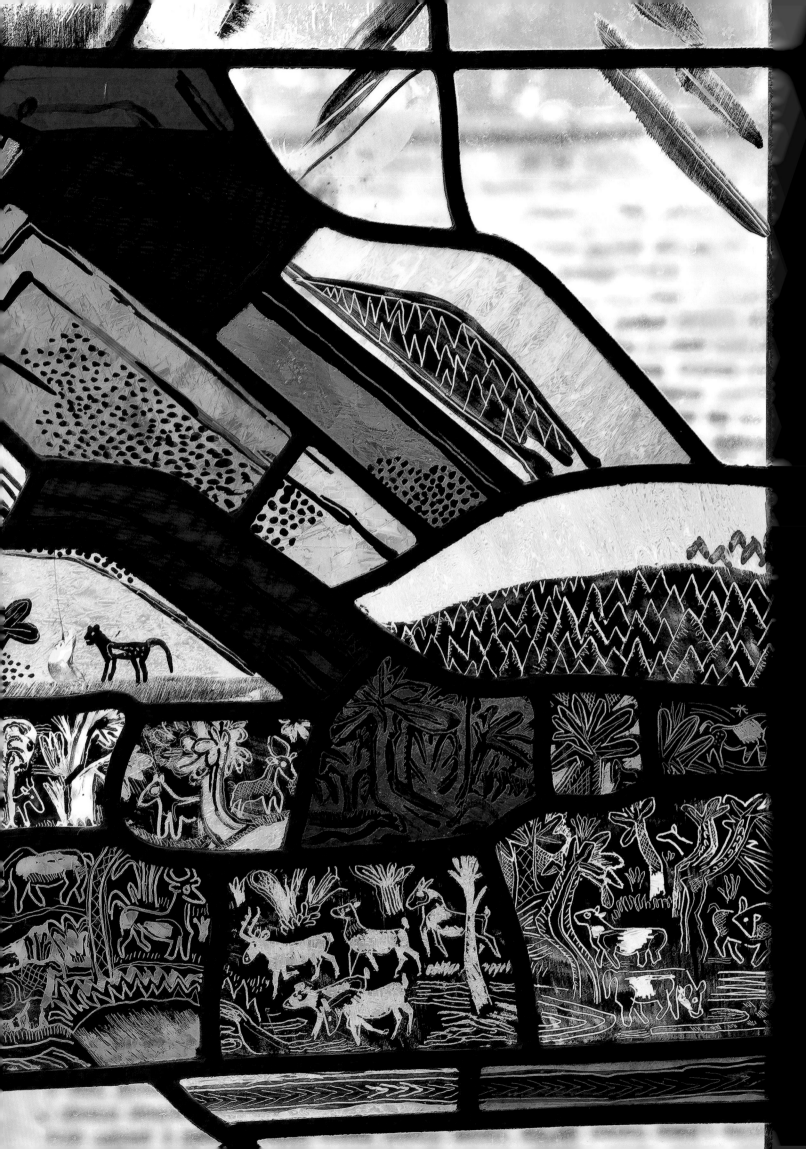

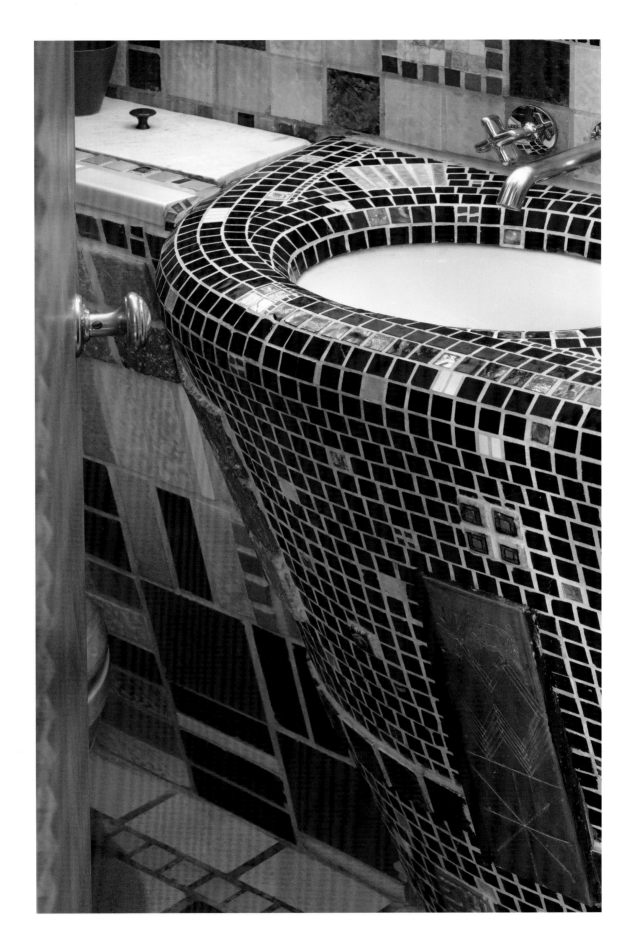

JESUS TORRES DESIGNED THE BATHROOMS IN THE SOL KOGEN STUDIO.

HORSES HAD SPECIAL
MEANING FOR EDGAR.
WHEN HE WAS ELEVEN,
HIS FATHER GAVE HIM A
PONY NAMED WINNIE.
MILLER CONSIDERED
WINNIE HIS "FIRST
INTIMATE FRIEND."

FOLLOWING PAGES: THE
VIEW FROM THE SECOND-
FLOOR BALCONY. THE
BANQUETTE BENEATH
THE FRESCO WAS ADDED
RECENTLY BUT FOLLOWS
AN ORIGINAL DESIGN.

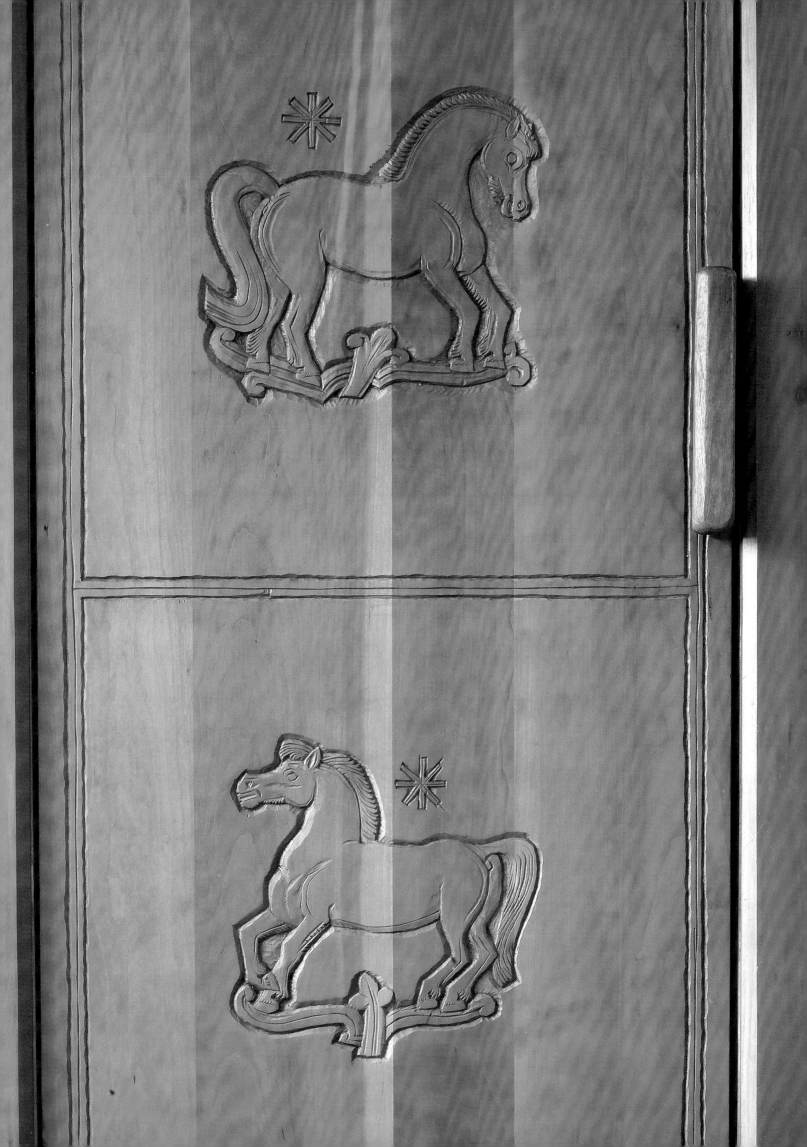

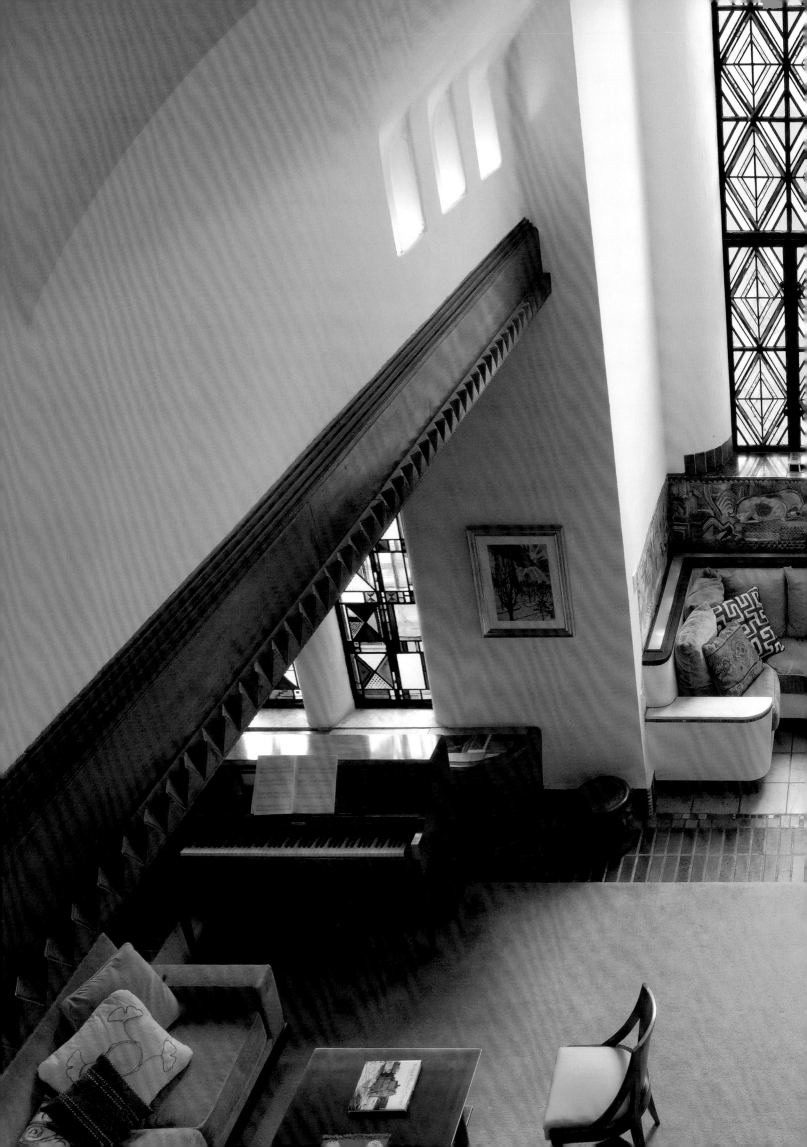

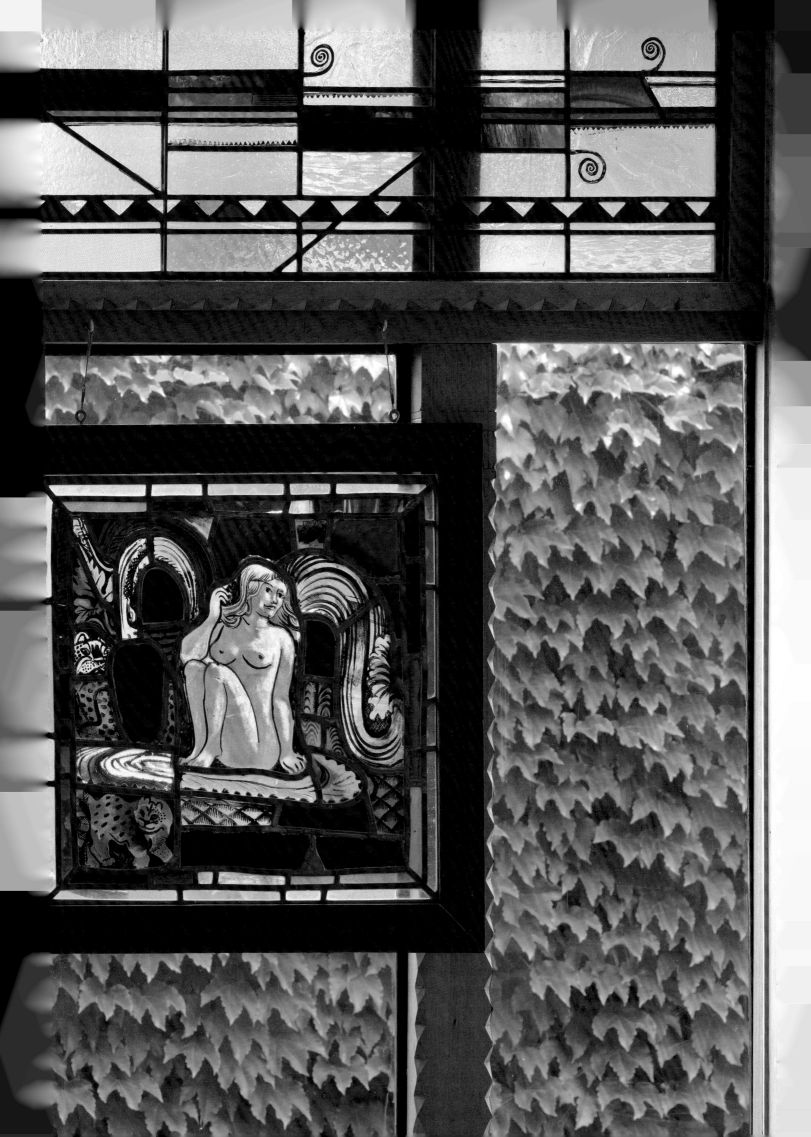

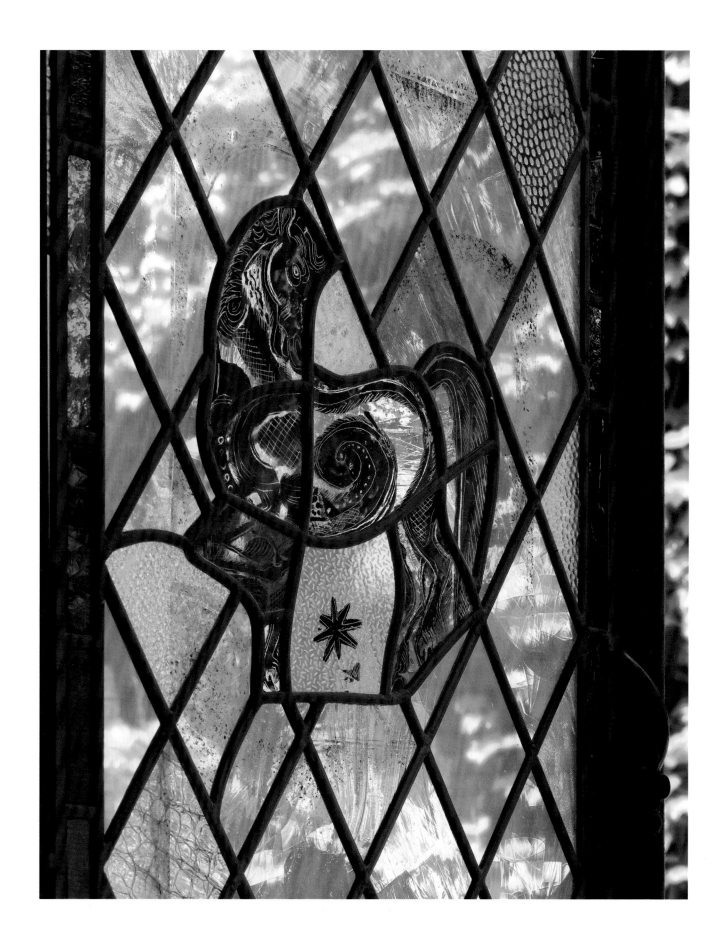

ABOUT SIXTY YEARS SEPARATE THE CREATION OF THESE WINDOWS. MILLER MADE THE FRAMED WINDOW IN THE 1920S AND THE WINDOW IN THE TRANSOM IN 1990. THE WINDOW ABOVE IS INSCRIBED "ONE OF THE LAST."

STUDIO 1

MILLER USED THE ANCIENT TECHNIQUE OF SGRAFFITO TO APPLY LINE AND TEXTURE TO WET PLASTER. A WINDOW OF NEARLY TWENTY FEET DOMINATES THE LIVING ROOM.

No plans or blueprints exist for Studio 1—or any of the studios that Edgar Miller designed at Carl Street. This doesn't surprise Larry Kolden or Bob Horn, artists who have spent more than twenty years maintaining and restoring the complex.

"I really think Edgar built the studios more like a sculptor than an architect," Kolden said. "He would create a space and then react to it as it evolved. As work progressed, the building told him what it needed." Bob Horn agrees. Miller and Kogen worked by instinct, he said. "I don't think they had a plan at all—they were more opportunistic."

Kolden believes that Miller possessed the confidence and talent to create finished art without a clear understanding of where the work might lead. "Like Picasso, Edgar had a sureness to what he was doing," Kolden said. "And what carries the work is the authority of being correct—and he never lost that. I think he had a powerful sense of design, but he probably didn't do a lot of planning—it was more intuitive."

That Edgar built without plans and created by instinct has caused considerable challenges for Kolden, Horn and others who restore and maintain the studio complexes. But they are committed to following Miller's original vision. "We tried to make changes as minimally different and seamless as possible," Kolden said. "We've tried to honor Miller's original intent."

MILLER CARVED THE WOOD FRAME OF THIS LIGHT FIXTURE IN ADDITION TO PAINTING THE GLASS.
THERE IS NO OTHER FIXTURE LIKE IT AT CARL STREET.

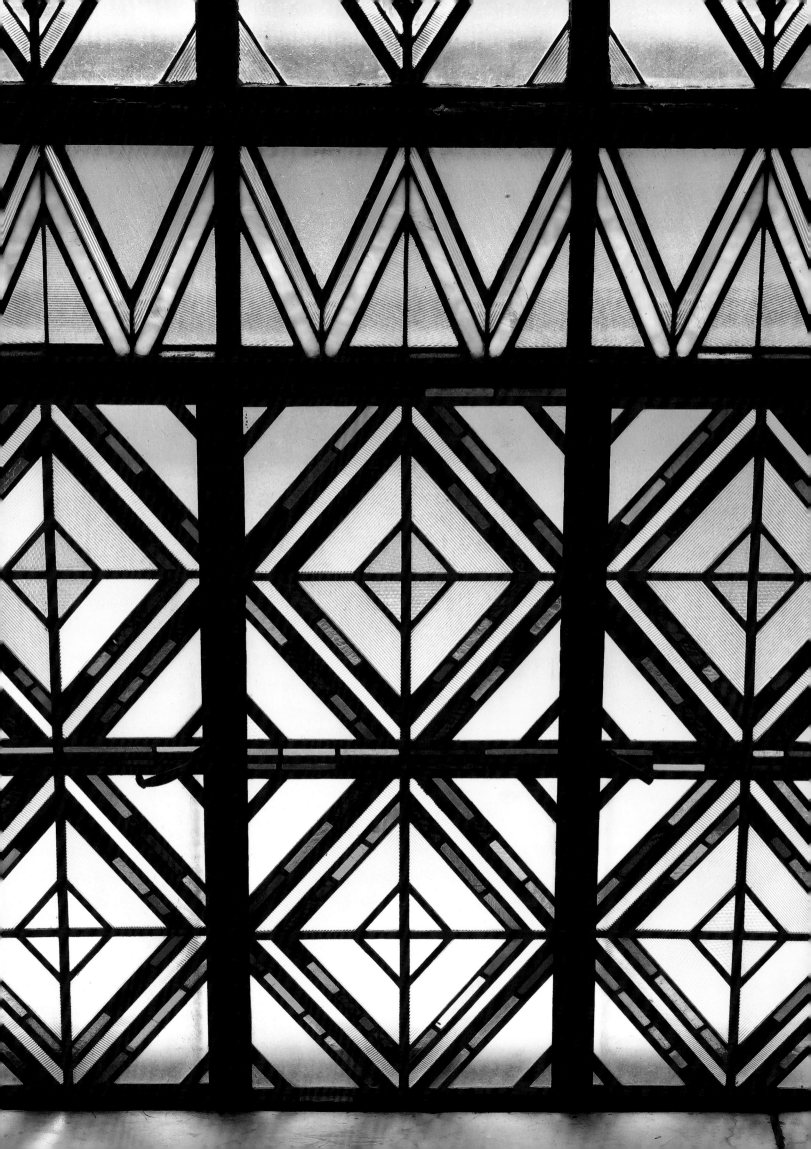

STUDIO 6

MILLER ADDED SMALL BANDS OF COLOR TO THESE CASEMENT WINDOWS. IT PROBABLY TOOK HIM MORE THAN A WEEK TO CARVE THIS DOOR OUT OF DENSE WHITE OAK.

FOLLOWING PAGES: THE TINY LIVING ROOM

Edgar Miller approached each of his studios with a different visual concept. Some would be dominated by his huge stained-glass windows, others by his carvings or frescoes. For Studio 6, he chose to feature unlikely mediums—tile and stone—and picked an earth-tone palette, a mix of rust, sable brown, white, red Mexican marble, yellow ocher, and soft greens. The space, including the floors, staircase and bathroom, is bathed in these rich, colorful materials.

Kogen and Miller salvaged many of the materials in bulk from demolition sites during the 1920s and '30s. The pair took a special interest in large pieces used commercially, like stall dividers for office building bathrooms. They used these slabs in the courtyards as pavers, in the studios as flooring, for stair treads and risers, and even to plug holes in the leaky decking on the roof.

When laying tile, Miller loved to contrast bulky, oversize pieces with tiny rows of smaller tile, creating complex patterns of unexpected beauty and sophistication. He was particularly fond of joining broken or irregular pieces with straight sections, then filling in the remaining space with a funky mix of tile odds and ends.

His distinctive style makes his designs easy to spot at Carl Street. Jesus Torres, the complex's other designer, favored more balanced, symmetrical arrangements and was influenced by the popular art deco style of the period. Miller was driven by his own sense of design and bristled at being considered an art deco devotee. Asked once by a reporter if his style could be called deco, Edgar shouted an insult and walked away.

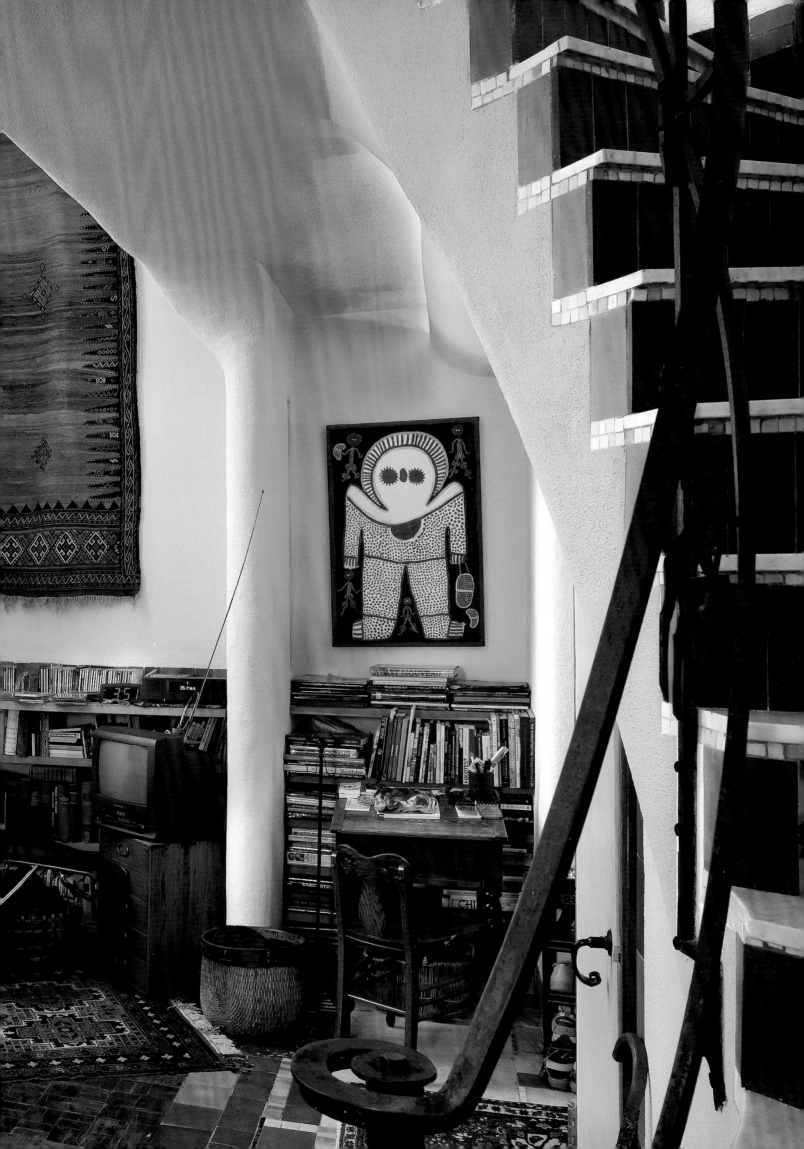

EXAMPLES OF TILE WORK IN STUDIO
6. TENANTS HAVE TRIED TO EMULATE
MILLER'S DISTINCT STYLE AS RESTORA-
TION WORK IS CARRIED OUT.

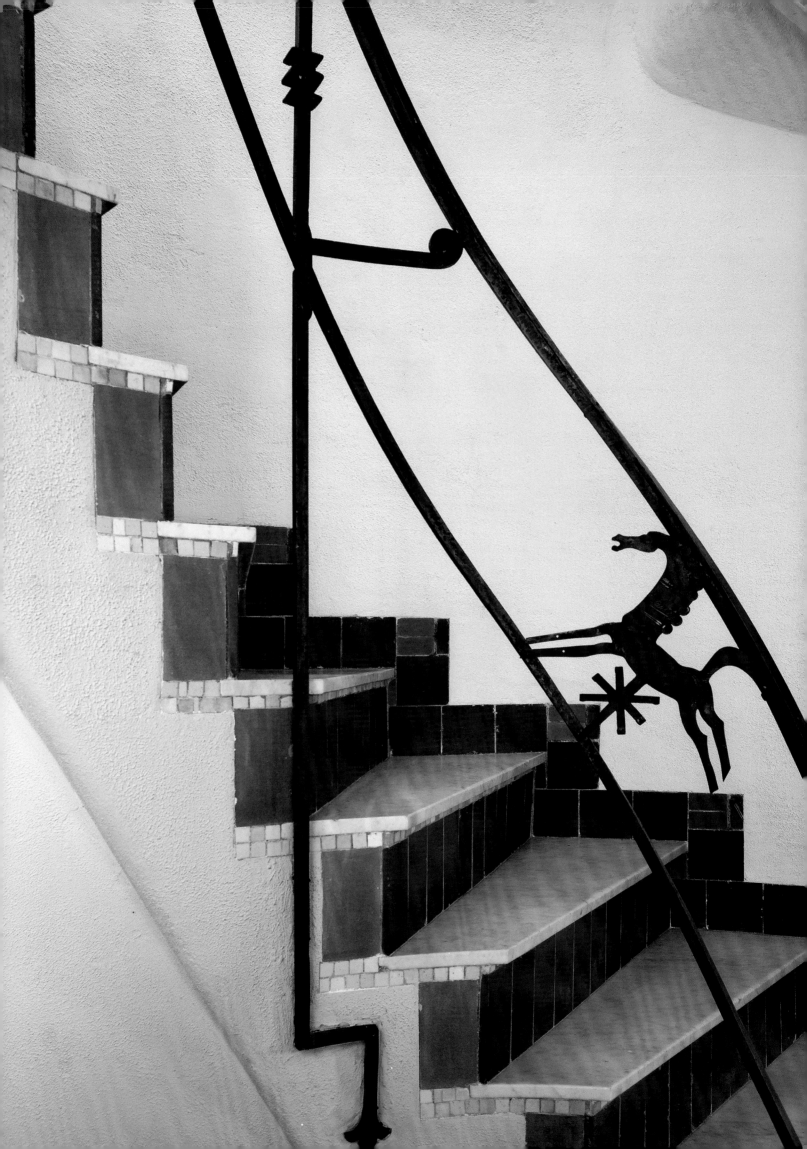

MILLER USED FROSTED GLASS AND GLASS BLOCK IN STUDIO 6, BUILT IN 1935. IT IS POSSIBLE THAT THIS IS HIS FIRST EXPERIMENT WITH GLASS BLOCK AND FORESHADOWS ITS USE THE FOLLOWING YEAR AT THE FRANK F. FISHER APARTMENTS.

STUDIO 7

MILLER PAINTED THIS FRESCO IN AN
EXTERIOR HALLWAY OUTSIDE STUDIO 7. IT
CONTRASTS WITH THE OVERALL DESIGN OF
THE STUDIO.

FOLLOWING PAGES: MILLER RETURNED TO
THE PALEOLITHIC CAVES, CREATING SEVERAL
PRIMITIVE FRESCOES IN AND AROUND
STUDIO 7. THE FIRST IS IN THE HALLWAY,
THE SECOND IS ABOVE THE MANTEL, AND
THE THIRD IS IN STUDIO 9.

Growing up in Idaho Falls, Edgar Miller had little access to the world's art treasures. The nearest museums were hundreds of miles away, and the small town didn't have a library until a Carnegie library was built in 1914.

Edgar's world expanded when he arrived at the Art Institute of Chicago, where the seventeen-year-old was exposed to one of the world's greatest art collections. The museum offered Miller a chance to learn from studying up close paintings by French impressionists to American modernists.

But nothing in the museum influenced him as much as the cave paintings from Europe that he saw in a book in the school's library. "It had a much greater effect upon me than the enlarged access to the works of the great masters that the museum of the institute furnished," Miller wrote. "To Paleolithic man, his drawing was not a picture to decorate a wall. He was inventing a nonverbal language of images to supplement the social verbal language which was confined to the moment of speech."

The prehistoric paintings that most inspired Edgar were found in Altair, Spain, in 1879 and in other caves in Spain and France. At the time, the discovery of prehistoric art was of more interest to scientists than artists. He admired the work and made it part of his artistic vocabulary— so much so that the writer Ben Hecht called Edgar "one of the outstanding primitives."

Miller created primitive frescoes in and around Studios 7 and 9, which are now connected. It is in Studio 9 that Miller painted his most direct homage to prehistoric art: a pack of wild horses, depicted in the same faded tones as the ancient cave paintings that impressed Miller, running across the plain.

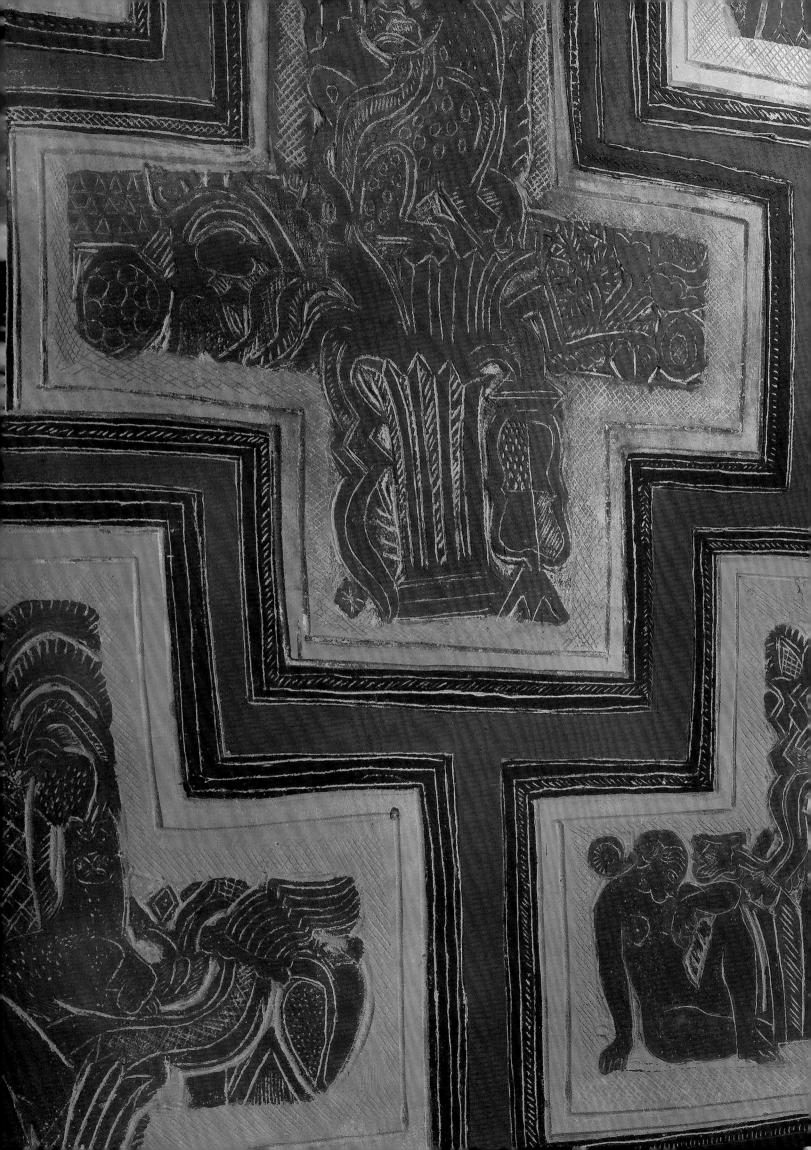

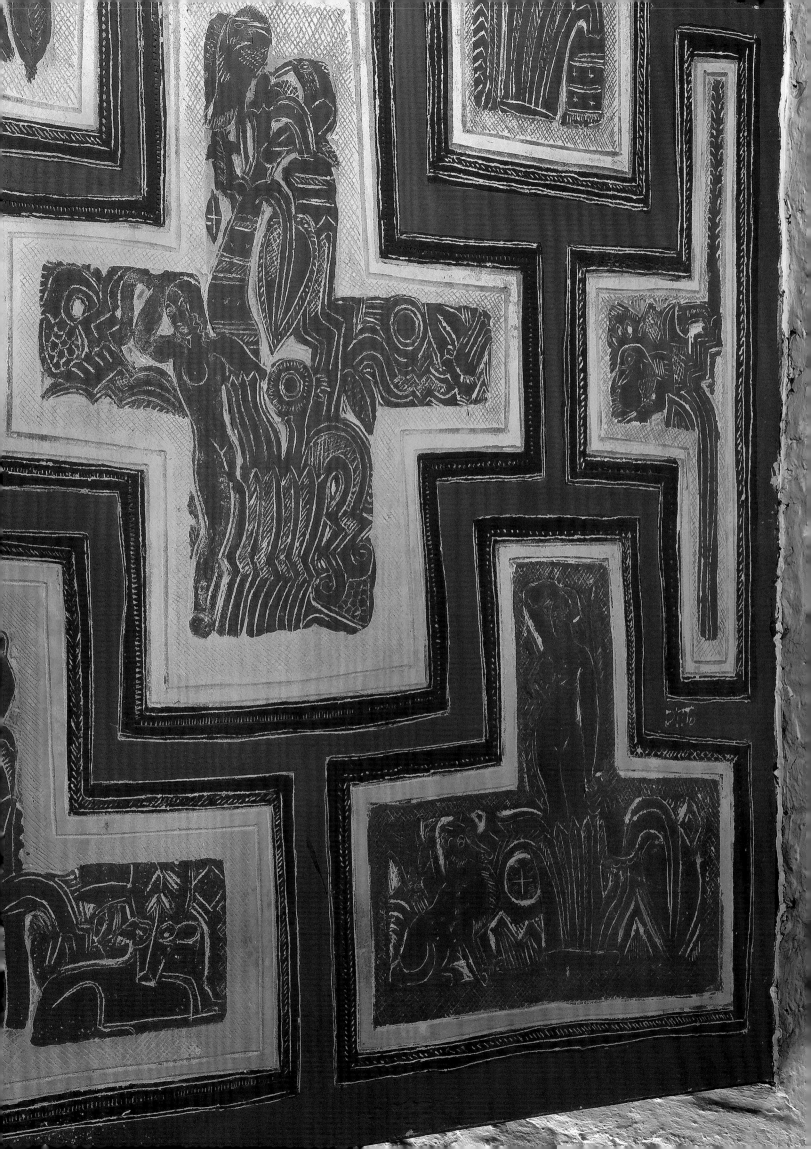

STUDIO 8

MILLER FILLED THIS SMALL BAY WINDOW WITH ORNAMENT AND THE COURTYARD CEILING WITH SGRAFFITO.

FOLLOWING PAGES: THE ARTFUL LIVING ROOM

At night, the stained-glass windows Edgar Miller created for Studio 8 dominate the facade of the Carl Street Studios. Twelve mischievous weasels glow in the darkness, not far from thirty illuminated horses.

Miller clearly loved animals. Throughout his life, he kept dogs, cats, rabbits, pigeons, turtles, birds and a skunk named Quelquefleur in his family homes. He even adopted a flock of wayward ducks from Lake Michigan. From an early age, animals and the natural world were the primary subjects of his art.

"At first he would draw things from memory," Frank Miller wrote of young Edgar's work habits in Idaho. "Soon he started carrying a small sketchbook, a habit that remained for the rest of his life. He began recording everything he saw: birds, animals, flowers, cloud formations, trees, mountains, the world."

Miller brought the West with him to Chicago. His studios were filled with images of the animals he grew up with, and his reverence for the natural world never diminished.

Bob Horn, who worked with Miller following his return to Chicago in 1986, recalled how the artist often seemed more comfortable around animals. "I remember once walking with Edgar and then suddenly noticing he was no longer with me," Horn said. "When I turned around, he was talking to a cat, saying, 'Hello, Mr. Kitty. How are you?'"

Edgar showed that love in all of his art.

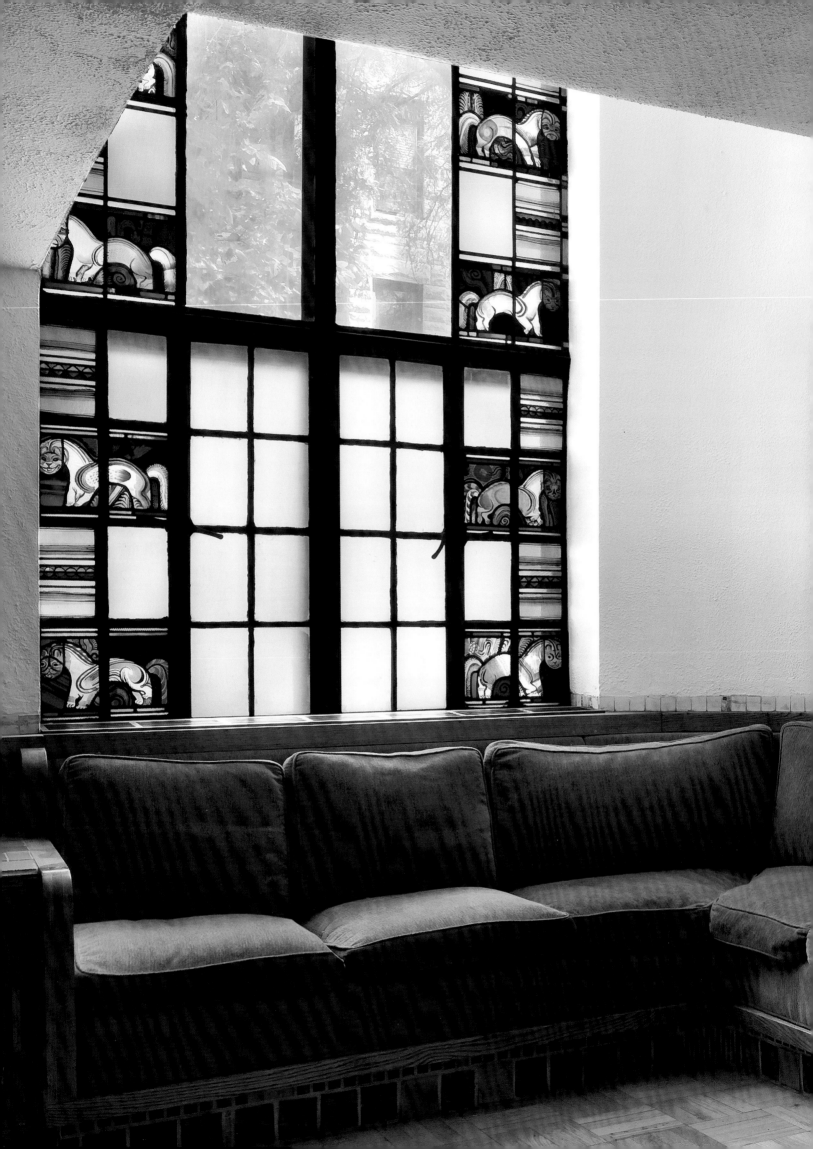

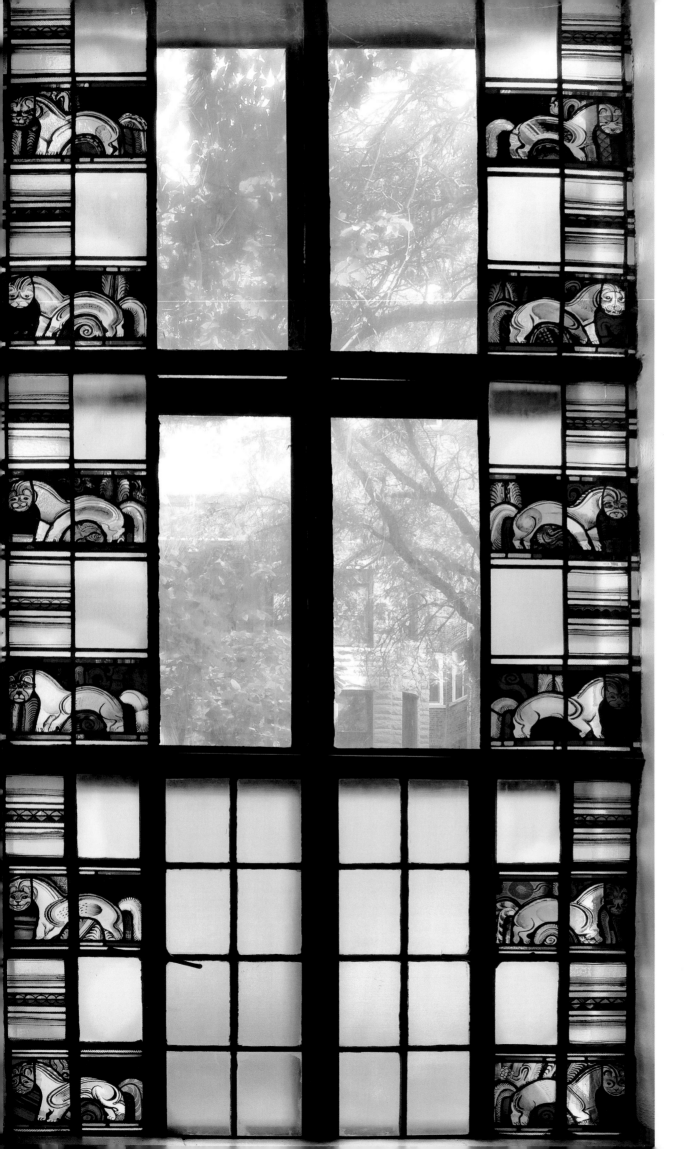

MILLER DEDICATED WINDOWS
IN STUDIO 8 TO THOSE WHO
LIVED IN AND HELPED TO
KEEP THE CARL STREET AND
KOGEN-MILLER STUDIOS
GOING, INCLUDING THE
DEVELOPERS SOL KOGEN,
RUDOLPH GLASNER AND
MAX WOLDENBERG AND THE
ARTISTS EDGAR BRITTON
AND OLGA SEGERBERG.
AFTER HIS SEPARATION FROM
HIS FIRST WIFE, DOROTHY,
IN THE LATE 1920S, MILLER
TRAVELED THE WEST WITH
SEGERBERG AND PRESENTED
HER WITH A BOOK OF
SKETCHES TITLED "THE
THINGS OLGA LOVES."

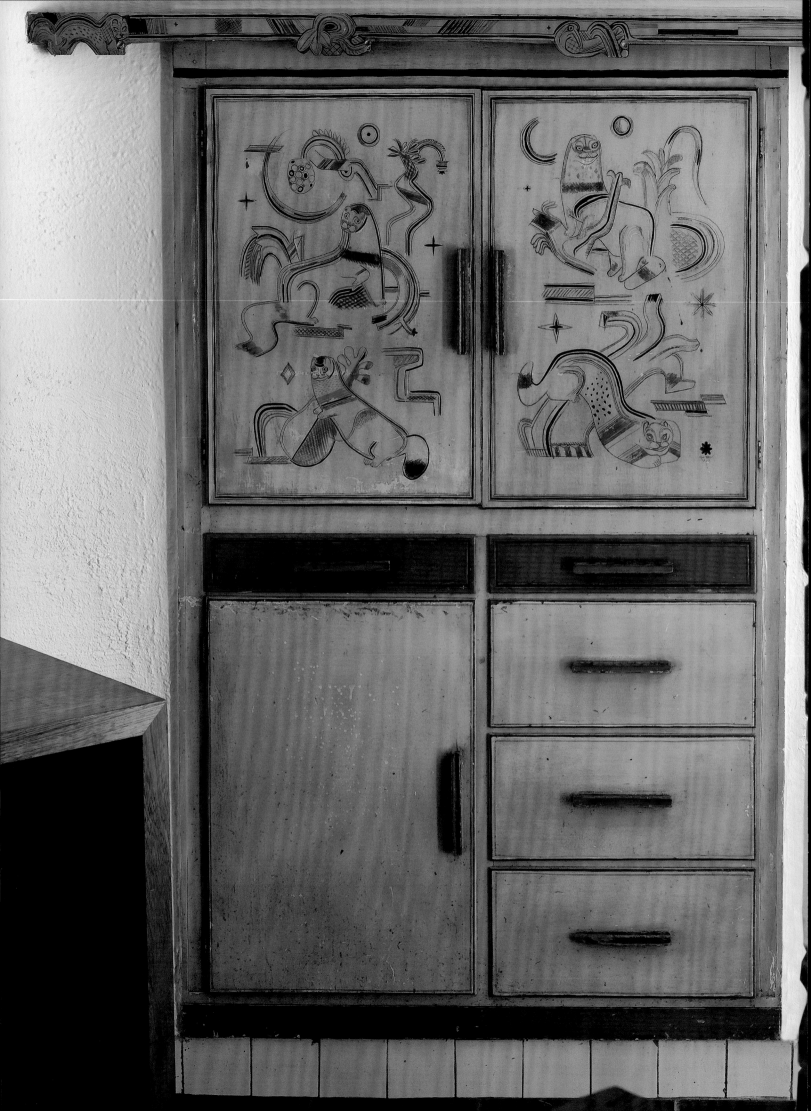

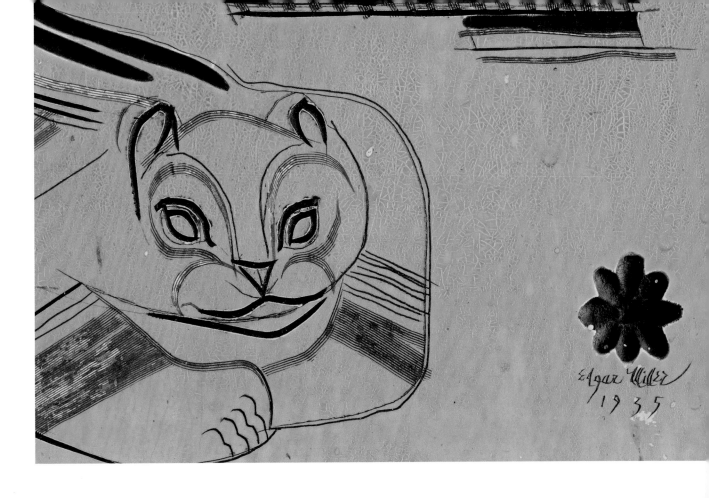

MILLER CARVED AND PAINTED
THIS BUILT-IN KITCHEN CABI-
NET IN 1935. THE DESIGN
IS UNUSUAL FOR MILLER,
WHOSE CABINETS WERE
GENERALLY UTILITARIAN. THE
ANIMAL DEPICTED IS MOST
LIKELY A WEASEL, THE SAME
AS FEATURED IN THE STUDIO'S
WINDOWS AND A MILLER
FAVORITE. "MY ENJOYMENT OF
ANIMALS WOULD ALLOW ME
TO CARVE THEM FOREVER," HE
ONCE SAID.

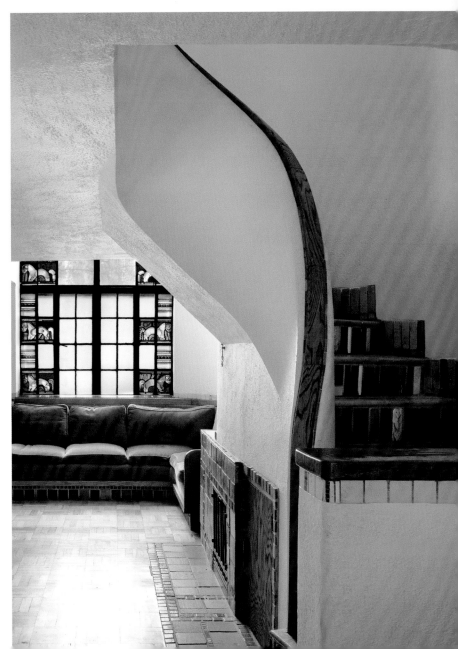

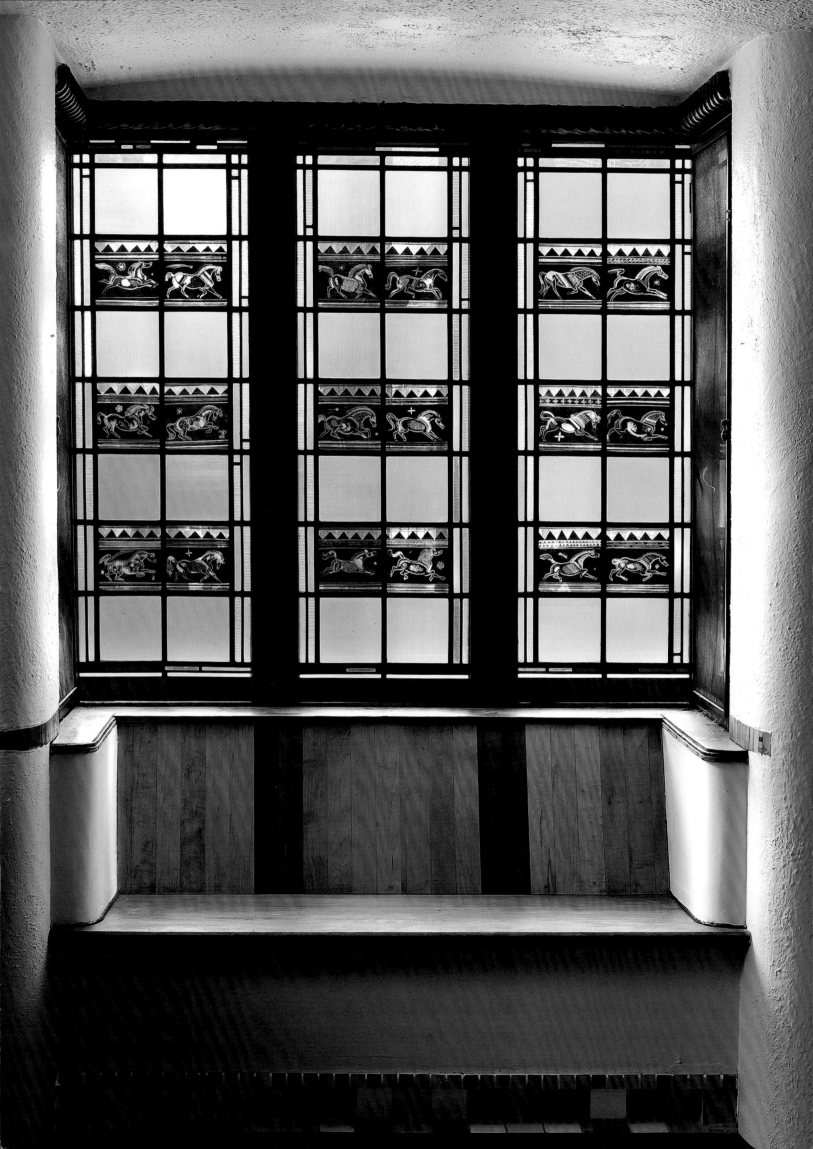

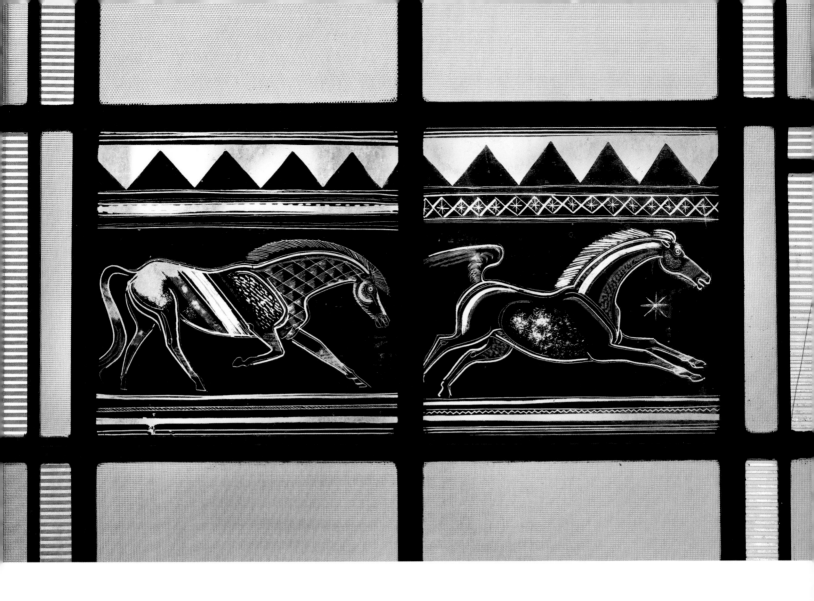

ON THE SECOND FLOOR, MILLER PAINTED A SERIES OF WINDOWS FEATURING HORSES. IN THE WEST, MILLER WROTE, "THE HORSE WAS THE OTHER HALF OF ANY ACTIVE MAN. UNLESS HE 'HAD A HORSE' HE WAS NOT 'IN BUSINESS.'"

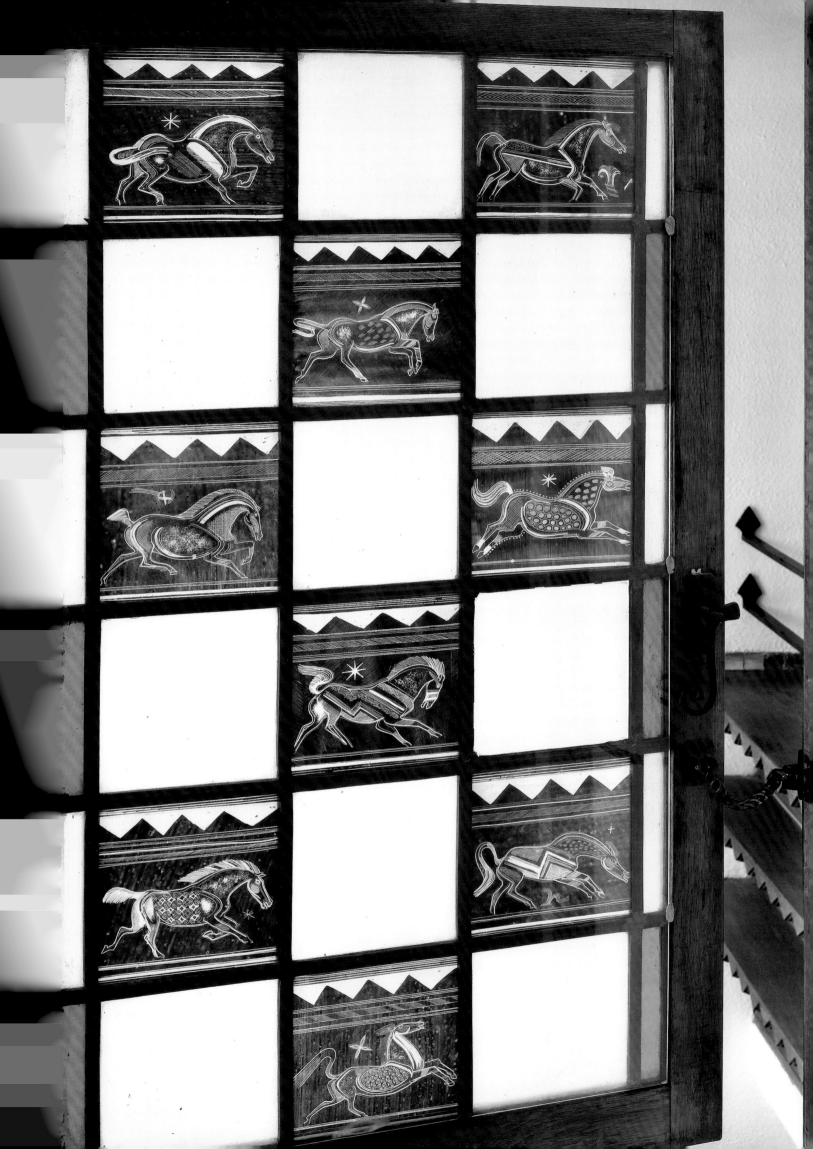

ANOTHER WINDOW FEATURING
HORSES OVERLOOKS THE FIRST
FLOOR AND MILLER'S CARVED RAIL-
ING. MILLER CREATED SOME OF HIS
BEST WORK FOR STUDIO 8 BECAUSE
OF HIS CLOSE RELATIONSHIP WITH
TAYLOR POORE, ONE OF THE LEAD-
ING GRAPHIC DESIGNERS OF THE
AGE, AND HIS WIFE, MADGE, WHO
LIVED THERE IN THE 1930S. THE
COUPLE FILLED THEIR HOME WITH
MILLER'S ART AND HAD A LARGE
COLLECTION OF HIS PLATES AND
CERAMICS. MILLER SAID HE EMBEL-
LISHED THE CARL STREET STUDIOS
WITH "LITTLE ARTS" THAT ARE
"INTIMATELY RELATED TO PEOPLE
IN ORDINARY LIFE." HE TOLD A
REPORTER IN THE 1960S THAT "THE
GREAT ARTS ARE BASED ON THE
CULTIVATION OF THE LITTLE ARTS,
AND THE LITTLE ARTS ARE STILL
LACKING IN THIS COUNTRY TODAY.
AN ARTIST SHOULD BE FUNCTION-
ING IN HIS ENVIRONMENT—HE
SHOULD BE AFFECTING THE ENVI-
RONMENT, RATHER THAN LETTING
MECHANICAL MEN DOMINATE IT."

WALTER GUEST APARTMENTS

2150 NORTH CLEVELAND AVENUE 1932

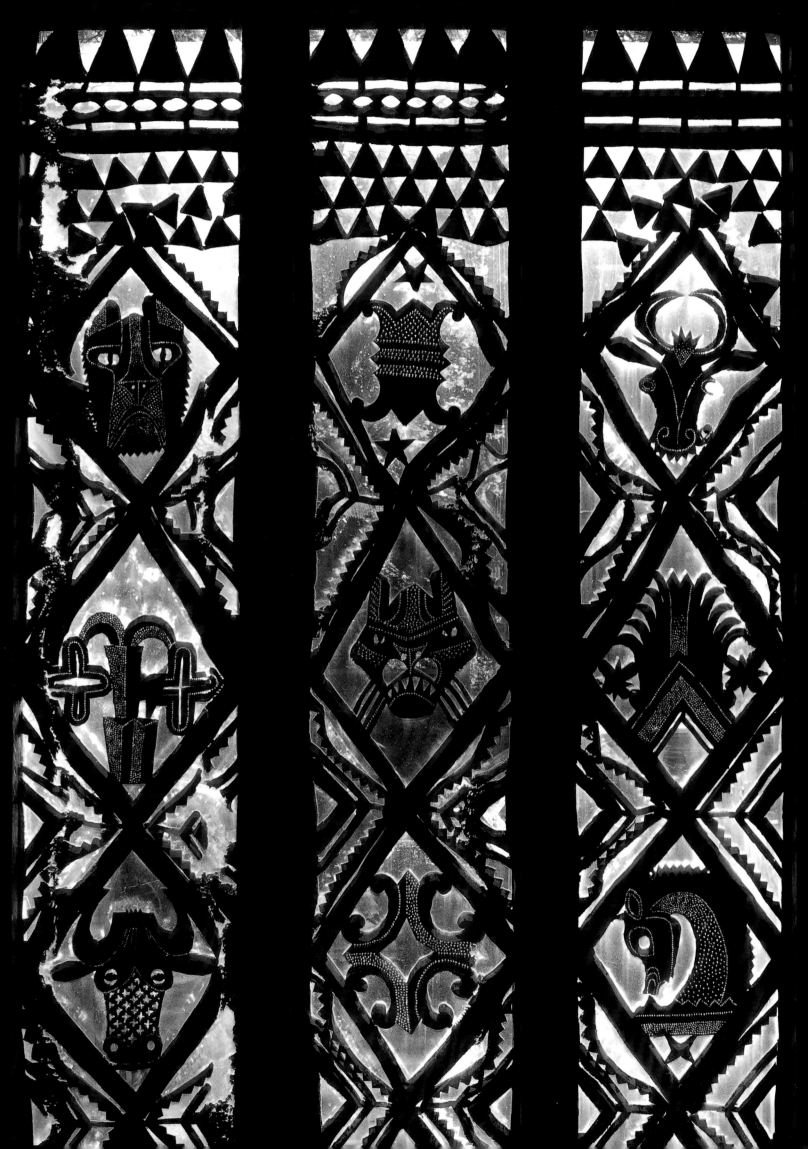

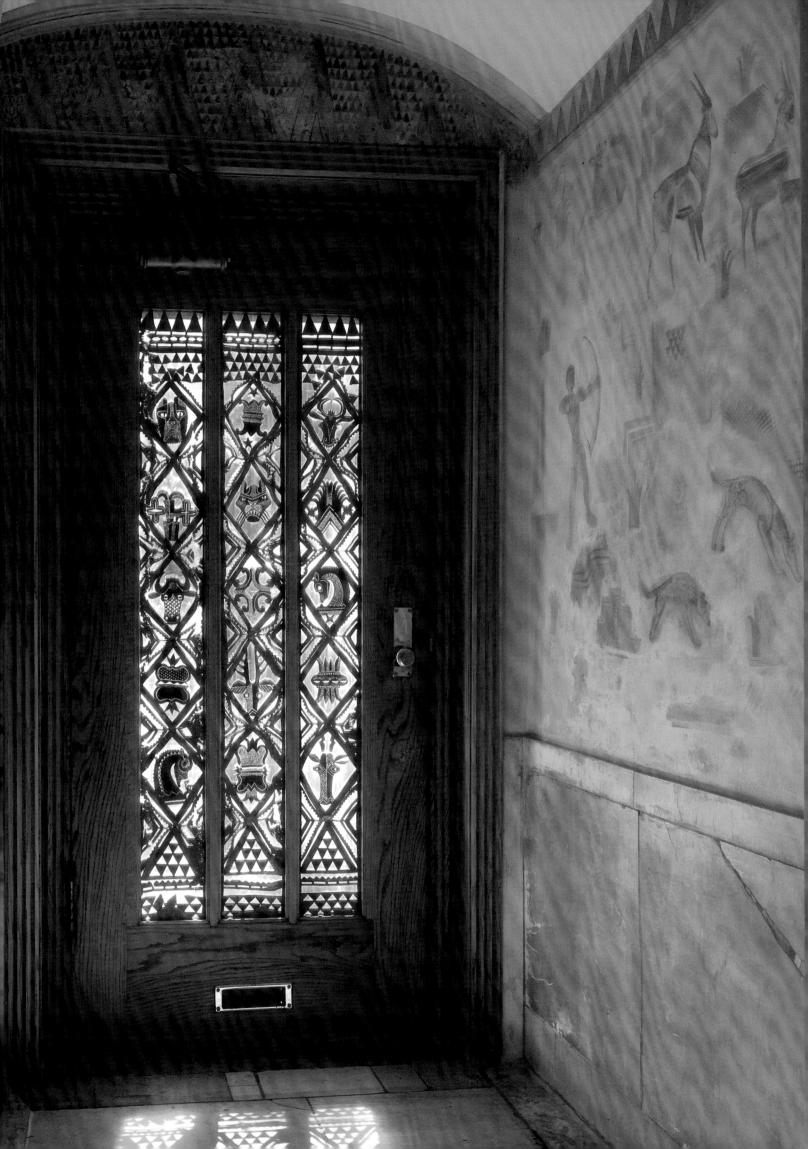

Shortly after work began on the Carl Street and Kogen-Miller studios, neighbors took notice of both the innovative design and the concept of recycling aging structures. On Carl Street, five projects began in the 1930s, and more were started on nearby Schiller Street and Lincoln Avenue. What Edgar Miller called a movement had begun.

Walter Guest, a salesman and former Miller client, took a special interest in what Miller and Kogen were doing and bought a building not far from their Wells Street complex, at 2150 North Cleveland Avenue, with the intent of creating his own artists' studios. He hired Miller as designer, but he did not invite Kogen. Instead, Guest acted as his own contractor. Work began in 1932.

The building that Guest chose was a three-story house from 1885. Like many in the neighborhood, the ten-room Victorian had been used during the 1920s as a rooming house; Guest himself had lived there, along with half a dozen or so others, according to the 1930 census. The renovated building included five units: three duplex apartments and two small studios. The sole alteration to the existing footprint of the building was the addition of ten feet to the front facade; a permit for that work was the only one secured for the property.

Edgar brought with him many of the collaborators from his studio buildings, including Jesus Torres, his brother Frank and his sister Hester Miller Murray. Hester, in particular, left her mark on the building. She cut lead for the windows that dominate the front facade and helped create frescoes and painted-glass windows in the rear apartment. Southwestern scenes featuring desert thunderstorms, wild horses and birds attacking snakes are depicted in the windows' deep blues, reds and yellows.

The Guest Apartments along with the Carl Street and Kogen-Miller studios sparked a strong rehabbing movement in Chicago. Edgar had mixed feelings about his role. He was proud that he and Kogen were credited with starting in Chicago what is called vernacular architecture—buildings rehabbed by owners rather than architects—but was not pleased that builders often copied his style without a firm understanding of the details that make his rehabs work.

MILLER'S SISTER HESTER HELPED CREATE THE CUT-LEAD AND PAINTED-GLASS WINDOWS.

FIRST-FLOOR STUDIO

THE LIVING ROOM WINDOW OF THE FIRST-FLOOR STUDIO IS ONE OF MILLER'S LARGEST.

FOLLOWING PAGES: SUNLIGHT CHANGES THE CHARACTER OF THE ROOM DURING THE DAY.

Unlike at the Carl Street and Kogen-Miller studios, entrance to the Cleveland Avenue units is through a traditional common vestibule. But the art Miller created in the shared entry is anything but common. The front door features examples of Miller's cut-lead work, executed with the help of his sister Hester, who also assisted with the fresco that covers the walls of the entryway. Animals, plants and an archer populate the Roman-themed fresco, along with Edgar's favorite primitive symbols and shapes. Under the fresco, Edgar used salvaged marble that matches the tones in the artwork.

The largest of the Cleveland Avenue units, the First-Floor Studio has much in common with the Sol Kogen Studio: both have living rooms that soar twenty feet; both contain God's Eye windows, which look like the image seen in a kaleidoscope; and both have an accompanying smaller window and beam ceilings. Although Edgar didn't carve or paint the ceilings on Cleveland Avenue, decades later he thought he had, which might indicate that this was always his intention.

Edgar's work on Cleveland Avenue is among his most distinctive. To some, like the *Chicago Tribune* art critic Alan Artner, it was Miller's best house. "He had more open space to deal with," Artner wrote. "His work had room to breathe."

The year the building was completed, 1932, was a busy one for Miller. In addition to his project on Cleveland Avenue, he was still working at the Carl Street and Wells Street complexes as well as planning and preparing for the Streets of Paris exhibit at A Century of Progress.

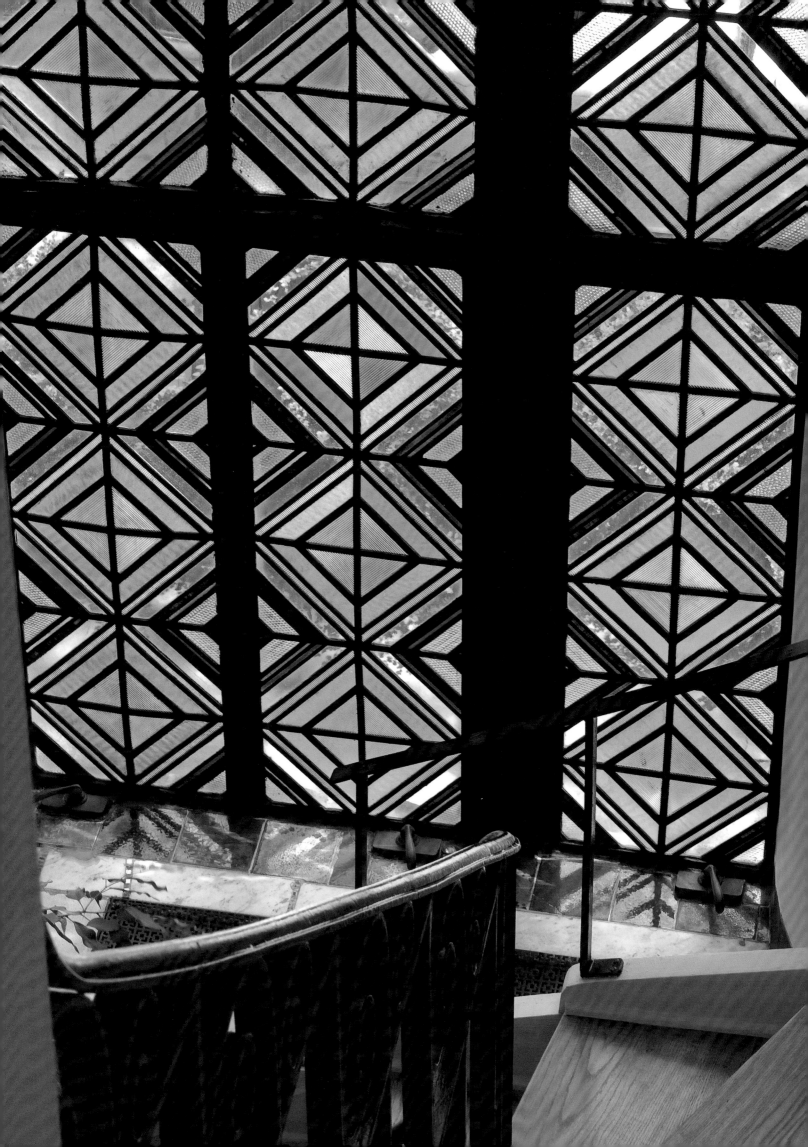

LEFT: THE VIEW FROM THE
SECOND-FLOOR BALCONY.

RIGHT: MILLER'S SISTER HESTER
MADE THIS PIERCED-BRASS
WINDOW FOR THE BEDROOM.

BELOW: MILLER DESIGNED A TILE
FIREPLACE IN THE GARDEN UNIT,
WHICH IS NOW CONNECTED TO
THE FIRST-FLOOR STUDIO.

THIRD-FLOOR STUDIO

ART FILLS THE STUDIO.

FOLLOWING PAGES: MILLER'S DREAM—A LIVING ART MUSEUM.

Edgar Miller's buildings have always attracted interesting tenants, and the Walter Guest Apartments are no exception. Almost from the start, a steady stream of actors, musicians and artists have enjoyed its dramatic spaces. In fact, before the first tenants even moved in, a legendary roller-skating party took place in the Third-Floor Studio, nearly ruining the pristine finish of its new oak floors.

For many years, the artist Lucile Leighton lived on the third floor, using the space's bright light to create her oil and watercolor paintings. She and her husband, Robert, traveled the world, sharing their stories in the 16 mm films he edited and assembled in what he called the home's kitch-den.

One of the building's first residents was Irene Castle. She and her first husband, Vernon, were one of the best-known ballroom dance teams in the world. After Vernon's death in World War I, a movie was made about them that starred Fred Astaire and Ginger Rogers. In 1923, Irene married the Chicagoan Frederic McLaughlin, owner of the Blackhawks. She is credited with designing the original sweater for the hockey team in 1926.

Today, the Third-Floor Studio is filled with art and artifacts, including many pieces of American and international folk art. Miller, who was profoundly influenced by the so-called primitive arts, would approve of Gerald W. Adelmann's large and varied collection. Edgar spent much of his life gathering motifs from around the world and channeling them into his art.

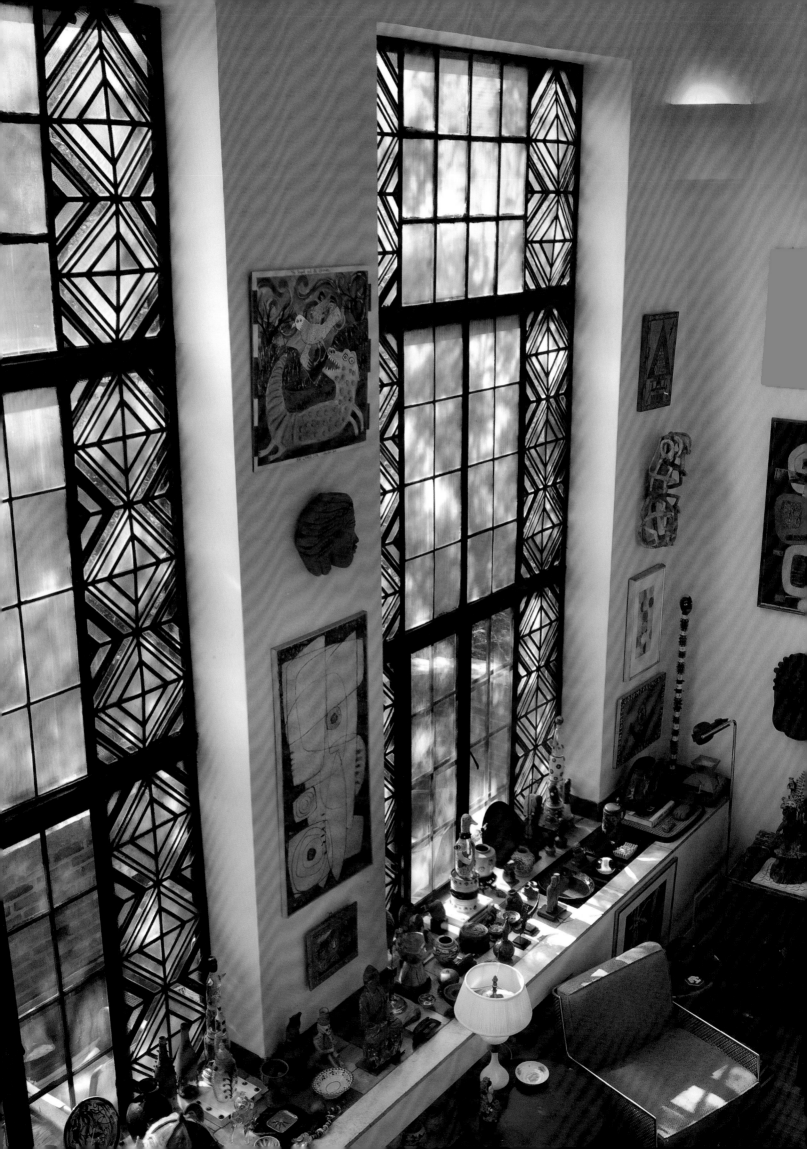

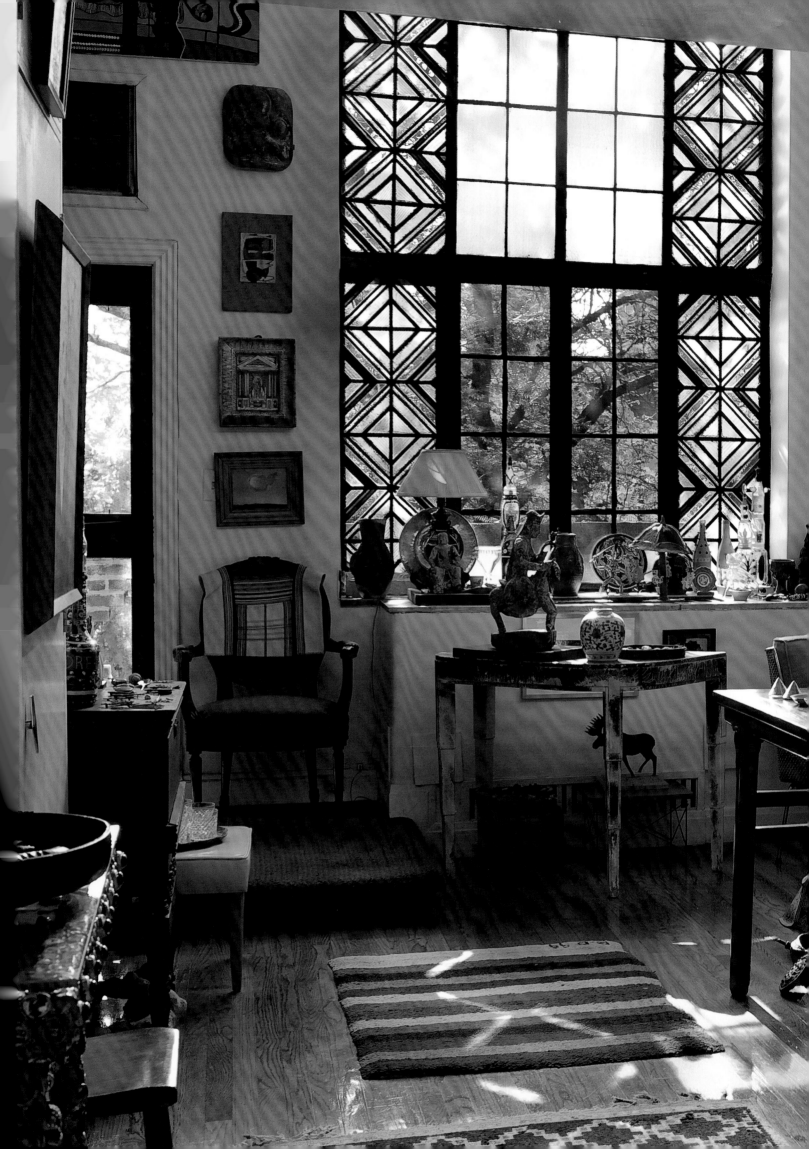

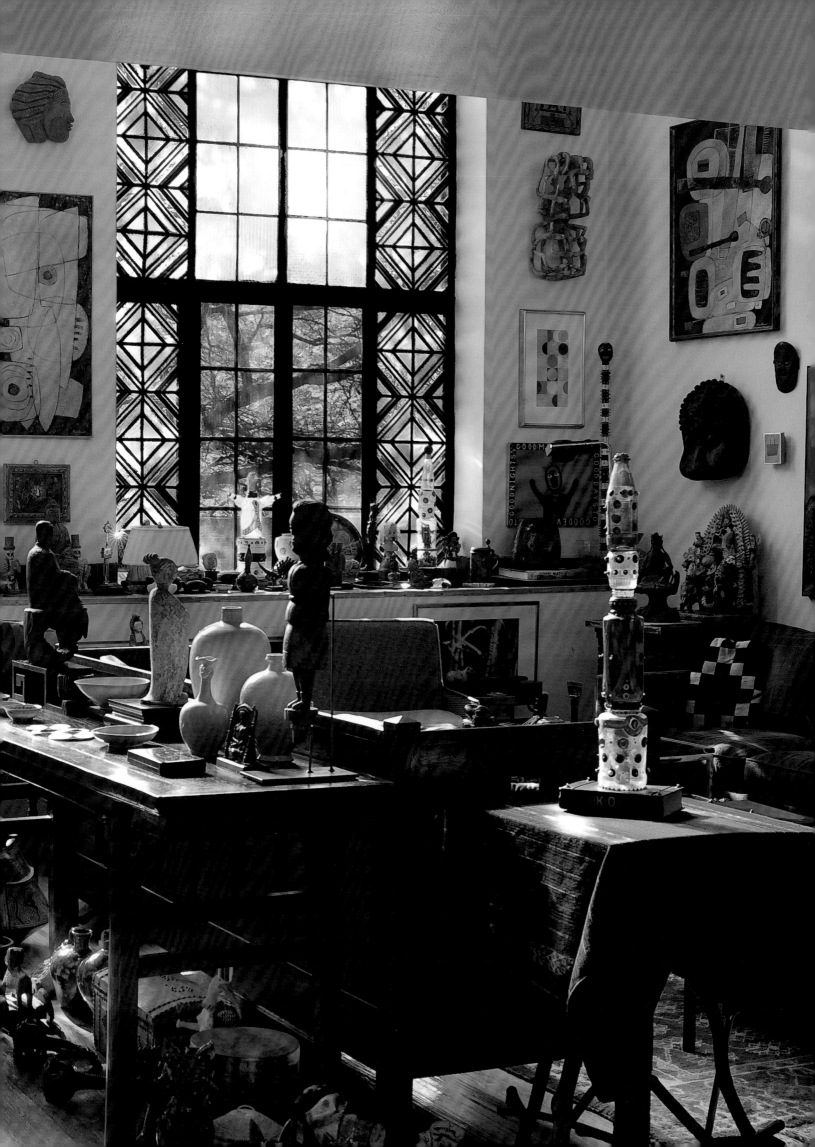

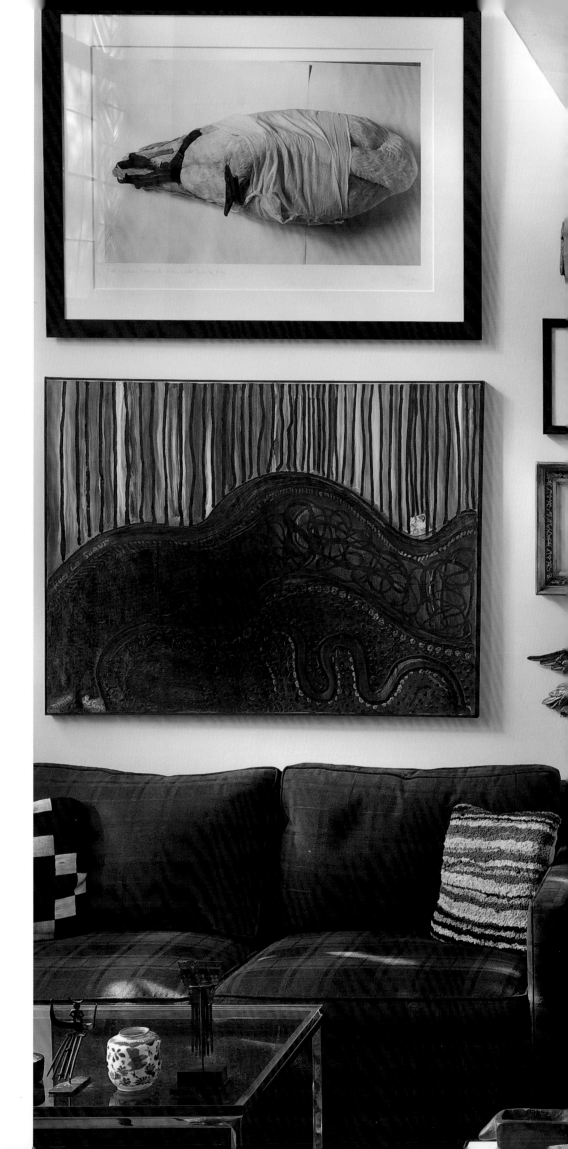

THE BAYEUX TAPESTRY, A FRENCH CREATION DEPICTING THE NORMAN INVASION OF ENGLAND IN 1066 AND THE EVENTS LEADING UP TO IT, INSPIRED MILLER'S FRESCO OVER THE MANTEL.

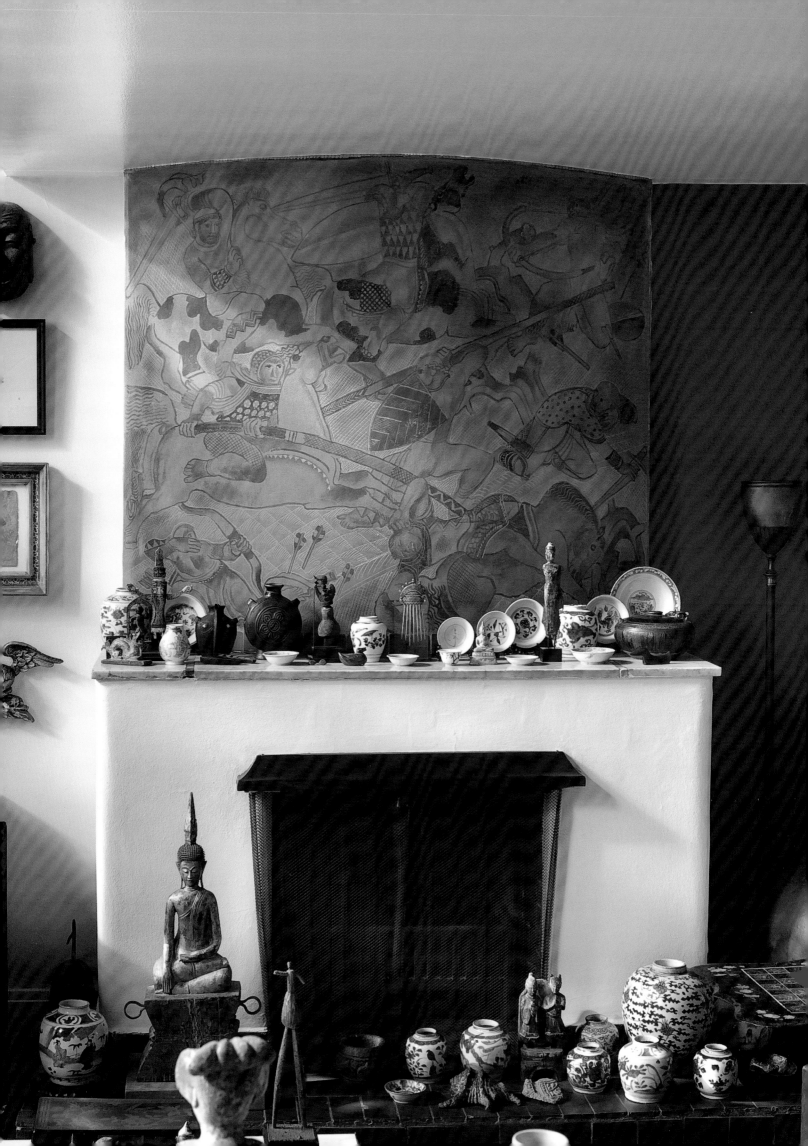

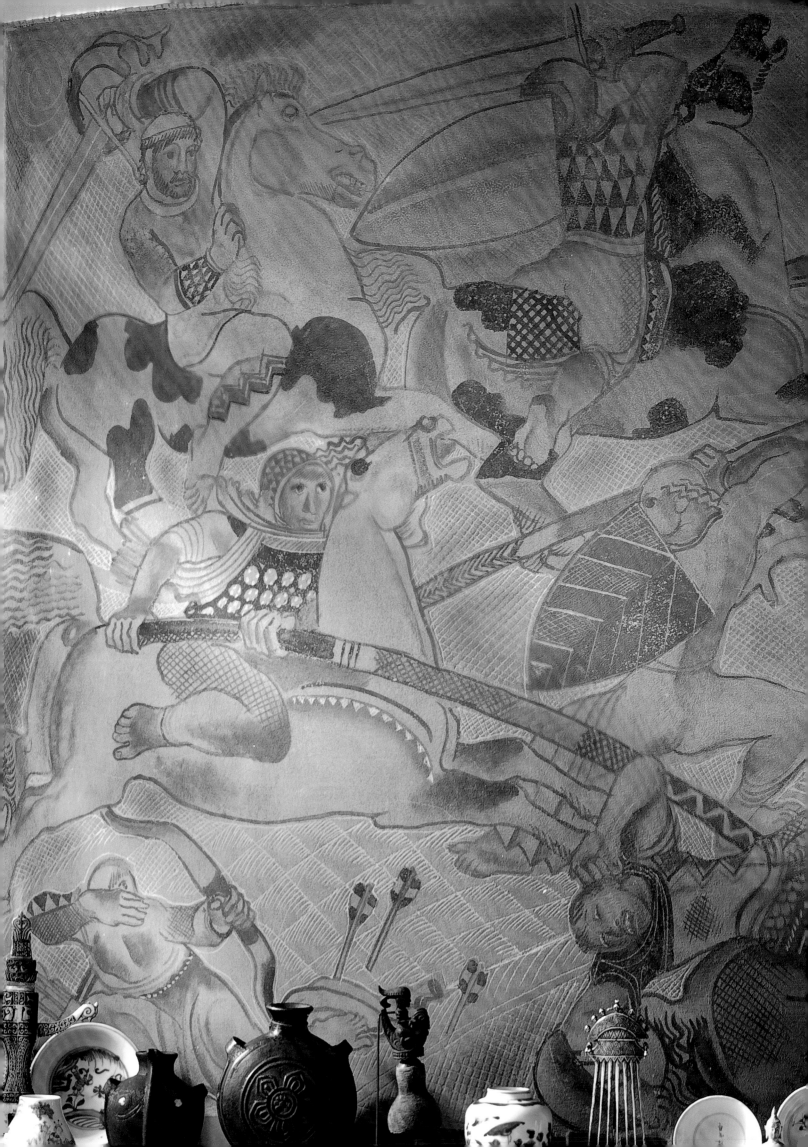

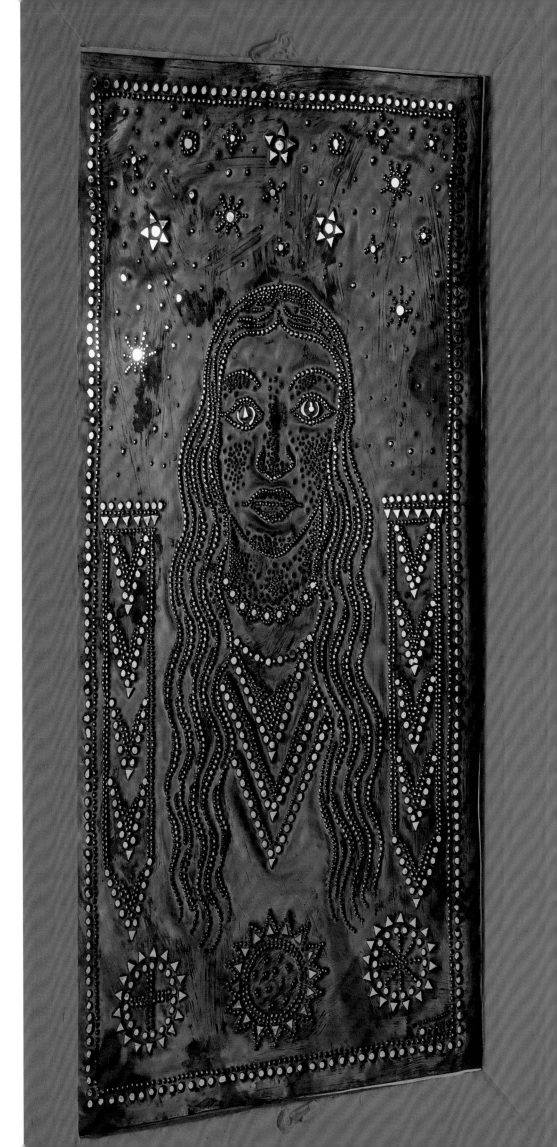

LEFT: MILLER'S FRESCO
CONTAINS GRAPHIC
SCENES OF BATTLE.

RIGHT: AN EXAMPLE OF
JESUS TORRES'S PIERCED-
BRASS WORK. HE ALSO
USED BRASS TO CREATE
LAMPSHADES, MASKS
AND JEWELRY, WHICH HE
SOLD IN HIS NORTH SIDE
SHOP.

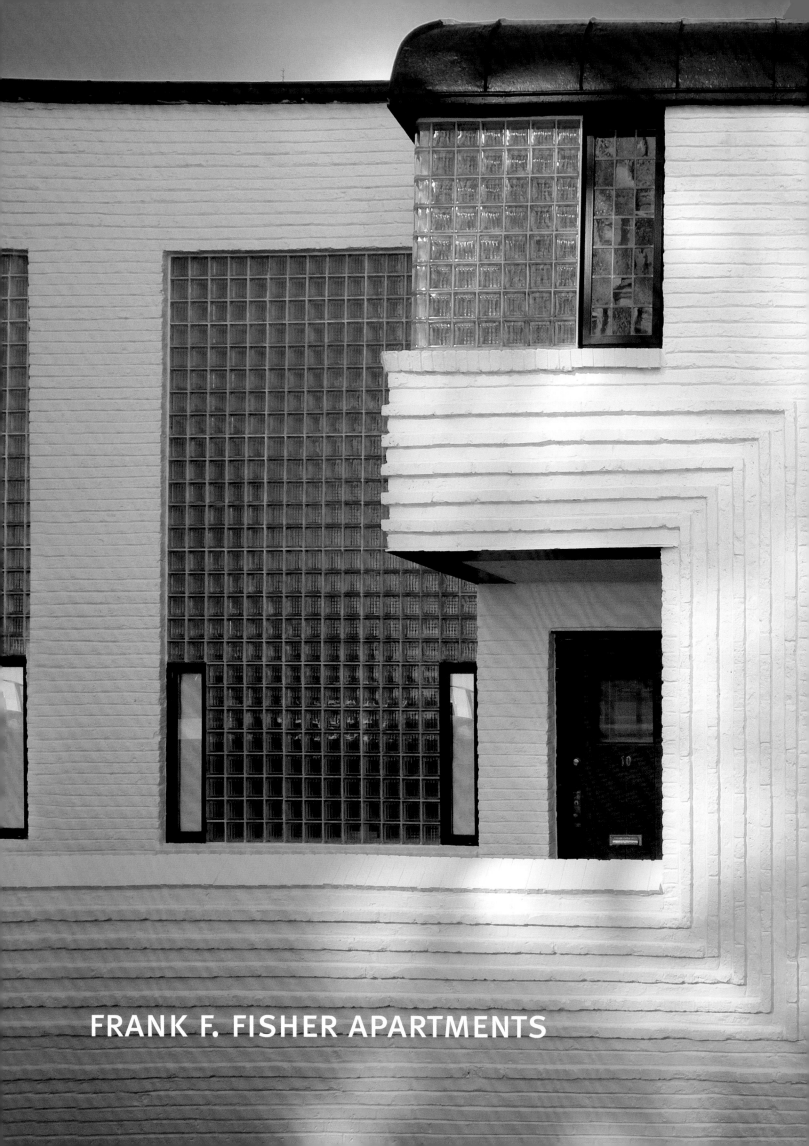

FRANK F. FISHER APARTMENTS

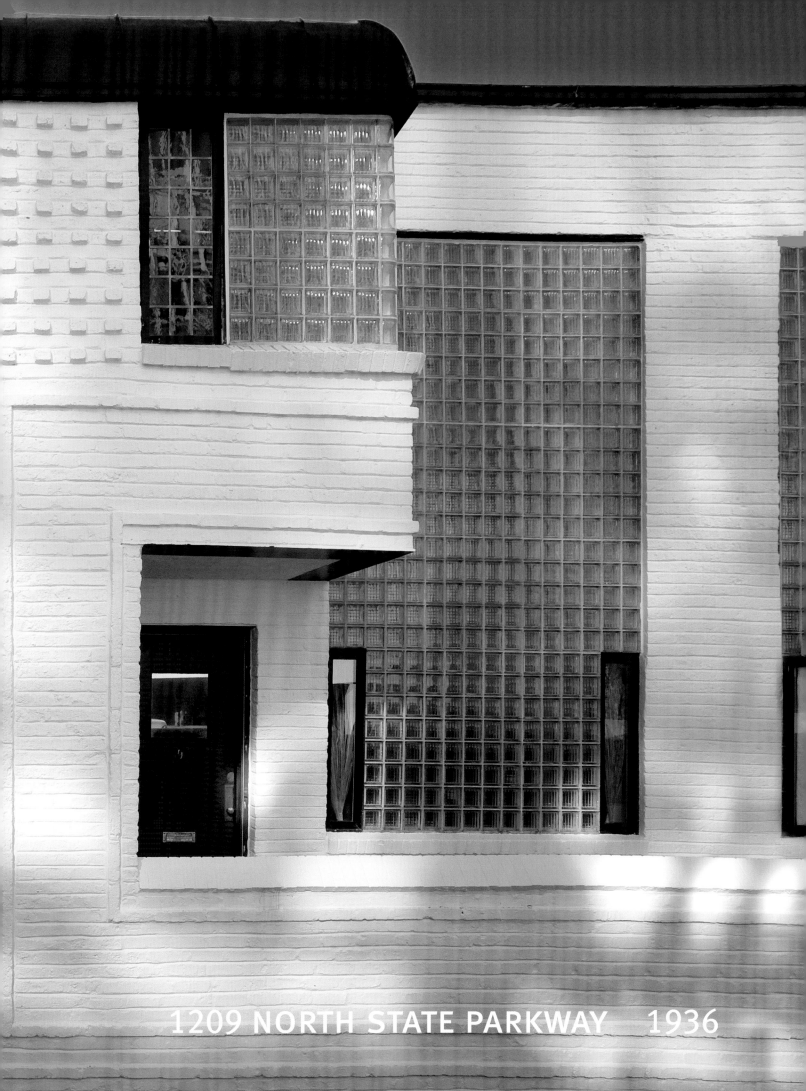

1209 NORTH STATE PARKWAY 1936

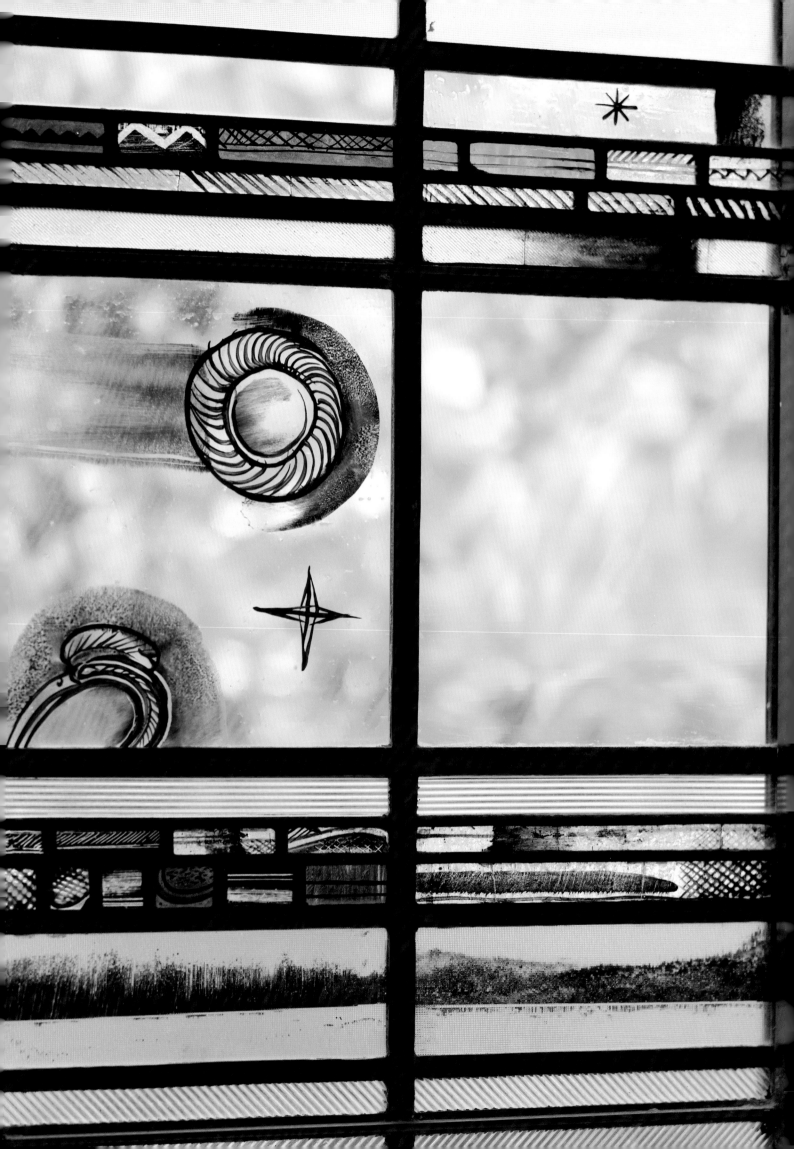

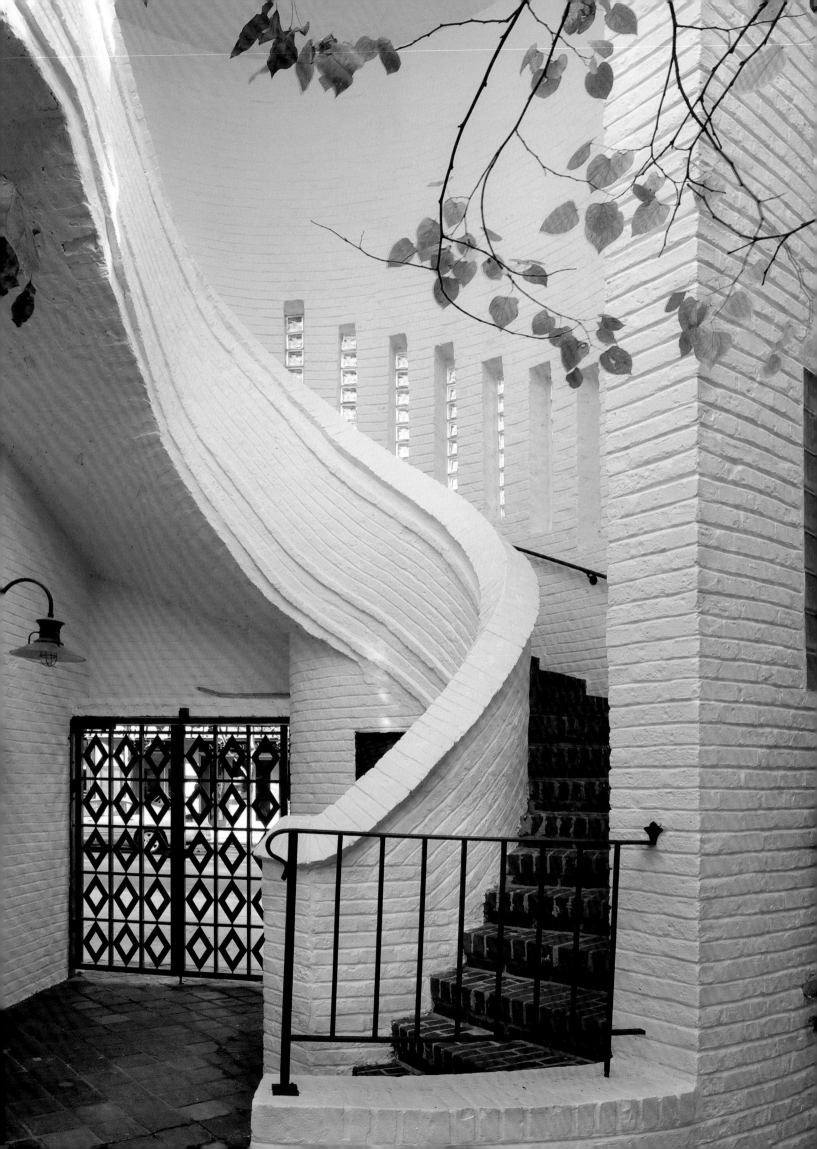

By 1936, Edgar Miller and Andrew Rebori had become close friends and collaborators. They shared the success of the Streets of Paris exhibit at A Century of Progress and suffered the disappointment of their failed nightclub, the Cascades in the Auditorium Theatre. But of all their work together, they will be best remembered for the Frank F. Fisher Apartments, a thirteen-unit building on Chicago's North Side.

The opportunity came when Frank Fisher, an executive at Marshall Field and Company, commissioned Rebori to build an investment property for him. Rebori needed the business. The 1930s were lean years for the architect, whose once prosperous architecture firm dissolved in 1930 due to the economic crisis. His personal finances were no better; he filed for bankruptcy in 1934.

After the Fisher job was secured, Rebori enlisted Miller to help shape the overall vision for the project. For years, it was assumed that Miller's role was limited to the stained-glass windows and carvings throughout the structure. But his role was far greater. "The Fisher building was a true collaboration," Miller wrote in the 1980s. "Andy saw it as the same kind of building that I had done on Burton Place. He had seen that building from its first development."

Drawings in Miller's sketchbooks show his hand in developing the distinctive brick staircase, as well as all of the carvings and castings and the front facade. "Andy accepted the design I made for the front on State Street without any change," Miller wrote.

The pair actually shared credit for the building—Miller as artist and Rebori as architect—in an article published in *Architectural Record* after the studio was completed. "Rebori was the only architect that could have handled it," Miller wrote. "The absence of my name on it has never bothered me."

NEW YORK TIMES ARCHITECTURE CRITIC ADA LOUISE HUXTABLE WROTE THAT MILLER AND REBORI'S BUILDING "SUGGESTS BOTH THE RUSSIAN CONSTRUCTIVISM OF CONSTANTIN MELNIKOFF AND THE PARISIAN CHIC OF ART MODERNE." THE WHITE BRICK WAS REPAINTED IN 2008.

STUDIO 1

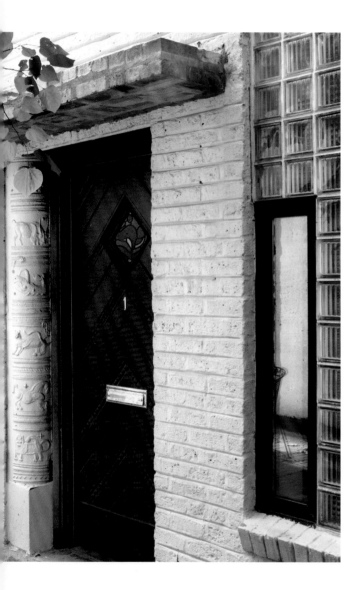

MILLER'S CAST-CONCRETE DESIGNS FRAME THE DOORWAYS OF THE FIRST LEVEL.

The Fisher Apartments share much in common with the basic design developed at the Carl Street and Kogen-Miller studios. Each features a series of small but bright duplex units overlooking a common courtyard. Each is built behind a sheltered wall that limits traffic noise. And each is bathed in Edgar Miller's art. But comparisons end there because the building on State Parkway was new construction.

While Miller had been creating unique interior spaces in his buildings, Andrew Rebori envisioned applying a spare, art moderne aesthetic to the Fisher project—one that all but eliminated the opportunities for significant decoration.

Rebori's vision dominates the building. His spaces are streamlined and controlled, with continuity from unit to unit. His aesthetic celebrates simplicity over ornamentation. Decorative details are secondary. He even painted the building's common bricks white, turning the complex into a lean, giant sculpture.

Yet Miller's art does play an important role. His beloved animals are painted in many of the windows, and the first level features cast-concrete doorways with animals in relief. These small but key elements soften the building, finding a middle ground between Miller's world, born of the arts and crafts movement, and Rebori's, marching towards modernism. In the end, it's a happy marriage.

The Fisher Apartments would be Miller's last dalliance in studio design.

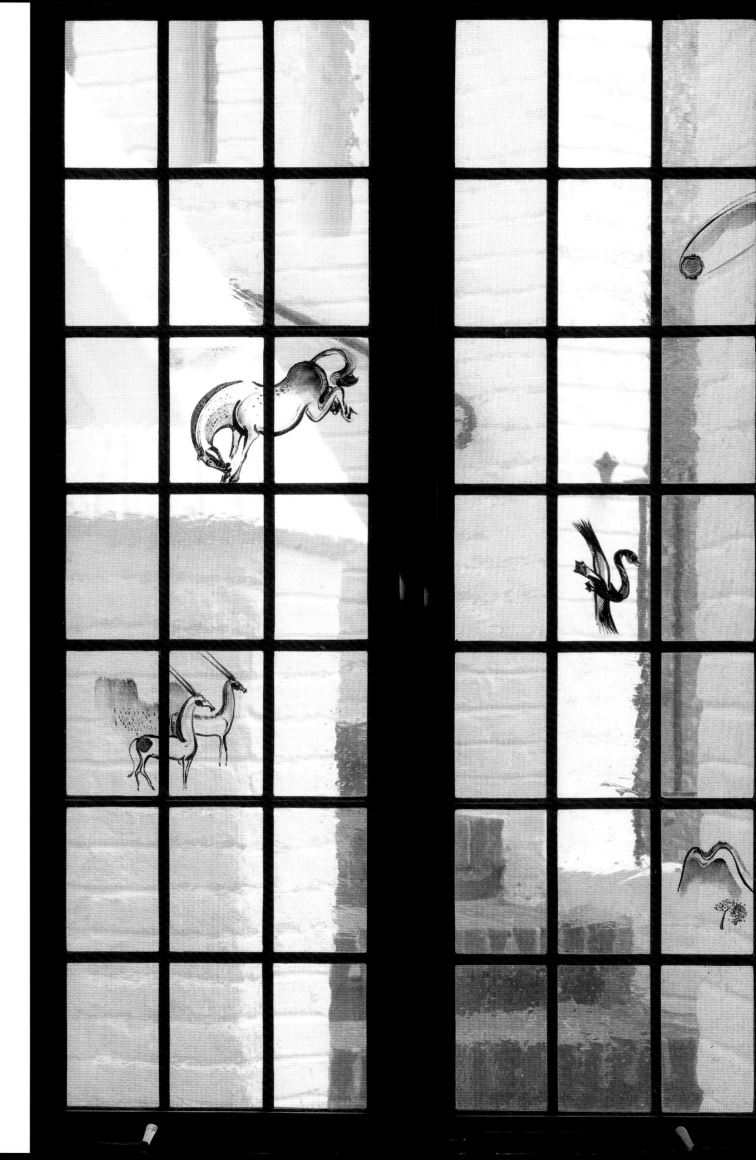

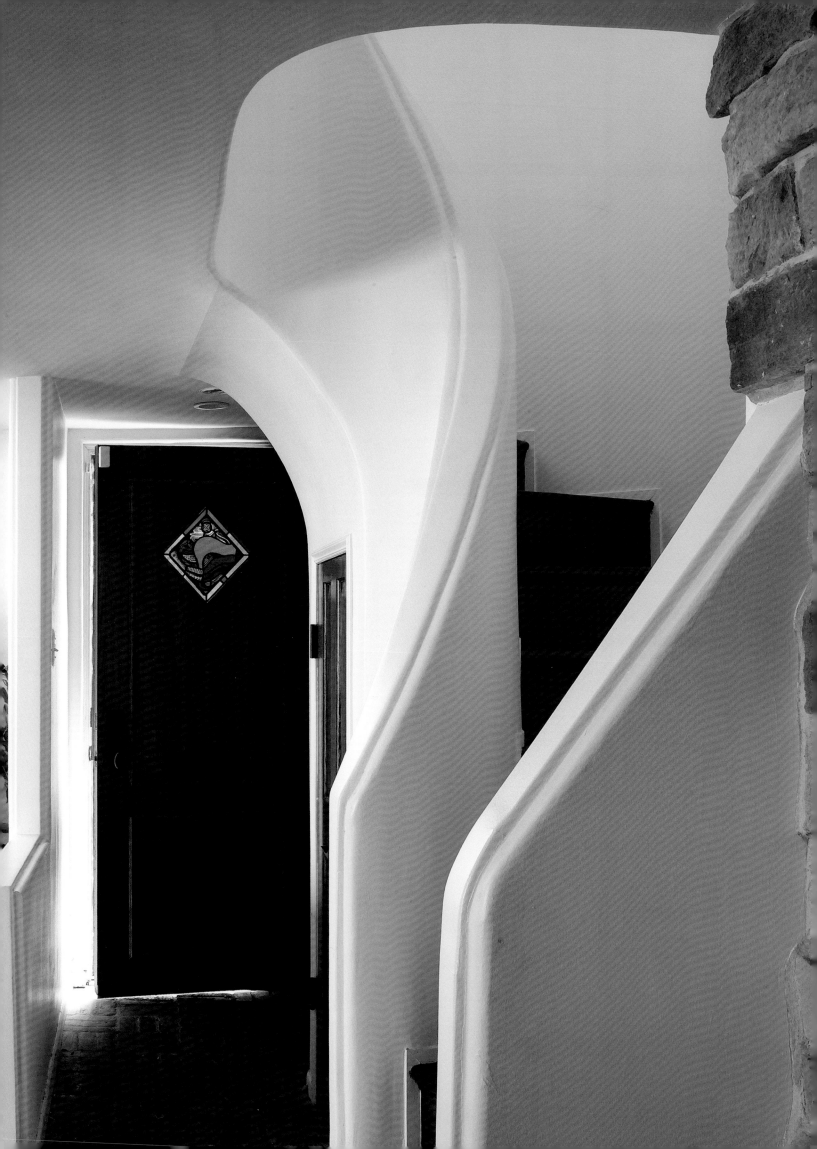

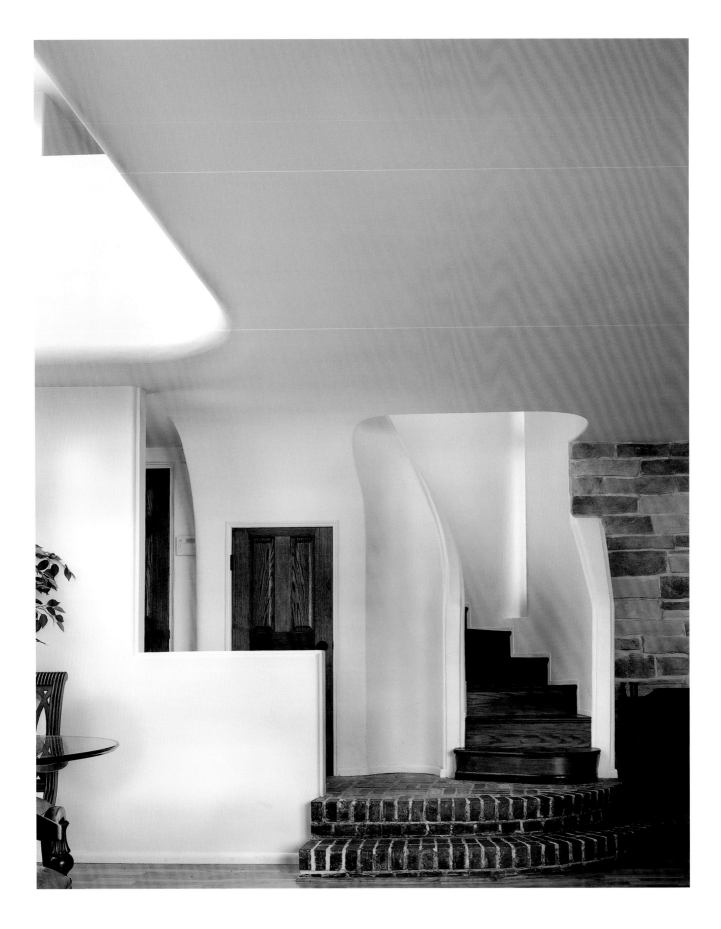

MILLER AND REBORI USED CONTINUOUS PLASTER WALLS AND CEILINGS IN THE INTERIOR WITH ROUNDED COR-
NERS, FREE FROM CORNICES OR MOLDINGS. "THE RESULT IS A RESTFUL FLOW OF PLANES WHICH FORM A PLEAS-
ING CONTRAST WITH THE LARGE GLASS SURFACES," THEY WROTE.

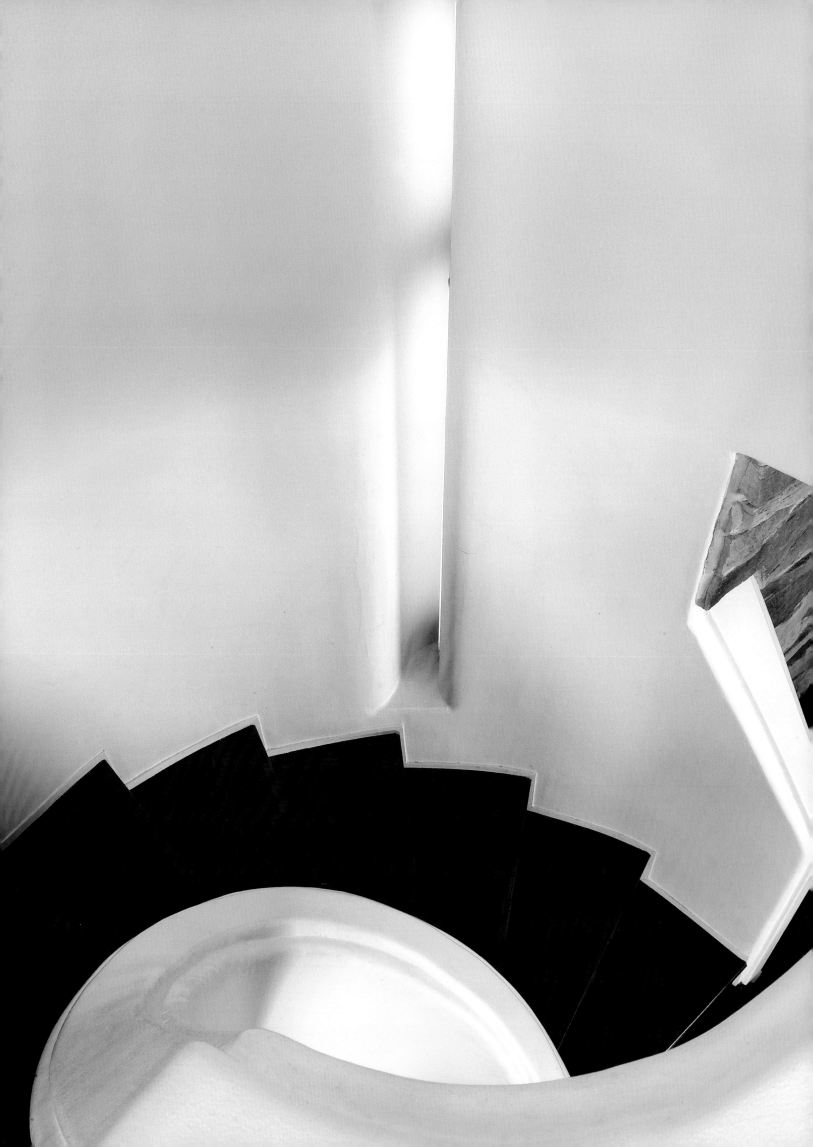

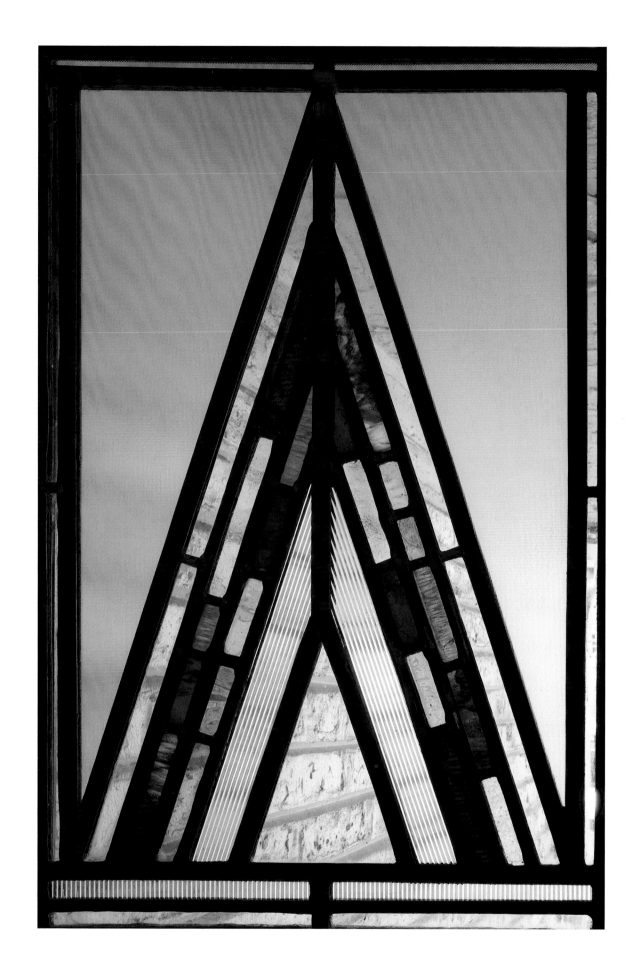

CHEVRONS AND SPIRALS ARE THE MAIN GEOMETRIC SHAPES OF STUDIO 1.

FRANK FISHER
STUDIO

**MILLER BRINGS THE WEST TO CHICAGO IN
A WOODEN GATE THAT GREETS VISITORS TO
THE STREAMLINED STUDIO.**

Edgar Miller and Andrew Rebori wrote in 1937 that the Frank Fisher Apartments "has inspired interest out of all proportion."

But sixty years later, interest had apparently waned. In the summer of 1998, the Fisher Apartments were under attack. Most of Edgar Miller's stained-glass windows lay heaped in a pile in the courtyard, and the building's delicate ribbons of brick were scarred and pitted from days of damaging sandblasting.

By the time city officials stopped the carnage, nearly seventy of Miller's windows had been thrown into the trash, including many with his elaborately painted animals and designs. Had it not been for the efforts of neighbors and architectural enthusiasts who brought the destruction to the city's attention, none of Edgar's art would have been left to salvage.

A housing court judge ruled that the building owner had to repair the damage, including to Miller's windows. Although the owner was slow to comply, most of the windows were eventually restored.

Frank Fisher's own apartment, at the end of the courtyard behind a gate carved by Miller, was not spared. It was sacked by the developer, who left the unit without a working kitchen or bath and with gaping holes in the walls and ceiling. Fortunately, most of the original details remained, including Miller's leaded-glass windows overlooking the courtyard.

With the return of many—but not all—of Miller's broken windows and a fresh coat of paint, the building is returning to its former glory.

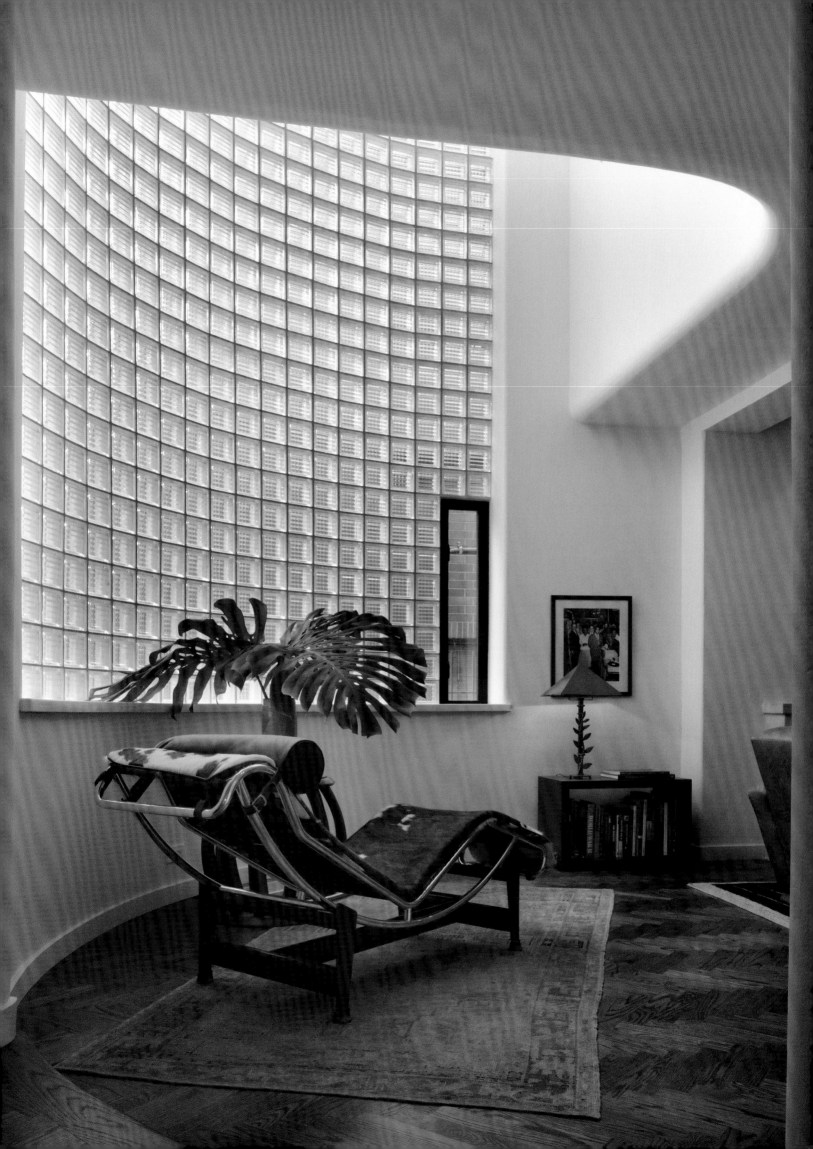

A CURVED STAIRWAY AND TWO-STORY WINDOW, BOTH REMINISCENT OF MILLER'S FIRST ARTISTS' STUDIOS. MILLER AND REBORI USED A COMBINATION OF GLASS BLOCK AND CASE-MENT WINDOWS THROUGHOUT THE BUILDING.

FOLLOWING PAGES: THE FRANK FISHER STUDIO IS THE ONLY UNIT LEFT WITH LARGE ORIGINAL STAINED-GLASS WINDOWS.

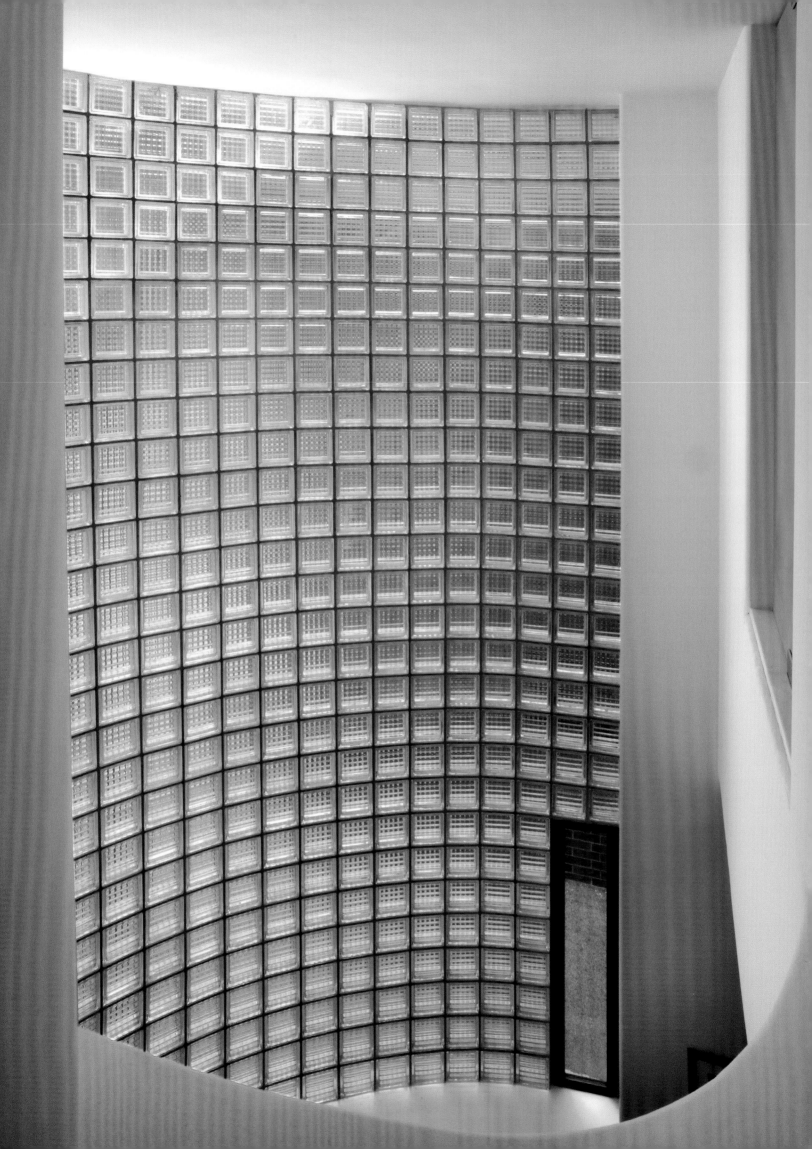

The Handmade Tradition

To me, the simple idea is the most important.

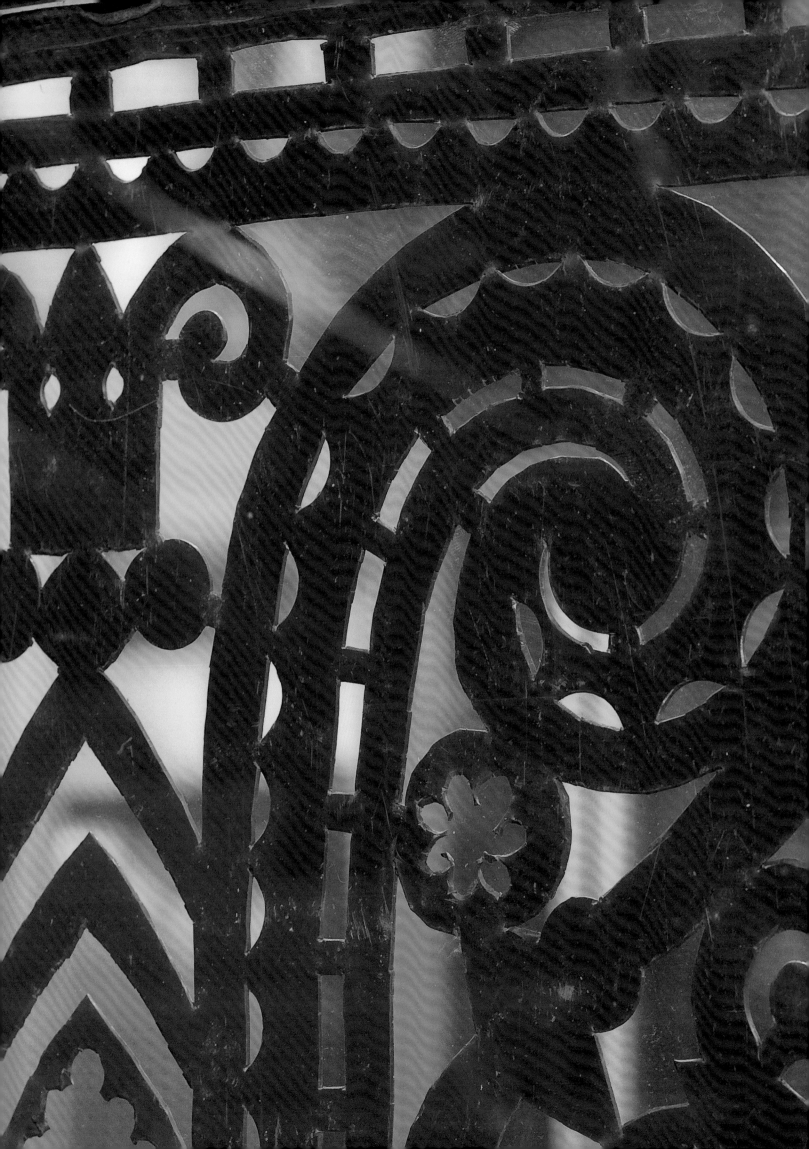

E dgar Miller took his first commercial assignment at thirteen and his last almost eight decades later. During his life, he worked in just about every medium and on every scale— from designing gift boxes and books to decorating restaurants and a state capitol.

Edgar didn't look at any of these jobs as drudgery, but rather as opportunities to practice, experiment and grow. "Everything you do is the sum of your past," he once said, and that could easily be his credo. With each job, something new was learned and carried forward to the next.

His five years in the commercial studios of Alfonso Iannelli likely had a lot to do with Edgar's attitude. Iannelli had the young Miller drawing, carving and sculpting—even if Edgar had no previous experience. It was here that Edgar learned to take on all sorts of work. "I was never stopped by a medium," Miller said. "I learned that if you want to do it, go ahead."

Personal work and commercial jobs blurred throughout Miller's career. He enjoyed them all. By the 1940s, Edgar had developed a reputation as one of the most prominent designers in the nation. Never motivated by money, he used his newfound status to look for special artistic challenges. They were all rendered in his handmade tradition.

Miller's commercial commissions number in the low hundreds. He worked nearly to the end, putting in long hours, often without breaks, into his nineties, despite the fact that he could only see out of the corners of his eyes. Finally, around 2001, he lost his depth perception, which made it impossible to continue creating art. "When he lost his vision, he started to quit," said Larry Zgoda. "He lost interest in life when he could no longer work."

MILLER DESIGNED WINDOWS FOR THE TRUSTEES SYSTEM SERVICE BUILDING IN 1930. LEAD MAGAZINE STATED THAT THE LOBBY WAS "VERY HAPPILY AND UNUSUALLY DECORATED BY LEAD CUT-OUTS."

WARREN DAVID OWEN LIBRARY

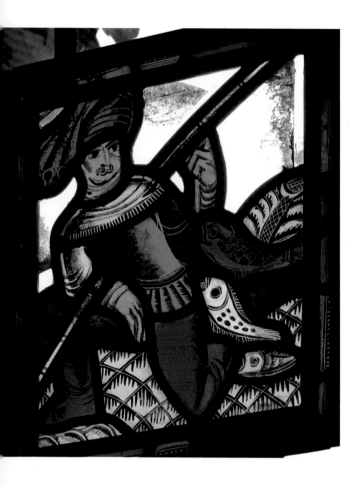

WINDOWS AT THE PRIVATE WARREN DAVID OWEN LIBRARY IN LAKE FOREST TAKE ON THE APPEARANCE OF MEDIEVAL MEDALLIONS.

FOLLOWING PAGES: THE LIBRARY WINDOWS. THE MANSION IS ON NORTH GREEN BAY ROAD NEAR LAUREL AVENUE IN LAKE FOREST.

At first glance, Edgar Miller and Howard Van Doren Shaw appear to be an improbable duo. When they met, Shaw was in his late fifties and the prime of his career; Miller was in his early twenties with little architectural experience. But they shared a deep appreciation for the Tudor and arts and crafts styles.

Their first collaboration was for an addition to the Lake Forest, Illinois, home of Warren David Owen, a wealthy investment banker, and his wife, Ruth, whose father, John R. Thompson, owned Henrici's restaurant and a chain of cafeterias bearing his name. Shaw designed a new library for the home, known as Chimney Cottage, with Miller creating ten medieval-themed stained-glass windows for the space.

At the time, Miller had just begun working in the medium, and his experience with the veteran architect proved invaluable. "Shaw gave me my first stained glass job in 1923," Miller recalled, "and nobody was more critical and knew more about stained glass than Shaw." Pleased with the work, Shaw hired Miller for two other projects in the early twenties: cut-lead windows for the Lakeside Press Building and the stained-glass windows for the sprawling A. G. Thomson House in Duluth, Minnesota.

The pair made plans for more work, but tragedy struck in 1926. "Shaw went away on vacation after telling me of the magnificent jobs I'd be doing when he came back," Miller recalled, "but he died, and I never saw him again. A meteoric career in that medium was brought to a dead end."

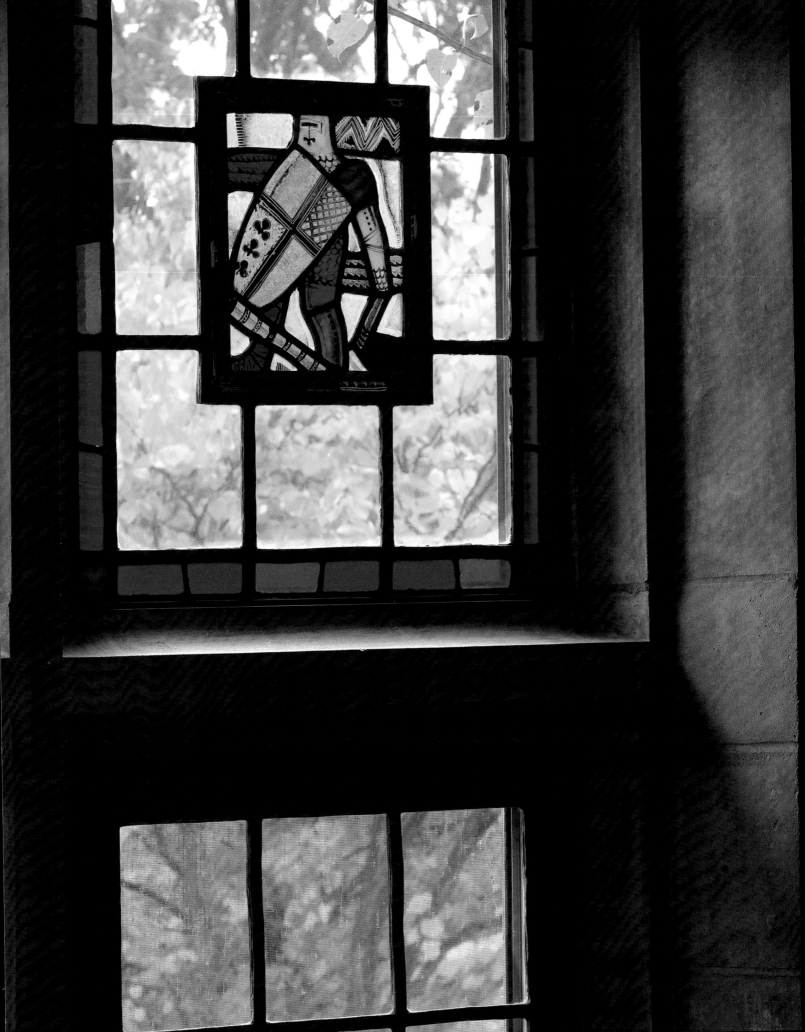

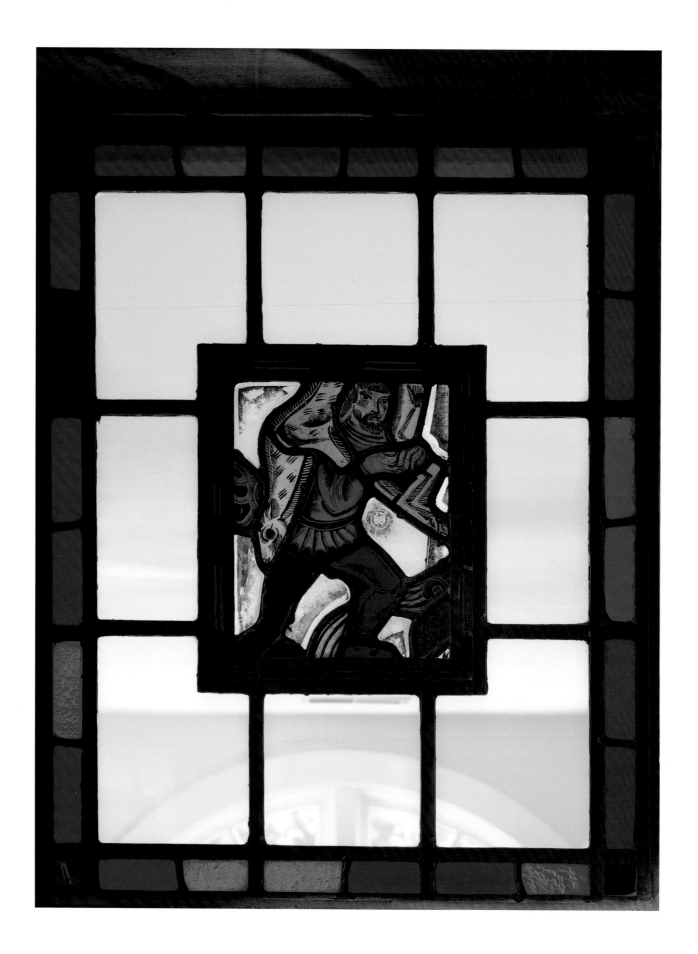

MILLER'S EARLY STAINED-GLASS WINDOWS LOOK LIKE HIS WOODCUTS—WITH COLOR ADDED.

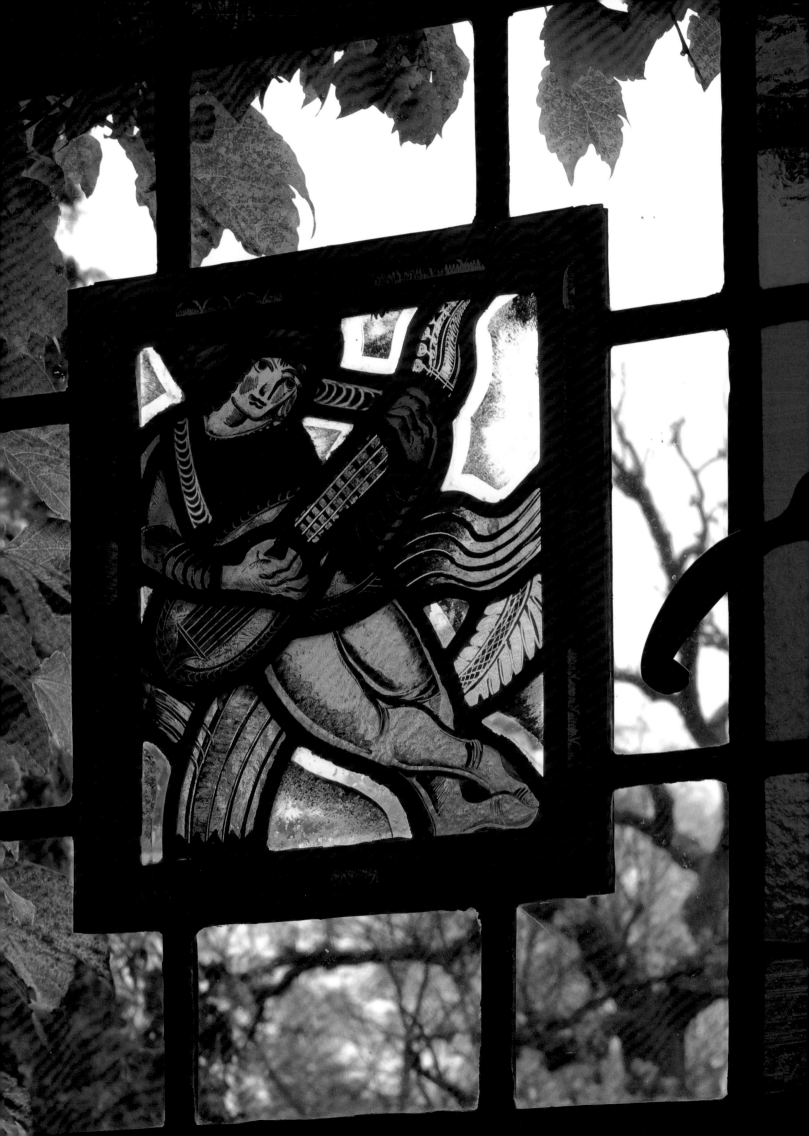

OAKRIDGE
MAUSOLEUM

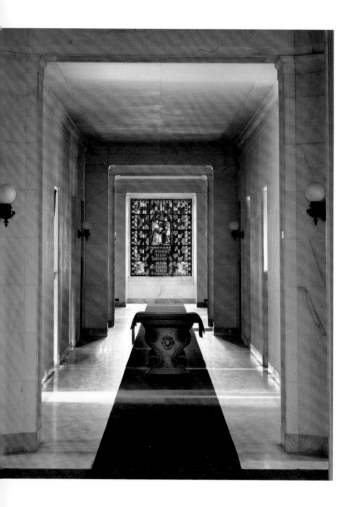

**MILLER SPENT ABOUT FIVE
YEARS CREATING WINDOWS AT
OAKRIDGE ABBEY.**

No single building holds more examples of Edgar Miller's stained-glass work than the mausoleum at Oakridge Cemetery in Hillside, Illinois. His windows fill the public areas, the chapel and many of the private memorial rooms.

The marble mausoleum, at 4301 West Roosevelt Road, was dedicated in 1928. Newspaper ads proclaimed: "This beautiful structure is built to endure, as endlessly as do the famed pyramids of Egypt, as faultlessly as does the Taj Mahal."

The commission came early in Miller's career and marked his largest commercial project. It is not known who hired Miller; neither the building's architect, Joseph Nadherny, nor the developer, Anders Anderson, had previously worked with Edgar. The pair built a nearly identical mausoleum at Acacia Park Cemetery in Norridge, but without Miller's glass the absence is dramatic.

Finding all of Miller's work at Oakridge Abbey is somewhat of a treasure hunt. His large Lady of Eternity window is easily spotted in the chapel. But catching sight of his stained glass for the private rooms that fill the huge building is more of a challenge because many are obscured by curtains.

Most of the glass is cosigned by Miller and Temple Art Glass, the firm that fabricated the windows. Hester Miller Murray helped paint many of the borders and was encouraged by her brother to sign the windows, but she declined. Hester thought Edgar should take full credit. She believed the dozens of windows that Edgar designed at the mausoleum to be among his best work.

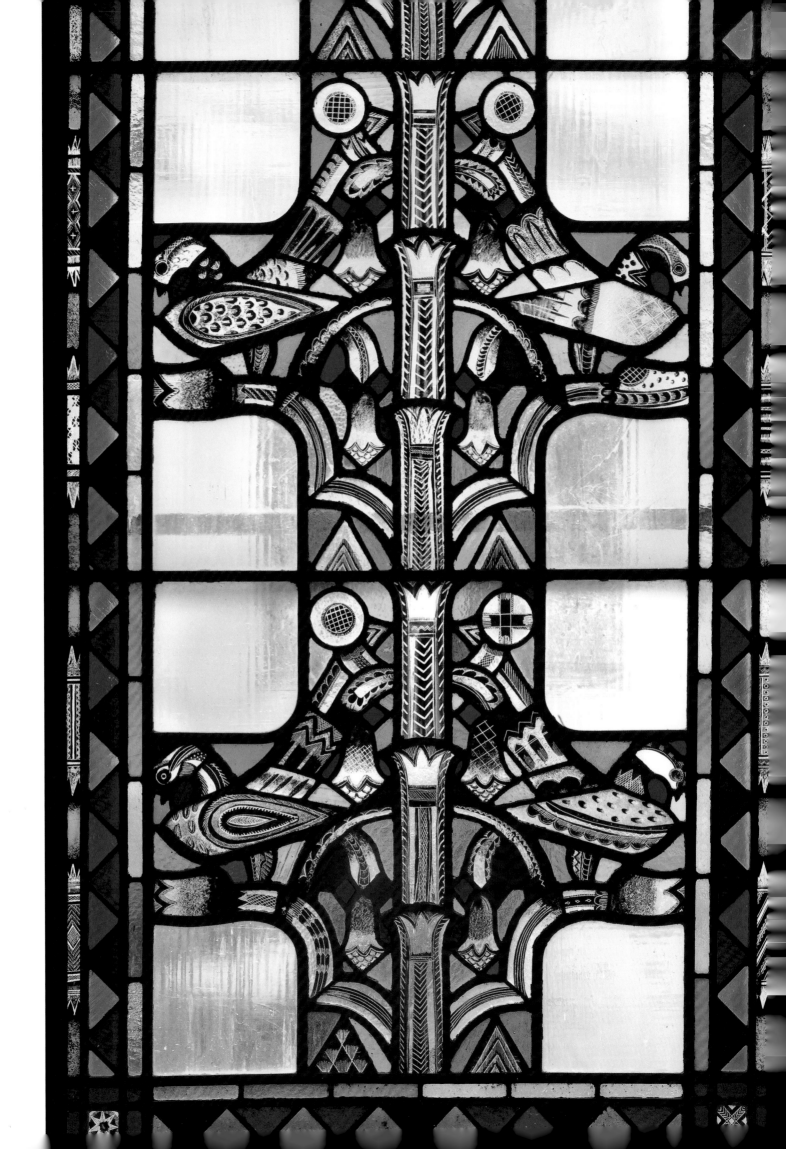

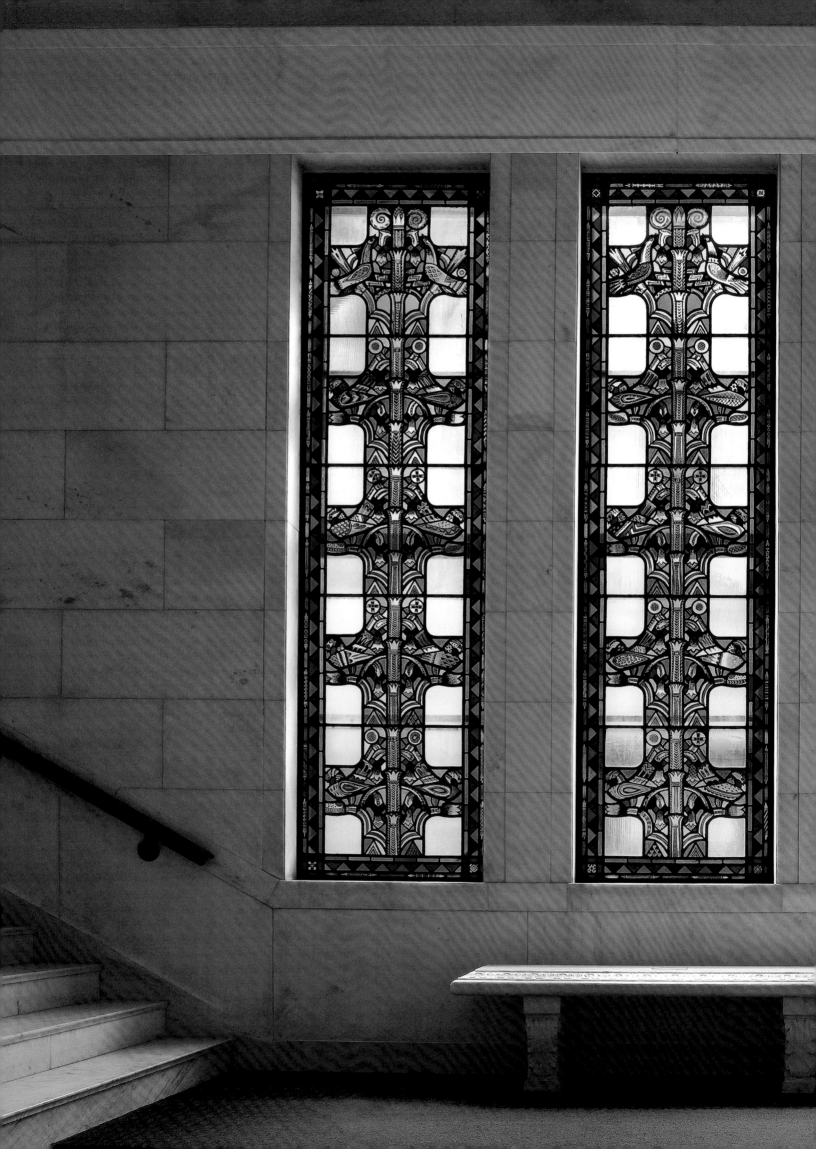

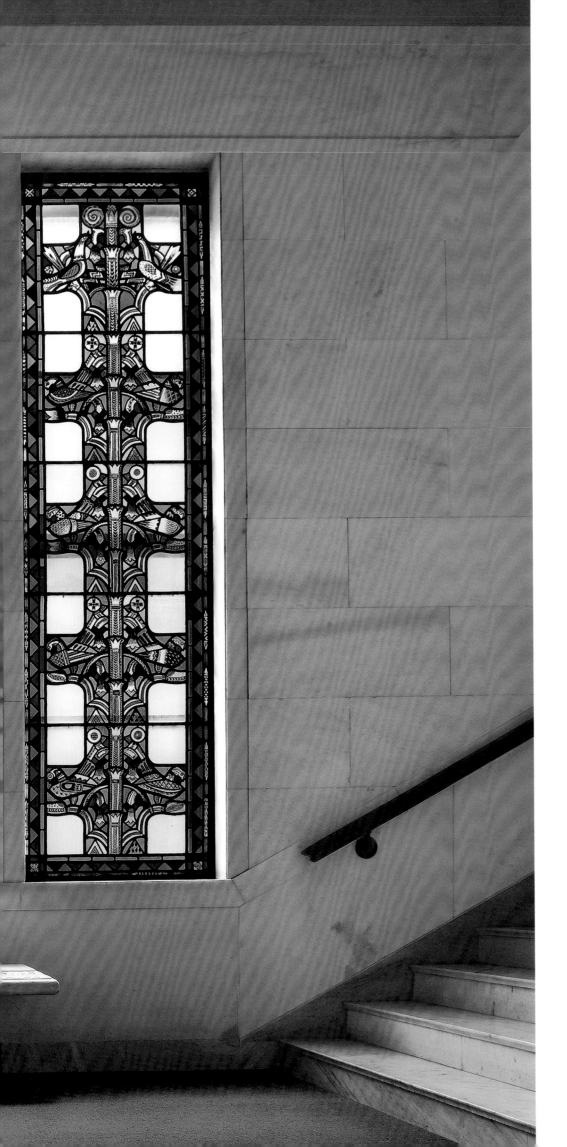

THE MAUSOLEUM,
DESIGNED AS A CRUCI-
FORM WITH INTERSECTING
AISLES, IS CRAMMED
WITH MILLER'S STAINED
GLASS. HESTER, WHO
HELPED HER BROTHER
AT THE MAUSOLEUM,
WROTE: "THE CHURCHES
OR MAUSOLEUMS WILL BE
HIS LEGACY."

FOLLOWING PAGES:
MILLER DESIGNED ALL
OF THE STAINED-GLASS
WINDOWS AND THE
LARGE SKYLIGHT IN THE
PUBLIC AREAS OF THE
MAUSOLEUM. HE WAS
ALSO COMMISSIONED
TO DESIGN GLASS IN
MANY OF THE PRIVATE
MEMORIAL ROOMS. THE
INDIVIDUAL ROOMS COST
$15,000 WHEN THE
MAUSOLEUM OPENED IN
1928.

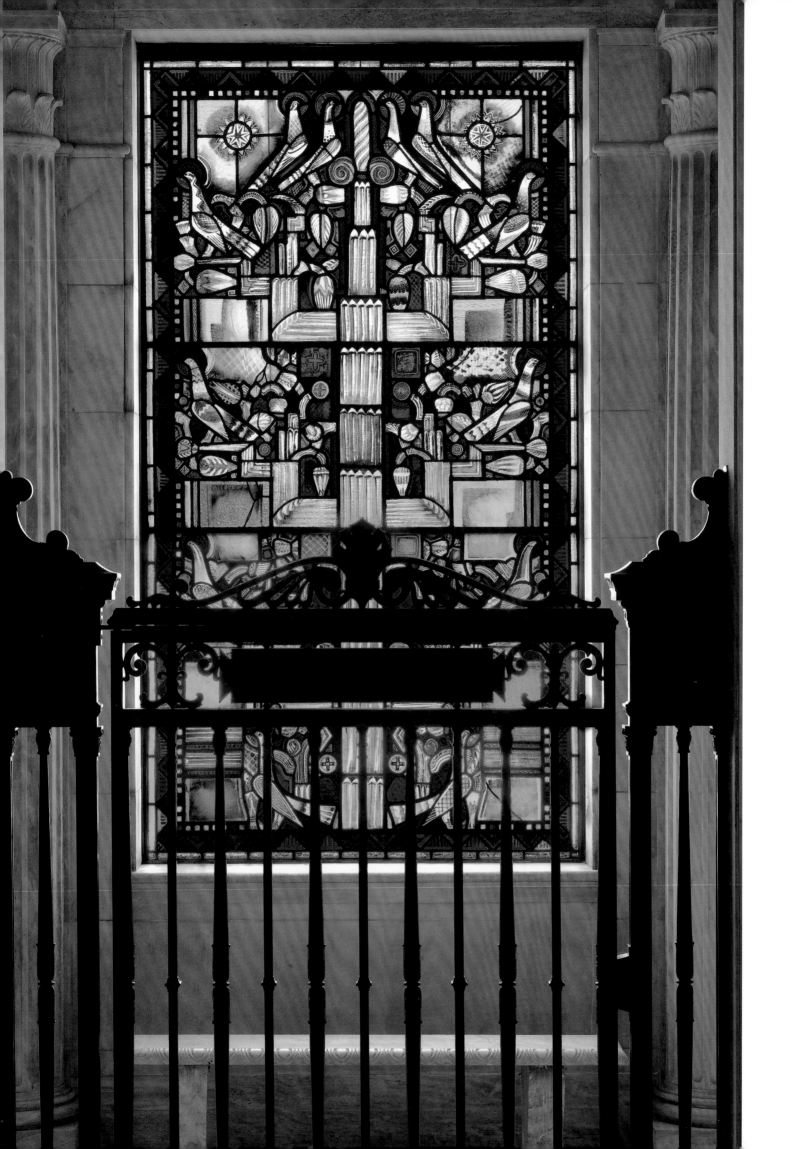

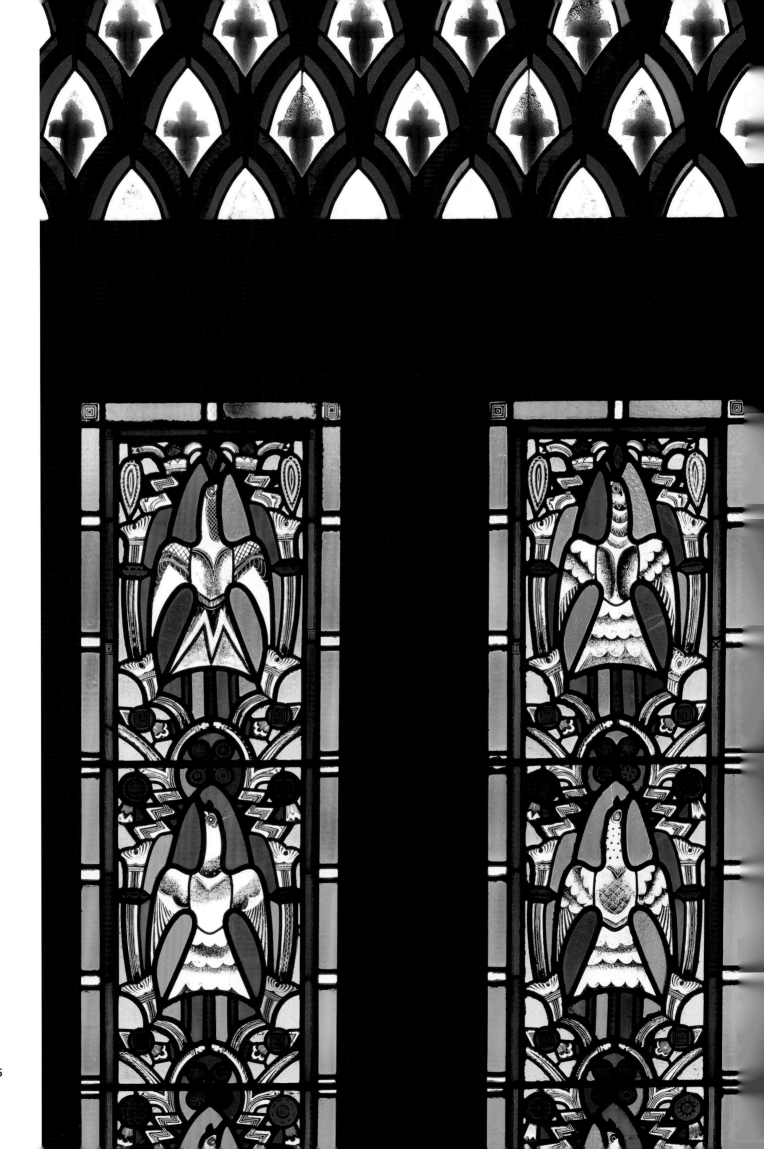

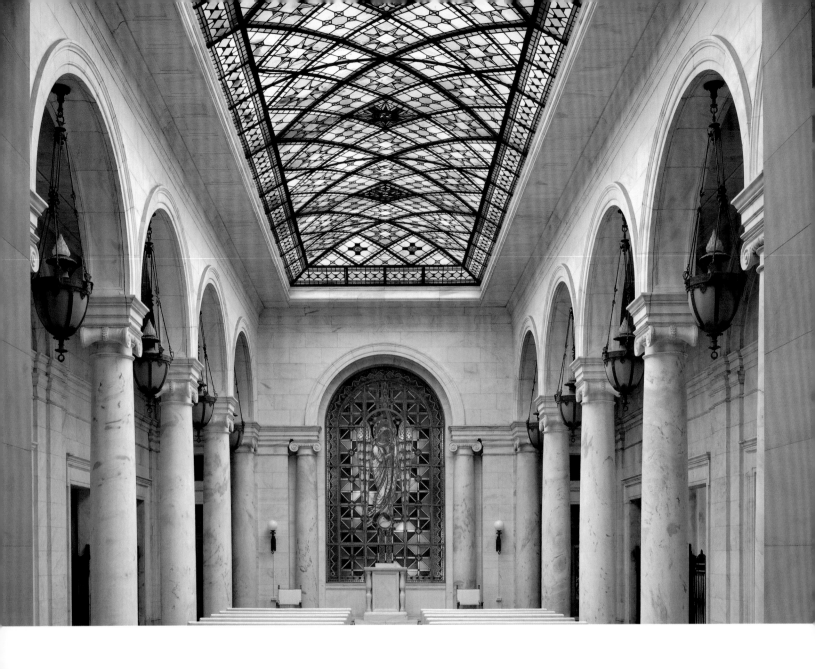

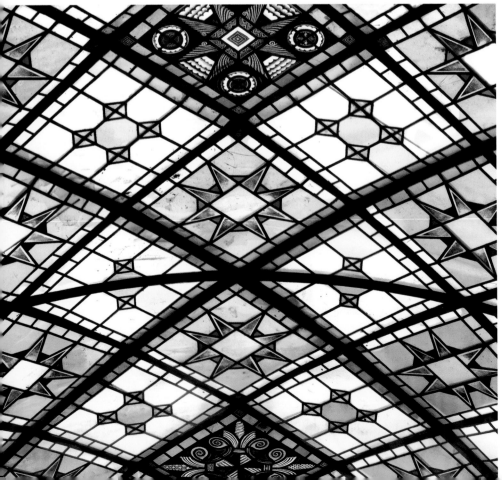

THE SECOND-FLOOR CHAPEL. "A CENTURY FROM NOW THOSE WHO VISIT THESE IMPOSING WHITE CORRIDORS WILL BE INSPIRED AND CHEERED BY THE QUIET RESTFULNESS AND CONSUMMATE BEAUTY," AN AD STATED WHEN THE MAUSOLEUM OPENED. THE CENTERPIECE OF THE ROOM IS MILLER'S NATURALLY LIT ART-GLASS SKYLIGHT AND HIS LADY OF ETERNITY WINDOW.

FOLLOWING PAGES: MILLER'S WINDOWS ARE AT THE END OF EACH OF THE GREAT AISLES AND MANY OF THE INTERSECTING CORRIDORS. HE ATTEMPTED TO RELATE THE WINDOWS IN THE PRIVATE ROOMS TO THEIR OWNERS, RENDERING THE GLASS WITH A MEDIEVAL INTERPRETATION.

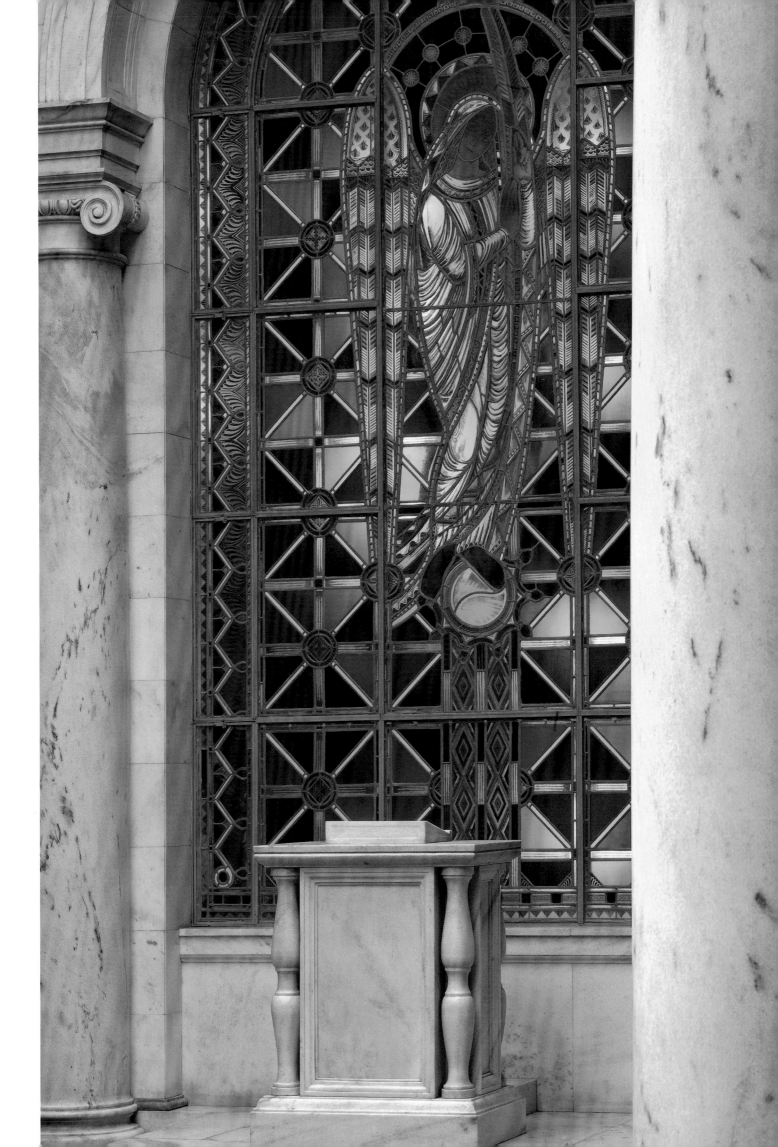

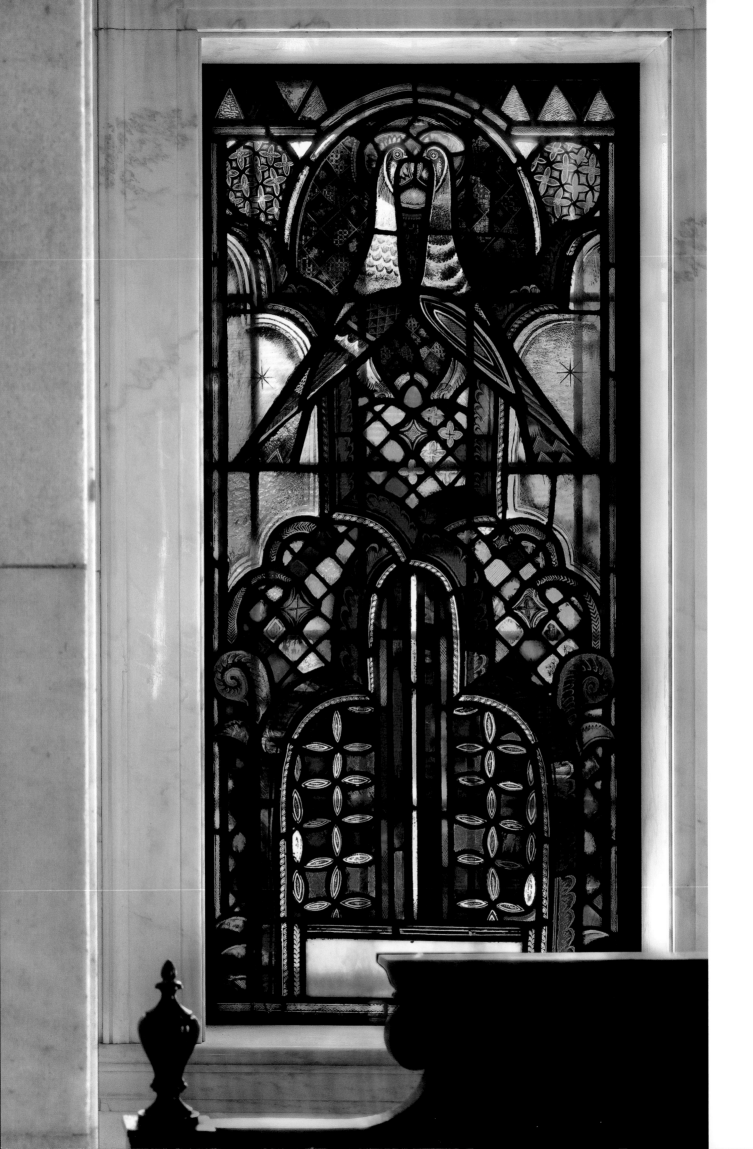

340

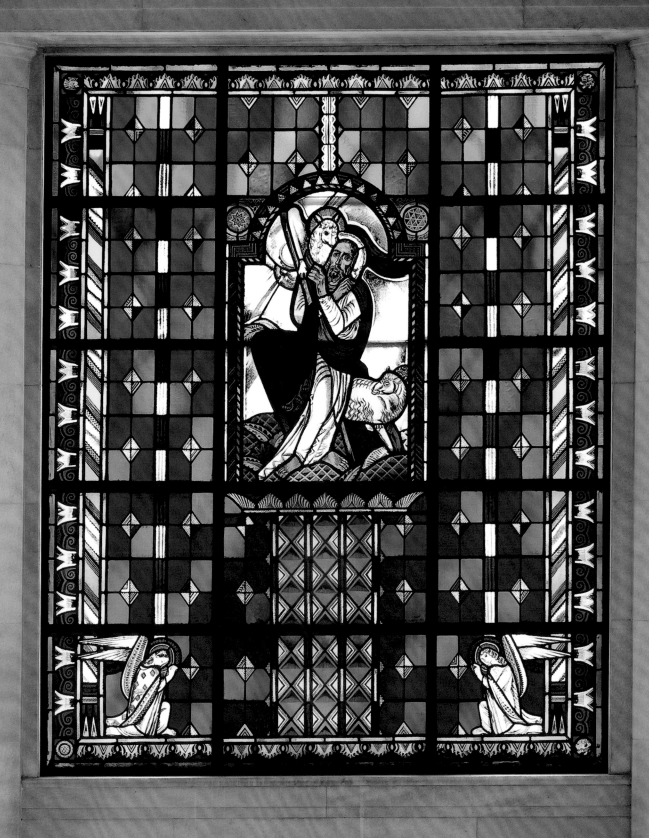

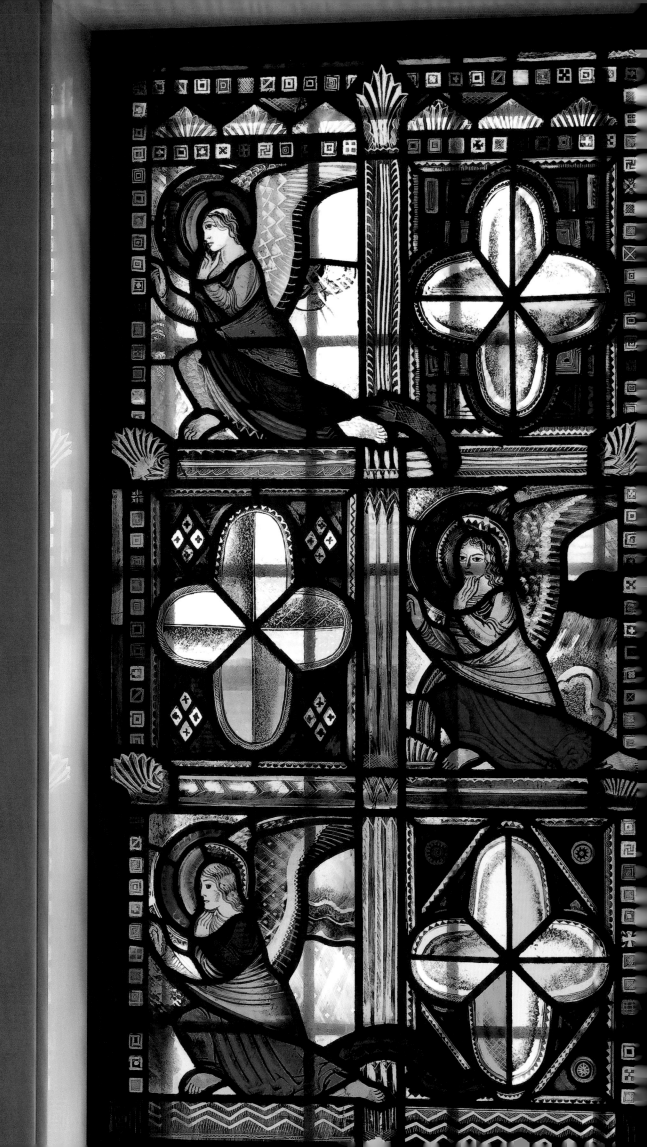

MEDINAH
ATHLETIC CLUB

THE BUILDING'S ARCHITECT PAID FOR THE MURALS IN THE ATHLETIC CLUB.

FOLLOWING PAGES: MEDIEVAL BATTLE SCENES IN THE KING ARTHUR FOYER AND COURT.

Built on the eve of the Great Depression, the 1929 Medinah Athletic Club didn't survive long as an upscale club and hotel. By the early 1930s, the club built by the Shriners was struggling to survive. In 1934, the lavish facilities, which included a swimming pool, bowling alley and driving range, closed.

The building at 505 North Michigan Avenue, now the InterContinental Chicago, was hailed as the "world's greatest club" when it opened. It cost $8 million, just half a million short of the neighboring Tribune Tower's price tag. The architect Walter Ahlschlager himself commissioned and paid for Edgar Miller to create the stained-glass windows in the men's lounge. The four windows depict classic medieval scenes in keeping with the Gothic architecture of the King Arthur Foyer and Court that Ahlschlager designed. A fifth window was removed during a renovation in the 1980s.

The windows were created in collaboration with Hester Miller Murray, whom Edgar came to rely on early in his career. While she had assisted her brother on a number of projects, this was the first for which she shared credit. "Years later, I went in and asked at the attendant's desk as to whom had done the glass," Hester wrote. "The attendant told me it was a count by the name of Hester Edgar. I was impressed. I did not educate him."

Hester went on to a successful career as a church decorator with her husband, Bert Murray. They worked on more than a hundred churches in the Chicago area together. She died in 1984.

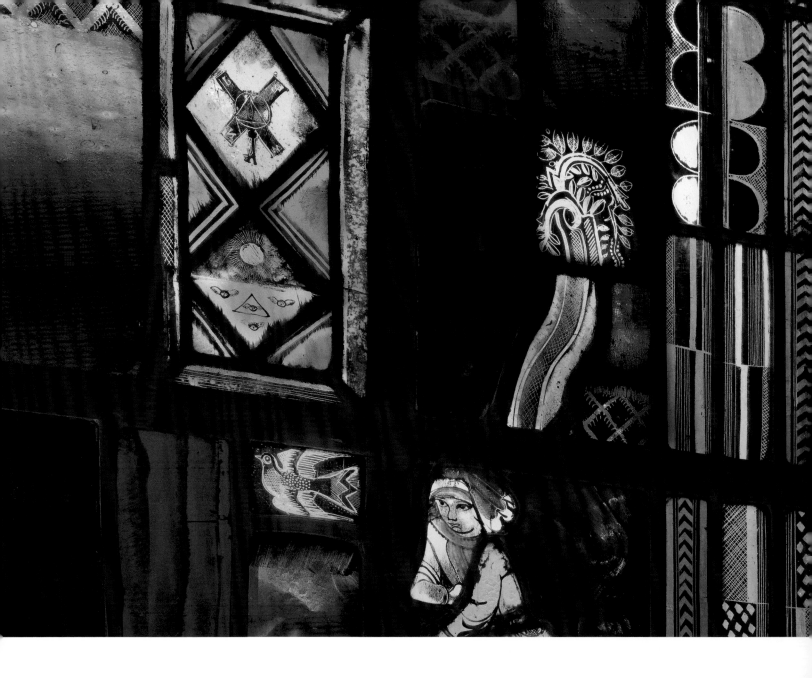

EDGAR ATTEMPTED TO INSTALL THE
WINDOWS HIMSELF, BUT RAN INTO
OPPOSITION. "I REMEMBER THE
THREAT OF THE UNION TO 'PUT A
LADDER THROUGH IT' IF I DIDN'T
COME UP WITH TWENTY BUCKS FOR
THE PUTTY GLAZIERS' UNION,"
EDGAR SAID. "UNIONS KILLED THE
STAINED-GLASS INDUSTRY."

TRUSTEES SYSTEM SERVICE BUILDING

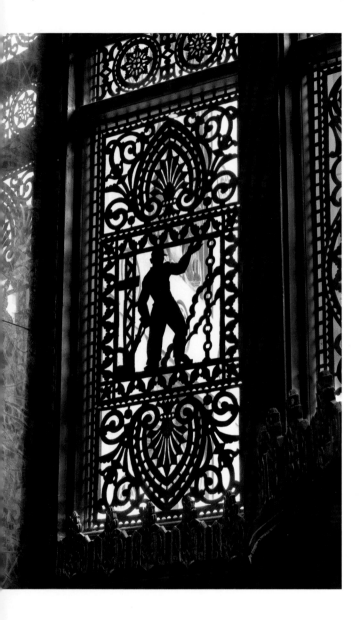

THE SOUTH-FACING LOBBY ILLUMINATES MILLER'S WORK THROUGHOUT THE DAY.

The Trustees System Service Building was one of the last skyscrapers begun in Chicago before the 1929 stock market crash. Edgar Miller's contribution to the art deco building at 182 West Lake Street in the Loop can be found in the lobby, where Edgar used his technique of cutting thin sheets of lead to create silhouettes that he sandwiched between two panes of glass.

Workers were the subject of the leaded glass, which was appropriate for the Trustees System, a bank that primarily provided small loans to midwestern farmers.

Miller had devised the cut-lead technique for one of his earliest commercial commissions, Howard Van Doren Shaw's Lakeside Press Building on the Near South Side. There, Miller crafted windows depicting a history of printing, which featured William Morris's Kelmscott Press and William Caxton's press in England, for the building's private library.

Miller used lead so that he could create silhouettes of pure black and white. "I had never seen this particular use of lead, but I suppose it exists, because it is obvious. I have never thought of it as an invention." It wasn't. Cut lead was used in glass windows since the 1890s by such well-known makers as the Tiffany Studios and the California architects Charles and Henry Greene.

Once again, Edgar designed the windows and Hester cut much of the lead. Edgar used the technique throughout his career, including in the executive offices of the Palmolive Building and at the Kogen-Miller and Carl Street studios and the Walter Guest Apartments.

The Trustees System went bankrupt in 1932. The building is now a residential skyscraper, called Century Tower. Its two-story lobby is the last homage to the Roaring Twenties.

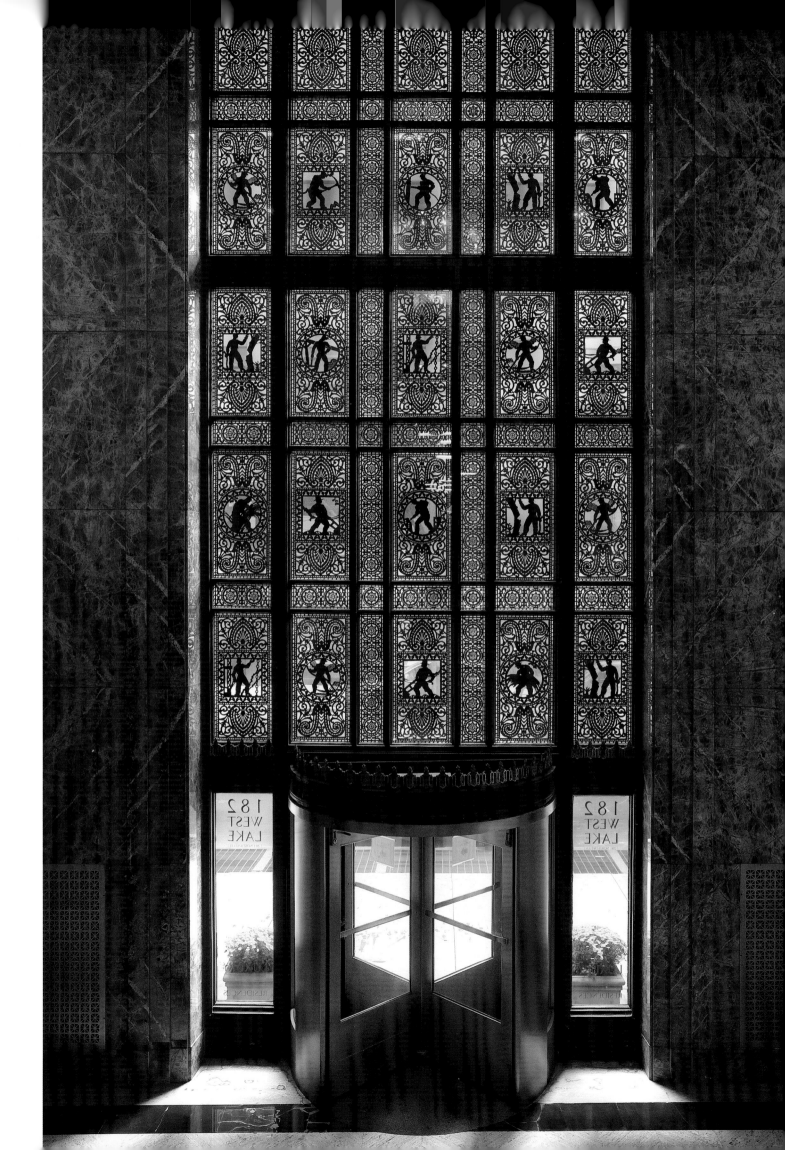

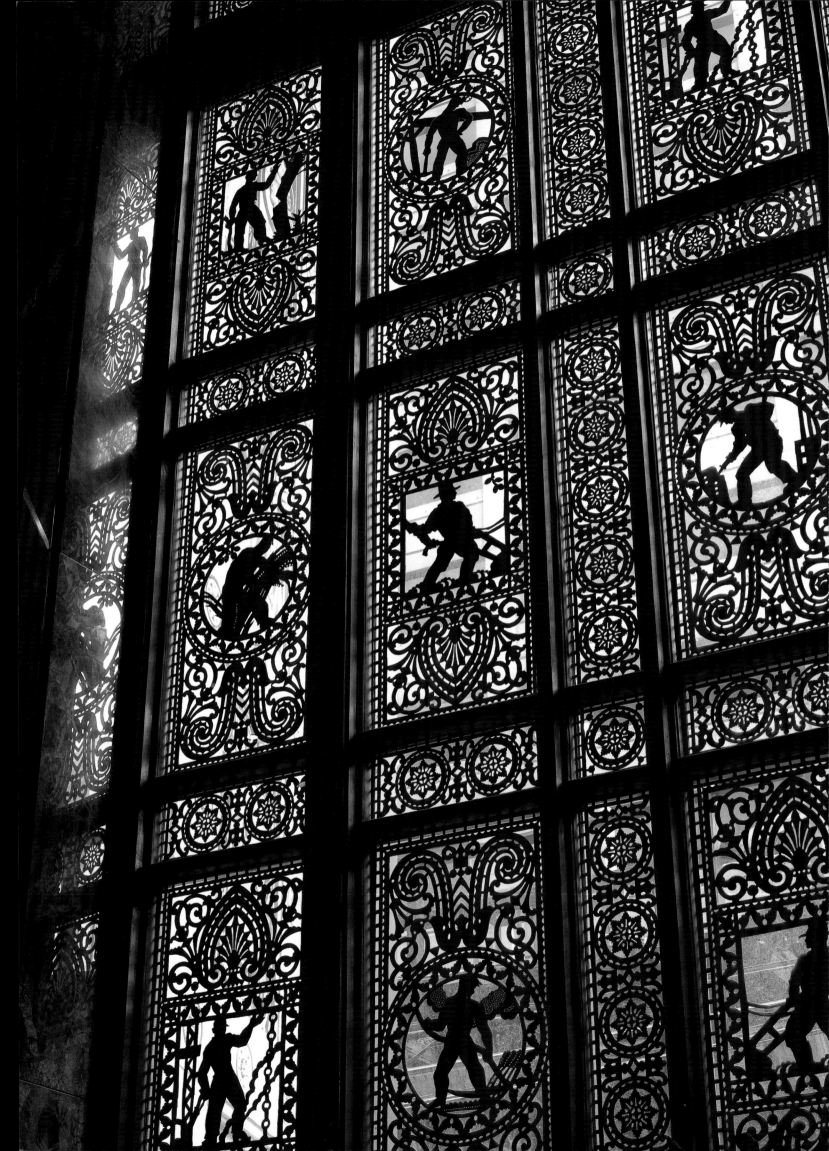

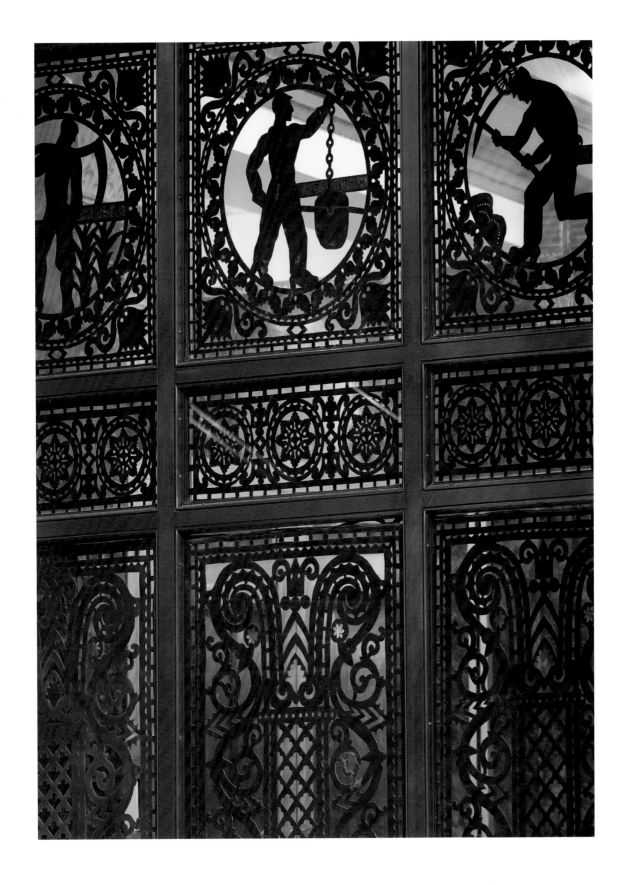

MEN AT WORK. A CONTEMPORARY BUILDING MAGAZINE REPORTED THAT MILLER'S CUT-LEAD
TECHNIQUE SAVED THE BUILDING'S ARCHITECTS, THIELBAR AND FUGARD, $8,000 OVER WHAT
ORDINARY BRONZE GRILLWORK WOULD HAVE COST. BUT MILLER'S CUT-LEAD SILHOUETTES ARE
NOT WITHOUT FLAW. OVER THE YEARS, MOISTURE HAS BEEN TRAPPED BETWEEN THE PANES, CAUS-
ING DAMAGE TO THE LEAD.

LAWSON YMCA CHAPEL

MEDIEVAL FIGURES COMBINE WITH ART DECO STYLES.

When Victor Lawson, the editor and publisher of the Chicago Daily News, died in 1925, he left behind an estate of nearly $20 million. His will stipulated that $1 million be given to the local YMCA, which used the money to help construct a men's residence named in his honor on Chicago's Near North Side.

When it was completed in 1931, the twenty-four-story Lawson YMCA House, at 30 West Chicago Avenue, was the organization's largest building to date, costing $2.75 million. The skyscraper was a modern social experiment, offering more than seven hundred male residents a radio and telephone in each room, a rifle range, hobby studios, and even a permanent boxing ring. The idea was to create a clublike atmosphere for the middle class.

Befitting the sleek YMCA, an ultramodern chapel was constructed on the second floor for private meditation and group worship. Edgar Miller was hired to design the leaded-glass windows. The windows demonstrate the versatility of Miller, who made these art deco–style religious windows at the same time he was constructing more traditional windows for other religious institutions.

Miller's stained glass from that period caught the attention of many art critics, including Margaret Weilert, who wrote: "Instead of using many small pieces of different colors, Mr. Miller, by using superior modern methods, is able to impart several colors to one piece of glass. The result, as has been said, is something the like of which has never been done before."

Because the building no longer functions as a hotel, Miller's chapel windows are not accessible to the public. But they look as modern as the day they were built.

KELVYN PARK
HIGH SCHOOL
LIBRARY

THE ANXIETY AND THRILL OF OCEAN EXPLORATION.

FOLLOWING PAGES: PANELS MOUNTED IN THE LIBRARY OF KELVYN PARK HIGH SCHOOL.

There is a long tradition of public art in Chicago's schools, which accounts for hundreds of murals by many of the city's leading artists. They communicate Chicago's history, values and beliefs through the artist's eye—usually on canvases or walls. Telling these stories in stained glass, as Edgar Miller did at Kelvyn Park High School, then a junior high school, is unique to the schools.

The five panels, each about three by two feet, were commissioned by the graduating class of 1933 to honor the principal, C. E. Lang. Arranged somewhat chronologically, they sum up Edgar's take on two thousand years of Western civilization, starting with the ancient Egyptians and Greeks and concluding in the United States. One panel features explorers such as Eric the Red, credited with discovering Greenland; Leif Eriksson (Edgar spelled his name oddly), who discovered North America; and Amerigo Vespucci, the Italian that America was named after. Two panels show navigators: Bartolomeu Dias, first to sail around the Cape of Good Hope, and Vasco da Gama, first to sail from Europe to India. And another two panels show eminent leaders and thinkers, including Britain's Richard the Lionheart, France's Jeanne d'Arc and the American presidents Thomas Jefferson and Abraham Lincoln.

The stained-glass panels were originally mounted in the windows of the school's library. They were later removed and sat propped against the wall for decades. About ten years ago the panels were remounted back in their original location. The library has changed drastically over the years, but the windows endure at 4343 West Wrightwood Avenue on the Northwest Side.

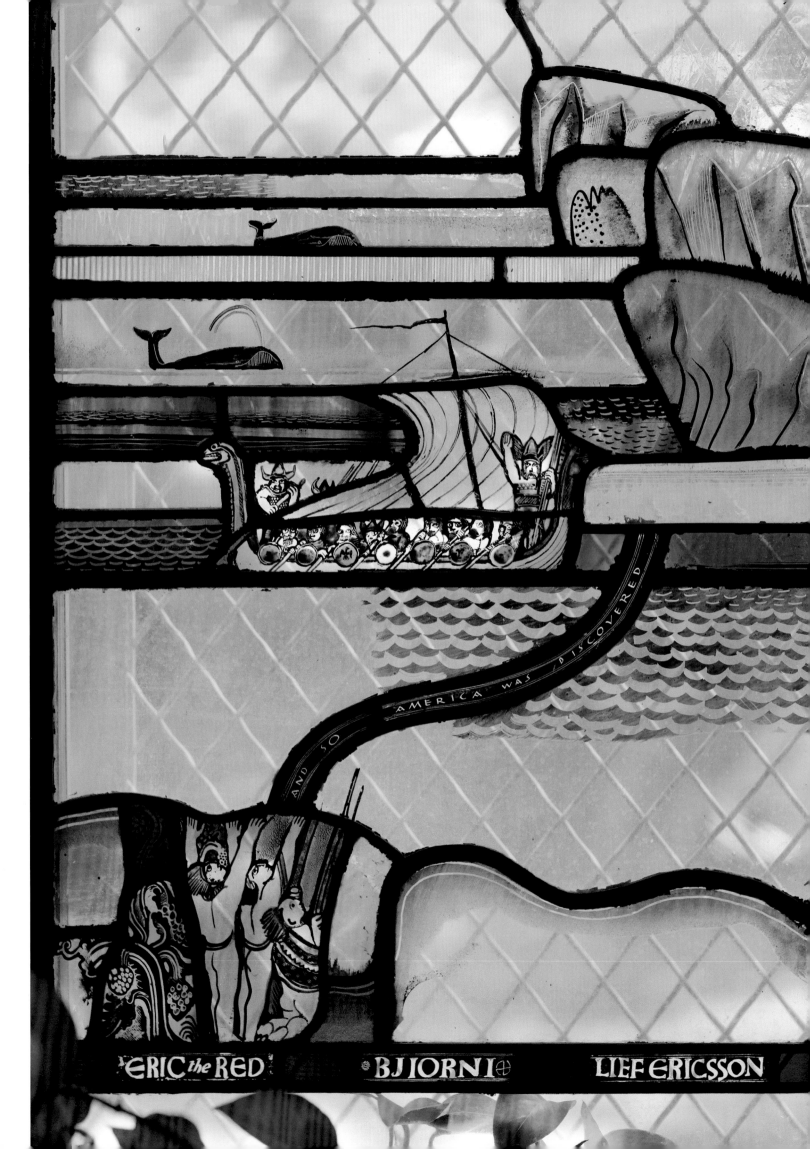

AND SO AMERICA WAS DISCOVERED

ERIC *the* RED BJIORNI ⊕ LIEF ERICSSON

MARCO · POLO · WENT · INTO · THE · FAR · PLACES · OF · THE · EAST ·

IBN BATUTA WENT TRADING INTO THE MIDDLE OF AFRICA

FRIAR ODORIC　　　　　CONTI　　　　　BENEDICT GOES

DEDICATED · TO · OUR · PRINCIPAL · MR · C · E · LANG · BY · THE

AMERICA

TIERRA DEL FUEGO

MAGELLAN SAILED INTO THE UNKNOWN PACIFIC AROUND SOUTH AMERICA

CORONADO WENT HUNTING THE GOLDEN CITIES OF CIBOLA

VASCO da GAMA DIAS DE SOTO BALBOA

JANUARY CLASS · IN GRATITUDE AND ADMIRATION · Helwyn Park 1933

THE TERROR AT THE WORLD'S EDGE

CHRISTOPHER COLUMBUS ALCAME ACROSS THE ATLANTIC TO DISCOVER THE NEW WORLD

HENRY *the* NAVIGATOR OJEDA VESPUCCI

LA SALLE WAS PROBABLY THE FIRST TO COME THROUGH THE COUNTRY WHERE CHICAGO NOW STA...

LAK... MICHIGAN

CHAMPLAIN | CARTIER | JOHN SMITH | STUYVESANT

NAPOLEON WAS LEADER OF THE FRENCHMEN.

...ASHINGTON LED THE AMERICANS

CHARLES XII | GARIBALDI | JEFFERSON | LINCOLN

...IS WINDOW IS DEDICATED TO ALL LEADERSHIP ~ BY THE JUNE GRADUATION CLASS 1933

PABST BLUE RIBBON ROOM

ALL THE TRADES CONNECTED TO BREWING ARE REPRESENTED IN MILLER'S HISTORY OF BEER MAKING.

FOLLOWING PAGES: EACH WALL AT THE PABST BLUE RIBBON ROOM STERNEWIRT TELLS A STORY.

During his career, Edgar Miller executed dozens of commercial commissions in restaurants, clubs, hotels and department stores. Only a handful exist today.

Against all odds, the Pabst Blue Ribbon Room still stands in downtown Milwaukee. Despite years of neglect, it remains one of Miller's triumphs.

On the grounds of what used to be the largest brewery in America, the company built the Pabst Blue Ribbon Room in the early twentieth century to entertain clients and guests. The structure was designed to resemble a traditional German Sternewirt, or private beer hall, with a bar and tables on the first floor and a small gallery with seating on the second. In 1943, Miller was hired to paint a simple history of brewing on the bare walls, but after much research and seven weeks of painting, he transformed the space into a veritable shrine to the malt beverage.

Painting in fresco, Miller covered most every aspect of brewing as well as the many workers that make the product possible, including glassblowers, barrel makers, pipe fitters and—of course—barmaids. Miller drew on his own background to bring the material to life. "Ever use a scythe?" he asked a reporter for the Milwaukee Journal. "I have," Edgar responded. "I used to cut the sweet clover of the irrigation ditch in the Snake River Valley when I was a boy."

In 1996, the brewery at North Ninth Street and West Juneau Avenue shut down when the Pabst Brewing Company was sold. For the next decade, Miller's work was exposed to extremes in the unheated Pabst Blue Ribbon Room. But it has survived, and it may be seen again when the brewery reopens as a residential and commercial complex.

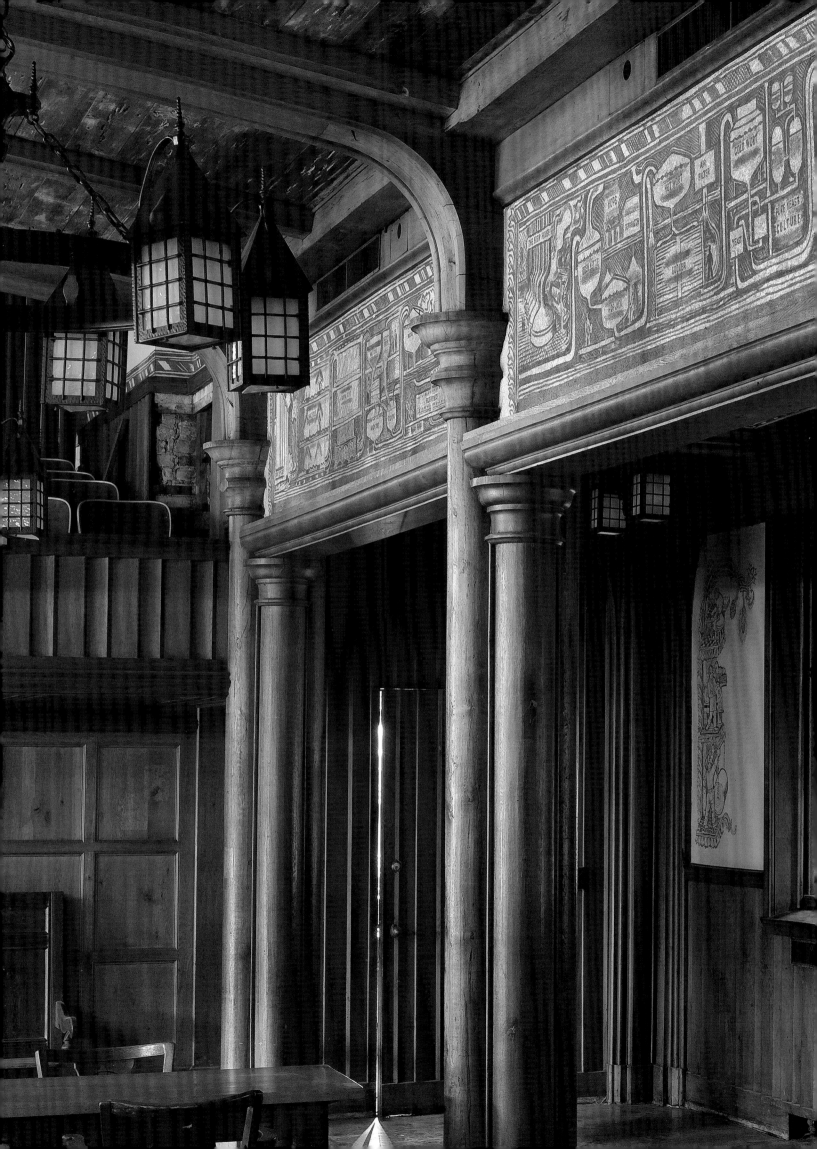

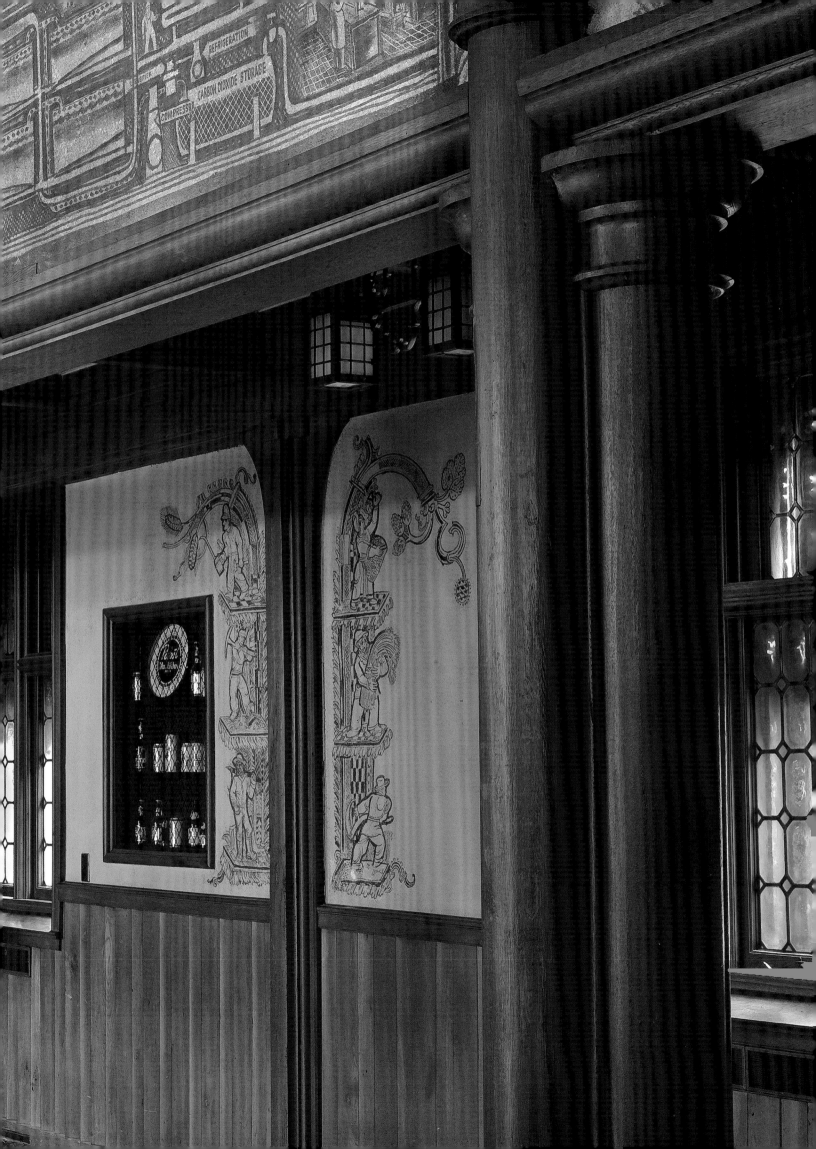

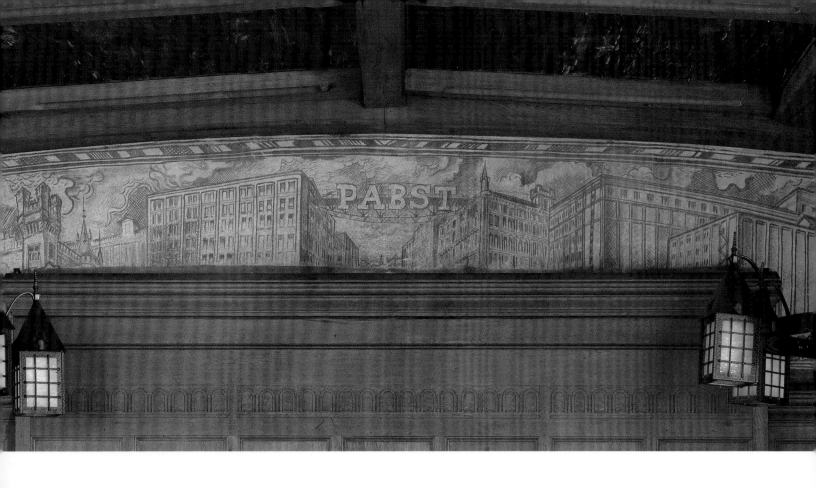

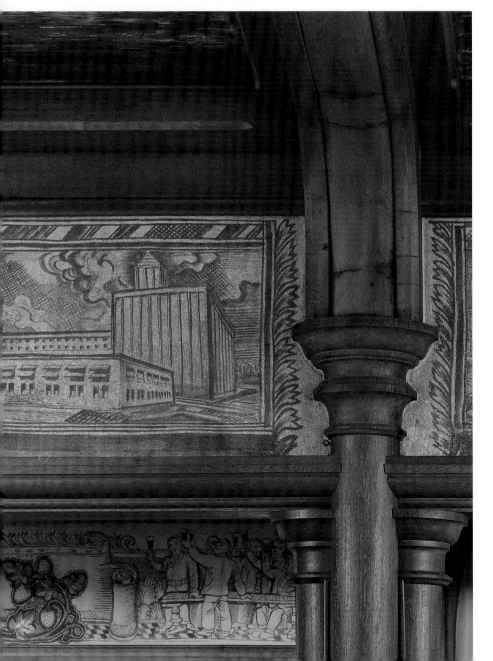

EDGAR'S WORK AT THE PABST
BREWERY WAS CHRONICLED
BY THE MILWAUKEE JOUR-
NAL, WHICH DECLARED THAT
THE MURALS WERE DONE IN
"RECORD TIME." FOR MORE
THAN FIFTY YEARS, THE
MURALS GREETED DELIGHTED
GUESTS. THE TAPROOM AT THE
END OF THE FORTY-FIVE MIN-
UTE BREWERY TOUR WAS THE
HIGHLIGHT BECAUSE ADULTS
WERE OFFERED FREE DRAFT
BEER THERE.

FOLLOWING PAGES: THE SMALL
TASTING ROOM OFF THE MAIN
HALL.

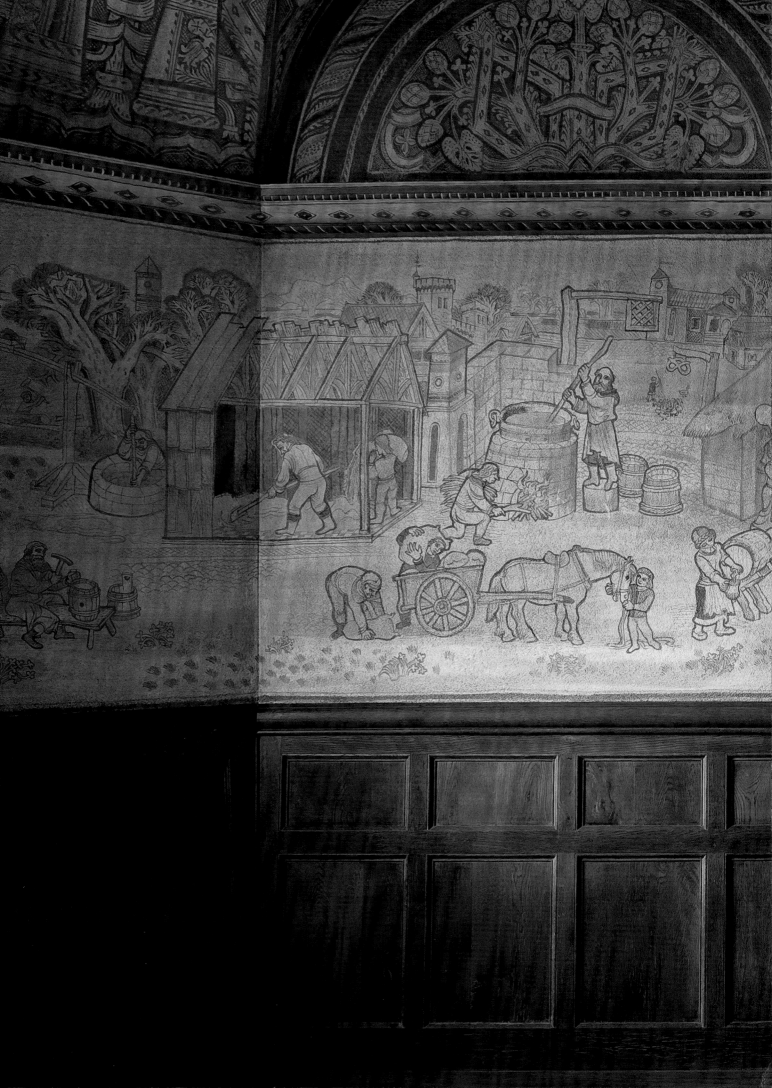

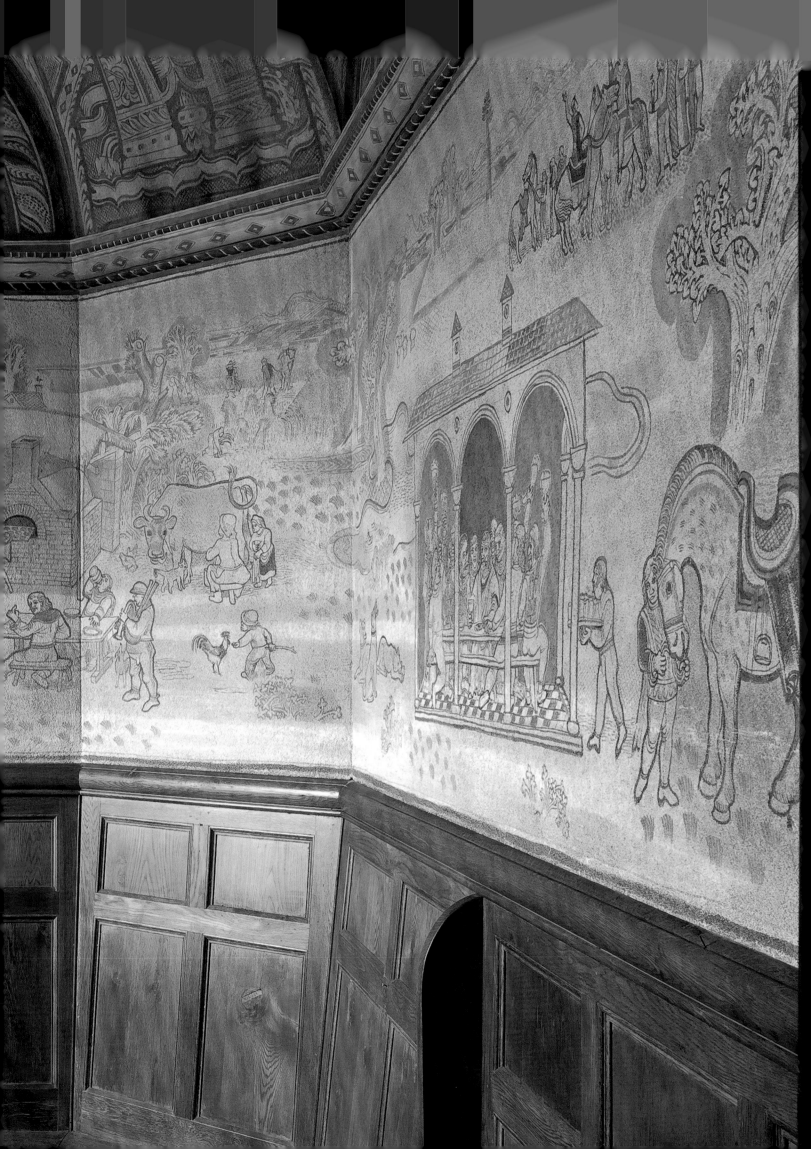

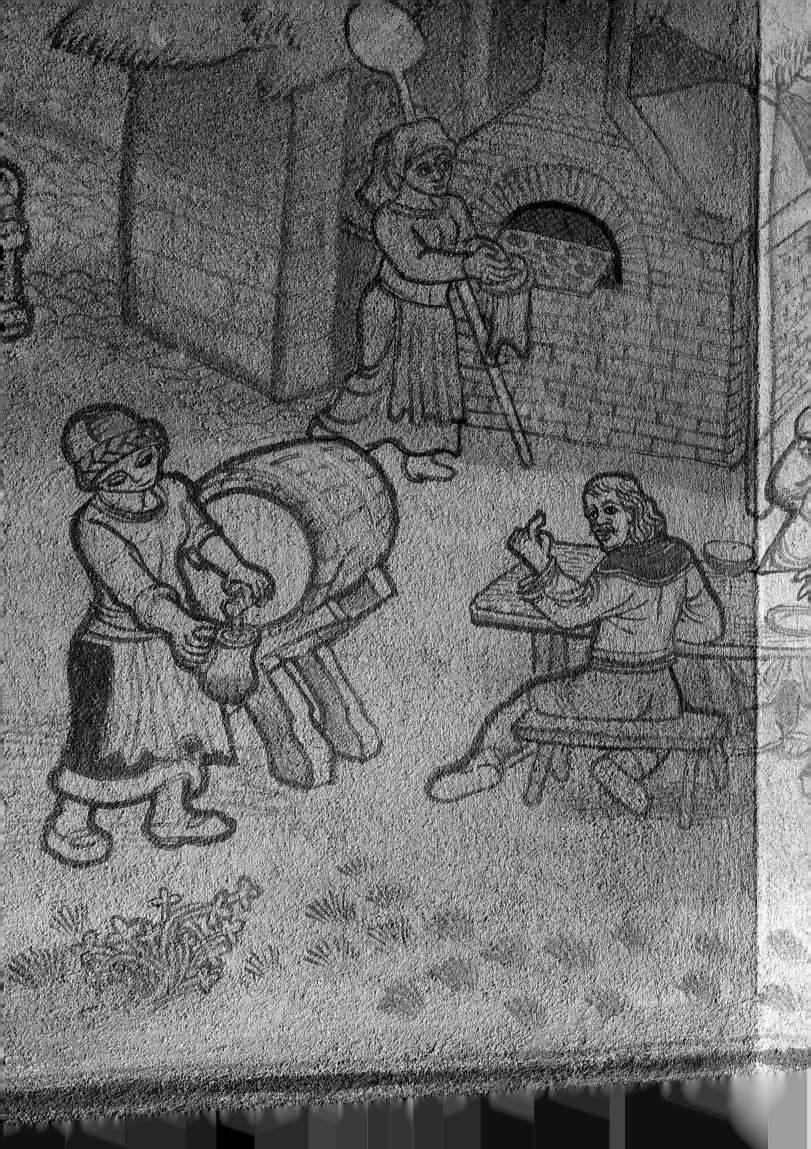

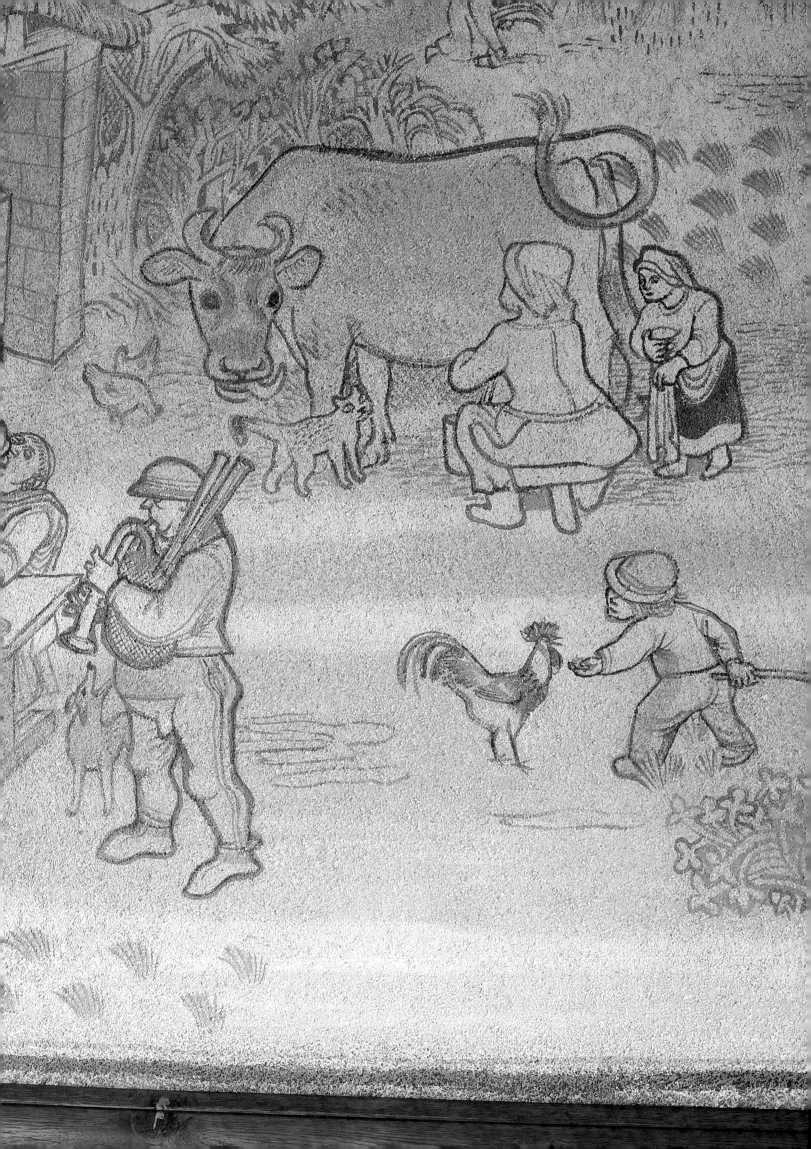

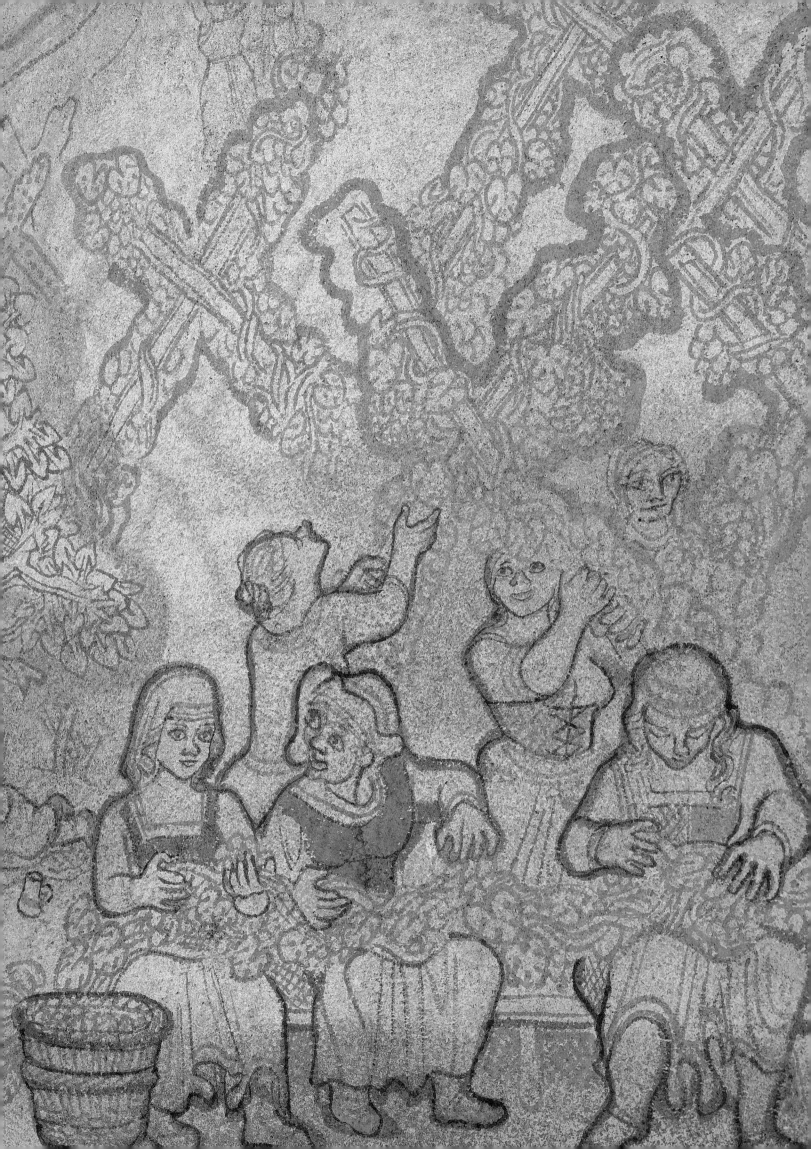

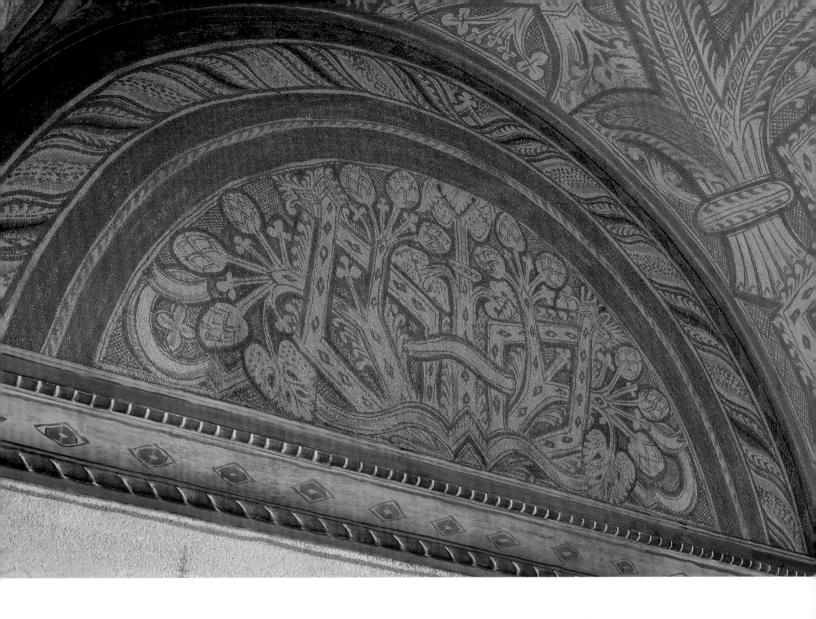

MILLER REFUSED TO USE THE
POPULAR COLORS OF THE
DAY WHEN CHOOSING HIS
PALETTE. "TAKE SOME SIMPLE
COMBINATION OF COLOR,"
MILLER WROTE , "GIVE IT
AN APPEALING NAME SUCH
AS POWDER BLUE, BUTTER
YELLOW, OYSTER WHITE, OR
A CHIC FOREIGN NAME LIKE
BEIGE OR BOIS DE ROSE;
REPEAT IT EXCLUSIVELY,
WHETHER IT IS WELL OR BADLY
USED, NO MATTER, AND IT
BECOMES THE MODE. SENSE-
LESS REPETITION CAUSES
THE PUBLIC TO TIRE, AND
ANOTHER 'NEW' MODE IS
BORN."

375

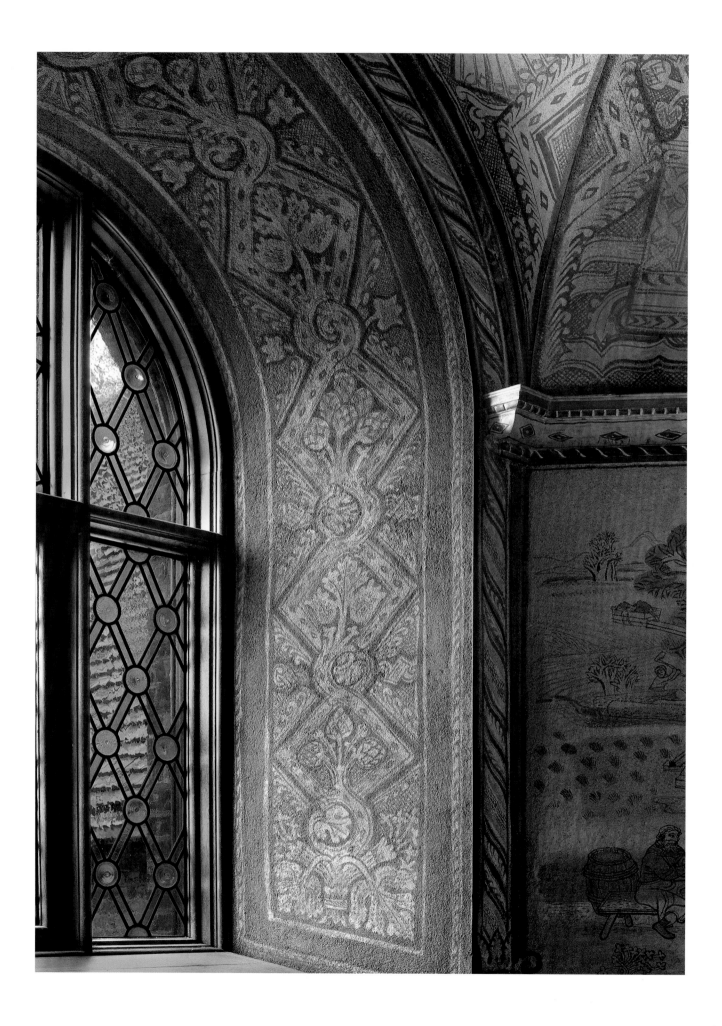

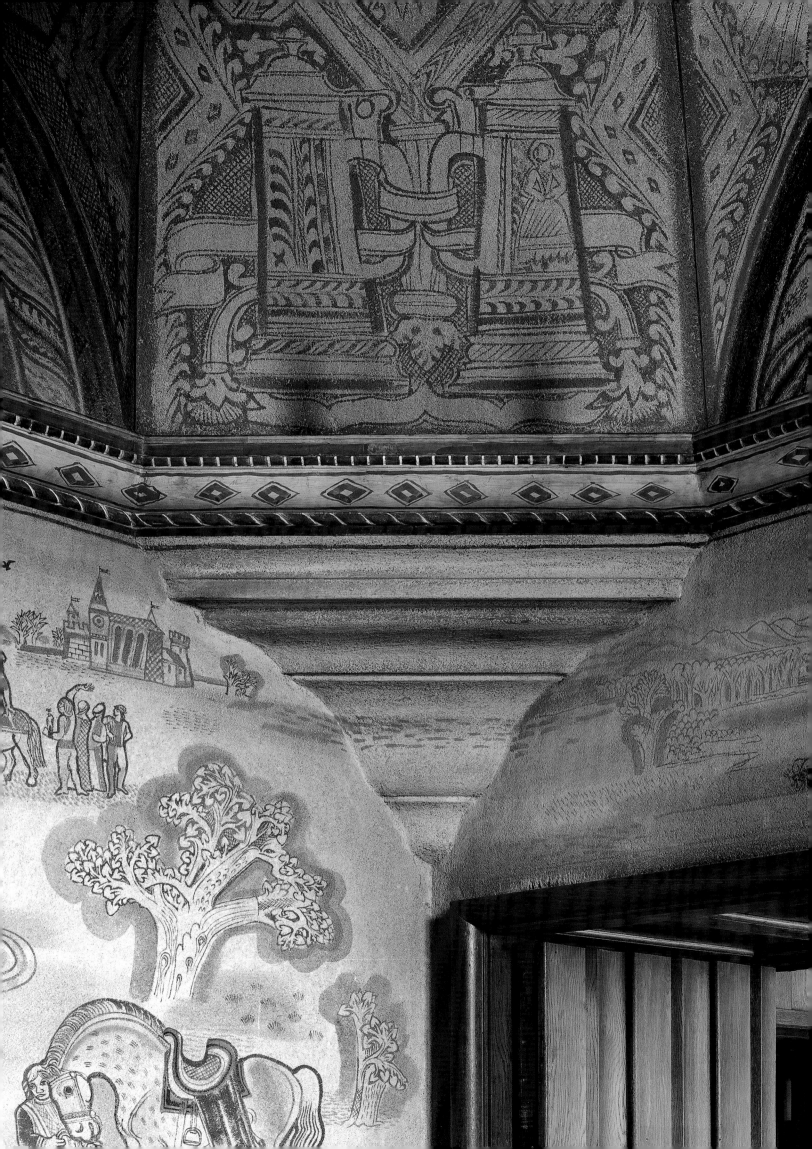

STANDARD CLUB

MILLER'S GREAT CHICAGO FIRE MURALS START WITH MRS. O'LEARY'S COW AND ENDS WITH THE REBUILDING OF THE CITY.

FOLLOWING PAGES: MILLER WROTE OF THE MURALS: "I WAS INTERESTED IN CATCHING THE HUMAN PATTERN RATHER THAN THE DISASTER ITSELF."

Edgar Miller spent most of 1954 telling the story of the Great Chicago Fire—in black linoleum. It took him nearly a year to carve the four huge panels, each six by twelve feet, hanging in the first-floor lounge at the Standard Club, at 320 South Plymouth Court in the Loop.

Using tools more appropriate to wood-carving, Miller carefully chiseled and gouged out the design like a sculptor, working on the murals in his Sheridan Road studios. "One line led to another," said Miller, who used no preliminary sketches. Edgar had only one chance to make each mural—for if his instincts led him astray, there would be no way to cover his mistakes.

While unusual, using linoleum for murals is not unique. Printmakers often use linoleum to make block relief prints, although Miller was fonder of using wood. Starting in the 1930s, students in art and handicraft classes often carved designs in linoleum for wall hangings.

The most likely influence on Miller was the work of Pierre Bordello, a contemporary whose linoleum carvings were found in ships and railroad cars during the 1940s and '50s. His carved and lacquered linoleum creations decorated bar fronts in buffet and observation cars as well as maps in railroad coffee shops. Miller might have been exposed to Bordello's work while researching his own railcar project, begun in 1955 for the Northern Pacific Railway.

Edgar also created a pair of sandblasted and stenciled glass doors for the Standard Club, using the techniques he had for the Diana Court windows two decades earlier. The theme of the Great Chicago Fire continued on the doors, with Miller playfully depicting Mrs. O'Leary's overturned stool and a fireman and his dog responding to the disaster.

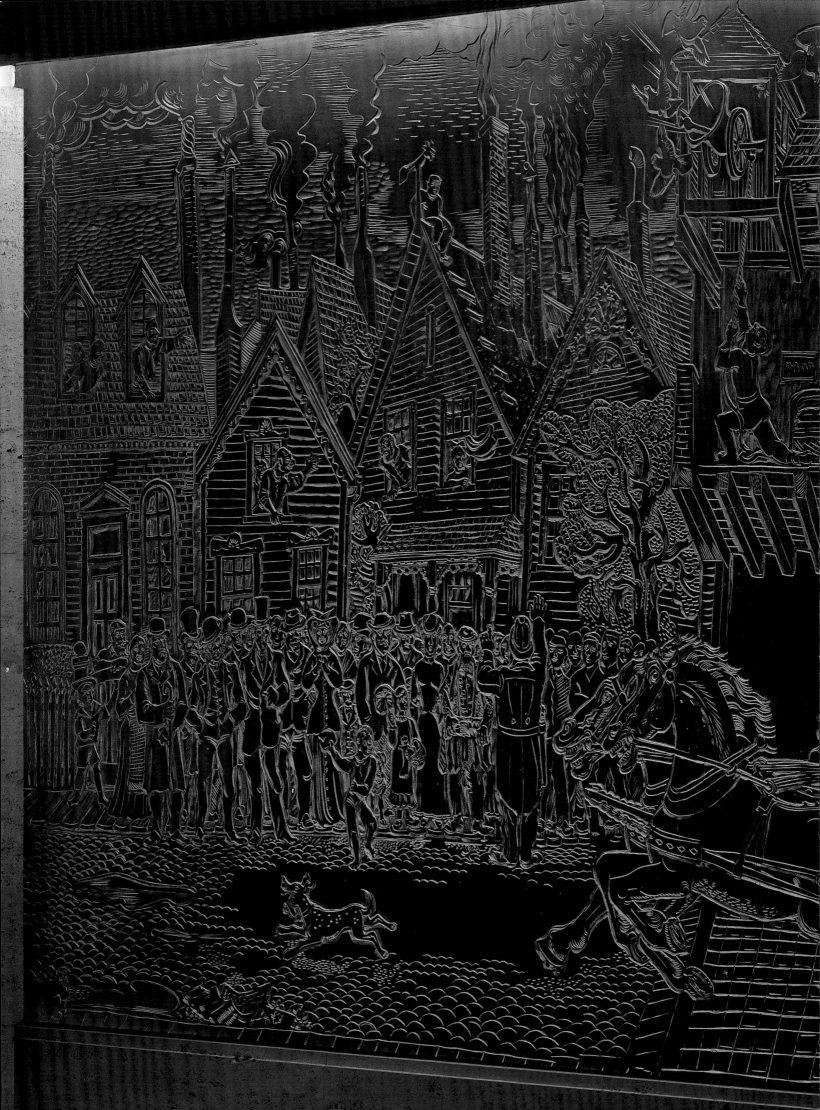

"AT FIRST THE PEOPLE JOKED ABOUT HOW IT WOULD BE AN IMPROVEMENT TO THE CITY TO BURN OUT THE RICKETY BUILDINGS OF THE PATCH," MILLER WROTE. "BUT IT BECAME A SERIOUS MATTER WHEN THE SPARKS LEAPED OVER THE WIDE STREETS AND BEGAN TO BURN THE FASHIONABLE HOUSES NORTH TO ADAMS, MADISON AND LAKE."

FOLLOWING PAGES: THE FOUR MURALS ARE A DETAILED LOOK AT THE REBUILDING OF A CITY THAT EDGAR MILLER GREW TO LOVE.

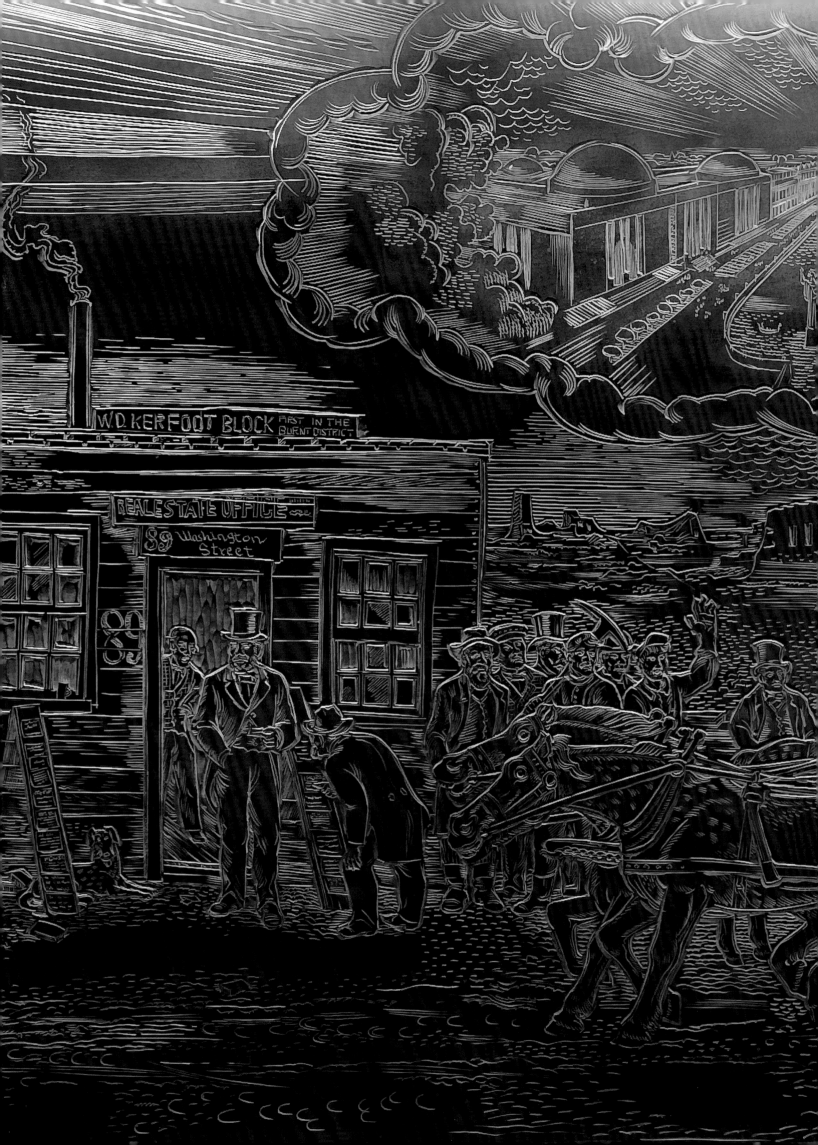

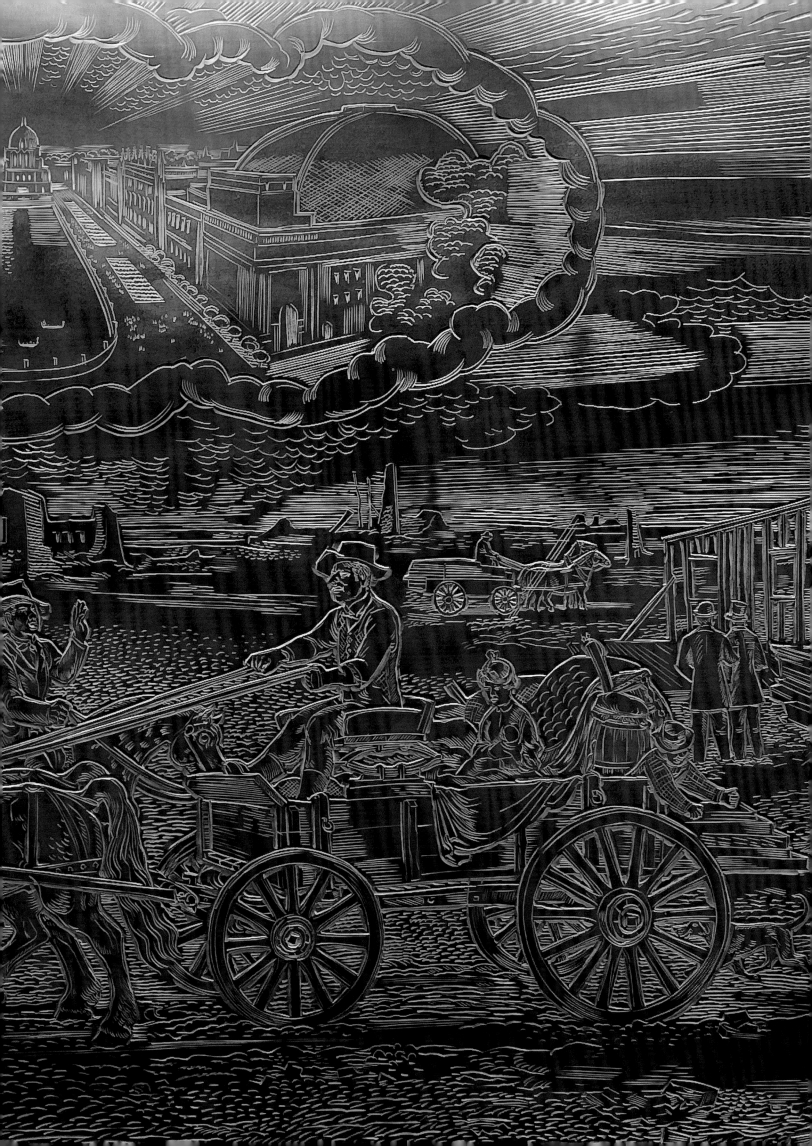

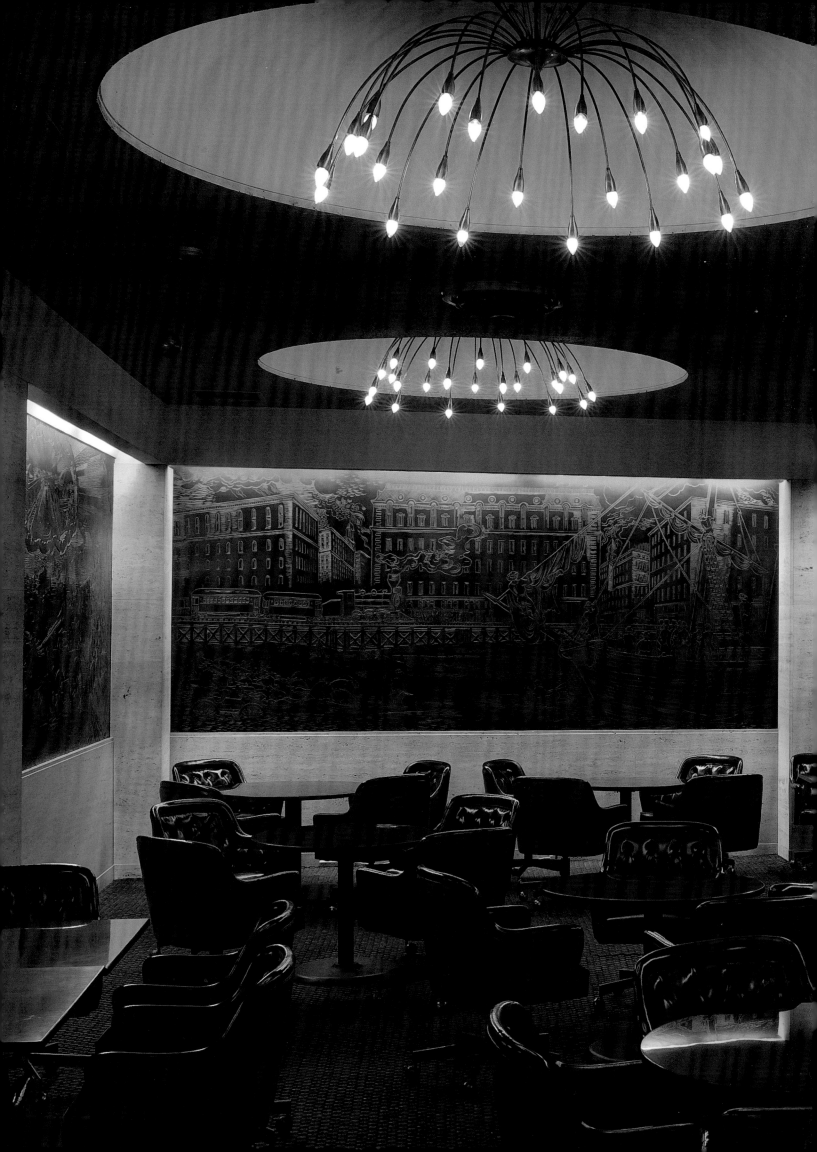

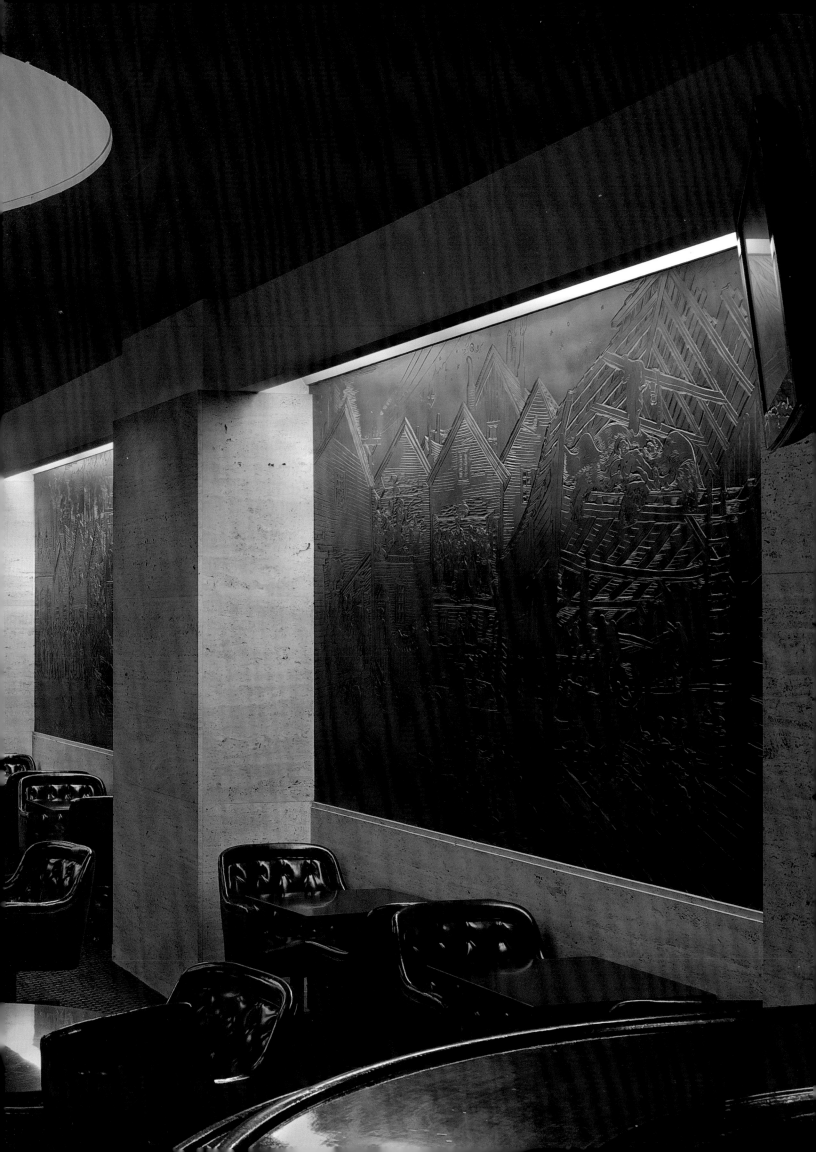

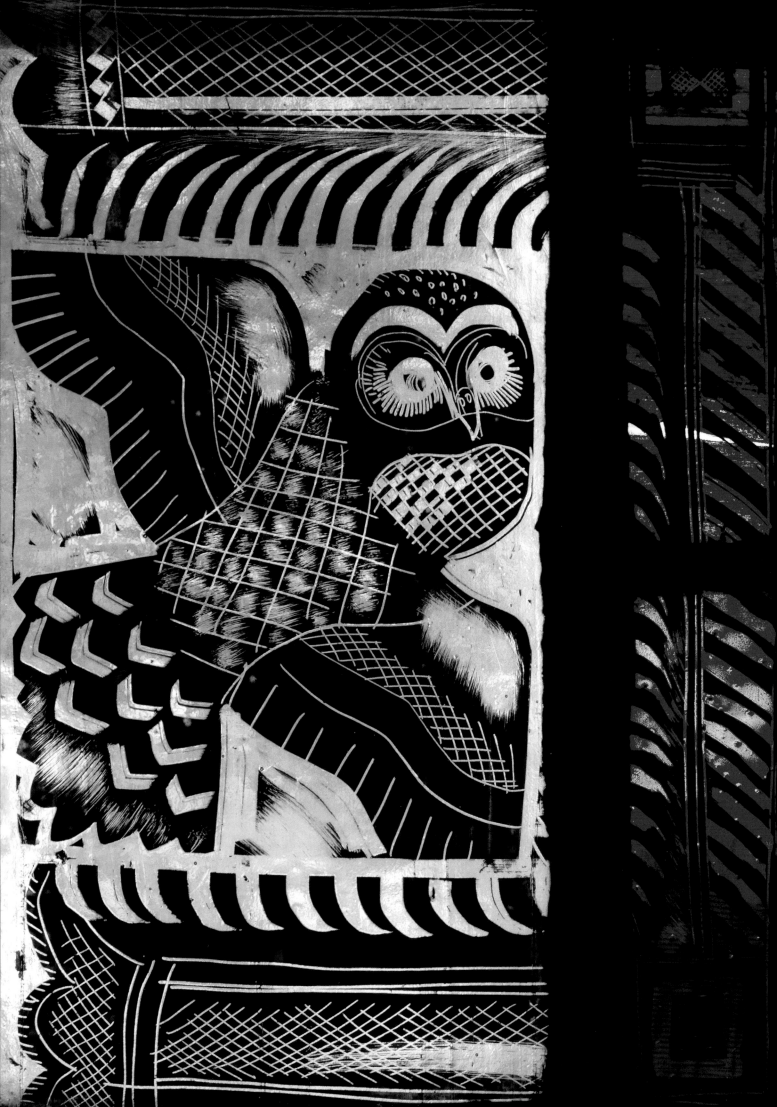

PART IV

Back Story

I'm getting tired. The one positive thing I have to say: Art began with the realization of life, and if you realize life, art will begin in you.

ACKNOWLEDGMENTS

To bring Edgar Miller to life and revisit the art he left behind, we depended on a far-flung cast. First and foremost, we must thank the owners of Edgar Miller's handmade homes, who welcomed us and let us document their "artistic studios." They include Mark Mamolen, Glenn Aldinger, Jannine Aldinger and Ron Cieslak, who live in or own the Kogen-Miller Studios; Ginger Farley, Bob Shapiro, Beth Jo Berkowitz, Ruben Sklar and Ingeborg Kohler, from the Carl Street Studios; Karen Harrison, Walter Freedman and Gerald W. Adelmann of the Walter Guest Apartments; and Michael Marienthal and Billy and Tasia Kerstein of the Frank F. Fisher Apartments. Roselynn Don and Gail Anderson, who live in homes with Edgar Miller art, also welcomed us and our cameras.

To better understand the handmade homes, we relied on Bob Horn and Larry Kolden, who have been updating Edgar's work for decades. Several owners and former owners of Miller homes shared their experiences and insights, including David Cooper, Michael Egan, Maureen Mohr, Robin Johnson, George "Jib" Chapman, Brian Ortiz and Kathryn and Gerald Molitor. Although living in a Miller studio can mean a sacrifice of space and modern conveniences, said Ortiz, a longtime owner and tenant, "I still find something new all the time."

The owners and managers of several buildings in the handmade tradition opened their facilities to photographs. They include Denise Bullocks of the Oakridge Abbey, Nancy Wickland of the First Presbyterian Church of Evanston, Christopher Bielat of the YMCA of Metropolitan Chicago, Jim Haertel of the Pabst Blue Ribbon Room, Sandra Fontanez-Phelan of Kelvyn Park High School, and Andrzej Dajnowski, who has started restoring Miller's Animal Court sculpture from the Jane Addams Homes in his Forest Park studios.

One of the most prominent artists in Chicago from the 1920s to the 1950s, Edgar Miller was mentioned in hundreds of articles in the *Chicago Tribune,* the *Chicago Daily News* and other newspapers. But he is largely forgotten today. The massive *Encyclopedia of Chicago,* for instance, lists fifteen Millers in its index, and none are Edgar.

Leading us in the search for information was Larry Zgoda, Edgar's friend and chronicler during the last ten years of Miller's life. Zgoda collaborated on twenty-six stained-glass windows with Miller and collected a remarkable amount of original material and newspaper clippings on Edgar's life, material that made this project much easier. He and P. K. VanderBeke have photographed more than two thousand items associated with Miller's career and deposited that digital collection in the Ryerson and Burnham Libraries of the Art Institute of Chicago. Zgoda not only shared his decades of research but also guided us to new sources and helped us shape the text of the book.

Also instrumental in tracking down information were Mark Mamolen, Jannine Aldinger and Glenn Aldinger, who purchased and saved boxes of Edgar's records and art, and offered us every shred of material they could find.

Tim Samuelson, the city's cultural historian and a Miller fan for decades, assisted us in many ways—particularly to understand the influence of Iannelli Studios on Edgar's work. He also showed us how to retrieve and make sense of building records stored in the basement of City Hall. The historian Robert Bruegmann helped us understand Edgar's work with Holabird and Root and focused our attention on North Dakota's capitol, which he calls one of the most important modern buildings of the century. Rick Nelson, Edgar's attorney and friend, explained the Florida years. Kristine Lang and Claudette Bour gave us insight into Edgar's final years.

Our work was made much easier by previous scholarship on Edgar, particularly work done by Sarah McCracken Potter, Duncan Hamilton, David Kate, Alicia Healy, Karen Lilly Mozer, Jonathan Black and Tim Frye. Potter and Frye each shared their theses, which set the stage for further research. Mozer, along with the Miller devotee Bob Roth, encouraged us to take the reins of the project.

To tell Edgar's story, we first relied on firsthand information, material written by Edgar, Frank and Hester, who must have been a formidable trio in Idaho Falls. Despite the fact that Edgar never trusted words, he was a fine writer, able to use his artist's eye to pick out telling details. We are glad that Edgar took writing classes while in Florida, because he mostly wrote rich accounts of his early life. He was also an excellent letter writer. Once you figure out his script, his letters open up his thoughts during his later years of exile from Chicago. Edgar also left dozens of

sketchbooks, which showed us what he was seeing.

Frank Miller lived and wrote with his heart first. Because of his unwavering loyalty, he is certainly a hero in this story. His account of the time he and Edgar spent with their father in Australia, which he titled "Bees in His Bonnet," is a wonderful, detailed gift to the Miller family, biographers and readers. Likewise, Hester Miller Murray's diary, "The Bitter and the Sweet," clarified Edgar's unique place in the Miller family.

Edgar's children were generous in helping us comprehend a man they knew often put art before family. Gisela Titman, Edgar's daughter from his first marriage, offered insight into the relationship between Edgar and Dorothy Ann Wood. Ladd Miller, Edgar's son from his second marriage, clued us in to Edgar as a father, and explained Edgar's art theories.

Also filling key gaps were Paul Miller, Frank's son, who provided us with photographs and written material, and Edgar's relatives Elizabeth van den Heuvel, Cathy Lass, Candy Lonis, David Dragovich, Roxanne Dragovich and Joyce Miller.

To better understand Sol Kogen, we relied on his daughter B. J. Ryan, niece Llois Alpert Stein, nephews Arthur "Buz" Alpert and Earl Kogen and grandnieces Doreé Stein and Ann Kogen. Every family member greatly admired Sol for his business acumen, artistic ability and good looks. The family's copy of "Autobiography of Isaac Bernard Kogen" gave us a peek into the life of Sol's father.

Elisabeth Simons, the daughter of Rudolph Glasner, and his relative Ann Serafin discussed the man who funded Edgar's largest studio on Wells Street. Andrew Rebori's relatives—Elizabeth Frothingham, Niall H. O'Malley and Andrew N. Rebori—painted a portrait of Edgar's artistic coconspirator. And Esperanza Dominques MacNeilly told us about her talented uncle Jesus Torres.

Women loved Edgar, and we were happily distracted tracking down stories of his admirers. Only a few made the book, but we got tips from Mike and Jill Shields, whose grandmother Ruby Welcher was enamored of Edgar, and from Marsha Segerberg, whose aunt Olga Segerberg was a mysterious love interest during the late 1920s and early 1930s.

Also helping were Mary Constable, Doug

THE GARDEN OF PARADISE ROOM SERVED AS A STUDY FOR MILLER'S ART AND ARTIFACTS.

DOCUMENTA-
TION OF EDGAR
MILLER'S WORK
TOOK PLACE
DURING THE
SUMMER OF
2008.

Sovonick, Elizabeth Broman, Mary Alice Evans, Carla Vanessa Mueller, Howard Kruse, Bart Ryckbosh, Mary Woolever, Scott Elliott, Don Rose, Terry Tatum, Bob Sideman, Stanley Paul, Alan Artner, Marie-Laure McKee, Ann Doemland, Nancy Poore, Barton Faist, Tom Sole, Julie Bleicher, David Jameson, Sunny Fischer, Bill Kuebler and Keith Sadler. Bonita Mall, Susan Mastro and Zurich Esposito told us about Miller's last public appearance. Sarah Rogers, of the Graham Foundation for Advanced Studies in the Fine Arts, went out of her way to allow us to listen to a taped Miller lecture. Carla Owens, of the Brookfield Zoo, spent hours tracking down Miller's work there. And Sheila Malkind, whose *Chicago Reader* article is the best profile ever written about Edgar, was kind with her time and encouragement.

We received valuable research assistance from the Chicago History Museum, Newberry Library, Museum of Idaho, Northwestern University Library and University Archives, Chicago Public Library, Evanston Public Library and Skokie Public Library.

Assisting with pictures were Erin Tikovitsch and John Alderson, of the Chicago History Museum; Cathy Cadd, who found the Jo He photos; Ginger Farley, who unearthed old photos of the Carl Street Studios; Vicki Quade, who opened the files of Paul Hansen, a longtime Miller friend, and David Phillips.

Amy Schroeder led the copy editing team, which included Caleb Burroughs.

Special thanks go to Cate Cahan and Karen Burke and Nora Nixon Vertikoff, who put up with husbands who never know when to stop. And to our families: Elie and Maddie Burroughs; Claire, Aaron and Glenn Cahan; Sheila and Jackson Williams; Daisy Castro; Christopher and Caedan Jinks, Carmen and Cole Vertikoff.

Mark Mamolen encouraged and supported this project from its conception. Mamolen is rightfully proud of the role he played in Edgar Miller's life, and he can be proud that he plays a role in Edgar's legacy.

A Few Secondary Sources

We relied on dozens, if not hundreds, of books to better understand the Chicago art scene. Few books mention Edgar Miller or his studio complexes, so we also depended on magazine articles. Here is a list of twelve books and magazines that we found most helpful.

Bruner, Louise. "Edgar Miller: A Versatile Artist and Craftsman," *American Artist,* May 1963.

Hochman, Paul A. "A Designer's Eccentric Moderne Vision Lives on in a Chicago Apartment," *New York Times Magazine: Home Design,* October 10, 1993.

Malkind, Sheila. "Always an Artist," *Chicago Reader,* April 23, 1993.

Matsoukas, Nick J. "The Kogen-Miller Studios," *Western Architect,* December 1930.

Mavigliano, George J. *The Federal Art Project in Illinois, 1935-1943.* Carbondale: Southern Illinois University Press, 1990.

Mix, Sheldon A. "Burton Place: The Handmade Street," *Chicago* magazine, Spring 1966.

Newman, Christine. "An Old Town Odyssey," *Chicago* magazine, October 2000.

Prince, Sue Ann, ed. *The Old Guard and the Avant-garde: Modernism in Chicago, 1910-1940,* Chicago: University of Chicago Press, 1990.

Rebori, A. N., and Miller, Edgar. "There Are Decorative Objectives in Apartment Planning," *Architectural Record,* October 1937.

Reed, Earl H., Jr. "Edgar Miller, Designer-Craftsman," *Architecture,* August 1932.

Roberts, Edith. "There's No Place Like Burton Place," *Chicago* magazine, March 1956.

Schlesinger, Toni. "Old Town's Mad Masterpiece," *Chicago* magazine, May 1988.

A Note on the Photography

The contemporary photographs in this book show Edgar Miller's handmade homes as they look today. They were built in the 1920s and '30s by Miller and his assistants and have evolved over the decades. Numerous artists have kept Miller's work alive by preserving his studio complexes and creating new work inspired by his original environments. Most prominent among them are Bob Horn, Larry Kolden, Claudia Cleveland, Bob Meyer, Kathryn Quinn, Darcy Bonner, Karen Lilly Mozer and Robin Johnson. Many others, too, have helped in this mission; their ideas and work have shaped the homes and are clearly evident in these photographs.

Alexander Vertikoff, who took the contemporary photos, specializes in available-light photography blended with a bit of digital manipulation, magic and luck to create images that allow viewers to experience the unique personalities of special spaces.

CHRONOLOGY OF OTHER WORK

THE HOUSE OF ENDLESS
DOORS ILLUSTRATION, 1922

BAUER AND BLACK ADVERTISEMENT,
CIRCA 1923

DIL PICKLE POSTER, CIRCA
1925

A. G. THOMSON HOUSE,
DULUTH, MINNESOTA, 1926

WOODCUTS SHOWING TWO
COMMISSIONS, CIRCA 1926

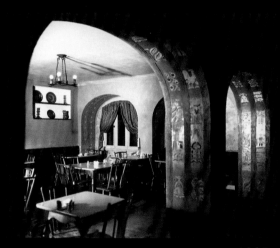

VASSAR HOUSE RESTAURANT, CHICAGO, 1925

ALSO—1925: DECORATIONS FOR THE RUSSIAN FROCK TEA ROOM, 749 NORTH RUSH STREET, CHICAGO. 1926: STAINED-
GLASS WINDOWS FOR CHURCH OF CHRIST THE KING, 1520 SOUTH ROCKFORD AVENUE, TULSA, OKLAHOMA. 1929:
FRESCOES, CARVINGS AND INTERIOR WORK FOR CINEMA ART THEATER, CHICAGO AVENUE NEAR MICHIGAN AVENUE, CHICAGO.

DRAWING OF PROPOSED WORLD WAR I MONUMENT, 1926

BOOK COVER, 1928

ADVERTISEMENT, CIRCA 1928

MOCKUP OF PROPOSED UNITED STATES GYPSUM MAGAZINE, CIRCA 1928

CARVINGS AT HIGHLAND PARK (ILLINOIS) PRESBYTERIAN CHURCH, CIRCA 1928

1933: PAINTING ABOVE THE BAR AT GREAT NORTHERN HOTEL TAPROOM, DEARBORN STREET AND JACKSON BOULEVARD, CHICAGO. 1934: WOODEN STATUE OF KING GAMBRINUS FOR OLD HEIDELBERG INN, 16 WEST RANDOLPH STREET, CHICAGO. 1935: "GREAT GENERALS OF HISTORY" MURAL AT 885 CLUB, RUSH STREET AND DELAWARE PLACE, CHICAGO.

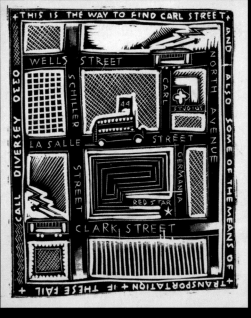

INVITATION TO FIRST CARL STREET STUDIOS
ART SHOW, 1927

CARVED BENCH, CIRCA 1931

DETAIL FROM DIANA
COURT WINDOW, 1929

EDGAR'S BRACELET TO DALE,
1933

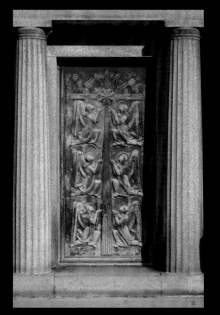

EDWARD CUDAHY MAUSOLEUM, CALVARY CEMETERY, EVANSTON, 1933

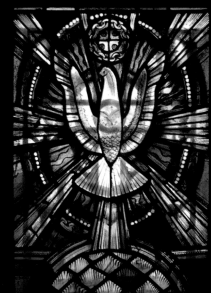

1935: BRONZE FIGURES FOR ENTRANCE OF HENROTIN HOSPITAL, OAK AND LASALLE STREETS, CHICAGO. 1936: ILLUST
TIONS FOR ATLAS OF THE WORLD FOR CONTAINER CORPORATION OF AMERICA. 1937: ILLUSTRATIONS FOR PAPER, WAS
AND PACKAGES: THE ROMANTIC STORY OF PAPER AND ITS INFLUENCE FOR CONTAINER CORPORATION OF AMERICA.

PROGRAM COVER, 1932

THE PERFUMED SAVAGE · BY ESTELLE BRINKMAN

BOOK COVER, 1933

STONE CARVINGS FOR MADONNA DELLA STRADA CHAPEL, CHICAGO, 1937

1941: MURALS FOR MARSHALL FIELD'S PLAYROOM, STATE AND WASHINGTON STREETS, CHICAGO. 1941 AND 1946: MURALS, INCLUDING "HISTORY OF FOOD," AT HOTEL PIERRE, 2 EAST 61ST STREET AT FIFTH AVENUE, NEW YORK. 1944: MURALS AT NORTHWEST AIR TICKET OFFICE, MICHIGAN AVENUE AND MONROE STREET, CHICAGO.

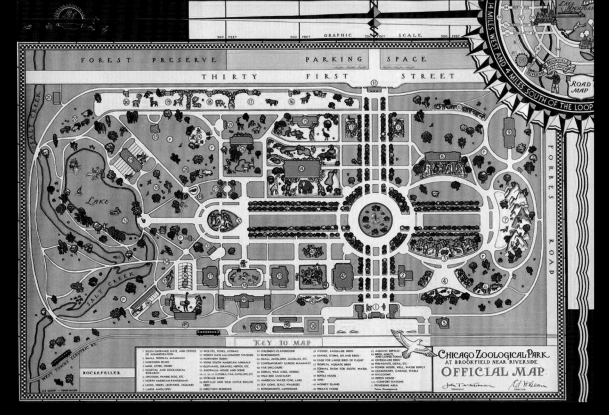

BROOKFIELD ZOO MAP, 1937

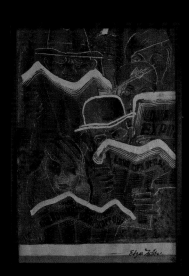

A PANEL FROM LOVE THROUGH THE AGES, 1934

TOMB FOR COLONEL ROBERT MCCORMICK AND WIFE AMY AT CANTIGNY, WHEATON, CIRCA 1937

1952: MURALS IN CASHIER'S DEPARTMENT OF CHICAGO TITLE AND TRUST, 111 WEST WASHINGTON STREET, CHICAGO.
1952: MURALS AT OAK ROOM BAR AT THE PALMER HOUSE HOTEL, 17 EAST MONROE STREET, CHICAGO. 1954: HOLY ARK
"TREE OF LIFE" AT TEMPLE EMANUEL, 5959 NORTH SHERIDAN ROAD, CHICAGO.

AGES OF LOVE, 1939

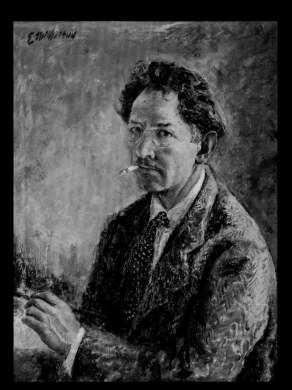

SELF-PORTRAIT, 1944

PEOPLE TO REMEMBER, A GIFT TO IRIS ANN MILLER, 1939

1954: MURAL FOR THE HUDSON PULP AND PAPER BUILDING ON MADISON AVENUE IN NEW YORK, 477 MADISON AVENUE, NEW YORK. 1957: ILLUSTRATIONS FOR FILMSTRIPS ON AMERICAN INDIANS FOR ENCYCLOPEDIA BRITANNICA. 1957: MURALS AT TALMAN FEDERAL SAVINGS AND LOAN ASSOCIATION, 5501 SOUTH KEDZIE AVENUE, CHICAGO.

RESTAURANT MENU, CIRCA 1940

MAP FOR NORTHERN PACIFIC RAILWAY'S
BUFFET LOUNGE CARS, CIRCA 1954

FABRIC BY EDGAR AND DALE MILLER, CIRCA 1953

1958: STAINED-GLASS WINDOWS FOR ST. DAVID'S EPISCOPAL CHURCH, 701 RANDALL ROAD, AURORA, ILLINOIS. 1959: MAP
MURAL AND MENU FOR THE MARCO POLO CLUB AT WALDORF-ASTORIA HOTEL, 301 PAR K AVENUE, NEW YORK.
1960: BRONZES OF SAINTS AT ST. MARY'S CEMETERY, 87TH STREET AND HAMLIN AVENUE, EVERGREEN PARK, ILLINOIS.

A PANEL FROM NEW LOVE THROUGH THE AGES, 1961

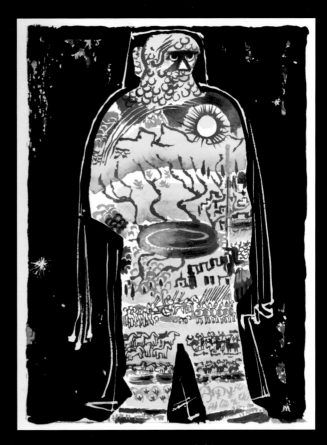

THE BOOK OF ECCLESIASTES, 1968

ORNAMENTAL TRANSOM, 1988

1965: CARVED DOORS AND GLASSWORK AT MAE HORWICH MEMORIAL CHAPEL IN MICHAEL REESE HOSPITAL, 29TH STREET AND ELLIS AVENUE, CHICAGO. 1984 AND 1988: WINDOWS OF BISHOP QUINTIN PRIMO AND REV. REMPFER WHITEHOUSE AT CHURCH OF THE EPIPHANY, 201 SOUTH ASHLAND AVENUE, CHICAGO.

PROJECT INDEX